YALE PUBLICATIONS IN THE HISTORY OF ART, 34
GEORGE L. HERSEY, EDITOR

RADIANCE FROM THE WATERS

Ideals of Feminine Beauty in Mende Art

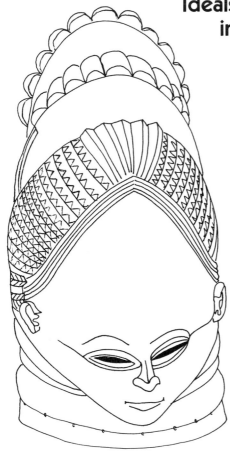

SYLVIA ARDYN BOONE

*Photographs by Sylvia Ardyn Boone
and Rebecca Busselle*

Yale University Press • New Haven and London

Photographs copyright © 1986 by Rebecca Busselle.

Designed by Nancy Ovedovitz and set in Baskerville type by
The Composing Room of Michigan, Inc. Printed in the United
States of America by Halliday Lithograph, West Hanover, Mass.

Library of Congress Cataloging-in-Publication Data
Boone, Sylvia Ardyn.
 Radiance from the waters.

 (Yale publications in the history of art; 34)
 Originally presented as the author's thesis (Ph.D.—Yale
University, 1979) under title: Sowo art in Sierra Leone.
 Bibliography: p.
 Includes index.
 1. Arts, Mende. 2. Arts, Primitive—Sierra Leone. 3. Sande
Society. 4. Feminine beauty (Aesthetics)
I. Title. II. Series.
NX589.6.S5B66 1986 700'.966'4 85-19077
ISBN 0-300-03576-4 (cloth)
ISBN 0-300-04861-0 (pbk.)

10 9 8 7 6 5 4 3 2

Dedicated to the memory of my mother
Alice Williams Boone

Ô tawa wa,
Ô nyapoi ma ngundia!

 Contents

 # Acknowledgments

This book is in honor and praise of Sowei, the wise women who are the leaders of the Sande Society. It is they who create the settings and situations in which Sande's lofty concepts and ideals are translated into a human program for female advancement. I want to express my admiration to the Sowei, and to all Mende women my appreciation for their sharing their lives with me. Conducting research on Mende arts on location in Sierra Leone is, frankly, always difficult and challenging. I must acknowledge my indebtedness to the "Bo preceptor" for taking me by the hand and giving me the language tools and knowledge of customs and traditions necessary for successful completion of my projects. He remains my companion and my guardian; so, as would a Mende woman, I bow to him, smile, and say, "*Bi siè.*" Correspondence with Harris Memel-Fotê, the Ivorian scholar, has inspired and guided my work; I am proud of his continued interest.

My dissertation on the Sande mask, "Sowo Art in Sierra Leone: The Mind and Power of Woman on the Plane of the Aesthetic Disciplines," was presented at the May 1979 Commencement of the Yale University Graduate School, and was awarded the Blanchard Prize in the History of Art. The three-year period of research abroad, 1975–78, on which that dissertation was based, was made possible by generous financial assistance from several sources. The Foreign Area Fellowship Program of the Social Science Research Council funded the first part of my work in England and later in Sierra Leone. A Dissertation Year Fellowship from the American Association of University Women and a grant from the Ford Foundation National Fellowships Fund financed additional research and then the write-up. The Concilium on International and Area Studies at Yale and the Roothbert Fund helped with initial supplements; and in the wings, blessing my graduate studies, the gracious mesdames D. M., and Simone Withers Swan. To all these organizations and persons, my gratefulness for their support.

Over the past several years, I have enjoyed further opportunities for travel, research, and writing on this and other art historical projects, made possible by a Yale Morse Fellowship in the Humanities and by grants from the American Council of Learned Societies and the American Philosophical Society. Again at Yale, the Center for International and Area Studies and the Griswold Faculty Research Fund have given welcome assistance. A special thank-you is due the Department of the History of Art for the generous subvention that paid most of the cost of the illustrations for this book.

To my professor and mentor, Robert Farris Thompson, I owe so much; I have benefited immensely from his example, teaching, and constructive criticism throughout my stay as a graduate student and faculty member at Yale. My deepest appreciation also to the Department of the History of Art, the Program in Afro-American Studies, and the African Studies Council, faculty and staff, for their continued interest in my intellectual and professional development. George A. Kubler, Vincent J. Scully, George L. Hersey, Anne Coffin Hanson, and John W. Blassingame have been especially encouraging.

Many librarians, curators, and collectors have made important data available to me, and I thank them all, especially J. Moore Crossey, who has never hesitated to assist. I shall always be grateful to Rebecca Busselle for making available her remarkable field photographs of Mende life; William L. Hommel and Priscilla Hinckley also were very considerate. There are several others I need to thank for their help: Eugenia W. Herbert kindly read an earlier version of this manuscript and offered invaluable suggestions for its improvement. Anne Granger gave unstintingly of her goodwill and expertise all along the way. Janet Giarratano came to to my aid with typing and other courtesies, as did Michael Bryant. I thank Judy Metro at Yale University Press for continuing to believe in and protect this book. Barbara Folsom, also of the Press, made it possible to get everything right.

It is only left to thank those loving hearts who saw me through. Bernard, Neville, Margaret Ruth, and Frederick were, as ever, sources of spiritual sustenance. The counsellors, K.N. and C.C., were always on call; little Abigail never let me down; and Dr. Jim was so supportive. Arlene Mancuso and Vera Wells helped steady this trembling hand, and Julius I. Rosenthal again came to the rescue—profound appreciation to them all. My soul looks back and wonders. . . .

Prologue: Conducting Research into Mende Art

The Mende people of Sierra Leone say: *Hani gbè lewe ma ngele ya nja gbili kaangò kpowa èè tò*—"There is a thing passing in the sky; some thick clouds surround it; the uninitiated sees nothing." By this one proverb we are introduced to the Mende, their thought, and their art.[1] The Mende are an ethnic group of about one million persons, mainly agriculturalists, who live in southern and eastern Sierra Leone, on the West Atlantic coast of Africa. They divide people socially and culturally into two groups: those who have been initiated into a *hale* (usually referred to as "secret society" in the literature) are *halemò,* while those who are not members are *kpowa.* All Mende humanistic and scientific knowledge is transmitted within the various *hale* institutions to the initiated members; the person who does not belong to a *hale* is considered an ignoramus, a simpleton, a fool.

The sun, source of all energy and matter, is the "thing in the sky;" even on the most overcast or stormy days we all know that the sun is still there in its glory pouring out light! The uninitiated *kpowa,* however, does not comprehend the workings of this fundamental constituent of life itself. A *halemò*'s vision is never blocked by vapors and mists; he always sees through them clearly. The *kpowa,* on the other hand, is so dumb that he misses the significance of even basic phenomena and obvious facts. This proverb presents the idea of *initiation as a condition of seeing,* as personal enlightenment. Everything is out in the open; nothing is purposefully hidden. Seasons change, flora and fauna go through their life cycles; people move about, interact, handle objects; events take place, things "happen." Initiates have had their eyes opened, so they have "eyes to see." These "eyes" are metaphysical: an informed intellect, a widened vision, a deepened discernment.

In relation to Mende art, every researcher is a *kpowa.* The object of my research was to learn the meaning of Sowo art produced by the women's

hale, the Sande Society. If people who grow up in the culture and language can be kept in the dark, how much more can the stranger unfamiliar with the background and context. Mende uses a thousand smoke-screens to obfuscate the life of the community and the significance of its artistic expression. Only a *halemò* is privileged and worthy to know the explanations and understand the meanings.

Mende have written almost nothing about their life experiences or about their concepts and ideas. They have the distinction of being one of the West African groups which invented its own ideographic and syllabic writing system (fig. 1). Despite this noteworthy development, little of what was recorded in the Mende script has ever become known to scholars.[2] In the present day, although many Mende families have been literate in Arabic or western alphabetic scripts for six or seven generations and hold advanced degrees from western and Islamic universities, we still have only a handful of literary materials by Mende writers. No Mende novelists or poets have been published internationally, so we have no fictionalized account of Mende childhood or village life and no record of how Mende view the rest of the world. It is to fill in these serious gaps that this investigation was in part envisioned.

The study for the present work, and the dissertation on which it is based, began in the fall of 1975 with a four-month residence in London. Through the assistance of the Sierra Leone High Commission, I secured a tutor in Mende, James Musa Moriba, a solicitor by profession; he is known among Sierra Leoneans for his impressive verbal skills in both Mende and English. Mr. Moriba gave me lessons for two hours a day, five days a week, for three and a half months, and generally encouraged my interest in Mende life. Toward him I feel great appreciation for his patience and dedication in trying to prepare me to function in the Mende language. Our textbook was Gordon Innes's *Practical Introduction to Mende* (1971). Innes, a lecturer in West African languages at the School of Oriental and African Studies (SOAS), University of London, is also the author of a key book for research, *A Mende-English Dictionary* (1969). The dictionary, 155 pages, is a mini-encyclopedia of Mende culture. I refer to it constantly, and have found it most valuable to my fieldwork in ways I shall discuss shortly.[3]

Through the courtesy of the African Studies staff at SOAS, I was able to audit lectures by Innes on African oral literature and those offered by Jan Knappert, a leading specialist in Swahili literature. During this term, I also attended a course on African art presented by John Picton, Deputy Keeper of the Ethnographic Collection (Museum of Mankind) of the British Museum, focusing on the art of the Igbirra. I should like to thank these scholars for their interest in my project and their kindness in alerting me to new (to me) avenues for fruitful research. In addition, the librarians at both SOAS and the Students' Room of the Museum of Mankind made every facility available to me.

1 The Mende Script

Most of the materials for this study of Mende Sowo art were gathered during two stays in Sierra Leone from January 1976 to August 1977 and March–April 1978. My work was done with the approval of the Institute of African Studies, Fourah Bay College, where I was affiliated as a visiting research scholar. I wish to thank the Director of the Institute, Dr. C. Magbaily Fyle, and the late Secretary, Mr. Jonathan E. Hyde, for their kind interest in my research. Also in Freetown, the Art Education Association of Sierre Leone undertook to help me in many ways; my special thanks to two of the association's founding members, Mr. Edward M. Margai and Miss Cootje van Oven. Through his post at the Ministry of the Interior, Mr. Fode Kallon introduced me to prominent Mende sponsors. And also, the Director of the Sierra Leone National Museum, Mrs. Dorothy Cummings, has been an ally and advocate.

The success of my study was made possible by many, many Mende friends and associates, *all of whom wish to remain anonymous.*[4] The Mende community is, in general, hostile toward any attempts at research. As Kenneth Little noted in 1967, "the ordinary Mende man is not attracted by the idea that one is writing a book to let the outside world know about him" (p. 10). Research requires probing, and no Mende wants to be asked a question by a *kpowa*. If somehow required to answer, a Mende reply will be as cryptic and elliptical as possible. Little: "One of the greatest sins a Mende man can commit is to 'give away' the 'secrets' of the country" (1967:8). Research assistants say they are often accused of "giving away secrets" merely because they interpret the language or act as travel guides. Those Mende who, by inclination, friendship, or payment, agree to cooperate with a stranger, are constantly threatened with retribution by their peers.

An example of what happens to those who "reveal secrets" is the story of the late Reverend Max Gorvie. In 1945 the United States Society for Christian Literature published his small book of seventy-nine pages, *Old and New in Sierra Leone.* Gorvie stated in the preface that he had "always believed that there are valuable lessons to be learned from African customs, and especially if these lessons are put in a form that will leave its impression upon the reader and occasion an interest and desire on his part to know more of the African people and of the Sierra Leone Protectorate in particular. It was by that inspiring 'urge within' that [I] was compelled to write it. Several notes and writings from able pens in Sierra Leone are in existence. This, however, is the first written on the Protectorate from the pen and standpoint of the aboriginal [*sic*] native" (1945:5).[5]

The Reverend Mr. Gorvie described the traditional laws and customs regulating chieftancy and the family among the different ethnic groups in the country and then outlined something of the myths and customs associated with three of the "secret societies—The Poro, the Wonde, the Bundu."[6] He said he had "tried to compress the mysteries of the customs of the

peoples of the protectorate into simple language that all may understand." Then he gave thanks to "the Honorable Paramount Chief Fomba Kutubu and his court and to the many unlettered sages who have helped [him] to unearth the hidden mysteries surrounding the customs of [his] country" (p. 5).

For his effort to project the wisdom of traditional life, Gorvie was branded a traitor and run out of the country.[7] After an exile of twenty-seven years, he returned to Sierra Leone, refused to grant interviews, and lived in obscurity until his death. It is nearly impossible to find copies of the two books Gorvie wrote; they have long since been stolen from the Sierra Leone Collection at the Fourah Bay College Library.[8] Generally, any student thesis or research paper whose subject is some aspect of Mende culture routinely disappears from departmental files and the Sierra Leone Collection. We can only assume that traditionalists, fearing that the texts will "reveal the secrets," feel duty-bound to remove them.

My second day in Sierra Leone I was told of Gorvie and the wrath of the community toward those who try to probe into Mende customs. I was immediately labeled "an anthropologist who has come to study Sande"— that is, to uncover and expose "Sande secrets." I was continually regaled with one horror story after another about the frustrations and disappointments, not to mention abuse and humiliations, awaiting me. More than one university colleague advised me bluntly to abandon my study and return home.

Through this trying period I questioned the advisability of attempting to continue my project in Sierra Leone. Certainly I was more than averagely prepared for life in West Africa, since I had traveled throughout the area and lived and worked there for extended periods.[9] But some of the difficulties I was encountering had to do with the special nature of doing research in Sierra Leone, and among Mende in particular. As Little has aptly pointed out, "secrecy is of institutional significance in Mende life. A large part of their culture is controlled by societies and cults whose more important rites are intentionally concealed from the wide community. . . . To the Mende, a good deal of their traditional lore is sacred as well as secret and cannot, in any circumstances, be imparted to an outsider" (1967:8–9). From another researcher: "Unlike Europeans, who seem to wish to universalize their style of life, Mende guard the deep core of their cultural values within the veil of secret societies. No Mende could compromise the secrets of a secret society and still be counted a full Mende" (Reeck, 1976:65).

Mende believe that information about Mende life should not be transmitted to those not subject to its laws. Learning, knowledge, information do not circulate freely in the Mende community. As a traditionally oriented people, communication among Mende is face-to-face, oral, passed from one person to another by word of mouth. All information, then, is

part of the *social network* and the only sources of information are *other people*. To belabor the obvious, a printed book cannot decide who is going to read it; its information is free. But a human being can give or withhold information at his discretion. The general principle behind an American university education is that anybody can read any book and obtain any information it contains. The general idea in Mende education is that information can only be disclosed in private and institutional settings from the person who possesses it only to one who is worthy of receiving it.

To a foreign researcher, as well as to a Mende person, this means that one knows only as much as people choose to tell, no more. There is hardly a Mende without a sad tale of something lost—buried coins, herbal formulae, artistic technology—because the treasure's owner found no relative deserving enough to inherit it. The older generation finds the younger frivolous and untrustworthy, so it prefers to die with its knowledge rather than pass it into irresponsible hands. Implored on her deathbed by her frantic children, a famous old woman just said that she would watch the family from the spirit world and, if one of them proved reliable, she would appear to him or her in a dream and reveal the information. If no one receives such a dream, it is only a further indication of his or her continued insufficiencies.

The art I had come to Sierra Leone to study is under the strict control of the women's secret society, the Sande. Sande, like Poro, its male counterpart, not only regulates a Mende woman's day-to-day activities, it also has an almost total monopoly over all female artistic expression. Any song sung by a member of Sande is by definition "a Sande song" and subject to Sande strictures. I soon realized that it would be virtually impossible to provide an understanding of the meaning of the Sande Society's representative object, the Sowo mask, without dealing at some length with Sande organization and social functioning.

The Sande Society, as a *hale*, imparts its knowledge only to its initiates and only within the institutional confines of its encampments and meetings. "Each new initiate in the secret societies takes an oath never to disclose what [she] learns, and from this there is no future release" (Little 1967:9). This climate of extreme secrecy presents a great challenge to the researcher, but despite many demoralizing and sometimes harrowing impediments, I was able to carry out my study. Like Gorvie, I must thank a paramount chief and his court. I was the guest of the venerable Paramount Chief, B. A. Foday Kai, O.B.E., and he is the patron of my research. Also, like Gorvie, I must thank those "sages who helped me unearth the hidden mysteries surrounding the customs of [the] country."

Interviews on the subject of beauty provided me an opening into Mende society. After many months of frustration, I slowly came to realize that people were quite willing to talk freely and candidly about female beauty. These sessions about beauty were bright and high-spirited, spiced with

anecdotes and laughter; from among the scores of persons whom I interviewed and from the dozens more who gathered around for entertainment, I made contact with my preceptors and assistants. As my work evolved, I found that I had three different kinds of research relationships. "Informants," the usual term in ethnographic literature, I used for casual, short-term contacts with a wide variety of people who kindly answered my questions. I termed "assistants" those persons whom I had known for a longer time, and whom I paid to act as guides and interpreters. They were usually recruited from the young adults in the crowd who quickly "caught on" to what I was looking for and evidenced interest in my research.

After about ten months in Sierra Leone I could count on five women (three schoolteachers, one nurse, one policewoman) and several young male schoolteachers as assistants and companions. As in Little's experience: "Once persuaded of the sincerity of one's intentions, many of the members of this group did a great deal to allay traditional suspicions on my account, and a number went out of their way to seek out fresh channels for me even at the cost, in some instances, of laying themselves open, also, to the charge of 'betraying the country'" (1967:10). To all of them my sincerest appreciation for hundreds of hours of what Ghanaians would call "work and happiness."

While conducting interviews about beauty, I had the good fortune to meet three older persons (two men and one woman), who answered my routine questions with rare perspicacity. I later sought them out individually, and they graciously agreed to discuss with me a wide range of artistic matters at length in informal seminars. Each explained that he would cooperate with me so that the beauty and integrity of Mende art and philosophy would be recorded and preserved against the tides of westernization and Islamization that are bringing great changes to traditional life. Because my relationship with them was as student to teacher, as junior to senior, as *kpowa* to *halemò,* I refer to them respectfully as my "preceptors."

The "Njala preceptor" is a woman in her fifties of *ligba* (middle) level in Sande and famous as a dancer and dance instructor. Cavalier about Sande restrictions, she good-naturedly talked to me freely about Sande masquerading, dance, music, ceremonies, processions, and with good humor and patience tried to teach me how things were done. Despite her cheerfulness and bonhomie, she is a stern critic of Sande arts, dedicated to the highest standards of production and performance. The "Telu preceptor" and the "Bo preceptor" are renowned elders in the traditional Mende community. Both hold offices of public trust and, in addition, function as spiritual leaders and judges for followings numbering in the thousands. As a temporal ruler and master politician, the Telu preceptor was able to call upon his people and show me many aspects of Mende life from which I should ordinarily have been excluded. The Bo preceptor is acknowledged as an expert in Mende language and philosophy. A man of towering

intellect, his explanations of the thought behind Mende words and conduct have remarkable objectivity and depth.

A parenthetical commentary: There is a wrinkle of American history adding even more interest to my particular study of Mende culture. My home base is in New Haven; my institutional base is at Yale. In the mid-nineteenth century, this town, this university, and the Mende were linked in a remarkable incident—the case of the *Amistad*. The year 1839, fifty-three West Africans, most of them Mende, were in chains on board the Spanish schooner, the *Amistad,* bound for slavery on the plantations of Cuba. The African men managed to break free, take command of the ship and, under the leadership of a Mende named Cinque, attempted to sail home to liberty. But their plans were foiled, and they found themselves transported not back to Africa, but to Connecticut shores where they were recaptured and then put in jail in New Haven. Their trial, held locally, excited a furor nationwide, while the abolitionist cause and the dignity of the victims won them supporters among a circle of Christian activists at Yale Theological Seminary.

Although he was still imprisoned, the noble Cinque was allowed to leave his cell to sit for his portrait, painted by the artist Nathaniel Jocelyn. Commissioned by the American Anti-Slavery Society, this beautiful painting, complex and sensitive, is currently the most famous object in the collection of the New Haven Colony Historical Society.[10] After two years, all of the men were freed by a decision of the U.S. Supreme Court, and most of them returned immediately to Sierra Leone. At this time, Yale's first student of African descent, the Reverend James W. C. Pennington, led the drive to raise funds to support their repatriation and the work of the Mendi Mission in Sierra Leone, a prosletyzing religious organization that established schools and churches. One of these, the Amistad Primary School, happens to be where the Bo preceptor was a pupil some fifty years ago! May the circle be unbroken.

To return to the field, in view of the intricate secrecy covering most aspects of Mende life, I at first purposely refrained from asking questions about anything but beauty and household routines. Gradually, as people became accustomed to me, and as I became more attuned to Mende ways, I could make more direct inquiries, but I hardly mentioned the word *Sande,* finding it more advisable to say "women's," as a "women's song," not a Sande song. They are the same thing, but one type of questioning was preferable, the other not allowed. I was fortunate in being invited to view Sande life through the graces of my adoptive household in Bo. One of my research assistants, L.K., kindly invited me to live for extended periods in her home. The head of the household was her mother, a distinguished woman of about fifty-five years, first wife of a prominent chief and of *sowo* level in Sande.[11] Separated from her husband, Mme. K. had established herself with her six daughters (aged sixteen to thirty-two), four grand-

children, and a number of nieces and wards in a comfortable compound consisting of two modest stone houses, a kitchen area, a large paved yard, and a bathhouse. When younger female relatives were inducted into Sande, Mme. K., in her capacity as Sowei, kindly arranged for me to visit the *kpanguima,* the sacred initiation grove, to observe and listen. However, I was not allowed to ask questions.

As our mutual confidence grew, my three preceptors advised and counseled me on my relations within the wider community and acted as protectors of my well-being and patrons of my project. Only of them did I feel free to ask pointed questions. As elders, they knew the parameters of the secret and the sacred; although they sometimes refused to give me the information I requested, what they did tell me checked out as being always accurate and truthful. Over the months I gathered data in fragments from my interviews, observations, and experience. I could take these undigested materials to them, and they would help me make sense of them. Alternatively, I could present them with my own conclusions or those of other researchers and they would offer their opinions and analyses. I am honored that these three outstanding personalities found me a fit vessel for their outpourings of knowledge and insight. This volume is only a "partial fulfillment" of my promises to them.

Thus, through the cooperation of the Mende community, I have been able to amass a large quantity of new data on a wide range of questions about Mende art, aesthetics, and moral philosophy. The development of my topic is based almost entirely on original interview materials contained in some five thousand legal-sized pages bound in nineteen volumes, in composition notebooks about individual Mende artists and their products, and in visual documentation. To protect the anonymity of my informants, most references to particular quotations or particular subjects will be indicated only by place and data; when possible, I do refer to persons by their initials. Note also that, out of respect for the requests of the elders, certain materials of a more secret nature are omitted from this book, even though they may already have appeared in print elsewhere, and although they may have been written about in my dissertation (Boone, 1979).

The first three chapters on the Mende people and the women's Sande Society prepare the reader for the core of this work, concerned with the art. Chapter 4 is a study of Mende aesthetics, beginning where West Africans suggest we start, with a study of the beauty of women.[12] The Sande Society creates loveliness in the human community. To paraphrase Robert Farris Thompson, it works to transform a woman into art, and to make her body a metaphor of ethics and aliveness, and ultimately to relate her to the gods.[13] Feminine beauty is seen as a physical entity whose quantities and proportions can be seen and measured. An examination of the physical leads to an understanding of the philosophical, an analysis grounded always on the concrete and palpable. The fifth chapter is an experiment with

new ways of analyzing the iconography and iconology of an archetypal mask, the Sande Sowo, in terms of aesthetic conceptions about the person and the human body. For the first time in the literature, a distinction is made between the two types of masks: one, of supernatural provenance, representing the divine Sande spirit; the other, made according to the fancy of the individual Sowo-dancer at the middle level of the society as her private choice and property. The Sowo mask is viewed against the background of the Mende natural and metaphysical world from which it emerges and to which it refers.

A traditional Mende art form, masquerades feature the presence of an entity incorporating sculpture, costuming, and props, presented to an audience in a staged display of dance, entourage, lighting, mime, music, procession, song, and sound effects. Sowo, and the other Mende masked figures, remind us that human beings experience a twofold existence: one in the world of the concrete—flesh, matter, things; the other in the world of the spirit—dreams, aspirations, reason, imagination, faith. The masks are, in effect, fabrications of this spiritual reality. In the form of emissaries from an "outer space," they dance into sight, and as Incarnations they mingle with us mortals in the human arena. Mende elders have helped me to see that the masks are the collective Mind of the community; viewed as one body, they are the Spirit of the Mende people. They are materializations of Mende aesthetic canons and moral ideals; they are role models, shaping the character of the Mende, influencing their feelings, thoughts, and actions. The overpowering presence of a Sowo obliterates the mundane. The eye blinks in dazzled acknowledgment of what one should and could be: intelligent, capable, authoritative, adaptable, courageous, patient, honest, persevering, strong, and "straight."

"Nor custom fade her infinite variety. . . ." I came to the Sande Sowo initially because it is the one instance in African art history of female masquerading. This archetypal image in all its manifestations has been the subject of my brooding attention year after year, and still I am fascinated. Central to Sande teaching is an insistence on balance and beauty in everyday life, taught to Mende women through the visual and performance arts. I have come to see that the study of the mask is a cultivating, refining discipline. It makes one mindful of a slight nuance, a shade of difference, a delicate gradation, a subtle variation, of barely visible yet significant changes. An encounter with Sowo, an appreciation of Sowo, is a major intellectual and spiritual experience.

This book represents only a portion of my concerns in Mende art. My research has covered the full range of art historical questions about Sowo sculpture—the study of the mask in time perspective (origins and chronology), meaning (iconography of motifs and objects), and cultural context (philosophy and world-view). As the bibliography indicates, my work builds on five hundred years of scholarship on the Mende. My interest

extends from the traditional art historical emphasis on objects to an observation of the mask in full theatrical presentation. My aim is "cultural portraiture," with Sowo as an artistic center around which revolves the intellectual, social, and spiritual life of the Mende community. In future publications I shall deal with Sowo in ceremonial and ritual motion, and with the Mende male masquerades.

The spelling of Mende is well-standardized; an accurate rendering of Mende in writing requires the use of three letters from the International Phonetic Alphabet, not available in this typeface. As a compromise, a dot placed above a letter will indicate speech sounds as follows: *ė*, the "open *e*," written as the Greek letter *epsilon*, is similar to the vowel sound in the English word 'pet'; *ȯ*, the "open *o*," written as a backward lowercase *c*, is similar to the vowel sound in the English work 'pot.' A dotted *ṅ* substitutes for the "tailed *n*," which occurs at the middle or end of a Mende word to indicate the nasality of the vowel sound preceding it, and at the beginning of a word to represent the sound that in English, is written *ng*, as in 'sing.'

Notes

1 The one ethnographic work on the Mende is by Kenneth Little, *The Mende of Sierra Leone: A West African People in Transition* (London: Routledge and Kegan Paul, 1967). "The term Mende [Mėnde], or, in the earlier literature, Mendi, should strictly speaking be applied only to the country; the language is *Mėnde yiėi*, and the people are *Mėndebla* (singular *Mėndemȯ*). Europeans have applied the term to both the language and the people, and as this has been established usage for several decades, the term will so be used here" (Gordon Innes, *The Structure of Sentences in Mende* [London: School of Oriental and African Studies, University of London, 1963], p. 1). This book follows Innes's guidelines.

2 See David Dalby, "An Investigation into the Mende Syllabary of Kisimi Kamara," *Sierra Leone Studies*, n.s. 19 (July 1966): 119–23. This article brings together material available in the literature and the results of Dalby's field research. Also of interest is S. Milburn, "Kisimi Kamara and the Mende Script," *Sierra Leone Language Review* 3 (1964): 20–23.

3 Most useful to the student are the following works of Gordon Innes: *The Structure of Sentences in Mende* (London: School of Oriental and African Studies, University of London, 1963); *A Mende-English Dictionary* (Cambridge: The University Press, 1969); and *A Practical Guide to Mende* (London: School of Oriental and African Studies, University of London, 1971). Also of interest to learners are two small publications from the United Christian Church Literature Bureau, Bo: *Mėnde Yėpėwu Bukui* [Mende word list] (n.d.); and S. Brown, *A Mende Grammar with Tones*, n.d. Richard Spears's *Basic Course in Mende* (1967) stresses tone and phrasing.

4 Another researcher expressed it thus: "All my Mende informants who generously provided valuable information deserve individual acknowledgment. However, they wish to remain anonymous for reasons, which being a Sierra Leonean myself, I fully understand" (from acknowledgments section of Ph.D. dissertation by J. V. O. Richards, "Factors of Limitation in the Art Forms of the Bundu Society of the Mende in Sierra Leone," Northwestern University, 1970). It is significant also that Little's major ethnographic work on the Mende thanks only one Mende person by name, his research assistant (1967:17).

5 The Mende are not at all "aboriginal" to the area, but rather are conquerors of the aboriginal peoples. For discussion of movements and interrelationships of ethnic groups in this area, see Walter Rodney, *A History of the Upper Guinea Coast, 1545–1800* (Oxford: The Clarendon Press, 1970).

6 The use of the word *Bundu* requires elucidation. In Mende the word means "secrets, private area" (Innes 1969:6) and can be generally exchanged for the English word *secret* both as a noun and adjective. *Bundu* is the general Sierra Leonean term for a women's initiation society. I have heard variously that it is a Temne or Sherbro word, but this is unclear. Gorvie's own explanation may be accurate: "The great cult for women and girls in the Protectorate is the Sande or Bundu. It is a secret organization with closed doors to female uninitiates and to the menfolk. It exists among all the tribes with varying modifications, and different names, e.g. Sande is used extensively among the tribes occupying the Southern Province, Bundu among the Susu but designated Suna farther north among the Jolloffs, and Serere among the Kuranko" (1945:44–45). Carol MacCormack, an anthropologist who studies Sherbro culture, gives *Bondo* as a Sherbro word, *Bundu* as Krio (the language of the Creoles of the western coastal, colonized region) and Temne, and *Sande* as Mende (1977:190–200).

7 Personal communication, Victor Mambu, Department of Economics, Fourah Bay College, Freetown, January 1976, corroborated by others.

8 Under the direction of the librarian, J. Sheriff, Fourah Bay College Library tries to collect every published item about Sierra Leone. The Yale University Divinity School Library does have a copy of Gorvie, 1945.

9 See my work on travel and contemporary urban culture in the area: *West African Travels* (New York: Random House, 1974).

10 I am grateful to Richard J. Powell for sharing the results of his research on "*Cinque*: A Portrait by Nathaniel Jocelyn" (unpublished seminar paper, 1983). For further information, see Mary Cables, *Black Odyssey: The Case of the Slave Ship Amistad* (New York: The Viking Press, 1971) and Bertram Wyatt-Brown, *Lewis Tappan and the Evangelical War against Slavery* (Cleveland: The Press of Case Western Reserve University, 1969)—both cited in Powell's bibliography. See also, Bernard Heinz, "The First Black Student," *Yale Alumni Magazine,* November 1978, pp. 8–10. The *Amistad* as a symbol of freedom is a recurrent theme in Afro-American political and cultural affairs. For the one-hundredth anniversary of the drama, the famed Black artist, Hale Woodruff, painted in a series of three panels the narrative of the story. *The Mutiny Aboard the Amistad, 1839, The Amistad Slaves on Trial at New Haven, Connecticut, 1840,* and *The Return to Africa, 1842,* all large oil canvases, are on display at Savery Library, Talladega College, Alabama. In 1970 and 1971 there was a radical historical and literary publication named *The Amistad,* and at the moment there is an Amistad Historical Society in New Orleans, Louisiana, and a Cinque Art Gallery in New York City.

11 For a discussion of women as household heads, see MacCormack, "The Compound Head: Structure and Strategies," 1979.

12 See Harris Memel-Fotê, "The Perception of Beauty in Negro African Culture," *Colloquium on Negro Art* (Paris: Présence Africaine, 1968), pp. 45–66.

13 Robert Farris Thompson, *African Art in Motion* (Los Angeles: University of California Press, 1974), p. xiv: "Received traditions of standing and sitting and other modes of phrasing the body transform the person into art, and make his body a metaphor of ethics and aliveness, and ultimately relate him to the gods."

1

Mende History and Culture:
A Brief Overview

The history of the West Atlantic coast of Africa, the entire "Upper Guinea Coast" area, is presently the subject of intense debate among historians, anthropologists, and ethnolinguists. In the past twenty years much new research has been conducted based on hitherto unexamined sixteenth-century writings, mostly Portuguese, and several important books and articles have appeared. More than one historian has suggested the need for a conference of scholars to consider the possibilities suggested by the data and to resolve some of the conflicts.[1] The debate revolves in part around the Mende—who they are, their origins, how they are related to neighboring ethnic groups and, most vexing, when they settled in Sierra Leone (fig. 2).

All these writers trace the Mende to the medieval Mande kingdoms of the Western Sudan[2] but question the closeness of the relationship.[3] Earlier commentators hold that the Mende have long resided in Sierra Leone, while the most recent theorists place the date of their arrival as late as 1790–1800. Using a set of criteria based on material culture, G. P. Murdock classifies the Mende as "Peripheral Mande": "Since they exhibit none of the cultural complexity of the nuclear Mande, these Peripheral Mande, as we shall call them, probably left the Niger basin prior to the rise of the great Malinke kingdoms and the civilizations of Mali" (1959:259). According to this theory, the Mende left the Western Sudan before the late 1200s during an "intermediate period" after the collapse of the ancient kingdom of Ghana but before the establishment of Mali under Sundiata. This was, indeed, an agitated period of many small warring states, with great movements of population. And by this calculation, the Mende have been in the area of modern Sierra Leone for approximately seven hundred years.

With all due respect to Murdock's account, surely the Mende did not

1

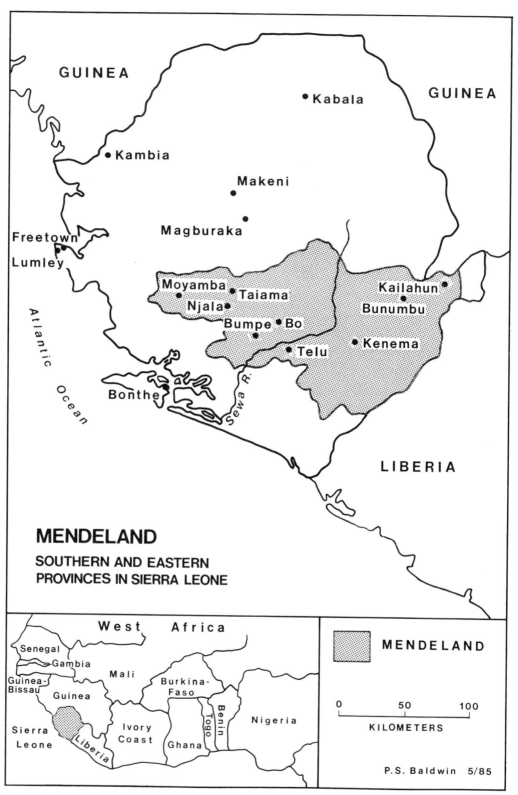

MENDELAND

SOUTHERN AND EASTERN
PROVINCES IN SIERRA LEONE

2

arrive without some knowledge and practice of the civic arts of the great empire of Ghana which preceded Mali's rise.

> Ancient Ghana, approaching maturity in the Western Sudan about the same time the Franks were organizing their empire in Western Europe, could draw strength and revenue from the movement of two precious minerals: gold from the south and salt from the north. . . . These were the prize of political success. These were the means by which the new states and empires could support their soldiers, their governors, craftsmen, courtiers, singers of songs. [Davidson, 1966:98–103]

Kenneth Little thinks the Mende came much later, drawing much of his opinion from Mende oral traditions: "Possibly [the Mende] arrived in what is now Sierra Leone at least four hundred years ago, as small bands of hunters, little larger in size than the immediate family" (1967:26). A. P. Kup agrees, citing the "prolonged warfare begun in the seventeenth century by the Mende immigration" (1961:190). At this time, refugees from the former great empires of the Western Sudan were streaming south into the forests, and much of this portion of the Guinea Coast was in turmoil. The trouble stemmed from the break-up of the great Sudanic empires and raids by Europeans for slaves. Writing in 1696, Ogilby—one of the first explorers to mention the Mende—said they were one of the groups "jockeying for position" on the Coast of Sierra Leone.[4] The implication is that their contesting of coastal territory at this time meant they were interlopers, recent arrivals.

Little depicts the Mende as excellent soldiers, led by shrewd strategists, who systematically vanquished local ethnic groups and securely installed themselves in a wide area. This later arrival would mean that the Mende entered the forest regions with the full armature of technological knowledge derived from the great urban trading states of the Western Sudan, Mali, and later Songhay, together with an inherited tradition of cosmopolitanism, international commerce, sophisticated warfare, and highly developed arts.[5] "From the fourteenth century, Mandinka traders organized in little companies or combines, and travelling far and wide were active elements in the whole West African trade . . . and became in time the founders of market-towns, cities, and even states" (Davidson, 1966:133).

Gold from the Western Sudan formed the currency for Mediterranean trade in "copper and cotton goods, fine tools and swords from Arabian workshops and afterwards Italy and Germany, horses from Barbary and Egypt, ivory and kola nuts and household slaves from the south" (ibid.: 103). The main form of agriculture was rice-farming, as it is today in Mendeland: "[The Manding] and their immediate neighbors were among West Africa's most successful—and perhaps earliest—cultivators of the soil, producing rice and other foods in the rich hinterlands" (ibid.:114).

The most authoritative version of Mende history is asserted by two

Sierra Leonean historians, Arthur Abraham and C. Magbaily Fyle.[6] In their work they refer to data from material culture, oral traditions, and early written sources:

> This geographical area of present day Sierra Leone, before the foundation of the colony, included a number of ethnic groups widely dispersed over its mountains and plains. Among the oldest inhabitants of the coastal area are the Bullom together with other ethno-linguistically related West Atlantic groups like the Gola, Kissi, Baga and Nalou. . . . A reorganization of these coastal groups occurred due to the invasion of a Mande-speaking people called the Mani, in the middle of the sixteenth century, which also gave rise to the largest ethnic group in Sierra Leone, the Mende. The Mani were a Mandinka group emanating from the Mali Empire, whose leader, a queen named Mansarico, is said to have been exiled by the *Mansa* (king) of Mali. Mansarico led her followers first southwards, then westwards until they finally made a base in the Cape Mount area of Liberia by the 1540s. From this area, their armies were sent out to subjugate most parts of the present-day Sierra Leone hinterland, thereby creating sub-kingdoms, owing allegiance to the parent one. Often if the sub-kingdoms failed to recognize their obligation to the headquarters at Cape Mount, a further invasion was sent against such entities. Thus successive waves of Mani invasions, sometimes twenty years apart, led to further settlement and often the creation of a new ethnic group. . . .
>
> The largest ethnic group to emerge in the Cape Mount area from the Mani invasion was the Mende, another product of a mixture of Mani on the West Atlantic Bullum/Gola substratum. It was only in the eighteenth century that the Mende began moving west of the Sewa river in small invading bands. The first dynamic move of the Mende into the Sierra Leone hinterland proper occurred *apparently by the early nineteenth century*. It is identified with the Kpaa-Mende (a subgroup) who pressed the original inhabitants, the Banta, southwards to form the Mendenized state of Bumpe (usually referred to as Banta). [1977:3–6; italics mine]

Mende are characterized as an ambitious, dynamic group who tend to dominate others politically and culturally. In the early nineteenth century, they were conquering more and more land and gaining control over indigenous peoples. Arthur Abraham uses the term *mendenization,* to sum up the processes of infiltration, migration, settlement, warfare, and taking of spoils used by Mende to gain control over the southern half of Sierra Leone.[7] "Since the imposition of colonial rule at the close of the nineteenth century, the process of Mende territorial and cultural expansion has proceeded peacefully as Mende communities have been established in non-Mende lands and the Mende language has increasingly become the mother tongue of people whose grandparents spoke languages such as Sherbro and Vai" (Kilson, 1976:7).[8]

Modern-day Mende are the most populous of the sixteen ethnic groups represented in Sierra Leone. Mende boast a proud record in battle against the invading British, and of relentless resistance to the imposition of colo-

nial rule. After falling to the British in 1898, the next generation of Mende were at the forefront of regional and national political movements in action for self-determination and independence. When the new state of Sierra Leone was admitted to the United Nations in 1961, its first head-of-state was a Mende.[9]

ECONOMIC AND SOCIAL ORGANIZATION

Today, the vast majority of Mende are agriculturalists who "live in small towns and villages. Around a town or village some bush is usually reserved for gardening while the outlying land is used for rice farms. A system of shifting cultivation exists. Every year part of the land is used for farming, and then it is allowed to lie fallow for about eight or ten years." The main crop is rice; it is at once their staple food and their cash crop. Rice farming is central to Mende livelihood, and it is the organizing feature of their culture. "Most Mende men from the chief downwards, either have their own farms, work on someone else's farm, or have some more or less direct connection with a farm. In short, farming activity based on rice production supports virtually the entire life of town and country" (Little, 1967:78). Both men and women farm, going out early in the morning, returning in late evening. Palm nuts are grown for their oils; cassava, yams, and sesame are supplementary food crops; and there is some cultivation of cocoa and coffee for commerce. In addition to farming, women fish by wading and deep-diving the inland rivers, swamps, and creeks; they spin and dye cotton and in cottage industries produce vegetable oils, soaps, and other items. Men specialize in the crafts of weaving and blacksmithing and also leave the village to seek their fortunes in the mines and at sea. Both men and women may be part of the clerical, professional, and trading communities in the towns.

In Mende society, the *mawè* is the basic economic and social unit. Little describes a *mawè* as a farming household:

> It corresponds in the main essentials as to membership and function, to the joint family in that it is often three generations in depth and is relatively self-contained. Numerical composition varies very greatly, but a larger sized *mawè* may consist of one or more older men and their wives; some or all of their sons and daughters; husbands and wives of the latter; and a number of grand-children. Such a household may also contain additional members in the shape of more distant blood and official relatives, as well as one or more dependents of the head of the household who are unrelated to the rest of the group. . . . A small size household . . . would not be spoken of as a *mawè*, unless the owner of it possessed at least four wives. [1967:96]

Thus the family structure is patrilineal. The family unit is patrilocal; polygyny is strongly developed and most polygynous unions are virilocal. The *mawè* as a functioning family seems very much under the control of

the senior wife: "Women do a great deal of farm work and the number of farms a man is able to cultivate depends on the number of his wives" (Hofstra, 1937:106).[10] It is the senior wife who organizes the women's farm work and so is largely responsible for the prosperity of the household. Further, as senior wife, she is entitled to a garden plot of her own whose products she may use to earn cash or provide raw materials for prestige items.

A young wife, whether of a son or the father, enters the *mawè* as a junior expected to be obedient to the senior women. She will regard the head wife of the compound with the respect due to both a mother and a mistress and will call her *yie*, "mother," or *ma*, "lady." The senior wife, in turn, will treat her somewhat as a servant. "Just as the status of a man rises with each additional wife entering his household, so does that of his first wife who assumes the position over them to which she is automatically entitled by virtue of her seniority" (Little, 1967:133).

The authority and standing of the senior wife is of special interest in Sande art. In later discussions we shall see that the Sande Society is similarly organized hierarchically, with senior women responsible for the younger in an organization not based on blood-ties. Since, as Little points out, the sexes have limited contact with each other after puberty (1967:164) and the female side of the household is run by women, the Sande Society can be seen as a reflection of the basic Mende living and production unit. The lessons it teaches the initiates will very much prepare them for *mawè* life, and the standards of behavior set by its Sowei will be examples to women in positions of responsibility.

MENDE LANGUAGE

Most scholars accept Welmers's subdivision of Mande languages into Northern, South, West, and South Eastern groups; Welmers places Mende in a "South Western group" along with Bandi, Loma, and Kpelle.[11] The varied times of arrival in Sierra Leone for Mende groups account in part for the three linguistic subdivisions: Kpaa-Mende in western Mendeland (Bauya, Moyamba), Sewa-Mende in the southeastern area (Bo), and Kòò-Mende in the northeastern Mende territory (Kenema, Daru) (see map, fig. 2).

The Mende language presents numerous challenges to the English speaker and to the *kpowa*.[12] Mende is a tonal language of high, low, rising, and falling tones which distinguish words and determine their meanings. Tones are not fixed but appear in "patterns" in relation to preceding and succeeding words of the sentence, phrase or compound. Mende vowel sounds as written differ from English, and two extra letters, "open e," and "o," are necessary to convey the Mende. Nasality of vowels is indicated by writing a tailed n after the vowel. Mende consonants consist of seventeen

single and eight paired letters. The author of the standard modern texts on Mende, Gordon Innes, notes that Mende spelling is now fairly well standardized and that his dictionary follows the now established rules of Mende spelling (1969:v). Most Mende words have a change of consonant(s) if they are not the first element of a sentence, phrase, or compound (as in the example of *ngu* becoming *wu* in *sowo-wui*.) Also final vowel stems can change before the definite suffix (as Sow*o*, indefinite, has a final *o* change to *e* before suffix *i* in definite Sowei). The dictionary gives the full forms that "occur in slow and careful speech" (p. v), but most Mende pride themselves on speaking rapidly. The tendency is to drop final syllables (*sowo-wui* sounds like *so-wui*) and to omit internal consonants (*lewe* becomes *lee*).

Having only some one thousand to two thousand words, the Mende lexicon is very small. However, like the ten cardinal numbers or the letters of an alphabet, these few words are constantly combined, recombined, and modified in tone to produce a rich vocabulary. Mende often does not have a "word" for a thing but, rather, expresses it by a construction. English is the opposite: in English there are usually two words for a single thing— one of Latin derivation, the other Anglo-Saxon. Whereas in English most things can be said in two or more ways—an elegant, refined Latin way or a robust, blunt Anglo-Saxon one—in Mende most things can only be referred to, without directly being named.

In layman's terms, Mende conversation is "situational" and "contextual." Words have different meanings in different situations, and the context of words changes their meaning. So, in the case of the Mende word *kole*, five different tone combinations give five different meanings (Innes, 1969:47). Let us examine only *kole* L H (low-tone high-tone combination), meaning [it is] "white, clean." *Kole* is the stem of *magole* (*ma* = on, *gole* = kole = white; *magole* = put white on). When *magole* refers to things, it means they are clean, fresh, white, washed; when *magole* refers to people, *it means the opposite*—they are dusty, ashen, dirty. So only in the context, the whole idea, does the meaning become clear.

A musical term for the Mende language would be "programmatic," as in program music, descriptive music, "music that suggests things outside of itself." A single Mende word evokes a picture of the thing itself. Thus, *pèlè*, "house," suggests only the traditional, village, clay-walled, thatched roofed house; any house not of this traditional design requires adjectives and modifiers. *Pèlè* as house presents a picture not only of the standing house but also signifies the home and all the activities taking place within it. Mende usage is strongly metonymical, using a single word to encompass both the raw material and the finished product, or the start and the finish of a process. Thus, the Sande instrument, *sègbula*, is made from a particular gourd that is also named *sègbula* (ibid.:131). Or, *hakpa* is at once "vegetables" and "the sauce made from vegetables" (ibid.:23).

A mundane word can relate to a concept. Thus *koima* is a young lactating mother (ibid.:46), but it is also the term for all the protective qualities of one human being nurturing another, promoting another's welfare. The word *nje,* biological mother, is a different concept, implying kinship obligations and seniority. Furthermore, when Mende call a thing by a name it is supposed to have all the components of that thing; the word is a formula and *means* the whole thing, complete and correct in all its parts. Thus, again *hakpa* as a sauce consists of leaf vegetables, herb flavorings, oil, pepper, salt, fish condiment, and bits of fish or meat. These are the ingredients of *hakpa.* It may have additions (say, onions, mushrooms, tomatoes, meat chunks, and such); but unless the sauce fills all the basic requirements, if anything of its original formula is missing, a Mende will dismiss it categorically, saying: *Hakpa ii le,* "that's not *hakpa.*" This Mende sense of the word as expressing the perfection of a thing will have important implications in Mende concepts of beauty and aesthetics.

RELIGIOUS ORIENTATION AND THE *HALE*

It is difficult to distinguish the traditional Mende religion from the culture of which it is a part. As in so many other aspects of their lives, Mende take pride in being intelligent and plain in religious matters.[13] They sometimes admire the colorful and exciting practices of other African peoples, but they themselves have no pantheon of gods, no mystery cults, no standing priesthood, no kingship court shrines. They also seem impervious to fanatical modern movements of a syncretic, fundamentalist, charismatic, or Pentecostal nature. Always, Mende are determined to conserve and preserve their uniqueness as a people, as Mende.

The Mende believe in a supreme being, one God, *Ngewò,* who is the creator of the universe, the ruler of the universe, and the all-seeing, all-knowing father-protector. By his word and by his desire, *Ngewò* "called into existence" the man, the earth, and the "fullness thereof." Because he is ruler of the universe, things that transpire in life happen only with *Ngewò*'s permission. As father-protector, "*Ngewò* is good. He is the author of goodness [and] He is on the side of righteousness, fair-play, and justice" (Sawyerr, 1970:65). *Ngewò* is a living presence in Mende life; his name is invoked, as the day unfolds, by his children in need of strength and guidance. The individual approaches *Ngewò* directly in prayer merely by "standing with the palms of both hands turned upwards" (ibid.:81). Group prayers for group concerns may be offered at a special gravesite.

Another word for God in the sense of the Great Ancestor, *Leve,* is used only in the term, *Leve-Njeini,* "God's decree." It is suggested that in ancient times Mende may have conceived of *Leve* as the female deity consort of *Ngewò,* forming the feminine half of the cosmic Creator Couple (ibid.:92). Sierra Leonean scholars struggle for ways in which to phrase this concept

in English words. Canon Sawyerr expresses appreciation to the Reverend Isaac Ndanema for years of seminar discussions which led to a still-flawed explanation of *Leve-Njeini:* "customary etiquette [as well as] traditions, laws, customs. . . . All social institutions, all those features of creation which could not readily be accounted for, such as the male and female adult initiation societies for men and women respectively—Poro and Sande—are attributed to *Leve*. . . . [Therefore] *Leve* is thought of as having brought to birth the bases of the moral codes which determine good social behavior and accordingly maintain the continuance of the life of the tribe" (ibid.:85–86). Some elders gave Innes the definition: "Any ancient custom, institution, or artifact whose origin is unknown, but which is ascribed to God" (1969:70). The Bo preceptor discusses *Leve-Njeini* as the power-mix of God-and-the-Ancestors, God-and-heritage, God-and-noble-precedent, God's-rules-as-lived-by-the-Ancestors. It would appear, then, that in the deepest, most sophisticated Mende thought there is the intention that the Mende nation should be inspired and ruled by a lofty combination of the Supreme Being and an "unwritten constitution."

Ancestors and nature divinities are lower classes of spiritual beings. "Ancestors are the true exemplars of the spirit world. They having lived on this earth in the past, are easily conjured in the minds of their descendants. They provided the codes on which the children were brought up earlier in life and which can be understood by their successors. . . . Indeed, prayers to the Supreme God are usually channelled through the ancestors" (Harris and Sawyerr, 1968:3). The other category of spirits are a host of deities and genii associated with natural phenomena. The land the Mende occupy is one of unusual scenic variety and natural grandeur. Migration from the dry, flat, open spaces of the Sahel (region bordering the Sahara Desert) grasslands to the remarkable geography of the dense forest zone had a profound emotional impact on the Mende. Harris and Sawyerr believe that the natural environment presented them with a great psychological challenge and that they observed the wonders about them with rapt attention.

> Sierra Leone is a country in which natural forces often oppress at their most awesome. [There are] thunderstorms, great rains and winds, and the abiding presence of the mysterious bush. The rainy season begins and ends with a succession of tornadoes, which consist of fierce flashes of lightning, heavy thunder and strong wind, followed by driving rain. During the dry season many of the smaller rivers are almost dried up. Some of the smaller ones become so shallow that extensive banks of sand appear in mid-stream. Huge rocks are also uncovered, many of them having strange and awesome configurations due to the constant wearing of the water. In almost every part of the Mende country there are hills, stones, large trees and deep places in the rivers. And so these various physical formations accordingly arouse in the Mende a

response which associates them all—storms, huge trees and peculiarly shaped rocks—with the supernatural because of their oddness. [ibid.:3]

Today the impression is that the majority of Mende are adherents of either Christianity or Islam as Catholics, Protestants, or Muslims. Since in traditional belief Mende profess one God, they are comfortable with the concept of Jehovah or Allah. There are fundamental antagonisms between a world religion and Mende religion centered around the conflict between the Mende obsession with safeguarding their cultural uniqueness and the emphasis in world religions on universalizing the religious and secular culture of the founders. Thus, Mende distinguish between practice of a cosmopolitan religion along imported cultural lines, and that same religion as it is adapted to traditional Mende conduct.

So there is "town Christianity"—a westernized, modernized religion whose practices include an acceptance of Euro-American missionary lifestyles (use of the English language in worship, western dress and names, monogamy, companionate marriages, scientific medicine) and a prohibition of key traditional behavior (drumming-and-dancing, Ancestor veneration, membership in secret societies, use of alcohol or tobacco). And there is "village Christianity"—informal, simple, musical worship meetings in private homes, without minister or sacraments, using the Mende tongue. Village Christianity abides by village folkways and mores, but tends to shift the emphasis in prayer from supplication of the Ancestors to more direct communication with Ngewò, God. Reeck's informant, a Mende social scientist, suggested that "the best contribution of Christianity to village life has been increased and regular sociability, as compared to the seasonal sociability of the secret societies" (1976:74).

By the same token, "Stranger Muslims" are those townspeople who form part of the international network of West African Muslim merchants, traders, and intellectuals. Their strong sense of group identity is based on their commitment to elaborate and strict religious observance and their conformity to northern, Sahelian (from Mali, Senegal), Arabized values and lifestyles. "Mende Muslims" are, again, country cousins, village folk who live by subsistence agriculture, identify by ethnicity, not religion, and conduct themselves as traditional Mende.

As we have discussed, one step from the Supreme Being, Ngewò, is Leve-Njeini, God's decree; and by God's decree were formed "somewhere up above, before they are sent down to man" the hale, the religio-legal institutions that develop and govern Mende life. Hale are initiation associations. Probably the nearest English equivalent to hale is the word sodality, meaning a fellowship grouping of people, male or female, involved in religious activities; but in general usage the popular term is secret society or just society. No book on any phase of Mende economic, political, or cultural life can or

will be written without reference to the presence and role of the secret societies. An American religious historian writes, "Secret societies have traditionally acted as fundamental unifying and controlling agencies in Mende society" (Reeck, 1976:83). The Mende historian Arthur Abraham considers that the *hale* give "continuity to Mende culture, and a sense of unity to the Mende people" (1978:160).

Kenneth Little searches for an analogy that can communicate to a western mind the importance to Mende of the *hale* associations:

> These institutions, as already indicated, are of primary importance in determining ritual behavior and affecting social attitudes, because the sanctions in nearly every sphere of the common life derive from them. The principal societies involved, in addition to the Poro and the Sande, are the *Humui*, concerned with the general regulation of sexual conduct; and the *Njayei*, concerned with the cure of certain mental conditions and the propagation of agricultural fertility. . . . Through their staff of hereditary officials, masked "spirits," and rituals, the secret societies canalize and embody supernatural power. Collectively, they provide an institutional structure which bears resemblance to the medieval church in Europe; but with one or two important differences. Like the medieval church, they lay down various rules, prescribe certain forms of behavior, and are the sole agency capable of remitting certain sins. On the other hand, both their control over supernatural power and their regulation of lay conduct and behavior is, to some extent, departmental and even a matter of specialization. That is to say, particular fields of the cultural life and their regulations tend to fall within the province of specific societies. The combined effect, however, is a pattern of life which is influenced very largely by the secret societies. [Little, 1967:240–41]

Notes

1 Among the scholars are Walter Rodney, *A History of the Upper Guinea Coast, 1545–1800* (1970), and "A Reconsideration of the Mane Invasions of Sierra Leone," *Journal of African History* 8, no. 2 (1967): 219–46; Kenneth Little (1967), cited; P. E. H. Hair, "An Ethnolinguistic Inventory of the Upper Guinea Coast before 1700," *African Language Review* 6 (1967): 32–70, and "An Ethnolinguistic Inventory of the Lower Guinea Coast before 1700: Part I," *African Language Review* 7 (1968): 47–73; Arthur Abraham, *Topics in Sierra Leone History* (1976); Christopher Fyfe, *A History of Sierra Leone* (1962); and Yves Person, "Les Kissis et leurs statuettes de pierre," *Bulletin* de I.F.A.N., series B, vol. 23, nos. 1–2 (1961): 1–59, and "Ethnic Movements and Acculturation in Upper Guinea since the Fifteenth Century," *International Journal of African Historical Studies* 4, no. 3 (1971): 669–89. I am grateful to C. Magbaily Fyle for alerting me to the new developments in Sierra Leone historiography.

2 A note from Hair clarifies the use of the term *Mande:* "Mani/Mali/Mande are variants of a single term: the original meaning is uncertain, but in historical times the term has been applied (a) to an ethnolinguistic unit on the Upper Niger, speaking a language known as Mandingo or Malinke, (b) to a political unit formed and ruled by this people, the 'Kingdom of Mali,' and (c) to groups deriving and dispensing from this ethnolinguistic unit. In addition, in the last hundred years linguists have applied the term 'Mande' to a closely related language family of which Malinke (and its near dialect,

Bambara) form the main part of the largest sub-unit; and in recent decades eth-
nographers have borrowed the term and applied it to all the peoples in this language
family, although it is very doubtful whether the implication of cultural homogeneity
throughout a very large area is scientifically justified (for this use, see G. P. Murdock,
Africa, 1959, 'Nuclear Mande,' 'Peripheral Mande'). [In Hair's work] 'Mande' is em-
ployed in its purely linguistic sense. The language of the Upper Niger is termed
'Malinke,' and 'Mani' is used solely to designate the invaders of Sierra Leone"
(1968:60–61).

3 See G. P. Murdock, *Africa: Its Peoples and Their Culture History* (New York: McGraw-
Hill, 1959), pp. 259–65; Kenneth Little, "The Mende Chiefdoms of Sierra Leone," in
C. D. Forde and P. M. Kaberry, eds., *West African Kingdoms in the Nineteenth Century,* pp.
111–37 (London: Oxford University Press, 1967); and A. P. Kup, *A History of Sierra
Leone: 1400–1787* (Cambridge: The University Press, 1961).

4 This refers, in Little's bibliography, to J. Ogilby, *Africa, the Regions in Egypt, Barbary and
Billedulgeria* (London, 1696).

5 W. Rodney, in "A Reconsideration of the Mane Invasions": "The Manes brought
improved military techniques and advances in the manufacture of iron and cloth" (p.
246).

6 I am grateful to C. Magbaily Fyle for permission to quote from this unpublished draft
of a larger work in progress in collaboration with Arthur Abraham.

7 See A. Abraham, "Mendedom," in *Mende Government and Politics under Colonial Rule*
(1978), pp. 1–41 and passim.

8 Marion Kilson, *Royal Antelope and Spider: West African Mende Tales* (Cambridge, Mass.:
The Press of the Langdon Associates, 1976).

9 For discussions of Sierra Leone political history, see A. Abraham (1978); C. M. Fyle
(1981); J. R. Cartwright (1970).

10 For discussions of traditional Mende economy, see S. Hofstra, "The Social Signifi-
cance of the Oil Palm in the Life of the Mendi," *Internationales Archiv für Ethnographie*
34, nos. 5–6 (1937): 105–18; and Little (1967), "Rice Farming and Land Tenure," pp.
77–96.

11 See W. E. Welmers, "The Mande Languages," in *Report of the Ninth Annual Round Table
on Linguistics and Language Studies,* W. M. Austin, ed. (1958), pp. 9–24.

12 There is more information on Mende than on any other indigenous Sierra Leonean
language. The historian and ethnolinguist P. E. H. Hair has written a comprehensive
article, "Bibliography of the Mende Language," *Sierra Leone Language Review* 1 (1962):
38–61. It contains an annotated listing, arranged chronologically, of every book relat-
ing to Mende, comprising early vocabularies, texts, studies of the language (including
dictionaries and grammars), Bible translations, general literature published in Mende,
and previous bibliographical works. Most Mende titles have been published by the
Provincial Literature Bureau (formerly the Protectorate Literature Bureau), founded
in 1937 in an eastern Mende town named Bunumbu, by the Methodist Mission. The
offices of the PLE were moved to Bo in 1946, but it is still popularly known as the
Bunumbu Press. "The achievements, and some of the limitations, in Mende publish-
ing must be attributed largely to the close relationship between the press and the
missionary movement" (p. 40).

13 Discussion in this section is based on the following: W. T. Harris and H. Sawyerr, *The
Springs of Mende Belief and Conduct* (1968); H. Sawyerr, *God: Ancestor or Creator?* (1970);
D. Reeck, *Deep Mende* (1976); interviews with the Bo preceptor and Telu pre-
ceptor.

2
The Sande Society

The Sande Society is one of the most powerful patrons of the arts in West Africa. Over the years the society has commissioned thousands of pieces of sculpture for use in its educational and social projects. The documentary opportunities provided by a study of this society are extraordinary. Sande is most important for a study of women and art in contemporary West Africa because *it is the only known instance in Africa in which women customarily wear masks.* An appreciation of Sande is crucial to the history of art because it brings into focus aspects of the feminine presence in West African art—a facet of African creativity and productivity long ignored within the literature.

In the early 1900s, T. J. Alldridge was in West Africa on the Queen's business as British Travelling Commissioner in Sierra Leone, then a colony and protectorate of Great Britain. His first book, *The Sherbro and Its Hinterland,* published in 1901, records his observations on the land and life he saw about him. Alldridge was especially impressed by the secret societies, the powerful traditional organizations that he likened to Freemasonry. He devoted his chapter 14 to a study of the women's society, now more correctly referred to as the Sande Society. One of the book's illustrations shows a photograph of "The Bundu Devil, Upper Mendi," apparently the first visual document available of the Mende Sande Society mask. Even more important for art historical research, the mask is presented in costume; a second photograph, "Bundu Devil with Attendant Digbas" (p. 142), shows another costumed mask with its ceremonial entourage. These photographs mark the beginning for a visual history of this masking form.

Sowo, the society's classic mask (fig 3), has a central role in Sande ceremonial and ritual activities. The fully robed mask-in-motion is the spirit of Sande, the concrete materialization of the society's precepts and ideals. The carved mask head, *sowo-wui,* is the representative piece of sculpture of Sierra Leone, featured in a dozen picture books and catalogs of African

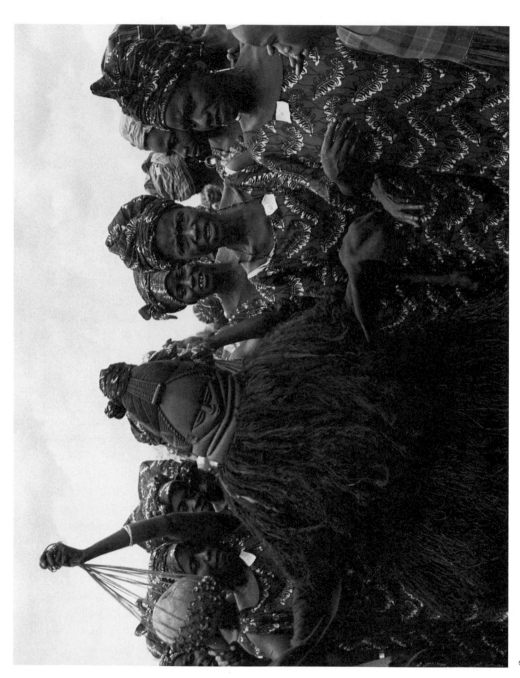

art; these mask-heads are easily collected and there are examples of them in museums throughout the world. Nineteenth-century travelers and colonial officials made the first drawings and photographs we have of Sowo. Over the past hundred years many visitors, historians, sociologists, and ethnographers have recorded their observations about Sande and its Sowo dancing mask. This book is a full-length study of the Sande mask as a lived tradition; it is a study of form and meaning which describes the mask in its social and artistic context and attempts to explain something of the philosophical and religious systems to which the masks relate.

The Sande Society is ubiquitous in Mendeland—where there are women, there is Sande.[1] Throughout a woman's lifetime Sande influences every aspect of her physical, psychological, and social development. Sande was there before she was born and remains when she is gone; it shapes a woman, influences her every thought and action, endows her with her identity and personality. In addition to its religious and legal responsibilities, the Sande Society functions in part as a school for female artistic expression. Understanding the Sande Society and its plastic and performing arts adds depth to one's appreciation for a great African creative tradition while simultaneously expanding the contribution of women to the arts of Africa. Every Mende woman goes into the Sande Society—she goes because her mother sends her there, because her sisters and aunts are there, because it is the ruling, governing institution in a female's life. Mende women love Sande: they sing its praises; recite its virtues, dance in its honor. They treasure it, preserve its virtues, and pass it on to the next generation. In return, Sande is the guardian of the women: their spokesperson, shield, protector, battling to give women life space, power, health, love, fertility, self-expression. And, as it guards and cherishes the women, they in turn rally round it and hold its standard high.

As participants in Sande, the Mende women of Sierra Leone join in the most vigorous and important of West Africa's female associations. The following aspects indicate Sande's importance. *Sande is international:* its membership includes women from Guinea, Sierra Leone, Liberia, and as far east as the borders of the Ivory Coast. Sande's axis of territorial extension roughly equals the distance between Boston and Chicago. *Sande is multi-ethnic:* almost every woman of the Mende, Susu, Vai, Temne, Sherbro, Gola, Bassa, and Kpelle peoples has passed through its initiations, is a recipient of its guidance, and benefits from its law.[2] *Sande is numerically immense:* the present membership is estimated at more than a million and a half. Moreover, it is still growing: a whole ethnic group may enroll en masse—for example, the Bassa of coastal Liberia accepted Sande quite recently—or an individual woman may join as a convert.[3]

Sande is organized at various levels for the pursuit of a number of common goals, both practical and spiritual. The orientation is at once political and social, religious and philosophical, educational and artistic.

Political and Social

Sande offers women the opportunity to acquire political expertise and exercise authority by virtue of the offices they hold in the society. Using her Sande fellowship, a female politician always has a potentially strong power base. It is surely relevant that Mende and Sherbro women have long held from ten to twelve percent of the paramount chieftancies in Sierra Leone.[4] They draw on jurisprudential and governmental insights richly embedded in Sande lore. This fact alone emphasizes the extreme importance of the society: it is a world of government by and for women, an extraordinary instance of female power in African traditional government.

Sande is a socially consolidating force throughout a broad geographic area. It unites ethnically heterogeneous people in an area long characterized by large movements of populations, political dislocations, and now, modernization. Rather than diminishing in importance under the pressure of contemporary economic and social development, Sande adapts to changing times while remaining vital and attractive.[5] Sande leaders, Sowei, are models to other women of the community, for they exemplify in their persons the highest of Mende social values. To them is entrusted the duty of enforcing right social relationships and removing whatever might harm women and upset community equilibrium.

Religious and Philosophical

Sande is a religion with the power to make life good and to inspire the highest aspirations among its members. It is a moral philosophy aimed at constant refinement of the individual. It is concerned with defining what it is to be human and what are the ways of promoting love, justice, and harmony. According to tradition, the root source of all fertility, productivity, and wealth is female, so Sande exerts its strong spiritual influence over both women and men. Sowei, the high-level leaders of Sande, are adepts with access to spirit ancestors and the forces of nature; they have a monopoly over certain sacred knowledge crucial to the development, happiness, and success of the individual and the well-being and prosperity of the community.

Educational and Artistic

The most influential institution within the society is the Sande School, a select grouping of initiates led by a preceptor and her assistants. Sande is in session at varying times, three to six months in yearly cycles, at specially selected remote forest sites. For young girls, Sande School is a school of initiation where they are trained in matters designed to enhance their potential as wives, mothers, and full-fledged members of the community. Sande School is a traditional equivalent of the western finishing school,

teaching young girls grace and elegance, beauty and refinement, pleasing deportment of mind and body. It is also a music school emphasizing singing and dancing as life-enriching arts that bring refinement to the individual, grace to the community, and recognition and prestige to gifted, serious performers. Sande School functions as a "university of the forest" with an advanced curriculum: myth, history, ethics, herbal medicine; all is self-consciously intellectual; all is graded and ranked. The Sande School, however traditional, intersects with national government-sponsored campaigns to introduce modernization. Thus, social welfare and community development extension officers teach health and hygiene, child care, and literacy at Sande convocations.[6] Furthermore, in the rural areas, where 95 to 100 percent of the women are Sande members, only those who are themselves Sande initiates are accepted as government representatives.[7]

THE ESSENCE OF SANDE

Sande has many facets and can be seen as many things. Every Mende society has material items that it holds sacred, that activate it, that are a repository for its essential being, its *hale*. The name of the female society's *hale* is *Sande*. Women speak of "getting Sande" out of a stream, of "finding Sande" in a river. The item taken from a stream may be an animal horn, a shell, a stone, a neolithic celt or axhead—the "Sande" that is kept wrapped and hidden is one of these natural items revealed from its place underwater.[8] In a certain way, then, *Sande is a stone*.

Mende call an adult female a *Sande nyaha*, Sande woman. This Sande word compound alludes to two facets of Sande—the organization and the body of knowledge. A Sande woman is a member of the Sande corporate body: she has been initiated into the society, and she belongs to a chapter or lodge. Furthermore, as a *nyaha* she can move freely in any Sande gathering or shrine, sharing the communal life of Sande women. Thus *Sande is an organization* with a structure within which the individual woman locates herself.

A *Sande nyaha* is also a woman who is cultivated, refined, and knowledgeable, fully aware of the powers and responsibilities of womanhood. *Sande is a body of knowledge* concerned with child care, home-craft, beauty, the arts, healing, ethics, and morality which a woman learns, practices, and teaches. A woman demonstrates her learning by keeping herself healthy, productive, artistic, well-groomed, well-mannered, and respectable—all qualities that bring her admiration and reflect on the society's good name.

Sande members conduct their activities as human beings, manipulating physical objects. *This mixing together of persons and things develops its own identity which makes mundane objects temporarily Sande.* So, for example, at the end of the Sande session, when the women are moving house from the Sande encampment (*kpanguima*) to the corner of the leader's house where

Sande paraphernalia is stored (*sopèèbu*), they will declare that they are "moving Sande." Along with the sacred stones and masks will be quite ordinary household items—mats, pots, basins, cutlery, clothing, vegetables, furniture—all, for a period, parts of Sande manifestation.

A sacred seed-stone, an organization, a body of knowledge, a collection of objects—these things are indeed "Sande" but not its essence, its real being. A Mende proverb cautions us not to look at the surface of Sande: *Sande manèèwu mia lee a hojo kè Sande wui ii na*—"Hojo clay is there to make Sande nice [appealing, sweet], but it is not the essential of Sande." In the Mende public's mind, the visible symbol of the society is *hojo*, white clay, kaolin. White is Sande's color (to be discussed fully throughout) and the clay is used to paint the initiates-in-training. White is beautiful in itself; by using white clothing and white objects, and applying white clay to persons and surfaces, Sande is thought to improve, sweeten, brighten community life. As viewed by the community, *hojo* stands for Sande, but it is not Sande.

A common social misdemeanor helps us grasp the profound meaning of Sande. Village streams have designated male and female bathing areas. A man creeps to the women's place and surreptitiously observes their activities. Hearing a suspicious noise, one woman will call out: *"Ye mia"*—"Who's there?" and if the answer is not correct, all the women will rush to apprehend the intruder. Brought before the chief, he will be accused of the crime of "spying on the Sande"—*Sande ma nee lei*.[9] Thus, a few women splashing about together in the water can be "Sande." By this, we see the heart of the *hale: Sande is women in fellowship*. Women create Sande on any spot where they group together, sharing with one another, excluding men, the space defined by their group in privacy and secrecy (fig. 4). This is Sande—women together in their womanhood, in a free exchange of words and actions among sisters. Wherever "two or three women are gathered together," there is the spirit and authority of Sande.[10]

PORCELAIN CLAY—*HOJO*

In the mind of the Mende public, the one thing that stands for the Sande Society is *hojo*—the white clay, kaolin, porcelain clay. *Hojo*, not the mask, is the symbol of Sande. The picture Mende have of the society is the white clay; it is the thing Mende say stands for the concept of the society, is identified with the idea of Sande (fig. 5). *Hojo* has several properties which, looking through Mende eyes, make it especially suitable for identification with Sande. *Hojo*, as clay, is moist and cool, alluding to admired womanly qualities of fresh youthfulness and composed character.[11] In appearance clay is smooth, glossy, shiny, with an at-surface reflection of light that Mende find eye-catching and beautiful. *Hojo* comes from the waters; like other aspects of Sande it is amphibious, found in the riverbed and also at the riverside. In nature, *hojo* is a variety of beige-to-white shades, but

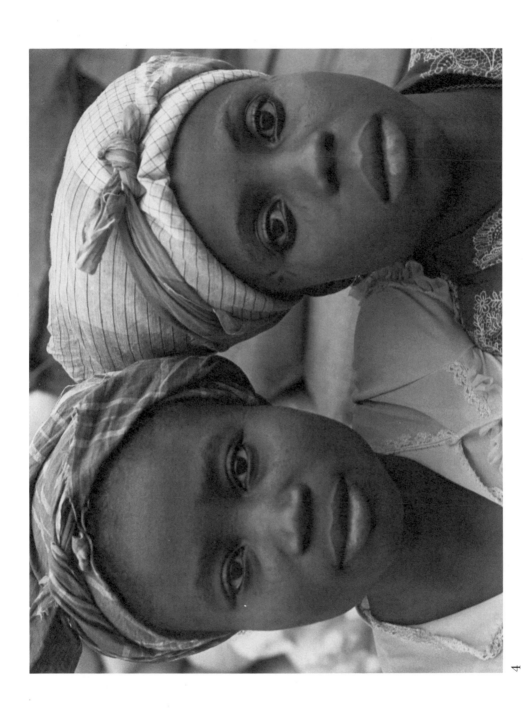

4

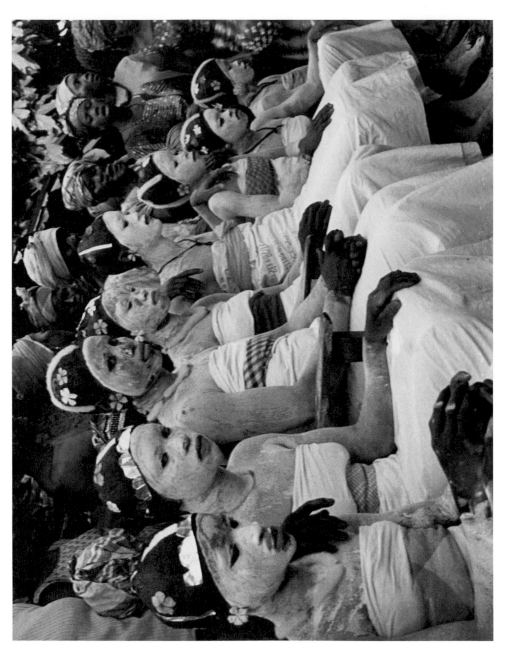

gleaming white *hojo* is only found far beneath the surface. So, like Sande, *hojo* is secretive, at its purest when it is most hidden.

Mende "know Sande" by the clay; the white clay is Sande's trademark, so to speak. By extension, the color white is also related to Sande. Or it may be the other way around—that white is the image of Sande and that *hojo* is the one God-given accessible item whose identity is whiteness. Young girls scoop up surface *hojo* and handle it like putty. They squeeze it into doll figures which they then use in their play. The responsible Sande women treasure the brilliant white *hojo,* which they dig for. Once it is excavated, they mold it into egg-shaped ovals which they dry and store. When dry, *hojo* is hard and its surface is dusty. It needs only to be crushed and mixed with water to be restored to its original malleable state. *Hojo* is a materialization of *whiteness;* it is an embodiment of mystic whiteness that can be handled and used.

White is Sande's color; not black, as one might surmise from the mask, but, like black, an absolute. In Mende thought, the color white is accorded the highest values and most prestigious associations in both the physical and metaphysical worlds. White signifies immaculate cleanliness, the absence of blemish or defilement. It shows "harmlessness"; it is void of all things satanic and is thus "a positive and helpful color." The purity of white makes it stand for the spirit world and for the secret parts of human society where people strive for the highest ideals. This appreciation of white implies the Mende preference for cut ground, cleared spaces, shorn growths; white is "empty," clear, free of everything extraneous. So it is bright and visible, with nothing hidden in dark corners, and therefore harmless and helpful. Brightness and gleam make white beautiful. Things in the world become dirty and discolored; but anything pure white defies mundane deterioration and triumphs despite the gravitational pull down into ruin. White is so notoriously difficult to keep clean, that it is automatically *yĕngĕlĕ*—jewel-like, delicate, poised: jewel-like because it shines out and catches the eye; delicate, because the merest spot will spoil it; and poised, because it triumphs over a world of things eager to sully it.

The Sande Society daubs objects with *hojo* to indicate that they are under Sande's control and protection and are subject to the full authority of Sande law and punishment. In the rural areas, the Sande initiates-in-training go about with their entire bodies painted with *hojo.* The white paint marks them clearly as Sande "property," under Sande control, not to be tampered with (fig. 6). Sande may also declare, for example, that a certain grove of fruit trees is under its law. A daub of paint on each trunk is a warning that the tree is not to be touched until Sande releases it. By the same token, Sande will restrict use of a stream, well, or other village resource, put a diseased location under quarantine, or, by otherwise delimiting and sanctioning, help to ensure the well-being of the community. In every case, the *hojo* is read by Mende very much as we would read a

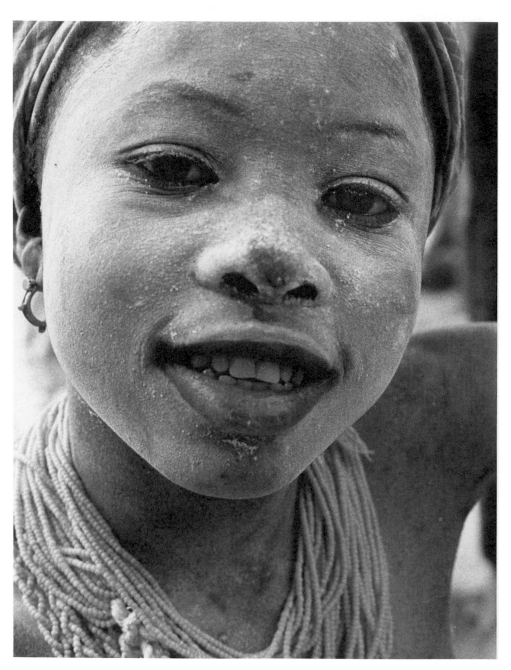

6

municipal sign saying "No Trespassing—Violators Subject to Fine or Imprisonment or Both."

Further relating to Sande and the law, Sowei as the judge of women uses white as a symbol of fair, clear thinking and justice—the qualities of a just adjudicator. Though the reason for the connection between white and justice was not stated, it can be seen in Mende thought. White is the color of the spirit world of God and the ancestors—*Leve-Njeini*. *Leve-Njeini* is always impartial, without favoritism, beyond influence, interested only in the truth and the promotion of life and goodwill. Since any human judge is seen as a medium through which the wisdom of *Leve-Njeini* can be heard, white expresses lucidity, leading to justice.

Ruling Sande women wear white headdresses (*fengbè*) and often white clothing as one of the honors of their high rank. White clothing indicates the closeness of a Sowei to the spirit world and lifts her to a lofty plane. Chief Foday Kai said: "A Sowei is the white light of the village among women" (fig. 7). Masks that represent the Sowei often bear a white scarf tied to the topknot of the coiffure, falling in white streamers. This identification of Sowei with white head ties is the subject of a proverb: "*Sowoi fengbè ii yèlò bi yeya kongo panii mia ba pèlè wumba.*" A figurative translation is, "You, a Sowei, do not have a white satin headtie, so you have put a white basin upside down on your head." The saying ridicules a Sowei caught unprepared to go before the public because she does not have the proper white headdress, who then is so foolish as to think she can get away with wearing a white pan as a head cover.[12]

The proverb teaches that the quality of a thing is in its function and not its appearance; it tells people to get the real thing. A pan is white and it can be worn on the head but it still is no substitute for a satin scarf; it is not pliable, it cannot be tied; it slides about on the head, out of control, liable to fly off. What is called for is something one can manipulate and control, something one can dance with. It says: You don't have the real thing, but you think you can make do with a ridiculous imitation. In your position you should have everything necessary to play your role satisfactorily and meet the expectations of people who look up to you.[13]

ORIGINS

In his research into the early history of the Upper Guinea Coast, Walter Rodney found descriptions of female societies in the writings of Portuguese travelers Valentin Fernandes (1505) and de Almada (1569):

> In the early sixteenth century, both male and female secret societies were concerned mainly with the training of young girls who had reached the age of puberty. All the girls of a given area who were to be initiated were placed in a large, isolated house, remaining there for a year or more under the guardianship of an old man. During the period of seclusion, the girls were given new

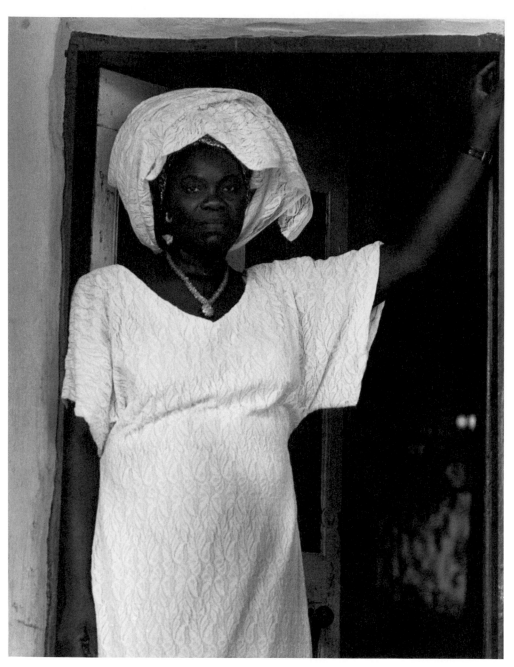

7

names, were sustained by food supplied by their parents, and underwent train-
ing which prompted the Portuguese to regard the institution in which they
were housed as a convent. On graduating they dressed in their best garments
and attended feasts and dances, where the nobles and the young men had the
opportunity of selecting their wives. These initiates were called *Mendas*. Almost
in every detail this description fits the Sande and Bundu female secret societies
as they have survived into the twentieth century. [1970:65]

It is certain that these earlier indigenous women's institutions are di-
rectly related to today's Sande. Rodney suggests that Mane women (from
the Mali empire) came into the Sierra Leone area with their own powerful
initiation society and met and amalgamated with the female sodalities they
found in situ. Furthermore, Mane women were always powerful, often
regents, and the principal Mane migrations were led at the outset by a
warrior queen, Mansarico. From this, Rodney concludes that as the Mane
mixing created the Mende as a people, so the Mane female heritage gave
new strength to women's institutions (1967:242–44).

A picture, then, of the time when the Mende were firmly installed would
be instructive. John Matthews, an English explorer, visited Mende country
in 1788; his fascinating account shows how fully developed the details
were two hundred years ago, indicating that Mende incursions brought no
disruption to the women's original rituals but rather blended with them,
maintaining continuity. His description offers a reliable index of the main
outlines of Sande activities in the *kpanguima:*

> Every season during the dry season, and on the first appearance of a new moon,
> the girls of each town who are judged marriageable are collected together; and
> on the night preceding the day on which the ceremony [excision] takes place,
> are conducted by the women of the village into the inmost recesses of a wood.
> Grigories, or charms, are placed at every avenue or path which might lead to
> the consecrated spot, to warn and deter the approach of the ignorant or design-
> ing, during their confinement which continues one moon and one day. . . . It is
> principally during their confinement in the wood, when the body is subdued by
> pain, and the mind softened by the gloomy stillness of everything around them,
> that they are tough [*sic*] the religious customs and superstitions of their coun-
> try; for until that period, they are not thought capable of understanding and
> practicing them.[14]

Though the Mende as we know them today have been a cultural entity
for less than two hundred years, they prefer to think of themselves as a
people present since the dawn of recorded time. The beginnings of the
Sande Society are also stated in mythic time. Sowei say that the society is as
old as the Mende and that there can be no Mende people without the
society, their existence is coterminous, each completely related to the
other.[15] A story related by Gorvie leads to other inferences. According to
Mende tradition, Sande came into existence because of a dream experi-
enced by a woman named Sande Jo. In her dream she received instruc-

tions about the purposes of the *hale* and the full authority to organize it and put it into operation. Sande Jo formed the society bearing her name, designated the other officers, and was the first woman to function as a Sowei (1945:46).

Though sketchy, the structure of the myth outlines certain crucial facts. For one, people existed before the society and people organized the society. So the society was made for people, not people for the society—people are the cause, not the effect. Second, Sande was founded by a woman for women, not by a man; by a human being, not a deity. The inspiration for Sande came from a dream; in Mendeland dreams serve as vehicles to humans from the divine for the transmission of innovative ideas, occult knowledge, artistic talents, secret know-how.[16] Furthermore, the power of the dream gave Sande Jo the confidence and courage to carry out her vision—a new mantle of authority and certitude is the mark of the genuineness of claims to divine guidance.

ORGANIZATION

There is no consistency to be found in descriptions of the Sande organizational structure among the Mende. Several versions are recorded in the literature, each one different; and in the field I recorded several others. The many different accounts present a picture of considerable variety. Clearly no rigid pattern is required; rather, Sande organization is adapted from locale to locale and from year to year. Conditions change, resources increase or decrease, personnel move around—all the flux of ordinary human existence affects the Sande corporation. A large, complex Sande organization with many officers and grades is the most admired, but most often the paucity of personnel and resources limits the actuality. Although community support of Sande is fervent and unstinting, it must be recalled that the communities themselves are usually scattered, in fact often quite isolated, and seldom is there a population on hand of more than a thousand persons. Nonetheless, despite local shadings, certain features of Sande organization are constant, serving as parameters within which the variations occur.

The cosmic body of Sande exists in the reality of a temporal town as a chapter or lodge; the lodge is named for the woman who founded it, for its home village, or for a paramount chief. Sande operates as a hierarchy. The top rank, leader, is *sowo*; the grade beneath it is *ligba*; an ordinary member is a Sande *nyaha*; a novice or initiate-in-training is a *mbogboni*; anyone not a member is a *kpowa*.[17] Starting with these basic designations, many changes occur in the dynamic Sande Society activities. Also, as always in Mende Studies, each word itself is subject to numerous renderings and will have within it allusions to further meanings.

The head of a Sande lodge is the Sowei, one of the *sowo* rank (*sowo,* the indefinite, becomes *Sowei* in the definite) and is called *Sande Jowei* (the initial consonant of the second word of a Mende compound mutates; an *s* mutates to *j*). In Mende, a *sowo* is an expert, a person—male or female— who leads the activities or excels in the job because he or she has the requisite ability and know-how. So, for example, an expert weaver will be a "weaver *sowo*"; the most popular girl at a school will be that "school's sowo." An especially capable, bright child will be dubbed "Jo" (the short-ened mutated form of *sowo*), indicating the promise of his or her being a future leader. Thus the *Sande Jowei* is the expert in Sande, the master and keeper of Sande knowledge, the head of a Sande unit or speciality.

Several Sowei in association will designate one of their group as the head Sowei. When the society is "in session," several lodges in a town or in a chieftancy will come together to initiate the girls in a group.[18] Phillips notes that each girl, however, remains "attached to a particular group and pays fees to its officials." The women in charge of the other Sowei and Sande activities are called the *Sande Waa Jowei,* an interesting term to examine. Phillips writes that "one amongst the Soweisia in a town will be chosen as the supreme head and the title of Sande Wa Jowei ('big Sande Sowei') will be bestowed" (1978:267). Her misunderstanding of the term will serve to illustrate the confusion existing in the literature. Phillips heard the *Sande* and the *Jowei* correctly; the problem is with the middle word, *Wa. Wa* in Mende means "big, large, important" (Innes, 1969:149). "Important" or "senior" would better render the Mende word *wa,* since it is social standing, not physical size, that is under discussion.

Still, I suggest that Phillips has missed a nuance of the language, and with it the true meaning of the title. The title is, in fact, *Sande Waa Jowei,* the middle word being the long vowel rendered in English by doubling the letter. *Waa* is a mutated form of *paa; paa* means "to kill"; when related to a society name, it means "to form a society" or "to organize a society" (Innes, 1969:121). In Mende metaphysical thought, which Innes does not record, an individual who joins a secret society is said "to die into the society" (*ha halei ma*). A girl "dies into Sande"—a death of her old self—and is reborn as a new, higher being. The society official who initiates a member is said to "kill" her, thus ending her previous life and ushering her into a better existence. This is a religious concept familiar to westerners: "Except a man be born again, he cannot see the Kingdom of God" (John 3 : 3).

It can be seen, then, that the head Sowei is designated as the *Sande Waa Jowei,* meaning, literally, "Sande Initiating Sowei" or, figuratively, the Sowei who initiates a Sande. She is known as the sole initiator and the organizer of the *kpanguima* (Sande encampment), and is its chief admin-istrator. It is she alone who initiates the entering girls, and she is the one held accountable for their well-being. As the executive of the Sande ses-sion, the *Sande Waa Jowei* is responsible for all Sande activities during this

period. The woman who occupies this role retains the title for the entire year and is the single most distinguished woman in a locale.

Also of special standing is a *Hale Waa Jowei*. She is a woman of *sowo* rank, or maybe lower, who managed to obtain an object or material Sande *hale*, and with its authority organizes a new Sande chapter of which she is head. Another notable *Sande Jowei* is the *Sowo Kundoi*, keeper of the Sande paraphernalia. When the *kpanguima* is in session, other Sowei of the area assist *Sande Waa Jowei*. Certain of them will be known as *Nyande Jowei* and others as *Ndȯgbȯ Jowei*, with the former having the higher status. The exact meaning of *nyande* here can vary but will be found in the cluster of "beautiful, good, kind, nice." To add to all the admiration and respect due a Sowei by stressing that she is beautiful and good is to make *Nyande Jowei* adored and beloved as well.

Ndȯgbȯ Jowei is the "bush Sowei," short for "the Sowei who goes to the bush." Any Mende ceremony or ritual begins with the exchange of a token sum of money given by the secular patron to the sacred practitioner. The sum is called *pili ndȯgbȯ*, translated as "send to the bush"—meaning the money is a down payment (Innes, 1969:124), the contract is engaged, and the practitioner is sent off "into the bush" to gather plants and herbs necessary for the operation.[19] So these *Ndȯgbȯ Jowei* are those who receive the contract money from the chief which seals their mutual obligations, and with it they set about making the cultic preparations.

The second rank in Sande is *ligba*. Within *ligba* there are two distinctions—*Ligba Wa* and *Ligba Wulo*. There is only one *Ligba Wa* (senior *ligba*); she is assistant to the head Sowei and acts in her absence. Another name for her is *Sowei-gblangȯmoi*—"the person at Sowei's side," in recognition of the close association with the authority. Figure 8 shows Sowei and *Ligba Wa* together. *Ligba Wa* is a woman of weight in society and community affairs. It appears that she is the executor of Sande: she does not make the decisions, but she is empowered to carry them out. According to one source, it is really the *Ligba Wa* who is in charge of the surgery on the initiates. She must be a brave and lion-hearted woman, I was told, skillful and sure with the knife, well-versed in herbalism.[20] She must be physically strong, because she is the person who carries the arks and bundles containing Sande ritual materials. Respected and feared, it is *Ligba Wa* who proclaims Sande decrees, applies Sande restrictions, and administers punishments to those who offend Sande.

Before she can take leading roles in Sande artistic activities, a woman must qualify at least as a *ligba wulo*. Women in this grouping are given different titles at different times as they carry out a variety of functions. Probably the most important of the *ligba wulo* is the *Ndoli Jowei*, "the expert in dancing," the woman who dances the mask in public and teaches dancing to the girls in the encampment.[21] In a community where everyone dances before they walk, to be named "Expert in Dancing" and to display

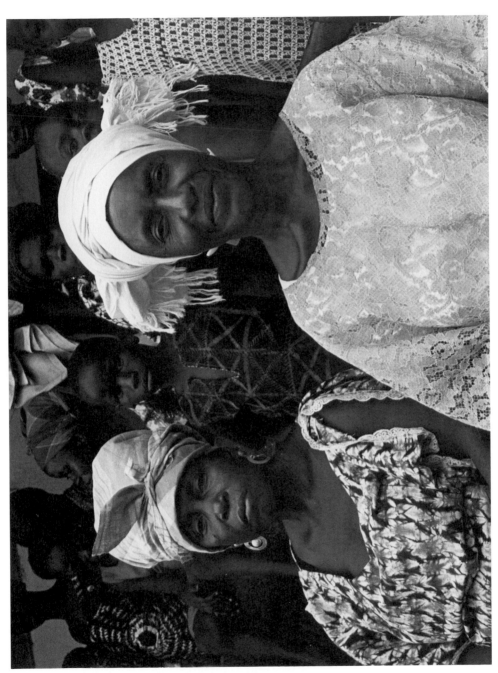

skill in public calls for enormous poise and self-confidence as well as masterful technique and artistic imagination (fig. 9). Girls are sent to Sande to learn how to dance; dancing well is essential for their success as individuals, as women, as Mende. Within the *kpanguima* enclosure the *Ndoli Jowei* has the responsibility for teaching the girls to dance, a large part of their socialization into adult female life.

Learning the dances requires the initiate's attention and devotion. *Ndoli Jowei* is a kind of sergeant getting the recruits ready for combat. Dancing is the discipline. Practices goes on for hours until the girls drop. Mme. Boi (herself an *Ndoli Jowei*) explained that she would show a girl a step twice; if she had not caught on by then, she would be switched whenever she made a mistake.[22] The constant criticism, observation, testing, hitting, and shouting make the girls quite disoriented for a while. The dance mistress uses shock techniques—awakening the novices in the middle of the night and ordering them to dance or forcing them to stay awake for forty-eight hours in a row, dancing almost all the time. After a couple of months of this treatment the initiates are transformed. They are tough and confident under harsh conditions, inured to negative comments, dry-eyed under beatings. They are in excellent physical shape—the added weight is firm and muscular, they have stamina and endurance; they move quickly, are alert and responsive.[23]

Interestingly, the woman who dances as Gonde (the comic "anti-aesthetic" mask that matches Sowo) is also an *Ndoli Jowei*. Inside the *kpanguima*, Gonde becomes a "friend to the initiates." She amuses them with buffoonery and high-jinks, trying to make them forget their hardships and pain. She coaches those who are slow in dancing and encourages those who are in despair over their inadequacies. Ridiculous and disreputable in the community, Gonde is a funny, lovable character who lightens the gloom and reminds everyone that Sande is not always so deadly serious.

The other personality of *ligba wulo* rank is the *Klèi* (Klawa), a very colorful individual. Her other name is *Ndoli Jowei Mayèpè Lemoi*, "the person who explains about the dancing Sowei." *Klèi* acts as liaison between Sande and the public; she is Sande's town crier and announcer. She proclaims the times of Sande gatherings, calling the women forth with the words *Sande nyahanga bèèle a halei kpanguima*—"Sande women, assemble at the society's encampment." At the same time, she warns the men and children to stay in their houses. *Klèi* is the mistress of Sande ceremonies, organizing and arranging for all the public social events. When Sowo is on display, she accompanies it as guide and spokeswoman. Holding a long staff or a headtie, she walks before the mask shouting its praises and speaking on its behalf (fig. 10). As Sowo proceeds on its way, *Klèi* will run a distance ahead, then bow down in homage to the mask as it approaches.

An ordinary graduate of Sande who has not attained a higher rank is a *Sande nyaha*—Sande woman. As any Mende who belongs to any society,

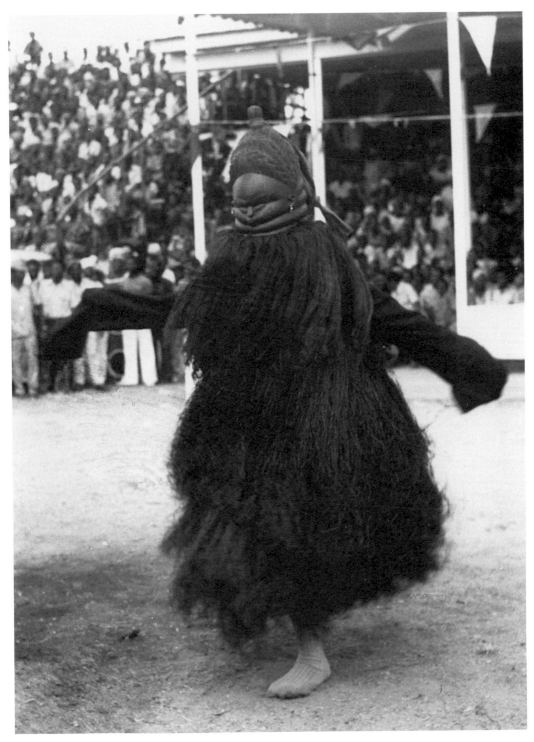

9

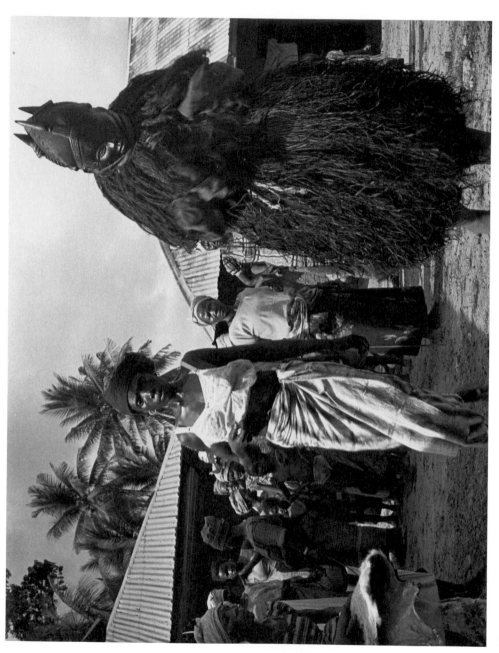

she becomes a *kpaamò*. *Kpaa* is the Mende word for the mysterious work-ings of *hale*.[24] Once a person is privy to the mysteries and secrets of a society and has undergone its ritual bath, he or she can call on Spirit and start *kpaa* working. A *Sande nyaha* has this knowledge and power, the necessary equipment for her well-being and success in life. When a girl has just finished her Sande training she is a *Sande yo*, a "Sande small one" (Innes, 1969:154). A *yo* is any aspirant, a learner; it is the future thing in progress, not yet fully mature. The fruit of a development process is also a *yo*, so the *Sande yo* is the product of Sande training. Still, no matter how recent her graduation or how tender her age, once a girl has finished Sande training, she is a grown woman in the eyes of the community. The proverb says, "*Sande nyaha ndopo ii le*"—"A Sande woman is not a child."

Sande is all-pervasive, a complete system. Every woman can be measured in terms of her relation to Sande: if she is not located *within* it, she is *outside* of it. There are two kinds of non-*nyaha*—the *mbogboni* and the *kpowa*. The former is the initiate-in-training; her life will be described in the following section on initiation. A close look at the *kpowa* will highlight, by contrast, the virtues of the *nyaha* and the despised state from which the *mbogboni* wishes to escape. *Kpowa* "the uninitiated," as a person and as a concept is everything that is ignorant and uninformed. In the Mende world, those who belong to a *hale* society (*halemò*) are intelligent, educated, savvy, dis-cerning; those who do not are mentally deficient, dopes, dupes, dummies. *Kpowa èè tò*, "kpowa doesn't see it." Things pass right under the *kpowa*'s nose, but she does not see; things are said within her hearing, but she does not understand. *Kpowa* is fooled; *kpowa* is deceived. There is a derisive pun: *kpowa wova*—*kpowa* meaning both "uninitiate" and "cork," *wova* meaning both "old" and "floating." So *kpowa wova* is like a cork floating on the water who, in turn, is like the old noninitiate who has spent her life just bobbing around on the surface of things, never getting down to the truth.

Ndopoi ba pòò yafèi loli a sowo kpowayèi mia a bi waa—"The child that calls the Poro mask a Sowo mask will die a *kpowa*, a dunce." Every Mende child must recognize the different masquerades; if he calls a Poro spirit "Sowo" he is hopeless and probably will be stupid until the day he dies. If you are so dense that you cannot recognize the obvious in your community, then it is difficult to imagine that you can ever be taught anything. This identifica-tion of a *kpowa* with a child reinforces the notion of the childlike social level of the noninitiate, his or her inability to function as a citizen because he or she does not have the barest minimum of necessary know-how. The *halemò* is respected, has standing in the community; *kpowa* is despised. Since only the Poro and Sande determine when young persons are prepared for marriage, as a further insult a *kpowa*, as a social child, is doomed to remain a bachelor or a spinster, one who never qualifies for the pleasures and responsibilities of full adult life.

At the moment of her graduation after initiation training, the new

member of Sande is dubbed a *Poma Jowei*, "behind Sowei, after Sowei" (Innes, 1969:125). A more figurative rendering might be "a future Sowei." *Poma Jowei* expresses the Mende community's hope that in time some among these new initiates will rise to the highest rank of the organization, *sowo* level, and deserve the address, *Sowei*. Sowei everywhere are admired, praised, and respected (fig. 11). They are the finest among women and serve as an example to others of what it means to be beautiful, healthy, wealthy, learned, responsible, successful. The term *Poma Jowei* makes it clear that *Sowo* level is an earned honor, not an ascribed one. The young, inexperienced *Sande yo* is just beginning her life as an adult and as a member of the society. She is far "behind Sowei" now; but every initiate, regardless of the circumstances of her birth or family background, if she is intelligent and ambitious, has the potential to move ahead and become a leader.[25] There is no doubt that every Sowei has earned her post on merit alone and retains it through outstanding performance.[26] Sowei is a *sowo* person—an "expert." She is also an *ngi bèengo* person, "she knows how to do it" (Innes, 1969:3), the "it" being every function and task necessary for her position and role.[27]

SOWEI: TEACHER, JUDGE, AND HEALER OF THE WOMEN

This section looks admiringly and analytically at Sowei as arbiters and creators of beauty and morality in Mende society. An appreciation of the human Sowei leads to a greater understanding of her masked spirit counterpart, Sowo, from whose divine presence Sowei receives her temporal authority. Sowei is discussed both as an embodiment of Mende ideals of social conduct and in relation to her roles and functions as Teacher, Judge, and Healer of Women. Then, with this background on the social significance of the Sowei woman, we can delve deeper into a study of the iconography and iconology of the Sowo mask.

Mende people have a clear concept of what it means to be "a good Mende."[28] Individuals who display traits valued by Mende are termed *Mèndemèndemò*. Literally, this means "a Mende-Mende-person," with the doubling of an adjective expressing intense emphasis;[29] figuratively, it means "a Mende man who has a good knowledge of Mende culture and traditions, a Mende man who has little experience of European ways" (ibid.:86; fig. 12). As upholders of tradition, Sowei are definitely *Mèndemèndemò* at the same time that they are the embodiment of the best of Mende conduct. These admired and desired Mende qualities will be examined one by one. Taken together, they are a description of the Sowei personality and character, are intrinsic to her being, and, by extension, are a description of the persona of the Sowo mask as it represents Sande's social ideals.[30]

Nèmahulewe (nèmahulengò): cleverness, intelligence (ibid.:99), use of the

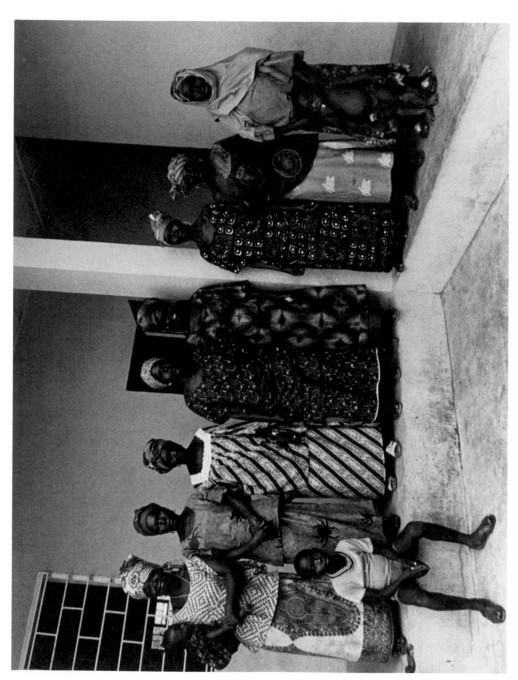

mind.[31] This means applying the intellect to any and all tasks and challenges so as to clear away difficulties in the most appropriate, efficacious manner. *Kahu* (*kahungò*): physical strength over and above the ordinary. The word itself means "body" (ibid.:38) but also refers to strength in the sense of endurance and stamina. *Kpaya* (*kpayangò*): authority, power (ibid.:95). As *kahu* is physical strength, *kpaya* refers to social strength, responsibility, influence, command over a unit in Mende society.

Ndilo (*ndilongò*): bravery, courage (ibid.:94). *Ndi* = heart, *lo* = stand; it means your heart can stand the strain, your heart can bear up. Lack of heart makes people fail because they withdraw from the struggle. But if you have *ndilo* you can press on to victory despite difficulties and pain. *Fulo-Fulo* (*fulo-fulongò*): quickly (ibid.:15), to do things smartly, sharply, finishing in no time. You put knowledge and skill into doing a job, and it is quickly completed. You put your whole self and concentration into a task and accomplish it directly. *Di* (*dingò*): persistence, continuing until the job is done (*ibid.*:74 notes *madi* as "zeal, diligent effort"). *Di*- tasks— such as daily weeding of large tracts of farmland or nursing a sick child through a long illness—require patience and attention to detail, not physical strength. The *di*-person is able to do small, difficult, tedious chores painstakingly right through to the end.

Malondo (*malondongò*): be silent, be quiet (ibid.:77). The silence of *malondo* means to be long-suffering, to endure hardships, trials, punishments, and misfortunes without complaint. *Tònya* (*tònyangò*): truth, as a judge of a situation, fearlessly declaring the truth in a dispute (ibid.:145). This is the man or woman who is elected chief, the person who sees the truth at once and declares what is right without fear or favor. *Pòna* (*pònangò*): straight, correct, does not bend, do properly, straighten (ibid.: 126). The *pòna*-person is reliable, makes decisions and sticks to them, is straightforward not underhanded, assumes responsibility for his actions and point of view.

One trait missing from the list is *hindawanda* "goodness, generosity" (ibid.:26). When I asked my Bo preceptor why "generosity-as-synonymous-with goodness" was never mentioned by anyone, he replied that this trait is assumed but unspoken. You can never excel in generosity; you can never be unexpectedly generous; you can never be too generous. All that it is possible to do for others should be done. Only the opposite trait, *kòli*— meaning greed, meanness, and, in the *ngò*-form being mean and refusing to give (ibid.:51)—is expressed. Thus, *Kòlimò* is a selfish, negative person in the village—"he grabs a thing, turns his back on the others, and consumes it."[32]

The special importance of the Sande leader, Sowei, derives in part from basic Mende social structure. The average Mende person's associations and activities are largely prescribed by gender identity. During the day men and women work in separate places at separate tasks and then in the evening tend to eat and socialize mainly with members of the same sex.

Relations between the sexes are formal, regulated by etiquette and convention as well as by *simòngama* laws that enforce complex sex taboos.[33] Designed to ensure sexual morality, the rules are so elaborate that, in smaller communities especially, it is easier for members of the opposite sex, even though married, just to avoid each other rather than risk being subject to fines, punishment, and "social-pollution"–removing rituals. Sexual separation and morality both are upheld and reinforced by the fundamental *hale* organizations, Poro and Sande, which bisect the Mende community. Every adult can belong to one of the two organizations but is excluded from the other by gender. Men and women have "secrets" that bind them to their own society peers but keep them apart from nonmembers, members of the opposite sex. As head of the Sande Society, a Sowei is responsible for the women of the community and is charged with promoting their well-being.

Sowei is an awe-inspiring personality in the Mende community. She is "not expected to live the normal life of a human being; that doesn't fit her." A Sowei is the "spiritual symbol of the women"; "like a paramount chief," she is "above the others." Sowei is "superhuman, can do no wrong," "not an ordinary person." All Mende remarks about Sowei are complimentary: all the women look up to her as a protecting mother, while all the men respect her as a formidable representative of female interests.

Sowei is teacher of the women

To fulfill their obligations to the community as women properly, it is best that women be taught by those who know the female side of life. Sowei is the most learned among the women, and she establishes Sande schools for the purpose of instructing all junior women.

Sowei is healer of the women

The needs of female health and parturition can only be experienced by another who has passed through the same developmental phases. The female body is secret and must never be revealed to a man other than the husband. Pregnancy and childbirth are exclusively female concerns and, again, secret from men. Sowei doctors and treats the women, and maintains them in health and vigor.

Sowei is judge of the women

Since women associate all the time, it is likely that there frictions and conflicts will arise that concern only their female groupings and not the larger community. So it is best that these disputes be judged by one of their number who understands how women interact. Sowei also hears marital disputes, in a sort of "court of domestic relations." Sowei is "the embodiment of feminine wisdom," is the most honest, the most impartial and so the most capable of adjudicating and resolving conflict.

As the Sande Society stretches throughout a woman's lifetime, it does so in the person of the Sowei. She exercises the tremendous authority of the spiritual forces of Sande on behalf of women. It is she who creates the situations and settings in which Sande concepts and ideals are translated into a human program for female advancement. Everything that can be observed about Sande and its enlightening, uplifting effect on Mende life is directly attributable to Sowei. As she is the custodian of the society's sacred relics, so she is guardian of the best in Mende thought, and the bearer of beauty, cleanliness, and sweetness. She determines Mende aesthetics, is the patron and critic of its major art forms, and ensures that both human women and their images in wood maintain the canons of beauty. Sowei, the Sande leader, and Sowo, the Sande mask, are at once complementary and reflective of each other. The majesty and power of the mask give Sowei her authority and confidence. As the mask is the visual representation and compilation of Mende aspirations and ideals for womanhood, so in her person does Sowei strive to exemplify and to personify, the very highest of feminine virtues.

But the Sande Society has two masks: not only Sowo but also Gonde. Any discussion of the nobility of human Sowei is not complete without recounting the faults of human Gonde. Mende women have created *two* masks because it takes *both* to *express fully* the realities of the social milieu out of which the Sande mask forms emerge.[34] Sowo is the classic image of transcendent womanhood—beautiful, elegant, serious, sumptuous, and with an aura of grandeur. Gonde, disreputable Gonde, is the "anti-aesthetic" mask—coarse, unkempt, gross; the top is broken or grotesque, the costume a pile of junk and scraps.[35]

As masks, Sowo and Gonde are opposite: Sowo is immensely superior to Gonde, while Gonde's comical appearance and behavior mock Sowo's rigid perfection. Sowo is scandalized by Gonde's antics, and so they never meet.[36] Still, for all their apparent antagonism, Mende people say of them: *Gonde a lua Sowei makè ti hugbate*—"Gonde fears Sowei [is Sowei's vassal], but that is their arrangement." Do not be misled; rival chiefs who always struggle against each other publicly may have their own secret understandings. Sowo and Gonde are both masks, both *ngafa* spirit apparitions, and thus are far above ordinary human beings. They may be opposites but they are equals. They can meet together privately, in those exclusive places where the mighty congregate and negotiate their deals. Although some important persons, companies, institutions, or nations may compete ruthlessly, still they will be united in their basic aims and ideology.

Together the contrasting yet complementary masks say that society is made up of the outstanding and the ridiculous. Sowei, the human woman, is of lofty stature, at the top because she disciplines herself into the most dignified and noble behavior. Sowei is a serious, conservative lady who acts in a principled way, always mindful of her image as an example to others; she

represents woman in her best social sense. Gonde, on the other hand, is the slattern of the village, raggedy, who has "let herself go." She corresponds to those village women who will not take the pains to be well-groomed, and who do not want the cares of responsibilities. Gonde (woman and mask) are usually well liked because they are free, bawdy, irreverent. The mask is the object of fun just like her real-life counterpart. You can laugh and joke without her taking offense; you can approach her informally, have casual sex with her, kid and tease her. Hapless Gonde has long since stopped minding what people think of her.

Gonde, a figure of fun, is in a sadder sense a figure of failure. There are many, many failures in the villages, people who are not of the fibre to meet the rigors of Mende life or find a niche for themselves in the Mende community. They are dependent, unproductive; they eke out an existence at the edge of society, eating crumbs, wearing tatters. Quite useless themselves, they live on the kindness of the capable and the hardworking. There is no longer any hope of reforming these n'er-do-wells; admonitions, blandishments, cajolings, punishments, scoldings—nothing so far has made them change their ways. Before she failed, it is most likely that Gonde tried, and tried again. A most poignant proverb tells her story: *Ngi pimbili gaa, ngi pambala gaa, ngi tea fee, ngi njea fee, ngi gbahanga*—"I have danced far and wide, I have danced round and round, I have leapt into the air, I have sunk onto the ground [but now] I give up." "I have done my best, but have failed, I have tried everything, but have failed" (Innes, 1969:121). Sowei and Gonde, representing the two poles of human experience which Sande is honest enough to present for our instruction, meet and live together in the sacred initiation grove—*kpanguima*, the world that Sande makes.

Notes

1 In this chapter I rely almost entirely on data from my field research. Historical references to Sande begin in the sixteenth century, but though frequent over the next four hundred years, they are always brief and scanty. There is no record of a full-scale anthropological study of the society, only scattered fragments from *kpowa* observations.

2 This is a most conservative estimate of Sande/Bundu coverage. I have taken as my distinction those ethnic groups which regularly display the archetypal Sowo masquerade figure and feel allegiance to it. If we were to include those groups in which the primary traditional female educational institution is an initiation society practicing clitoridectomy, then the number would be at least double.

3 Merran Fraenkel, *Tribe and Class in Monrovia* (London: Oxford University Press, 1964), pp. 171–72.

4 Carol P. Hoffer, "Mende and Sherbro Women in High Office," *Canadian Journal of African Studies* 6, no. 2 (1972): 151–64.

5 Sande is now strong in Freetown, the capital of Sierra Leone, and is growing in Monrovia, Liberia's capital. Its influence has extended to the cities as well as expanded in rural areas, recruiting among indigenous, Creole, and immigrant women. See

Michael Banton, *West African City: A Study of Tribal Life in Freetown* (London: Oxford University Press, 1957), p. 185. Furthermore, in the swirl of change and often shallow imitation of European ways, membership in Sande is considered a point of African pride, a special "extra" that asserts a positive self-identity. See Fraenkel, *Tribe and Class in Monrovia*, 1964:173.

6 Kenneth Little, *The Mende of Sierra Leone*, 1967:130; and reference to M. A. S. Margai, "Welfare Work in a Secret Society," *African Affairs* 47, no. 189 (March 1948): 227–31.

7 Personal communication, Robert McGuire III, 11 November 1973.

8 Neolithic artifacts are frequently found in the rivers and streams in southern Sierra Leone. For a discussion of problems in Sierra Leonean archeology, see Matthew H. Hill, *Ceramic Seriation of Archeological Sites in Sierra Leone, West Africa* (1970), and John Atherton and Milan Kalous, "Nomoli," *Journal of African History* 11, no. 3 (1970): 303–17. It is unclear why one item is "Sande" and another is not. Each of these items is a mineral/stone and each has been shaped for beauty and utility by God or, as in the case of the celts, by the ancient ancestors—the *Leve-Njeini* combination that Mende regard as the source of life and knowledge.

9 For a discussion of the often rough and disabling punishment that women can mete out to male trespassers, see W. T. Harris and Harry Sawyerr, *The Springs of Mende Belief and Conduct* (Freetown: Sierra Leone University Press, 1968), p. 104.

10 I am grateful for the development of this argument to the Bo preceptor, April 1978.

11 For discussion of coolness as a metaphor for composure, see R. F. Thompson, "Aesthetic of the Cool," *African Arts* 7, no. 1 (Autumn, 1973).

12 A similar proverb is quoted by M. Mary Senior, "Some Mende Proverbs," *Africa* 17 (1947): 202–05.

13 Discussion by Bo preceptor, April 1977.

14 John Matthews, *A Voyage to the River Sierra Leone* (London: B. White & Son, 1788), pp. 70–72.

15 Meeting of Sowei, Jaiima Bongor Chiefdom, February 1977.

16 My notes contain the results of my initial inquiries into the subject of dreams. Though a fascinating topic, it was not one I could pursue. For a discussion of the place of revelatory dreams in Mende belief, see Harris and Sawyerr, 1968:14, 20, et passim.

17 For clarity and precision these terms are stated in their indefinite, singular form.

18 One purpose of Sande is to form a fellowship among neighboring girls and women. The more initiates, the better, because each girl then has a number of initiation mates (*mbaa*). A class of only three or four is considered most unfortunate, and, technically speaking, no girl is initiated by herself alone. In smaller communities initiations are held only every five years so that there will be a larger grouping of girls.

19 In practice, every Mende ritual is carried out through the power of leaves/herbs. Herbs transmit power from the divine to humans, so every attempt to contact the supernatural requires a trip into the forest in search of the particular, necessary herbs.

20 Njala, January, 1976.

21 Note, not "the dancing sowei" as translated in Phillips 1978:268.

22 Njala, January, 1976.

23 This description of the harshness meted out to the Sande initiates will remind the reader of any number of western "training" situations designed to prepare the recruit for his future social responsibilities—military "boot training," a medical doctor's internship, novice service in religious orders, and so on.

24 It is interesting to note that the Innes dictionary (1969:53) has no less than eighteen different translations for *kpaa* words from the societies, but not this meaning. He comes close with "a society with functions similar to that of the Humoi." *Kpaa* is not an individual *hale*; rather, it is a word that expresses the unseen but manifest powers that "belong" to the *hale* institutions and which the members, *halemò*, can activate and control. Bo preceptor, 18 April 1978.

25 Women born as daughters, nieces, or granddaughters of Sowei naturally have an advantage over other aspirants to high Sande office, but top posts are not inherited. Even if your mother were a Sowei she would not be free to disclose *hale* information to you in private exchange. By Sande law, society knowledge is only taught within the institution of the lodge or *kpanguima*; once there, the Sowei's daughter must meet the competition of the other aspirants and obtain the backing of the other elders.

26 On rare occasions, especially gifted girls are appointed Sowei while still in their teens due to their performing some dazzling feat of mystery and magic—usually diving into the river and coming up with a quantity of new, hitherto undiscovered Sande stones. The wonder girl is installed as Sowei more as a symbol and a revelation; but, like all child-kings, her reign is buttressed by the solid work of seasoned subalterns until she matures to the point of being able to assume Sowei institutional and community responsibilities. This is the story of both Mme. Sata Foday Kai of Telu, and Mme. Kadiatu Foray of Lumley, Freetown.

27 This discussion is based on information, impressions, observations, and experiences gathered during my several field trips and from on-going associations with a number of Sowei. On two occasions Chief Foday Kai assembled several of the Sowei in his kingdom, in part so that I could interview them (March 1977). As always, my Bo preceptor made especially enlightening comments.

28 Students of "national character" attempt to define what is meant by generalities such as "so American" or "so French." This discussion, however, is about the individual who embodies a cultural type. A comparison with the Mende idea of the Mende-Mendeman might be the Latino "macho," the Afro-American "soul man," the Jewish "mensch," the British "good sport." (It is more difficult to think of female types.)

29 For a discussion of reduplication and repetition in Mende grammar, see Innes, 1971:108–10): "By reduplication is meant the doubling of a stem. . . . Reduplication occurs with neutral stems to express: 1. Emphasis, . . . 2. Repeated action."

30 The inspiration and model for this inquiry came from Robin Williams's seminal work on "Value Orientations in American Society" (excerpted in Stein and Cloward 1958:288–314). Williams says values are "things in which people are interested— things which they want, desire to become, feel as obligatory, worship, enjoy. *Values are modes of organizing conduct*—meaningful, affectively invested pattern principles that guide human action. . . . Values concern the goals or ends of action and are, as well, components in the selection of adequate means" (p. 288). Social values can't be hidden—they are "self-reporting" in choices and preferences, and they are "observable variables in human conduct." But Williams warns that "what is not said is often more significant than what is said, reminding us again that the things in a culture that are most completely taken for granted typically turn out to be of fundamental importance in that culture" (p. 290). Certainly what people were able to discuss with me were the ideals for Mende behavior, the desires of the community for the best character, but obviously not the rules for the interactions of ordinary Mende people.

31 The Mende language does not parallel English in parts of speech and grammar; so in this list the first word is the noun name of the thing, while the word in parenthesis is the *ngò*-form, the active "verb" form translating to "it is" or, with the pronoun *ngi*, to "she is." Gordon Innes's doctoral dissertation, "The Structure of Sentences in Mende" (1963), analyzes Mende word classes and the complexities of Mende sentences. He made his findings available to the beginning student in *A Practical Introduction to Mende* (1971). For discussions of Mende nouns, see 1963:9–90 and 1971:16–28; for discussions of *ngò*-forms, see 1963:91–141 and 1971:111–17.

32 The embodiment of *kòli* in Mende culture is *Kasilo*, the spider character in Mende folktales. Kilson writes that in her "collection of tales, a recurrent thematic issue is associated with the negative evaluation of greed as it is prototypically expressed in spiders' avarice for food." See Marion Kilson 1976:41.

33 For a discussion of ritual sexual prohibitions, see Harris and Sawyerr 1968: 94–99.

34 My findings contradict Phillips's statement that Gonde is a "minor women's masquerade, and is not a real *hale* [*ngafa?*] but a clown-like figure" (1978:273). The conclusive evidence of Gonde's position within Sande comes in the *kpanguima*; Gonde is seen as a *ligba*-level member who has special duties in "being a friend to the initiates."

35 For a discussion of the "anti-aesthetic," see R. F. Thompson, "Esthetics in Traditional Africa," *Art News* (January 1968).

36 My data are inconsistent. My informants report that Gonde and Sowo are never supposed to meet, since Gonde "disgraces" Sowo and "reveals Sowo's secrets." Still, Phillips reports that *Ndoli Jowei*, the masked dancer, "will try to chase the *Gonde* away" (1978:274). The distinction may be in the rank of the *Ndoli Jowei*. If it is a dancer of middle Sande level sent to entertain, then the occasion may be light-hearted and informal; while if the superior, "awe-inspiring" mask that only walks in procession representing the Sowei herself is present, Gonde dares not come out. This point is unclear.

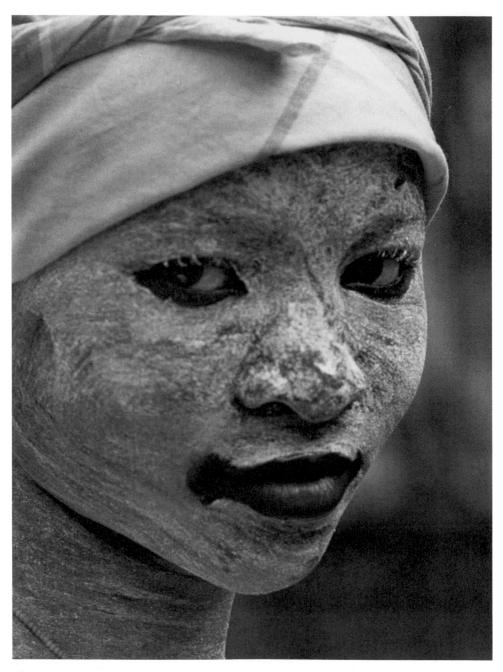

13

3

⫸ *Kpanguima:* The World of Beauty That Sande Makes

Kpanguima, the sacred Sande initiation grove, is a world apart. The Sande Society builds it as a special place where Sowei rules by Sande concepts and laws. Within the walls of the *kpanguima,* the women congregate for a Sande session; they separate themselves from the rest of the community and gather together in their own world for purposes both joyous and grave. Over a period of months everything that transpires within this sacred place is charged with religious and symbolic meaning. What the anthropological theorists term *rites de passage* and *liminality* will here be lived out by the participants in a sense of heightened awareness, as a disorientating *vie à l'envers.* What transpires has life-and-death importance to Mende women, and in the context of *kpanguima* time and space, lifeblood will be ritually spilled.

Traditional time for opening a Sande session is November/December, at the end of the rains, in the fullness of the harvest. This is a general period of leisure and abundance, the end of one agricultural cycle and just before the beginning of another. The weather is dry and thus more appropriate for healing and for bustling activities. There is ample food—the "hungry months" of July, August, and September are past—and it is not yet time for the more arduous farm work. A Sande session in a prosperous town makes for excitement and gaiety. Sande organizes the whole community into providing the means for a happy and successful initiation period, with the *kpanguima* as the center of all Sande activity.

The basic *kpanguima* consists of a compound enclosed by a high mat fence and containing covered sleeping spaces to accommodate all the resident Sowei and novices, several shaded rooms, a kitchen area, and a courtyard. Actual *kpanguima* vary considerably by locale: they can be made of clay, palm, or combinations of the two; some are stone houses; others are constructed of tin sheeting or wood planks. In the prosperous urban

area of Kenema, it is now the trend to build a permanent concrete or stone structure that can be used year after year. In other towns—Bo, Moyamba, Lungi—large houses may be temporarily occupied by Sande through either donation or rental.

The beloved *kpanguima* is a broad campus located in a quiet rural area and constructed of palm and wooden posts. It is a dwelling made with rich green leaves fluffed with strands of thatch. Fanciful and pretty, it is a confection of woven frond design on the outside, cool and spacious within; it is perishable and impermanent, seasonal like the Sande sessions, built fine, fresh, and new each year. High mat or palm fences screen *kpanguima* activities from public view. No one is allowed to photograph the *kpanguima;* however, in figure 14 the palm frond portals can be seen in the background. Sande marks of white, of *hojo* clay or cotton streamers, delineate the space before the entryway; and nearby trees may be painted white or draped with palm fronds. Still, even without these physical signs, there is no mistaking the *kpanguima*. Over its walls come the sounds of singing and whooping—continual noise, shouts, and the smells of cooking food, as a constant flow of women enters and leaves its portals.

Ideally, the *kpanguima* is located in a clearing at the edge of town, near a stream. It is built by men through communal labor under the direction of a man designated *ngegba* (the one man allowed into the enclosure to care for the structure). *Ngegba* (not noted in Innes, 1969) is a man who has been introduced into Sande and has undergone some sort of Sande initiation that makes him immune to the physical and spiritual calamities which normally befall men who violate Sande privacy. It is also a name given to the little grandsons of a Sowei who may regularly accompany her into the *kpanguima*. K.A. of Taima was an *ngegba* as a child, but as soon as his Sowei grandmother noticed that he was becoming curious and able to understand something of the proceedings, he was of course immediately excluded from further visits.

When the arrangement of the living area is completed, on a designated day, with the blessings of the chief, Sande women take the many necessary furnishings and ritual paraphernalia out of storage and transport it all across the village to the *kpanguima*. During these hours, no man or child is allowed to leave his house or to witness the procession. The *Klèi* spokeswoman goes through the streets, shouting and chasing everyone indoors, on threat of Sande punishment. The moving completed, *Klèi* announces that people may walk about freely again. Once everything within the *kpanguima* is in order, she happily runs to tell the town that Sande is in session and accepting new members.

Now a steady stream of women starts to go in and out of the *kpanguima*; There is a constant hubbub, with busy scurrying about. "The *kpanguima* is for women, it is for them," Mende say in English, meaning that no man can prevent a Sande *nyaha* from going to the *kpanguima* if she wishes. While

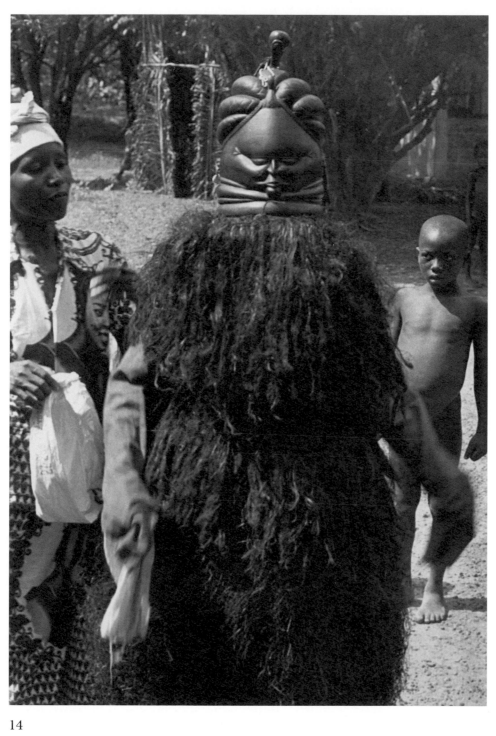

Sande is in session, every woman has the right to visit there at any time and to move freely about the town, explaining no more than that she is on secret Sande business. Husbands grumble that the women are acting frivolously, neglecting their duties, meeting lovers, wasting time, squandering money. But complain as the men may, during this period the women are cheerfully out from under family control, enjoying Sande protection. The situation is the setting for the proverb *Sande a ye ta hu nyaha hu ëë gbenge*—If Sande happens to be in the town, a woman will not be without a haven." The Sande *kpanguima* is the women's refuge.

Entrance to the *kpanguima* is forbidden to the uninitiated, for there is to be found the core of *Sande nduwu lunda,* Sande's deep secrets. The *kpanguima* is strictly for Sande *nyaha;* no one else is allowed in. Men, children, or other non-members may come as far as the fence but no closer. Parcels, bundles, messages, all are to be left outside. The *kpanguima* is hallowed ground, consecrated to the spiritual world and protected by supernatural means. It is a dreadful place where you trespass at your peril. The stern prohibitions against an outsider approaching a Sande encampment have given rise to this proverb: *Kpekelei a vala ngi gòwui-huvèi ma lo, a kpangui lalewe*—"Man-of-the-town, you must be very sure of the strength of your legs [before you] knock at the door of the Sande shrine." If you dare to go some place or do something that you know full well is forbidden, then you must be counting on some hidden advantage to save you from the dangers you are inviting. Before you challenge the mighty, you must be certain you have the resources necessary to protect yourself.

LIFE IN THE *KPANGUIMA*

The *kpanguima* is a world of *nyaha* exclusively, private and secluded, where a woman can unwind and feel free. In the austerity of everyday life, Mende standards for female grooming and comportment are strict: a woman must be clean and neat, every hair in place; her behavior must be submissive, self-effacing, patient, shy, sweet. In the Mende community a female appears as this modest creature, bowing to all with a charming, enigmatic smile. But in the *kpanguima* a woman's behavior changes dramatically, for here there is no need to be obedient and subservient to men. Mende term the *kpanguima* experience the "*nya mbaa* life." *Nya mbaa* means "my mate, my pal, my buddy" (Innes, 1969:82). Not necessarily deep friendship, *nya mbaa* conveys the sense of camaraderie, good fellowship (fig. 15). Although there is a hierarchy of authority and responsibility, only the two or three high officials have to be treated with deference. As for the others, they all mix together—senior wife with junior, mother with daughter, rich with poor, older with younger, moral with disreputable, the successful with the failures. Mende social relations outside the *kpanguima* are characterized by an asymmetry in which every individual is superordinate

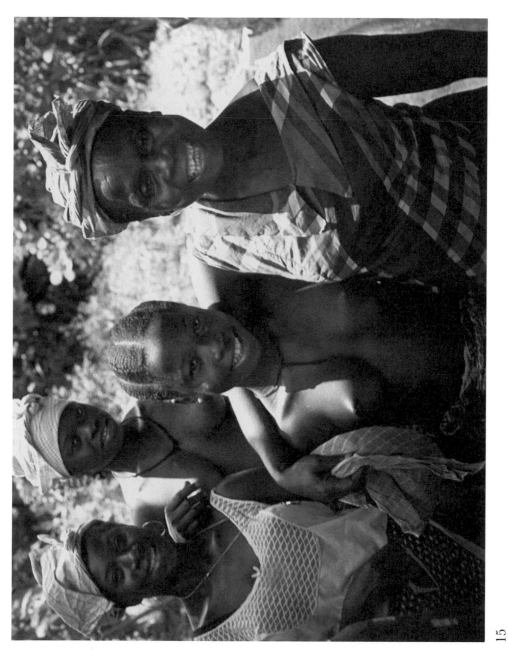

15

or subordinate to every other individual for complex reasons of age, sex, wealth, class, and character (Kilson, 1976:40). But the *nya mbaa* life, hidden behind *kpanguima* walls, is informal and egalitarian, free and communal.[1]

Richards has written about the Sande Society as the answer to certain felt needs of the Mende people—for cohesion, for inner security, for education (1970:53–65). He speaks of cohesion within the nation/ language; using his approach, *nya mbaa* can be seen to respond to the community's need for harmony and integration among the women of a particular area. That is, just as the Sande and Poro societies as institutions have "contributed to the coherence of Mende culture within a society of scattered communities composed of variously affiliated and fluctuating membership" (Kilson, 1976:10), so the seasonal *kpanguima* in the individual town has served to bind that community into harmonious relationships.

During the Sande session the Sowei sit in court to hear disputes between and among the *nyaha*. Women come with litanies of complaints and lists of grievances. All sides are heard and witnesses are called; the emphasis is on discussion, compromise, and concessions. Serious wrongdoing is punishable by a heavy fine or a harsh beating. Sometimes an apology or restitution of property is sufficient. Never is a woman banished, or incarcerated, or sent to coventry; the effort is toward resolution and reinstatement. Often the disputants are made to undergo a ritual bath—a scrubbing and rinsing of the physical body with herb-suffused holy water that is meant to cleanse and repristinate the spirit. A woman brings these social ills with her to the *kpanguima;* here they are resolved and then washed away, so the larger community, too, has been rid of crimes and wrongs and thus is healed. Resolution and reinstatement restore harmony and equilibrium.

These aspects of *nya mbaa* life can be stated in sociological terms by a westerner but Sowei's language will be metaphysical. She will smile, and say only, *kpanguima njabu lò,* "the *kpanguima* is under water." In this cryptic statement lies the whole explanation. The *kpanguima* is not of this earth but is located in the paradise of the river depths where spirits enjoy a divine existence of beauty and peace. The answer to an ordinary inquiry about a woman who has gone to the *kpanguima* is, *"Ngi njabu lò."* She, the village woman you see every day—that mother, that wife, that teacher, that farmer, that nurse—has left this realm and is now in a heaven, living in a medium of life-giving fluid. The pleasure of life in a *kpanguima,* with its abundance, generosity, and sharing, eases the soul. Underwater the *nyaha* sing and dance and rejoice; like the women in figure 16 with the *njabu* pattern on their dresses, she has joined the divinities and can frolic with the fishes. Justice is done; peace is restored. Immersed in cleansing, mystical waters day after day, the female half of the community is purified of its wrongs, healed of its ills, reunited and reestablished in goodness. A year from now misunderstandings and crimes will again besmirch community life, but again there will be *kpanguima* waters to wash sins away.

16

Mbaa like to feel that there are no secrets among women and that they must all be supportive and tolerant of each other. In the privacy of the *kpanguima* the mechanics and challenges of adult sexual life are taught the initiates and discussed among the *nyaha*. Maintenance of cleanliness and health of the sexual organs, the rota system, the etiquette of conjugal visits to the husband, extramarital affairs, contraception, conception, and sterility can all be discussed matter-of-factly in the relaxed *kpanguima* atmosphere without shyness or shame.[2] At any one time a number of *nyaha* will be in various stages of pregnancy and will talk about it to the initiates. Should there be a woman in town ready to give birth, she will come to the *kpanguima* to deliver, and the initiates invited to watch the ultimate mystery unfolding before their eyes (fig. 17).

For young initiates *kpanguima* life is good training and practice for life as a junior wife in a family far from her home. Mende life is sharply polarized and divided along sexual lines. Men and women do not mingle or socialize casually; marriages are not companionate. A young wife does not spend her time with her husband but bathes, eats, works, and relaxes in the company of her co-wives and the other females of the compound and village. It will help her if sex and marriage have been demystified, for she will sleep in the same room with other wives and share her husband with them. The Mende word for co-wife is *mbaa* (Innes, 1969:82), the same word as that used for a female friend and comrade. The most successful and happy compounds are those in which the spirit of *nya mbaa* prevails and the women manage to live together in harmony. Thus, Sande makes polygamy work: co-wives must live together congenially; if they are Sande *nyaha*, this is ritually preordained.

FEASTING IN THE *KPANGUIMA*

The *kpanguima* offers ease and abundance. The town knows the *kpanguima* by the delectable aromas of cooking that waft over its fences. Along with smiles and singing, a woman finds there a vast quantity of succulent food to be consumed at her pleasure. Bags of rice, gallons of palm oil, trays of onions and peppers, and proteins such as fish are sent to the gate by kin of the novices as part of the initiation fee. As one would at a holiday time, the *nyaha* outdo themselves in preparing lavish spreads of delicious entrees, sauces, garnishes, and snacks. In ordinary village life in a compound, cooking is done for one meal at a time, mealtimes are set, no food is eaten between meals, and for several months of the year there may be scarcity, even hunger. Usually, a woman cooks and presents the dishes to her husband and other senior male residents, offering them and their guests first choice, and only eating over to the side after the men have finished. But here in the *kpanguima* food in vast quantities is available all day long, so a woman can eat as much as she likes whenever she likes (fig. 18).

As always and ever, cleanliness and good manners prevail; however, in

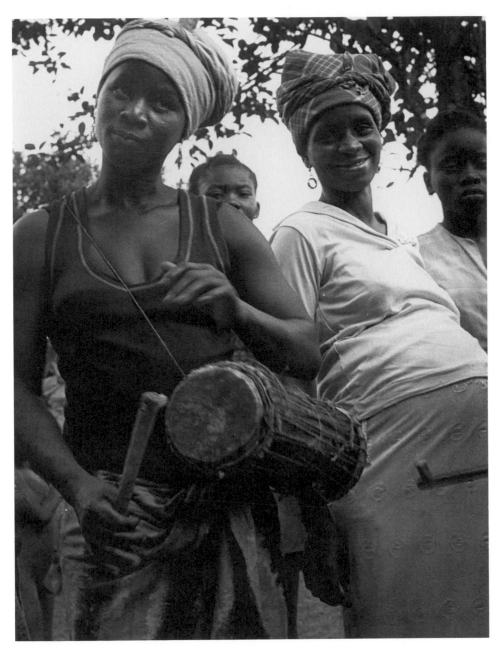

17

the *kpanguima* there are no restrictions or limitations. A *nyaha* is free to dip into a pot without permission from the headwife, and the headwife in turn is free from having to control and supervise. Friends from different compounds can meet and eat together, whereas before they had to mind their tongues in front of the seniors of the household. The special savor of a meal eaten in this free, affectionate atmosphere causes it to be called Sande *mèhè*, or Sande food, understood as nourishment for the personality and the community as well as the body.

The connection between Sande and food is the subject of a proverb: *Ti nyaha gomang aa kpanguima ye "Mbeindo jande hinda i gba mu jande ma"*—"If they refuse to give a woman food at a *kpanguima* she will say, 'The conditions at this Sande are different from the conditions of our own Sande [back home].'" You criticize when your demands and expectations are not met; certain institutions are supposed to be reliable and meet the community's needs. It is simply a truism that any woman present at a *kpanguima* is automatically offered food. Any Sande member can expect to move into any shrine freely knowing that she will be welcome to share in the feasting and merrymaking. If refused, the woman would be right to say, "This is indeed a strange type of Sande."

Cooking as a homecraft activity has additional didactic and intellectual facets. The *kpanguima* is a school not only for the initiates but also for *nyaha* who come for advanced courses (Little, 1967:127). Cooking is always part of the curriculum, with women exchanging techniques and expertise on the ingredients for and preparation of special dishes. Fine Mende cooking involves the preparation of greens, and though leaves are food for nourishment of the body, they are also medicinal and magical. Mende and Sande education is a study of the arts, botany being the only "scientific" subject. Sande engages women in the lifetime study of the properties and uses of the surrounding flora. Any advance in rank in the Mende *hale* presupposes the mastery of more advanced knowledge of plants. Promotion within Sande is based in part on the candidate's increased ability to recognize, identify, and manipulate herbs and all the parts of plants, grasses, shrubs, trees. Here in the *kpanguima*, Sowei and other senior women constantly instruct their juniors in the benefits to be derived from particular leaves. As an exercise, the young initiates are taken into the new bush at dawn in quest of herbs. Sowei teaches them to recognize among the nondescript weeds carpeting the forest floor a particular tiny leaf. Before, as *kpowa*, uninitiated, ignorant, blind, they trod on this leaf heedlessly; now they learn to appreciate it as a storehouse of healing power (fig. 19).

Sande *mèhè* creates an ambiance of sharing and open-handed generosity, engendering friendship and emotional satisfaction. The ingredients are a starting point for the study of herbalism and healing. Further, and more profoundly, Sande recognizes feasting as essential to the fertility and health of Mende women. Weeks of heavy eating of rich foods serves to

increase, often dramatically, the body weight and fat reserves of the initiates especially, and of all the other *nyaha* as well. Beauty, prosperity, health, and fertility are explicitly linked to plumpness (*gbògbòtò*) most graphically in the mask image. The opposite of plump is not thin but "dry," connoting among other things a withered and barren uterus. For the first three or four weeks in the *kpanguima* the novices are encouraged to loll about and eat continually. They are served stews rich with palm oil and quantities of fish; sauces of dark green vegetables are considered especially body-building. For the moment, the intention is to fatten up the girls; rigorous training will begin a bit later. Mende female children are usually fine-boned, "skinny kids." After this initial period of confinement and feeding, their weight increases dramatically, giving them soft, rounded contours. Chief Foday Kai tells of the transformation of his daughters: at times he simply has been unable to recognize them, they have returned home so changed (fig. 20).

Sowei are often stern, unbending women (comparable to the "headmistress," "dean of women," "principal" personality in western education) who enforce harsh discipline on the novices. However, as much as they may wish to "train" the girls, they know that too much scolding and beating frightens the youngsters into loss of appetite and a nervous, fast metabolism that burns away the calorie reserves. There is a strong probability that *Nyande Jowei*, the beautiful, good Sowei, is the same one called in English "my good Sowei." The title praises those Sowei who win the allegiance of parents for being loving to the initiates as well as firm and under whose care the girls bloom into plump prettiness.

Recent western medical research corroborates Sande's traditional working knowledge of the requirements for female fecundity. Frisch, a research physician at the Harvard Center for Population Studies, has found that "a minimum level of stored, easily mobilized energy is necessary for ovulation and menstrual cycles in the human female" (1974:949).[3] She notes that adolescent females go through a growth spurt that normally precedes menarche (1975:319ff.). She observed in a sample of white North American girls that the ratio of lean body weight to fat weight changes from 5:1 at the onset of the growth spurt to 3:1 at menarche. She suggests that a minimal crucial proportion of 20 percent body fat is required for the onset of menstruation. This crucial balance seems to cause a change in the metabolic rate per unit of mass, which in turn stimulates the ovarian and uterine changes that result in menarche. Encouraging the initiates to eat heartily of the abundant Sande *mèhè* advances this growth spurt and the crucial minimum of weight needed to render a girl fertile.

As with the initiates, Sande makes a deliberate effort to fortify all *nyaha*, especially the younger ones. In these rural farming communities, a flush of plenty follows harvest time; but soon village granary stocks begin to dwindle. After six months, food supplies are low, most scarce during those

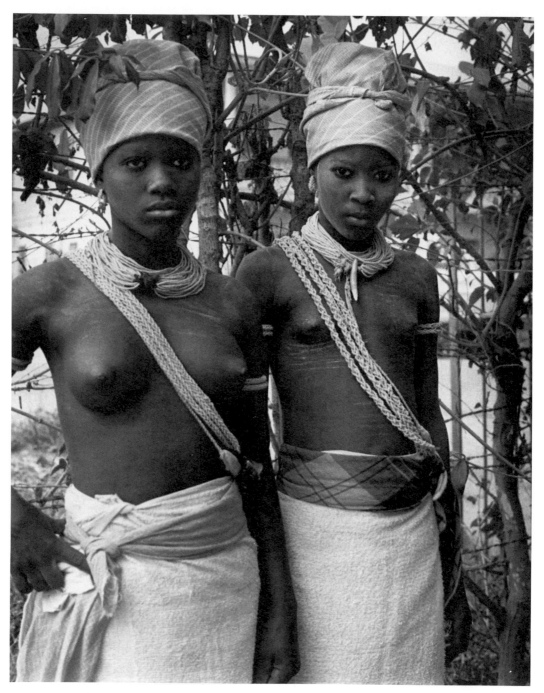

20

very months of the rainy season preceding the rice harvest when the heaviest amount of farm work is required. So, by *kpanguima* time many village women are emaciated and exhausted from the strain of daily toil combined with the physical demands of pregnancy and nursing. Frisch explains that "the cessation of menstrual cycles (amenorrhea) following chronic undernourishment or rapid weight loss in otherwise normal women is a well-documented, although often overlooked fact of human productive physiology" (1974:949). Sowei have taken this into account and make it their duty to restore the women's weight reserves so as to enable them to continue regular menstruation and fecundity.

Adding weight serves to trigger menarche in adolescent girls and to restart or maintain the menstrual cycles of overworked, undernourished adult women. Further, the increase prepares the bodies of both groups for the exigencies of pregnancy and lactation. It is reasonable to conclude that occasioning the growth spurt in adolescents and the regular replenishing of depleted body fat in mature women is advantageous to populations like the Mende who experience severe seasonal food scarcities. "Increased body fat is also adaptive in that there is a correlation between pregnancy weight and infant birth weight. Large babies survive in greater numbers than babies with low birth weight" (loc. cit.). In summary, the Sande strategy of intentionally fattening up initiates and *nyaha* serves to advance the age of fertility; to initiate, restore, and maintain regular ovulation; to enhance fetal health; to increase chances of survival of the baby, and to contribute to the safety and post-partum recuperation of the mother. Thus, feasting in the *kpanguima* nurtures Sande women so that they return to their homes strengthened and blessed.

MBOGBONI: THE INITIATE-IN-TRAINING

At the conclusion of the Sande session, the *Sande Waa Jowei* presents the graduates to the chief with the words: "You gave me girls; I bring you back women." This dramatic statement introduces a new group of women into the Mende world who are capable of fulfilling their responsibilities to the community as adult Mende. To the women, the *Sande yo* are new sisters and peers, soon to be co-wives; to the men, they are new brides and lovers; for the whole community, they are citizens who will participate in public life and mothers who will produce and rear the next generation so that the Mende race will continue. In the life of a Mende woman the period of her initiation is her most vivid and memorable experience.[4] She sees it as the turning point of her existence, the end of her childhood, the beginning of a new life. While undergoing initiation she reels from the insults, pain, injury, shocks, and stress to which she is subjected. And for years afterward she will reflect on these things and come to terms with what it means to be a woman in the Mende community.[5]

Every girl goes into Sande because her mother has been there and sends her there in her turn. From the time she is able to walk and talk, a girl begins to do Sande dance steps and sings Sande songs, encouraged by the older girls and women. The main part of female children's play is the imitation of Sande activities; girls tend to "practice Sande" all their lives. When she was four or five, a girl may have dressed up and played at being a *Ndopo Sande*. This "child Sande" is a mock initiation ceremony in which the little girls parade around dressed up as *Sande yo*, performing Sande songs and dances. *Ndopo Sande* is immensely amusing to the community. It can be compared to our "mock weddings," in which children of a church Sunday school go through an elaborate imitation marriage ceremony, much to the delight of relatives and friends; or to kindergarten "graduation" ceremonies with tykes dressed in caps and gowns. Little sees this mock Sande as advertisement, the society's way of getting girls interested (1967:130).

From the earliest age it is to a girl's advantage to recognize Sande officials and pay them special deference and respect. Every girl is supposed to recognize the Sowei; her mother will have presented them to her as individuals of great importance, and a sensible child will be well-behaved in their presence. There is a proverb which says, *Nyahalo èè Sowo gòò taa hu, a kòò a ngi gbua gbeei lò*—"A girl who doesn't know the Sowei in the town most certainly will know her at the time of her graduation [from Sande]." You are bound to know in the end, you had better start now to learn what is going on around you. Get to appreciate the essential elements for your development to maturity. You are wise to perceive at the proper time the things that must contribute to your full growth; prepare for life to avoid getting some rude shocks (fig. 21).

Despite all the singing and dancing associated with Sande, older children come to realize that initiation into the society is an ordeal, and they are terrified of it. They get to know of the surgery and its hazards. They know of the beatings and military discipline. And they know that some girls, unable to survive the pain and punishment, die there. Still, there is no way to avoid initiation; every girl must go through it. The proverb says, *Bi nyei i nuwo gbè ve numu èè hale jo numuwe*—"Even if your mother sends a paid stand-in to take your place, nobody can receive the *hale* for you." A mother who loves her daughter may want to spare her the rigors of initiation by trying to buy her release; but it does no good. If she sends another girl in her daughter's place, the only result will be that she will become qualified as a Mende woman, while her own daughter will remain a child. There are some things in life that no one can do for you or give to you; you must do them and get them for yourself. Only by enduring the ordeal do you gain the knowledge, power, and self-confidence you will need to live fully and successfully.

Initiation activities vary, as most things in Mendeland do, from locale to locale. Sande is most interesting in towns: as they have more people and

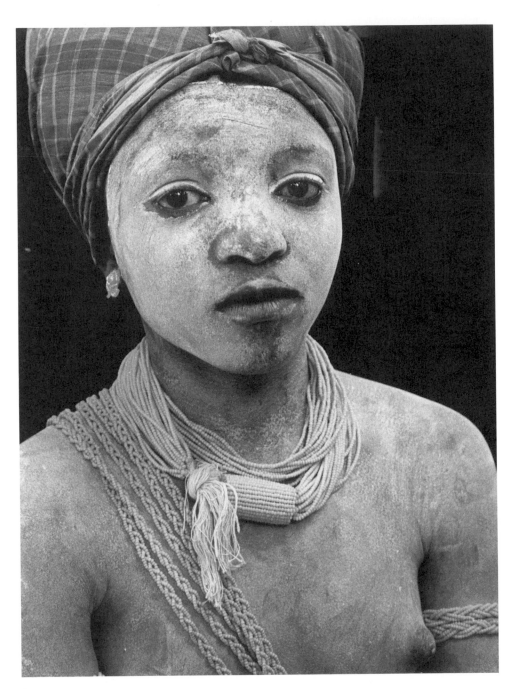

21

more money, there are larger entering classes, the full Sande hierarchy is in attendance, and fertile ground exists for a rich range of artistic expression. As has been noted before, Sande thrives in urban areas. The mixture of cultures introduces novelties that relatives and the public find delightful; so Sande in principal towns like Bo, Kenema, and (lately) Freetown is considered the best. Village Sande appears too sparse and meager for modern tastes, which now lean toward colorful displays of feminine finery and affluence. People compliment urban Sande, saying in English, "It is a fanciful thing, a better Bundu."

Sande Society elders are admired for their progressive attitudes in adapting to modern, changing life-styles.[6] It would appear that a Sande session must fulfill the formula of its definition; but beyond certain specified unalterable requirements, there is room for a range of variations which in no way compromise the integrity of the ritual. Because of this flexible approach, Sande sessions are easily made to harmonize with the national day- and boarding-school calendar. Such adaptations are called *holide Jande,* a Sande session whose term corresponds to school holidays for the benefit of schoolgirl initiates. It is possible for a girl to complete her initiation during a three/four-week school holiday, just long enough for her to recover from the operation; but such short stays are considered unfortunate. In the better, full initiation set-ups, girls enter Sande on the day Christmas holidays begin in the middle of December, are confined in the *kpanguima* for the next three or four weeks, and then go back to school for the next term. They return to live in the *kpanguima* during Easter vacation in March, and graduate just as the holiday ends.

Sande requires ritual separation of the novices, so rather elaborate arrangements are made for those weeks during which they must be away from the *kpanguima.* Day students may sleep in the *kpanguima* every night, while some girls in boarding schools return home every weekend. In the large towns (Moyamba, Kenema, Bo), when there are a number of initiates at a particular boarding school there may be a visiting Sowei who comes and gathers the girls around her every weekend for two days of instruction. Some towns have a permanent Sande house under Sowei supervision where schoolgirl initiates all live together rather than in a school residence; while at some schools, a separate part of the girls' dormitory is set aside for the initiates.[7]

In years gone by, it would not have been possible to hold a Sande during July, August, or September, the chilly and hungry months of monsoon rains. However, since these are the months of the national "summer vacation," within the past fifteen years or so Sande initiations scheduled in this period are gaining in popularity. July is still the month of doldrums, but by August morale is better and Sande activities shift into high gear. Stone or clay houses built to withstand the elements (rather than the palm-frond *kpanguima* built for shade and coolness) and, in a money economy, the

steady availability of food, even pre-harvest—these changing resources make it possible to hold a quite creditable Sande session during these difficult months. Interestingly, Sowei from rural areas or small towns will finish their own initiation programs in May and then travel on to the cities for *holide Jande.* In part, they always enjoy the Sande atmosphere; but they are there primarily to ensure that Sande standards are upheld, that every Sande school meets the basic requirements.

On the day set for the opening of the Sande session, girls arrive at the site one by one, accompanied by their relatives or a sponsoring Sowei, bringing with them rice, oil, onions, pepper, dried fish, and other provisions as part of their initiation fee. As each girl crosses the parapet, the women within let out shouts of rejoicing and break into songs of welcome. There is general jubilation as the girls are greeted with hugs and praises. After these exchanges of affection the girl is stripped and rubbed all over with *hojo,* the white clay. Certainly, as several authors have suggested, the clay has cosmetic properties; as a sort of "mud pack" it has drawing and astringent properties that dry and clear away surface blemishes, soften and smooth the skin.[8] But the primary purpose is to identify the girls by the Sande symbol and to mark them as being under strict Sande supervision.

When a girl enters Sande she gives up her old life and begins a new one; consonant with these changes, she gives up her present name and adopts a new one. Being first girl to enter the session is a sought-after privilege, with the place of honor named *Kema* (or *Duwo*). Designating *Kema* is a prerogative of the *Sande Waa Jowei. Kema* is selected for her leadership qualities, for her family background, wealth, and beauty. Mothers compete to place their daughters at the head and are willing to pay handsomely to afford them this excellent start in adult life. Often *Kema* is a niece or daughter of a prominent Sowei who is expected to inherit a Sande *hale* and rise to a leadership position. Sowei also compete among themselves to attach the most promising girls to their individual lodges and then to be their sponsors at initiation time. A *Kema* is often a girl of poised presence— delicately beautiful and graceful—making it appear that she was chosen mainly for her good looks. Certainly, with the frantic competition in the Mende community for lovely virgins, attracting the best-looking girls enhances the prestige of a Sowei or *kpanguima.* During the session, *Kema* is the head of all the initiates and they are under her control.[9] She is in liaison with senior Sande officials and their directives pass through her. She organizes the others for singing and dancing practice; she is the lead singer, the others are the chorus.

The special attention and training *Kema* receives is meant to qualify her for rapid advancement in life. Still, frequently in the course of initiation lesser girls will bloom and come forward as natural leaders or as talented singers and dancers, far outshining the favorites (fig. 22). The frequency

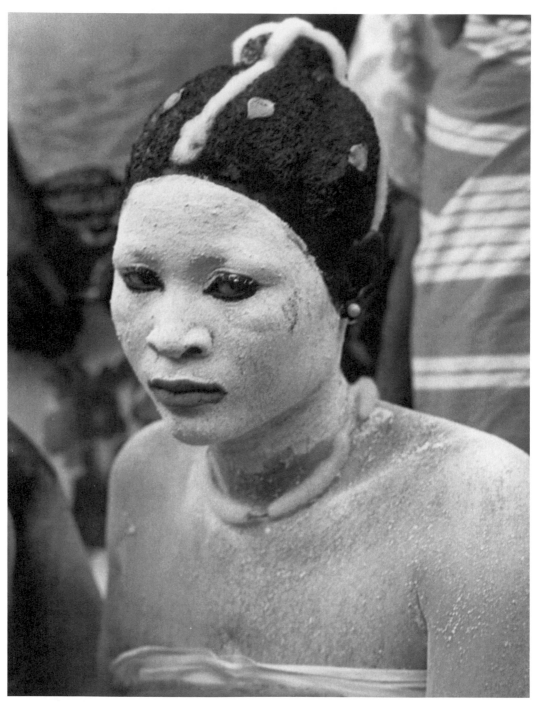

22

of this occurrence occasions a proverb: *Bi lima bȯgbȯnii ëë bi lima gbuëi ga*—
"Your heart's-desire-initiate does not dance your heart's-desire-'*gbuëi*'—
step." In other words, your beloved Sande novice, your favorite, most of
the time does not perform the dance in the fine way you want it to go. The
heart leads us to love, but love can lead to disappointment. You go to
Sande to learn how to dance, but unless you do the steps well you cannot
satisfy your patron. In life there is always an essential duty you must
perform in order to justify the confidence and investment people have in
you. No matter how much love I shower on you, I cannot make you be
outstanding if it is not in you to be so.

In a ritual sense, the new recruits now have been separated from the
social context in which they were girls and have had their appearance
transformed, made white and dusty, by the application of *hojo* clay. Just as
soon as all the girls have entered the *kpanguima*, it is time to conduct the
initiation surgery, excision of the clitoris. "The first girl to be initiated is
announced, and completion of the rite is celebrated by loud and joyful
singing and the beating of drums, there being a special song for this
moment" (Little, 1967:127). Informants speak of continuous music and
shouting, believed in part to drown out the cries of the initiates, and also to
disorient them and slightly hypnotize them so they can better bear the
pain. The rest is quiet until the next day at dawn, when some of the Sande
elders walk through the town, beating on a tiny drum and singing dirge
songs. The whole town is gripped by anxiety concerning the well-being of
the *mbogboni*, these first twenty-four hours being the most critical for their
recovery.

For all the secrecy surrounding it, clitoridectomy is a crucial component
in Mende life. All Mende men are circumcised in early childhood and this
is casual public knowledge, but female excision remains a "mystery." The
Sande Society nurtures and regulates the life of all Mende women; the *only*
way into Sande life is through the Sande ordeal. Sande initiation cere-
monies and procedures of all sorts may be modified, truncated, even elimi-
nated, but the excision operation must be performed; it is an absolute
requirement; it is the strait gate by which a girl enters into Sande fel-
lowship.

Sande initiation ritual aims at nothing less than annihilation of one
being—a female *kpowa* who enters the *kpanguima*—and the creation of a
finer, better person—a *Sande nyaha*. The fate of the *kpowa* is clear: she is
killed and all traces of her existence concretely and symbolically erased. To
join the society is "to die into it"—*ha hale ma*; the senior who initiates is said
to *hale paa*—to kill (someone)—into the society. Certainly the point of
"death into" the society is the clitoridectomy. Should a girl have to leave
the camp before the operation, she would simply rejoin her playmates, still
a child. Once the operation is performed, the process of transformation is
enjoined and must be continued until the end. The data suggest that being

killed into the *hale* requires the spilling of blood at the hands of a parent figure. The injury and bleeding "causes" the death of *kpowa*, killed by the hand of Sande senior. With the *kpowa* gone, the *nyaha* can come forth.

Sande initiation is a rite de passage that transforms a female child into an adult woman. To understand why anyone would eagerly line up to undergo an ordeal in order to become an adult, it is necessary to understand some of the sadness of Mende childhood. Being a child is a despised state of Mendeland, and childhood is not "idyllic" but bleak. After the initial two or three years of closeness with the mother, most children must give way to the next arrival. Mende children are constantly chastised and corrected, frequently beaten, bullied, and deprived of food. Children are non-persons without rights. They are rarely admired and their feelings or preferences hardly considered. The complex rules of Mende etiquette and the formal structure of everyday interactions make it prudent for a child to be (barely) seen but never heard. Girls work hard in the compound, sweeping, washing, and fetching wood and water, and at the farm weeding and chasing the birds away.

As the Mende community can be divided into freeborn and serfs, and the freeborn into chiefly families and commoners, so there are two types of childhood experience—*mahalo* and *makèlo*. *Mahalo* (*maha* = chief, *lo* = child) is the "chief's child," one of the privileged few reared more gently, always well fed, never overworked, never scarred from beatings, never a servant to strangers. *Makèlo* is the "child sent for training," the bitter, grim lot of the majority. This "training" may be servitude to a wealthy, important personage to raise a loan, repay a debt, or gain a favor.[10] In other instances children are deemed greedy, headstrong, or wayward, and so are sent to a stern relative to be (in effect) beaten, starved, and worked into submission.[11]

Sande *nyaha* tell MacCormack that unless initiated, a female "will remain a girl socially while achieving womanhood biologically" (1978:23). A girl is a child, subject to all the humiliations of childhood. But the moment she emerges from the *kpanguima* as a Sande *yo*, her childhood is over. Mende say, *Sande nyaha ndopo ii le*—"A Sande woman is not a child," and she can no longer be treated as a child. If pawned into servitude, she is now free. If made to toil for a cruel aunt, again she is free. All the mistreatment *stops*, absolutely; it is all over at last. The formerly beaten-down, scrawny nonentity is now plump, pretty, and in possession of an engaging personality. No more insults and tears; she is now a *nyaha*—desirable, admirable, commanding respect for her person and opinions, and being worthy of it, protected in her claims by the power and might of Sande itself.[12]

The initiate, Sande *nyaha* as she is called, is now ready for marriage and participation in community adult life. She takes a new name while in Sande school to commemorate her birth as a fully formed human being, and leaves her girlhood name behind her forever, along with her girlhood life

(Little, 1967:117). During her stay at the school the girl has been indoctrinated in proper and beautiful behavior. As a Sande *nyaha*, she has learned to be respectful, pleasant, hardworking, and modest in character. She now knows the ways of the good wife—both how to "keep house" and how to relate to her husband and her co-wives.[13] The skills she has learned include cooking, needlework, basket-making, pottery, home medicines, midwifery, and child care.[14] Sande has shown her how to win and keep her husband's affection (Schwab, 1957:293) and, most important of all, how to live harmoniously in a polygamous household (fig. 23).

SINGING AND DANCING IN SANDE

Musical training is a more
potent instrument than
any other, because
rhythm and harmony find
their way into the inward
reaches of the soul.
 —Plato, *The Republic*

In important respects, Sande School is a music school that emphasizes singing and dancing as arts that bring refinement and charm to young Mende women and true distinction to the gifted, serious participant in traditional Mende lore. Other ethnic groups of Sierra Leone know Mende *hale* as "dancing societies," where members assemble to create and perform a wide range of artistic activities. To the Mende themselves, initiation is a period when one "learns how to dance." "You go to Sande to make the dance part of your life." "Songs and dances learned in the bush are repeated and sung on all major occasions in the social and ceremonial life of the people" (Little, 1967:128).

"No bird is as beautiful as its song." No being is as beautiful as its essence. True beauty is artistic, not physical. Beauty in the soul is more moving than beauty in the eye. The eye is limited to reporting on a physical entity with all its flaws, but the imagination will shape invisible emotions and vibrations of sound to fulfill the individual personal longing for beauty. In joy, the community describes the singing issuing from the *kpanguima* as *manèengò*, "melodious," and *mahongò*, "enchanting." Songs ring through the Sande sessions. As they awaken each day, the novices gather and herald the dawn. "Girls greet all women of the higher ranks with a song, before proceeding on the domestic and other duties of the day" (Little, 1967:127). There are greetings and songs for the coming and going of the Sande leaders and songs that are sung when the initiates walk through the town. In Telu-Bongor, early in the morning the novices assembled outside the compound of the chief to serenade him brightly, then they passed on their way to the homes of other village notables. The

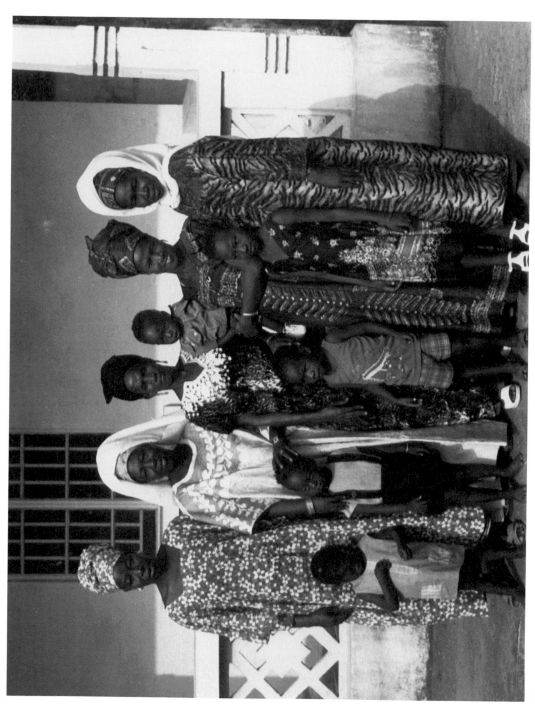

23

tender prettiness of the girls and the loveliness of their singing are, for Chief Foday Kai, "a sweetness of life" (fig. 24).

The wise women who developed the philosophy of Sande understand well the immense power of song: song has the ability to penetrate to one's heart of hearts—it communicates directly the knowledge, feelings, and impulses of the soul. A song "by the natural virtue of its form and content (musical modulation, character and meaning of its text) is also persuasively to elicit a new belief in the mind of one who listens to it or to make more intense the beliefs that already existed deep within that mind" (Laín Entralgo, 1970:120–21). Aristotle spoke of the deeply refining and curative powers of "embellished language, that which has rhythm, melody and is uttered in song," recommending its use in the education of the young.

At the same time that they give pleasure as artistic entertainment, Sande songs and group singing are considered a key element in Sande training of the novices and as important preparation for Mende life. Partly through song, the young initiate learns the history and traditions of her people and the society, their social value system, and their requirements and ideals of behavior. The problem of how to retain a vast storehouse of information is partially solved by the use of song. The rhythm, melody, and cadences are mnemonic devices that help to impress the lessons upon the mind. Each aspect reinforces the other, so that even if the words are forgotten the melody of rhythm is enough to recall the message and instruction.

As we have noted earlier, in Mende life there is an insistence upon self-restraint and social harmony. Persuasion and reconciliation are greatly valued in small, close-knit communities; for daily interaction to be comfortable and cordial, the constant use of verbal exchange and frequent mediation to achieve mutual understanding is necessary. Mende loathe greed and criminality, force and coercion; instead, they inculcate a respect for and submission to authority. The Sande Society fosters respect for the conciliatory power of the word. If Sande members should quarrel or fight, it is certain that the Sowei will intervene to restore peace. This desire for compatibility is reinforced artistically by the act of group singing. Sande elders teach part singing; throughout Sierra Leone, Mende women are known for their intricate harmonies and vocalizations. This singing in a chorus, the exercise of melding with one's sisters in concert, is stressed by Sowei as one of their main strategies for developing goodwill and cooperation among the women. Certainly the remarkable sisterhood characteristic of women living and working together as co-wives, co-workers, business associates, and partners is engendered by the training in the Sande School, with songs remaining as the most widespread vehicle for cultural communication and cooperation.

"Chores are done with a song" in the Sande School, a pattern that continues into the life of the women going about their workaday routine of farming, fishing, trading, or keeping house (Lewis, 1954:145; fig. 25). For

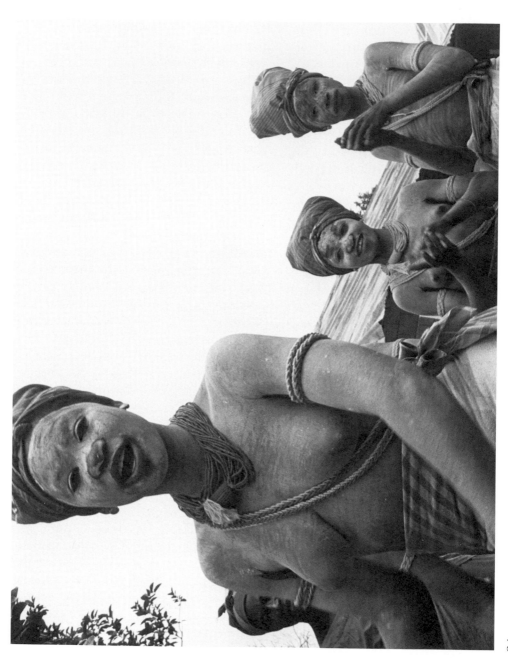

all the talk of Mende togetherness, in fact during the farming season the average woman will spend a twelve-hour work day at the farm, quite alone except for any pets or small children she may have to carry along (on her back). "The farm is a restless existential world where every sound is suspect, where a woman is without the support of her *kuwui* (fellow villagers) or of Sande, and is surrounded on all sides by the world of the bush" (Cosentino, 1977:40). The bush is Nature as an antagonist: the Nature of stinging insects, burning sun, poisonous snakes. What a *nyaha* takes with her to work is Sande songs. Sowei have taught her the necessity of singing all through the day—to keep herself company, to entertain herself, to calm her anxieties, to keep her mind on amusing and encouraging topics, to pace her movement, to lighten the toil, and help the hours fly. Sowei stated that songs are a tool, like a hand or a machete, a component of the production process; without songs it would be literally impossible for Mende to grow crops successfully and win in the struggle against a hostile environment.

Songs are also relaxation and recreation for the Mende. In line with Aristotle's advice that "poetics should be cultivated also as an amusement and as recreation and relaxation after labor," when the day's work is over, the girls and women gather for singing and dancing.[15] Storytelling is also a part of the evening's fun. Matthews noted in 1788 that "in the evening the head wife, surrounded by the rest of her husband's women, and her female attendants, is employed in spinning and carding cotton, while one of the company amuses the rest with telling stories upon the plan of Aesop's Fables; to these tales I have often listened with infinite pleasure" (p. 99). Two hundred years later, Cosentino, in his thesis on Mende narrative performance, observes that: "At night, after the dangers of the bush and the farm have been survived, and the whole town has bathed and eaten, then there may be time to relax on the verandah, to gossip, to drink wine, or perhaps to 'pull domeisia' (tell tales)" (1977:42).

In his study of Mende folktales, Gordon Innes found that a major part of the audience's pleasure comes from the songs.[16] He writes, "It would probably be no exaggeration to say that to many audiences the songs are more important than the narrative" (1965:54). Typical of the African trait of call-and-response in public presentations, "An extremely important aspect of the songs is the audience's participation in them; the vast majority of songs have two parts, the solo sung by the narrator, and the chorus sung by the audience" (loc. cit.). Songs are used in storytelling as a release from tension: "they are most often uttered by a character in a tale who is under severe stress, either physical or mental. . . . Under severe stress a character will often burst into song. . . . [The songs] are expressions of unpleasant emotions, commonly of intense fear or grief. It may be that song is felt to be more adequate for the expression of strong emotion than is ordinary speech" (ibid.:60).

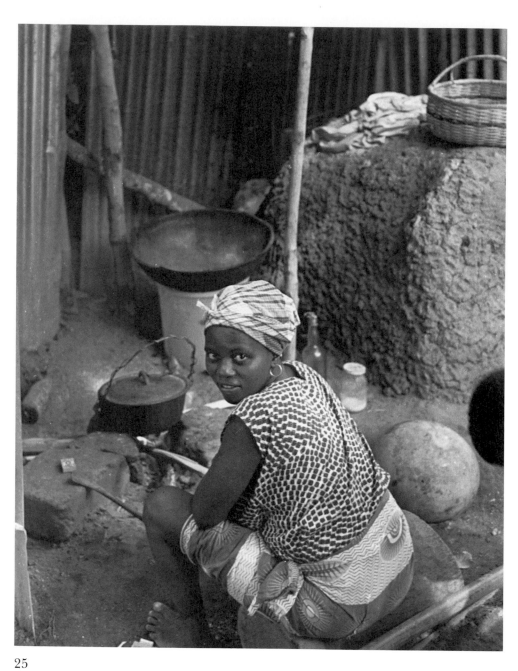

25

There is a Sande initiation story in which the terrified child bursts into song at the approach of the costumed Sowo mask.

Singer: Red is bad, red is bad, red ant is bad, ant on the leaf, brown bird on the leaf. Ngondoma o Sowoi
Chorus: Ngonodoma o Sowoi
Singer: I was greeting Sowoi
Chorus: Ngonodoma o Sowoi
Singer: I shall crawl on the ground
Chorus: Ngonodoma o Sowoi
Singer: Sowoi, hello!
Chorus: Ngonodoma o Sowoi
Singer: Oh, my goodness! Sowoi is Jebo

Innes gives "this song in full because it is interesting to see the decrease in tension as the song goes on. The song begins as the utterance of a terrified child, but as it progresses it reflects the child's gathering courage and self-assurance. Notice how toward the end of the song the child has mustered enough courage to address Sowoi, and how she finally comes to realize that Sowoi is not an object of dread, but is in fact merely someone called Jebo dressed up in costume" (ibid.:63).

Sande dancing is *dancing to song,* for singing seems to be essential and necessary to any public performance; there may be singing without dancing, but virtually no dancing without song: "The dance songs differ from the greeting songs" (Moore, 1970:127), reflecting the separation of the sacred school from the popular expressions. The singers accompany themselves on instruments. "If the occasion is a particularly important one, women singers provide additional accompaniment with their *sègbula* (calabash rattles), and there may be a number of male drummers. The dance is started by the leading singer—*Ngole Nje* (singing mother), shaking her rattle and intoning the opening verse of a song. This is taken up by her fellow singers and they reply in chorus. The drummers then join in" (Little, 1967:252). It is the singers who set the stage (fig. 26). Moore cites a "Mende song," executed just before the girls come out to perform. "The *Kengai* (dance instructor) and other musicians, flanked by other women, help shape the singing. The *Kengai* has a 'code name' for each girl. When it is a girl's time to come forward, she is called by this name" (Moore, 1970:127).

Only the most gifted girls are chosen to continue "in the dancing." They are practiced professionals who dance in troupes. The chief of a town may ask them to perform on a festive occasion, or, in the Liberian provinces of Sande, the president may ask them to perform for a visiting head-of-state. Their agility and delicacy impress all observers. In 1901 Alldridge was charmed and delighted by what he saw: "The girls not only dance together in a miniature ballet but execute very excellent *pas seuls* in the most creditable and pretty manner; and after an unusually well performed and difficult dance, some of the elderly women present rush excitedly into the

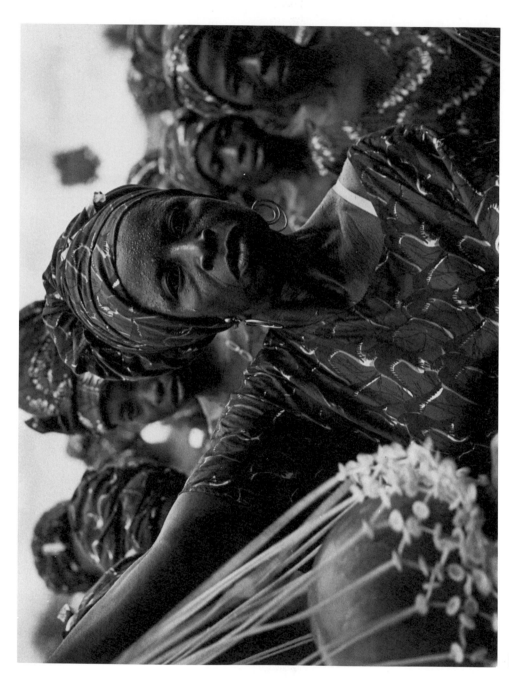

arena, embrace the successful dancer. . . .—admidst the frantic yells and gesticulations of delight from the ordinary onlookers—many of whom manage to find some trifle to present to the dancers after the performance is over" (1901:139). Newland was also impressed: "I can assure my readers that [the dance of the Sande girls] is almost as artistic and certainly more quaint than an Alhambra ballet" (1916:124).[17]

The description of the dance from Gervis, writing in 1952, also deserves extensive citation:

> Perhaps it was the chief who gave a signal, I did not see. Instead of commencing, as I had anticipated, with a crash of drums, there was wafted to us the sweet tone of the *gbololi* [a traditional 4-hole Mende flute], and gracefully and very slowly the girls bent to skim the ground first with one hand, then the other. Gradually the remaining instruments worked into the rhythmic theme as the girls swayed with snake-like movements of the arms and twistings of their glistening supple bodies, but still slow and studied; the expressions on their faces being that of concentration and entrancement. [*Sierra Leone Story*, p. 87]

Inspired by the excitement of the singing and dancing, little girls of four and five become interested in Sande and go through mock initiations. At the same time, as in kindergarten here, little ones are closely observed for signs of innate musical ability and are encouraged to develop these talents later within a Sande school. At the time for initiation, mothers will vie for the privilege of placing their daughters in a *kpanguima* with the best singing and dancing instructors; and girls practice hard to perfect their form. Those judged most promising stay for extra sessions and continue their training during the year. They perform in many community ceremonial and festive occasions and compete for prizes and public acclaim (fig. 27).

Traditionally, excellence in dancing and singing has been a stepping-stone to wealth and fame. At the very least, a good performer is more popular with the opposite sex, more sought after as a social companion and a wife. Say, for example, a girl betrothed before entering Sande school demonstrates her abilities as a dancer or singer. In this case the Sowei will approach her family and fiancé in an effort to have the wedding postponed so that the girl may continue for a couple of years in the arts. It is a very prestigious and honorable way to spend the time, and later the girl will be considered even more admirable and desirable. Dancers and singers make the best marriages with the most important men, stay on in Sande School to learn about medicine (Schwab, 1947:294) and forms of "recreation and entertainments" (Little, 1967:248), growing closer to the important women who run a good portion of the local economic affairs, traveling to various localities, and making valuable contacts. They are in a position to move up in the organizational hierarchy, obtaining the knowledge and enjoying the privileges that accrue to the higher ranks. The Sande Society feels that beauty of voice and movement in a girl of twelve or fourteen years is the certain indicator of future success in life.

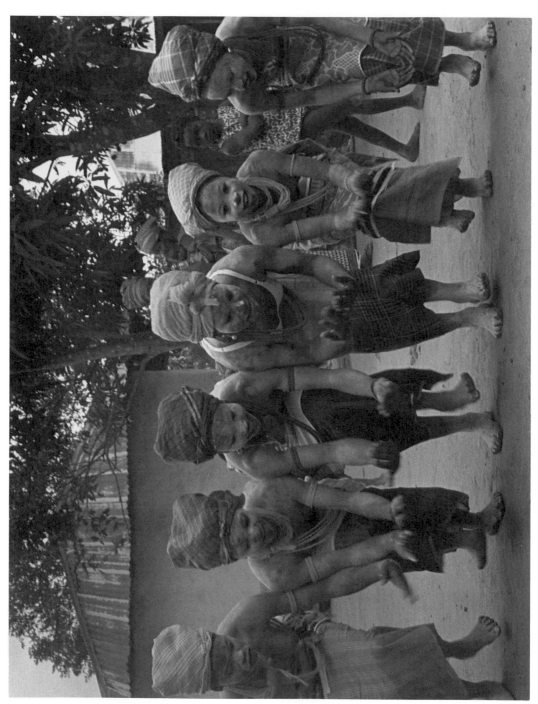

27

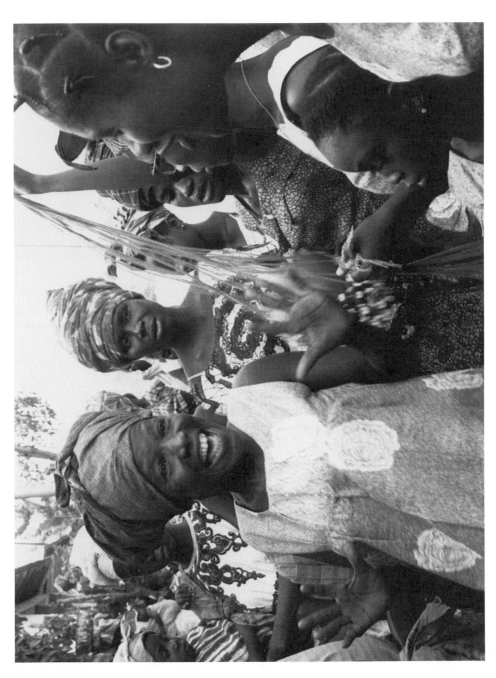

In general, Sande songs stand in the background, dance in the foreground; songs suggest the intellectual gifts and emotions of the participants, while dancing expresses those states and changes. The songs represent sustained energy, patience, endurance, social interaction, and harmony, while dancing is the intense moment, the virtuoso performance, supported by the strength of the musical background (fig. 28). To make of life a dance is a beloved aspiration of Mende savants. Dance, *ndoli,* is a word redolent of all that is happy in the human experience. As the Bo preceptor explained, when we learn the social *ndoli* we are syncronized with our fellows, our own movements are graceful, and we are coordinated with the community. Without *ndoli,* we bump into each other, step on each other's toes, get in each other's way. Without *ndoli* we have accidents, break things, stumble and fall. When we move together in *ndoli,* in the same beat to the same time, we are in harmony with the rhythm of the group, and so there is in life an unobstructed plan of communication and a positive, productive interaction.[18]

Notes

1 I am grateful to my Njala preceptor and to the Mme. K. compound, Bo for this explanation of *kpanguima* social relations. At the Njala University College Agricultural Show, Njala, February 1976, a Sowo masked dancer with a white Sowei head-tie came forth without any assistant. Women from all over the huge field rushed to surround her then filed into line. Sowo circled in a dance step, as more and more women joined the ring. A man at my side started a commentary in singsong: "Everybody is in that line—wife in that line, teacher in that line, thief in that line, tramp in that line, *haja* in that line, nurse in that line, chief in that line."

2 This frank discussion and display of sexual matters was truly shocking to prominent Mme. Z. K. (born 1904) of Freetown. Brought up to think of sex as "sacred," a taboo subject never to be mentioned, she remembers as a child being severely chastised for the most innocent curiosity or questioning. Then came time for her to enter Sande when she was fourteen. Exposed to casual *kpanguima* conversations on intimate topics, she was initially dumbstruck, embarrassed, and horrified. Later on, she laughed—it all became commonplace to her. Although she was graduated from the most prestigious girls' secondary school in Sierra Leone, she asserts that it was Sande initiation which prepared her for the responsibilities of adult life.

3 See Rose E. Frisch and Janet W. MacArthur, "Menstrual Cycles: Fatness as a Determinant of Minimum Weight or Height Necessary for Their Maintenance or Onset," *Science* 185 (8 September 1974):949–51; and Rose E. Frisch, "Critical Weight, a Critical Body Composition, Menarche, and the Maintenance of Menstrual Cycles," in *Biosocial Interrelations in Population Adaptation,* E. S. Watts, F. E. Johnston, and G. W. Lasker, eds. (The Hague: Mouton, 1975), pp. 319–52. Carol MacCormack must be credited for noting this research by Frisch and seeing it as a key to understanding the "fattening house" phenomenon in West African puberty rites de passage. See her "Health, Fertility and Childbirth in the Moyamba District, Sierra Leone," unpublished MS, 1978. In the twelve years since the publication of Frisch's article, the medical community and the American public have become well informed about these issues, especially the peril to girls and women of anorexia.

4 "In this area of West Africa, first menstruation, marriage, defloration, and the birth of

first child are not important social ceremonies for a woman, but initiation into Sande is" (MacCormack 1978:3).

5 Older women enjoy reminiscing about their own initiations. Their fond tales are a good source of information about the initiates' life.

6 K. Little: "Sande [is] adaptive to the march of time" (1967:129); and "in general there is a readiness to keep up with the times" (1967:130).

7 Information from Njala preceptor, Telu preceptor, Mme. K. compound, and various other informants.

8 "While in the bush, they are smeared heavily with clay and wear it on their faces and bodies for some time afterward. This is a form of beauty treatment" (Little, 1967:127). T. J. Alldridge, in *The Sherbro and Its Hinterland* (London: Macmillan, 1901), shows a picture of "Bundu Girls" (whitened) in fig. 43 facing p. 136. He says the coating is " *wojeh,* composed of white clay and animal fat" (p. 139), two substances (the animal fat is lanolin) that are used also in modern western cosmetics for healing and softening. This painting was noticed in 1907 by A. R. Wright: "The Bundu girls, during their training in dancing, deportment, medicine, and so on, by the *mesu,* or 'mother of the maids,' are painted all over with magical and protective qualities" ("Secret Societies and Fetishism in Sierra Leone," *Folklore* 18 [1907]:424). Margai's 1948 article features four photographs of large numbers of initiates covered with the clay.

9 "The first girl, who is known henceforward as Kema, acts as head over the other girls for the remainder of the session" (Little 1967:127).

10 The girl "acts as a personal maid and servant to her guardian. She prepares her bathwater, accompanies her to market, carries her loads, runs messages for her, and does a large part of the household chores" (Little 1969:116).

11 "She is sent away to relatives to be 'minded' . . . Mende fear that their children will be 'spoiled' if they remain too long at home" (Little 1967:115). I asked several informants about the *makèlo.* To my surprise, each one had been a *makèlo* himself/herself and had hated it. They all knew about other *makèlo,* confirming my Bo preceptor's remark that the community is full of *makèlo* stories.

12 "They seem to feel themselves *better* than other people, and will not bear a saucy, insulting word, or even contradiction, from an 'unsandied' woman. They must be treated with respect," from George Thompson, *Thompson in Africa . . . Mendi Mission* (New York, 1852), pp. 300–01.

13 Roy Lewis, *Sierra Leone: A Modern Portrait,* p. 145.

14 Pearce Gervis, *Sierra Leone Story,* p. 231.

15 Laín Entralgo 1970:134.

16 Gordon Innes, "The Function of Song in Mende Folktales," *Sierra Leone Language Review,* no. 4 (1965).

17 By which the writer probably refers to the famous gypsy dances of the south of Spain.

18 For discussions of synchrony, see Edward T. Hall, *The Dance of Life: The Other Dimension of Time,* (Garden City, N.Y.: Anchor Press/Doubleday, 1983).

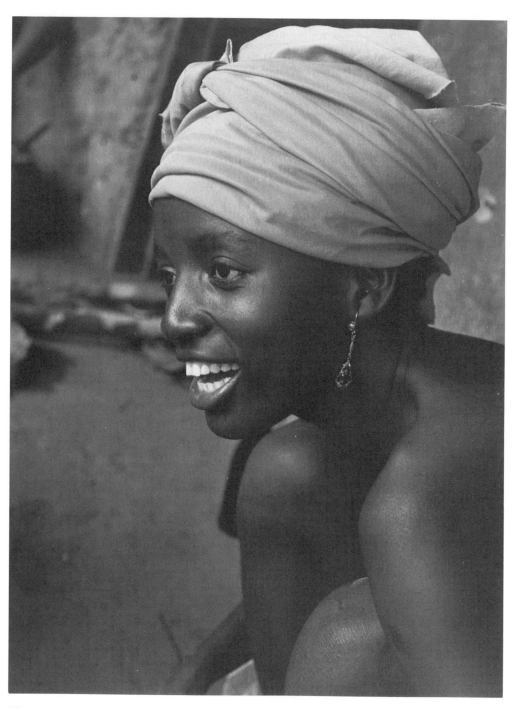

29

4

Physical and Metaphysical Aspects of Mende Feminine Beauty

FEMALE BEAUTY IN THE LIFE OF THE COMMUNITY

Mende think that human beings comprise the most interesting category of things in the world. No animal or plant, lake or mountain, cloud or star—no other creature or object which exists to be seen or sensed is more deserving of consideration than a person, *numu*. With their imaginations and speech, poses and movements, comings and goings, activities and entanglements, people rivet Mende attention. The development and expression of the human personality and the complexities of human behavior and interaction are an ever-fascinating focus of observation, comment, and speculation.

Within this context of the primacy of the person, women are thought to be by far the most interesting people. Admittedly, like so many of their sex, Mende women are dominated by their menfolk, and it is a fact that they often are callously treated; nevertheless, the community assumes that women have more possibilities and that the unfolding of their lives contains more surprises. The duckling-to-swan change of body lends drama to every female; the internality of her sexuality gives every female mystery. A woman is distinct and different from but no less than a man. And women have under their control the most important human capabilities: they are the sources of love and the makers of wealth.

Of all the women in the world, young women and especially pubescent girls exert a fascination which Mende themselves find dangerously excessive but seemingly uncontrollable and inevitable. Starting at the time of her initiation into adulthood and continuing until the birth of her second child, a Mende girl is the object of intense concern. The entire community worries about how she will "turn out": will she "do right" and bring riches, honor, and even fame to her family; or will she "do wrong" and cause chagrin and disgrace? Because a girl can be a blessing or a curse, her whole

world watches intently—advising, teaching, cajoling, encouraging, punishing—hoping she will bring only goodness.

Of all the things in the world, Mende also think that *people* are the most beautiful. If beauty is the promise of pleasure,[1] then for Mende the happiness and satisfaction to be found only in human company renders people "in the eye of the beholder" truly more beautiful than any scenery. Among people, the most beautiful ones are women (fig. 29). Mende agree that woman is primary beauty, and that the female face and body are beauty incarnate.[2] Woman is the most beautiful thing that God has put in the world; she is God's finest handiwork. It is against the standard of feminine pulchritude that other beings, creatures, and objects are judged. If a man is really handsome, Mende say "he is like a woman." When a local furniture store advertises on the radio the attractiveness of its well-made tables, the announcer declares that they are "fine like a woman."[3] Should a Mende sculptor wish to make something beautiful, he will carve on it the head or shape of a woman. Almost anything can have a female likeness— hotel-room keyholders,[4] hammock holders.

Mende elders are categorical on this point: a woman must be an object worth looking at, something you can adore. The sight of a lovely woman is considered one of the great pleasures of life; her presence brings a surge of satisfaction and contentment.[5] An attractive female is constantly being admired openly or surreptitiously, is always the focus of a certain kind of side-glance awareness. Though villagers may not decorate their homes (with drapes, wallpaper, pictures, or bric-a-brac), they nevertheless share the same human desire for gracious surroundings. To Mende, women are the decoration, the adornment—literally, the embellishment of the compound. So, a woman is expected to strive to be beautiful—it is her duty to society, her obligation to her appreciative audience (fig. 30).

Along with the emphasis on beauty, there is also a concomitant belief that every woman has something attractive about her. However plain the woman, she will always find a man to admire and marry her; no woman is rejected because she is not "pretty." A Mende proverb says: *Nyaha gahanёё lò pёё woma*—"A woman's hamper will not remain behind the house," meaning that no woman, no matter how bad-looking, is excluded from full social life. This is not to imply that people now are judging the character of the homely girl and giving her marks for being nice. Rather, it is that no woman is considered or called ugly, no matter how far she may be from the physical ideal. Just by the fact of being a woman, she is attractive. Another proverb puts it squarely: "Nothing that has vagina can be called ugly."[6]

Beauty, however, does confer immense prestige on a young woman and gives her a sense of independence and personal power. A belle is expected to be discriminating and selective in her activities and associations. It is believed that she makes her decisions and choices based on enlightened

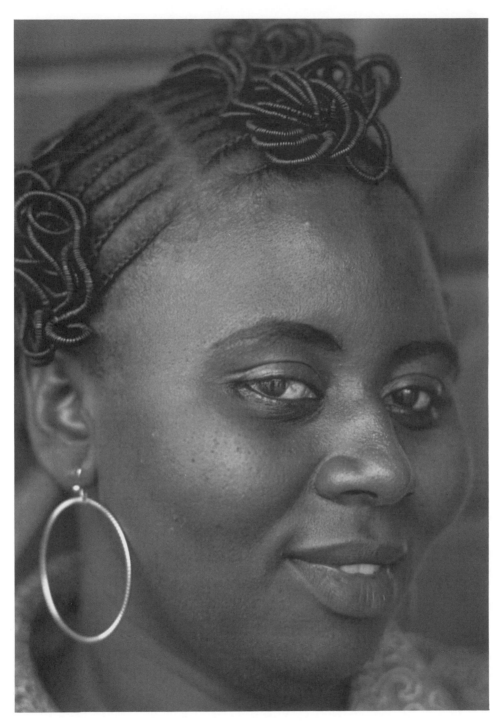

30

self-interest and high moral standards rather than on hasty, low expediency. For a young Mende girl to find herself possessed of a pleasing face and figure is a stroke of great good fortune. Beautiful women with whom I have spoken value their good looks.[7] They say it brings them attention, admiration, money, gifts, suitors, preferential treatment. Because they are beautiful they feel welcome everywhere, easily make friends, and are always respected. Men vie to be husband or lover to a beautiful girl; winning her means that a man has come out on top in a keen competition. A man with a beautiful wife is automatically an important person in the Mende community, and to have more than one beautiful spouse means a man is rapidly rising in the world.

Every woman is appreciated for her feminine attributes and will attract a husband or lover, but what makes all women reach for beauty is the competition of life in the *mawè,* the polygynous family arrangement (fig. 31). A husband with several or many wives always chooses the most attractive one as his consort on excursions. While other aspects of domestic life are regulated by a rota, with each wife participating equally, outside of the home on trips or at festivities only one wife will appear at the husband's side—the most beautiful one. Although another wife may be the husband's closest confidante or his beloved, when he goes out in public he will choose as his companion the wife who is most physically attractive.[8]

Because lovely young brides are so feverishly desired by the men of the community, competition for control over their minds and bodies begins early. The mother of a beautiful little girl can be sure that they both will continually receive money and gifts from eager men who hope to be regarded as suitors for the girl's hand. One attractive mother of a cute four-year-old in the town told me that on occasion she would make matching mother/daughter outfits for herself and child, get them both dressed up (including make-up and jewelry for the little girl), and together, they would go out strolling or visiting on a Sunday afternoon.[9] By the evening she would have collected two or three pounds in tips and gifts from neighbors and strangers as compliments to her and her daughter for their fine appearance.[10]

Again, a woman is a woman; all are desirable and valuable, and the custom of intrauterine betrothal still happens from time to time in Mendeland (Little, 1967:153). The discussion here focuses on the particular attention paid to a pretty child. Beauty bestows such personality on its possessor that it is difficult to keep a really lovely girl bound by a marriage contract her parents may have made when she was still a very young child. The community and her parents acknowledge that, as a young beauty, she may be destined for greater heights than originally foreseen, and it would be unfair to hold her back.

Sande officials are also very interested in beautiful girls and vie to have

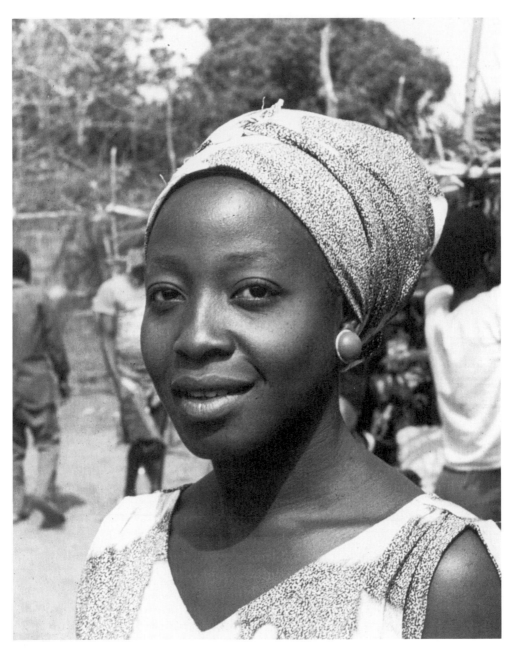

31

them affiliate with their lodges. Having a number of good-looking girls in her initiation camp enhances the prestige of the Sowei; if she consistently enrolls young beauties, her *kpanguima* can become famous and fashionable. From Madame Yoko to Madame Gulama, Mende female leaders have gained power in part through arranging strategic love alliances between initiates and important men.[11] The pawns manipulated in this game are the beautiful young virgins. If she is able to control or influence a young girls' marriage plans, a Sowei rises in the esteem of highly placed men of the area, something which an ambitious woman can turn to economic and political advantage.

The allure a beautiful girl holds for the wealthy and powerful also contributes to her father's social advancement. A brief examination of the economic workings of Mende society will make clearer the meaning and importance of a beautiful daughter, and my later description of her care and grooming will be more understandable. For most Mende, life means year after year of arduous physical labor. Men and women are trained to be hard-working and uncomplaining as they endure the toil of wresting subsistence from a harsh environment. There are very few ways in which a man may rise above his fellows or become eligible for important community positions. An athletic youth of exceptional strength and daring who excels in feats of hardihood and cleverness in hunting, battles, or contests, will favorably impress his elders. His reputation will earn him prestige and the rewards of land, money, and wives; at a young age he has everything for a happy future. On the other hand, a more restless and enterprising young man may decide to leave home to seek his fortune elsewhere. If lucky, he may unearth diamonds,[12] have good harvests of lucrative cash-crops on rented land,[13] or find employment in the civil service, in a large company, or at sea. Once he is known to have money and control over property and labor, his village will welcome him back as a success. However, the ordinary man who remains at home must prove himself the hard way, first as a prosperous farmer. Then, if he is of strong character, fair, even-tempered, reliable, and decisive, he will gain respect and eventually rise to positions of family and community leadership and responsibility.

After factoring out from observation these avenues to success and public recognition, I put my ideas to my informants. They agreed with me in part; but each one told me simply and directly that the best (most direct, sure, and easiest) way for a man to get ahead was by having beautiful daughters (fig. 32)! A girl who combines good looks with a demure, submissive manner is considered by her father as a gift fit for the paramount chief.[14] Because his enticing child certainly will be chosen as wife by one of the highly situated men, the father finds his own prestige increased. Then, as father-in-law, he is a special, well-attended-to guest in his daughter's new home. Through his son-in-law he is always sure of consideration and favor in high places.

THE STUDY OF MENDE FEMININE BEAUTY

This essay on Mende female beauty is directly inspired by the Ivorian ethnographer and historian Harris Memel-Fotê. He is the first Africanist to treat seriously the subject of West African concepts of beauty and to find in Africa tastes, preferences, and reflections on women's beauty, the new materials for a deep understanding of aesthetics, morality, and metaphysics. Showing great originality, his paper—a contribution to the *Colloquium* at the First World Festival of Negro Arts, Dakar, 1966—is a sort of introduction to and statement of the question; it is a comparative survey. In studying his article, I have extrapolated his methodology and used it for an extensive and intensive study of a single West African culture, the Mende.

The following quotations from Memel-Fotê give a picture of his basic ideas:

> Beauty, Africans think, is an indescribable something which inhabits all the regions of the universe—in any case a category which is applicable and which is applied to all kinds of things, to all sorts of beings in the world. There is an innate beauty in things and beings, natural beauty. And there is a beauty in man's acts and accomplishments, artistic beauty. . . . Let us listen to the stories and legends, let us observe life, these are all depositories of the aesthetic. . . . In the legendary or the authentic history of men, there are also memorable and proverbial beauties. . . . As cosmic as it may appear, beauty is, as far as understanding is concerned, marked by one foremost characteristic—*relativity*. . . .
>
> Relative and relativistic to a certain degree, the African perception of beauty is also a *unitary* perception. Here is not a question of beauty in the strictly physical sense nor of beauty in the strictly moral sense. It is not a question of physical beauty with neither ontological thickness nor moral radiation. And not a moral beauty that offers no carnal outlet. Beauty is one. But it is pluridimensional and presents various aspects.
>
> There is a physical-mathematical aspect of beauty, there is the ethical aspect, there is the metaphysical and metamoral aspect. Three aspects of the same reality whose analysis and genetics constitute an ontology. Thus, for beauty, we can sketch an aesthetic of sensitivity, an aesthetic of morality, an aesthetic of being.
>
> Is it a matter of physical aesthetics? It is in the form of criteriology that Negro cultures offer what is elsewhere called canons of beauty. [1968:48–50]

The study of female beauty was my entree into Mende culture. All other roads to an understanding of Mende art seemed barred by the restrictions laid down by the *hale*, societies; but beauty, as Mende affirm, has the power to open many doors. Never once in conducting more than a hundred interviews did I encounter the least reluctance to answer questions on this subject. On the contrary, everybody was eager to contribute his or her views. After I had started with one or two persons, others would arrive, and soon there would be a high-spirited gathering that offered me a good-

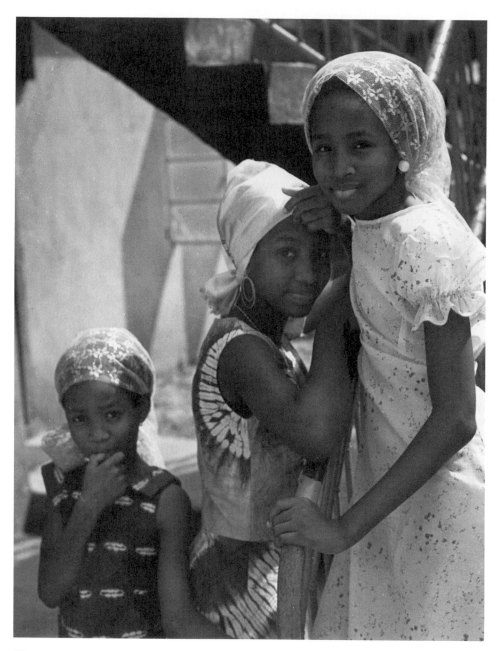

32

natured outpouring of information and anecdotes, punctuated with laughter and demonstrations.

Mende society is of one mind on criteria of women's beauty. Every adult has clear, articulated notions about what is beautiful—notions shared by every other man and woman in the community. As Thompson found, in Dan life, a cultivated awareness of movement (1974:2), so I found in Mende an extreme interest in all aspects of the female face, figure, and motion. Every Mende man and women seems to be an enthusiastic amateur critic and connoisseur of female beauty who wants to appear well-versed in all the criteria and how to apply them. Since everyone freely comments on girls' looks, children learn early what set of features is desirable, and by the time they are eight or nine years old they too can state clearly what a young woman should look like. Older, more experienced people continue to take beauty very seriously and never lose their sense of delight and interest in its development. They feel responsible for maintaining the standards of physical appearance while at the same time, with more settled, even temperament, they remind the community of the moral and ethical considerations.

The overwhelmingly obvious point about beauty in Mende life is that *discussion is solely about women.* Men are completely excluded from consideration. Men may evaluate beauty, desire beauty, pay for beauty, obtain beauty, exchange beauty—but they have placed themselves outside the arena; they are consumers of beauty, not its source. Our very guide to the study, Memel-Fotê, entitled his work, "The Perception of Beauty in Negro-African Culture," but *the article is all about women and their features!* His automatic and unconscious equation of beauty with the female face and form is an assumption that Mende share (fig. 33).

Using Memel-Fotê's instructions, I sought information about beauty from a variety of sources. In scores of interviews I asked simply: What is the best kind of breast? What is the best kind of eye? I let people start in any way they wished and I was sure that I covered all parts of the body.[15] When I had learned enough to ascertain patterns of thought and values in the replies, I began to study the implications more deeply with my preceptors. There does not seem to be any particularly beautiful heroine in Mende stories, rather, every female character is referred to as good-looking. The female lead performers in Mende stories must perforce be beautiful, otherwise they could not qualify as lead performers. There are several songs, not so much about a good-looking person, but rather giving instructions on "how you too can become beautiful" through the practice of art or graceful movement.

SHAPING A GIRL'S BEAUTY

Once diagnosed as pregnant, a young "woman is now subjected to certain taboos and negations, the infringement of which are supposed to have a

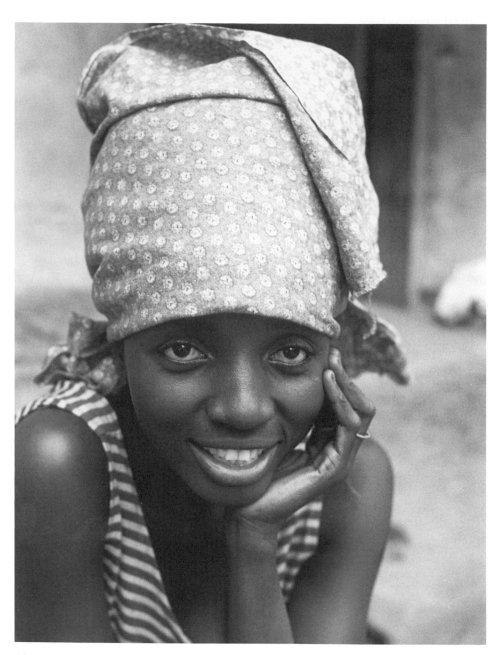

33

disastrous effect on the outcome of the pregnancy. The admonitions are then combined with the judicious use of herbs and concoctions to be used during the antenatal period" (Kargbo, 1975:3). A woman's primary concern must be to bring forth a healthy and normal baby and herself survive and be strong. But beyond the basics of health and well-being, a conscientious woman may seek to have an especially beautiful child. She will thus have additional rules to follow (such as not to look at ugly objects or animals), certain songs to sing, and particular amulets to wear. A complicated delivery is thought to be ruinous to a newborn's looks. One girl complained to her mother that she was not beautiful and her mother replied, "Well, for a breech-baby, you're not bad."

A Mende child's looks are considered from the very moment of her birth.[16] As the head appears, even before the umbilical cord is cut, one of the midwives begins rubbing the infant's head, shaping it round and smooth and pressing the ears to the skull. This effort at molding the head into a pleasing shape must be done immediately while the bones are soft and malleable. Over the next few weeks the mother and grandmother will continue the shaping process; and if the baby's ears seem to protrude, a band will be used around the head to pin them flat. A finely shaped head with small ears close to the skull is an absolute necessity for beauty; any odd shape will mean a lifetime of embarrassment.[17] A Mende person's head is always on display: a boy's hair is usually shaven off, leaving head and scalp visible; girls wear their hair in tightly braided sections, again revealing the contours and surface of the head.[18] There are no long or fluffy styles to disguise the head's outline; rather, Mende love to see the head itself, admiring its worth above all other parts of the body.[19]

A Mende mother encourages her child to enjoy splashing and playing in the water. "We are fish, we love water," one Mende told me.[20] Far beyond the requirements for cleanliness, a bath is one of the good things of life; for an adult an evening bath is so necessary and so satisfying that to miss one is as uncomfortable as missing a meal.[21] The daily bath is a beauty session for baby; a mother uses this time to attempt to improve her child's appearance. She will pay particular attention to shaping and enlarging the baby's buttocks. First the mother puts the baby on its stomach; then she squeezes the two dimples near the base of the spine. The baby reacts by kicking its legs back. This exercise is thought to develop a high behind. While the baby is still on its stomach, the mother will push in at the waistline (as though making an indentation) and will slap the buttocks from underneath up (fig. 34).

Some mothers throw the baby in the air and catch it—this rough play conditions a child to the shock of falling, so that she will take spills easily and not be injured or disfigured. The mother then holds the baby up under the arms, so that she makes pedaling motions in the air, a good exercise for strengthening the limbs. Laying the baby on its back, the mother presses the baby's knees and legs together tightly, and holding

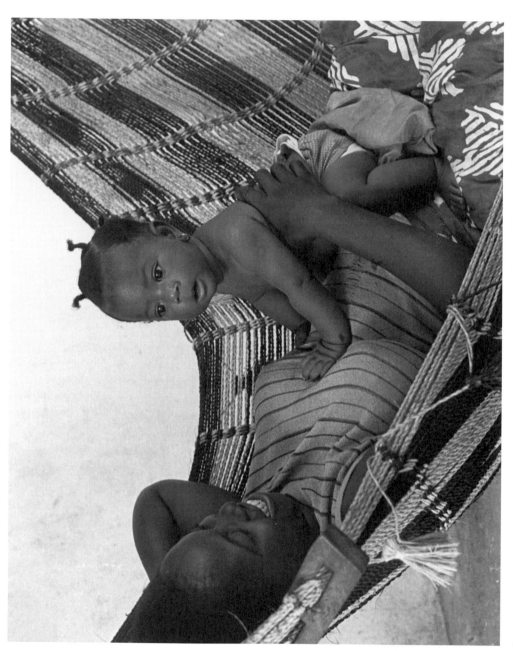

them with one hand, she uses her other hand to push them flat, attempting thereby to make the legs grow straight and close together. Then she will pull at each leg, to make the legs long and tapered. For flexibility a mother rotates the joints in their sockets; some tie strings around the baby's wrists, elbows, and knees, hoping that the slight irritation will cause the child to move the joints more. In another exercise for suppleness, a mother picks the baby up by one arm and shakes her, then by the other. Once the infant is rinsed and dried, the mother rubs her from head to toe with clarified, perfumed palm oil.

These cosmetic efforts must be made while the child is very young and the bones "soft" enough to be effectively molded into perfect shape. The devotion of women to this task is touching and much commended by husbands and family. Mende people know great beauty is a given from God but prefer to treat it as something that can develop from a mother's tenderness and love. If you compliment a Mende woman on her clear complexion she will tell you that when she was a baby her mother washed her clean; on her soft skin, that her mother rubbed her well with beneficial oils. A girl with a lovely, smooth back told me that when she was a baby her mother stretched her arms behind her so that now she is "double-jointed" and can comfortably reach and scrub all the rear parts of her body.

Once she is able to sit up and have her ears pierced, a baby girl begins to have occasions of playing a little woman. For an outing, the baby's eyes and eyebrows will be blackened with kohl, her hair plaited in a style; she will wear tiny earrings and bangle bracelets and be dressed in fancy cloth. Admirers will comment on how pretty and fine she is, a "perfect little woman." Although the mother lavishes time and effort on making her infant daughter into a little doll, she herself is expected studiously to neglect her own appearance. Beyond attention to basic cleanliness and neatness, she must not show any interest in her own looks—no make-up, perfume, jewelry, or rich clothing. A plump, pretty coquette fades into a thin, tired shadow, constantly complaining of being drained by trying to meet baby's incessant needs. Mothers boast of their child's vigor and loud demands and sacrifice their own good looks so that baby may thrive. The mother's beauty, then, is a tangible thing which she offers up as sacrifice for the good of her child.

The Mende community realizes that for many a girl the period between her debut into society and her subsequent responsibilities as a mother is too brief. Some girls cannot stand adult restrictions and long to return to a carefree life with their friends. Others cannot bear to give up their round faces and firm figures. A girl comes out of Sande School at fifteen or sixteen years of age. As a new *nyaha,* she is constantly praised, and an inordinate fuss is made about her looks. Then she is immediately married and is probably pregnant within a few months. In addition to all the new prenatal rules and taboos she must follow, the girl must no longer show

interest in her own appearance. The same older people who formerly swooned over her now berate her if she tries in any way to display her beauty. For many initiates, it is a difficult adjustment to make.[22]

A pregnant girl returns to her kin to await the birth of her child (Mac-Cormack, 1978:4). She is usually glad to escape the tensions of the *mawè* and be back under the comforting care of her mother. As is familiar to students of African social life, a Mende woman observes a period of from one to two years of sexual abstinence following the birth of a baby (Little, 1967:142); on no account must she cohabit with her husband before the baby walks. For the first year especially the mother is expected to give the baby close care. Of course, the new mother is inept and scared, so guidance by a grandmother helps to ensure the baby's well-being. As sympathetic as they are to a young mother's clumsiness, maternal kin are stern about her behavior: here, too, she is harshly criticized for any attention to her appearance. "Why are you putting on make-up, is it because you are going to a man?" "Are you going to abandon your baby?" "Why are you trying to attract men? If you sleep with men your baby may die." A nursing mother is not supposed to be beautiful any more. Denied are all the aspects of beauty that serve feminine pride and self-esteem. Beauty now is stated as being necessary only for the attraction of men as sexual partners; so, with the temporary proscription on sex comes the temporary banishing of beauty.

As she grows up, the little girl follows her mother in her daily routine (ibid.:115). Like her mother, she will go to the stream twice a day, morning and night, to bathe. In the morning she will clean her teeth by using a hard stick that is chomped to strengthen them, while the stump is used to scrub the teeth surfaces of any film. Alternately, mixtures of ash and salt may be used as abrasives. After her bath she rubs her skin with oil and uses pumice stones to clean her feet of dirt and calluses. Nails on her hands and toes are kept cut short. The little girls of the village wear a little *cache-sexe* of cloth, hide, beads, or an apron tied at the side. Otherwise they are quite naked and admired for their innocence (fig. 35).

BEAUTY OF FACE AND HEAD

The sensitivity of Mende to beauty and all its associations emerges particularly in considering the head and neck: the features should be fine and small, with small gradations determining quality and distinction. The Sande mask is an image of a head and neck; in evaluating it, also, delicacy is the major criterion. Every element of the mask is suffused with mystical associations beginning with its physical shape. This complicated and extensive lore will be examined in the following chapter, as part of the intellectual and spiritual concepts to be used in analyzing the symbolism of the form of the mask.

35

Head

Mende pay close attention to the shape of the head, *ngu,* and the face, *ngama.* General contours are settled in infancy and, as indicated before, women work to see that the baby's head is properly molded. A woman's face must be round, gently contoured. A long face is bad, "masculine." The chin must be medium: too spread out has no firmness; sharp is "ugly." High cheek bones are admired, and dimples on the cheeks or chin are considered charming. Ears, *ngoli,* should be small, close to the head, not large or protruding.

Hair

In the Mende lexicon, that which in English we generally call by the collective noun *hair* is designated by three entirely different words: *ngundia* is hair on the head; *njombo* is hair on the body; and *ndega* is pubic hair. Since Mende vocabulary is compact and Mende have a predilection for joining words together to form new nouns rather than inventing new sounds, this multiplicity of words is an indication both of the attention paid to hair and the sharp distinctions made among types. Judgments on hair concern its quantity and volume. Because a man's hair is kept shaved or cut close to the scalp, people say that "men don't have hair." Beautiful hair thus is a distinctly female trait; and the more of it, the more feminine the woman. This polarization of attributes by sexual label is the core of Mende aesthetic evaluation. In a way, the "further away from" a man's appearance a woman is, the more beautiful she is considered.

Beautiful hair is praised as *kpotongò,* literally, "it is much, abundant, plentiful" (Innes, 1969:62). The root word, *kpoto,* is most often used to describe fruits on a tree, rice, other things, and things of a kind that can be pulled together and tied. When referring to hair, *kpoto* means long and thick; Mende think the salient quality of hair is that it grows, and *kpoto* denotes an abundant, numerous quality of growing things. *Kpoto* objects can be tied together, the way hair is styled, using threads to hold it together or weaving it together in plaits tied at the ends. Other hair words play on this analogy between hair and flora, one growing on a woman's head, the other on the earth's surface. *Kpèndèngò* is a word meaning "stunted, not growing robustly"; it describes hair that is short or thin (ibid.:60). The opposite term, *pòpòòngò,* indicates thick growth, luxuriant like a farm or forest (ibid.:126). Hair that is *pòpòòngò* is growing in abundance as it should.

A woman's hair must be clean, smooth, shiny, well-groomed, and plaited into a flattering style. Only a black color is acceptable to Mende. Brownish hair is thought to be dusty and dirty. Men and women both dye their hair deep black, using indigo dye obtained from the *njaa* plant, the same dye used for threads and textiles. Commercial hair dye compounds are also popular. A woman normally washes her hair every week. After

rinsing out the soap she may apply a herbal mixture prescribed to make her hair healthy. Afterwards she will oil it with a perfumed animal fat that comes from goats (rather like our sheep-derived lanolin), or she may use clarified palm oil.[23]

Forehead

The forehead, *tawa,* of a beautiful woman is smooth and clear, free of bumps, blemishes, or wrinkles. The texture must be delicate and fine, appearing to be "thin," not tough or leathery (fig. 36). The forehead should slope back slightly, be even and level, and "fit well" between the eyebrows and hairline, in no way protruding or overhanging so as to cast a shadow over the eyes and face. Mende usually leave the forehead as a broad, open area of the face. In deep Mende villages, women still prepare for a festivity by making up their foreheads (not their cheeks or lips): using white clay they draw lines, stars, dots, circles, and other simple motifs to compose an individual and flattering pattern. After the party the design is washed off; a new one will be created for the next occasion. There are fads and fashions in forehead painting, but they are so ephemeral that we have no record of their variety. No doubt the patterns have communicative value within a closed time and social set, but I have no further examples of them.

Eyes

Mende love looking at eyes and adore them above all other human attributes. Eyes are the most beautiful part of the human body and its single most important feature. If the head is supreme over the body, then eyes command the head (fig. 36). The word for eye, *ngama,* is the same as the face, indicating that the whole aspect of the face is centered on and summed up by the eyes. The most beautiful eye is large and round—*ngama waja waja.* The eyes must not be too close together: they must be well-placed in the socket, slightly bulging rather than deep-set. A too-bulging eye is bad because it is "like a frog's." Little, narrow eyes are "like having no eyes at all." Any abnormalities, such as tearing, cross-eyes, tics, or squinting, are grievous faults. Almost everyone has black or very dark brown eyes, but the rare light-colored eyes—gray or blue especially—are considered delightful and are highly admired.

The whites of the eye should be clear, free of any film or discoloration; a yellow cast indicates sickness. Also, whites should not be red: a red eye is the warrior's eye as he goes fearlessly into combat; a red eye is the lover's eye, heated with sexual desire—both are unsuitable for pretty young girls. Eyes bright and shining, the shape large and round, the whites clean and white, and the whole surface glisteningly alert and sharp—those are the perfect eyes of health and beauty. Most people express a preference for rather thick eyebrows (*ngama gbeka*) of a curved, S-shape. They should be

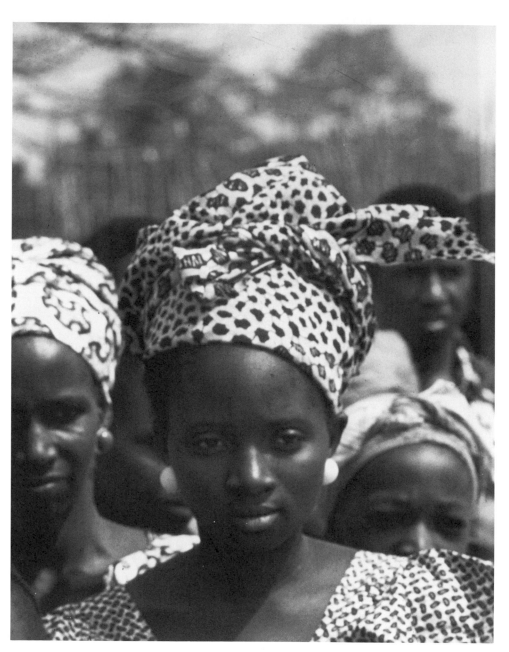

36

wide apart and distinctly separate, not meeting in the middle. Both the eyebrows and the rims of the eyes are darkened with a mineral cosmetic, kohl (*tiwo*). Again, the desire is for emphasis and clarity, black kohl making a contrast that brightens the whites of the eyes.

Nose

"The nose, *hokpa*, should be small, not too big." "It shouldn't be broad or flat." "It should be like the mask." A good nose is said to "stand straight"; the descriptive declarative, *wònangò*, means "it is straight, it is right, it is correct" (Innes, 1969:126). Alternately, a small, round, "pug" nose is acceptable; but in no case should the nose be large or wide. If westerners consider a broad nose a "typical Negro feature," Mende certainly do not; they hate broad noses. Answers to my questions about noses elicited raucous laughter as the ugliness of flared, open nostrils or sprawling flatness was evinced through appropriately vulgar grunts, snorts, and punches. Having a big nose is a disaster, a cause of a lifetime of teasing and derision. The great praise of a nose is to say the *ngi hokpèi kia puumoi*, "her nose is like a European's." In fact, the only European physical feature which Mende do admire is the nose: Mende consider them "smallish," and say that aquiline noses look sharp and "cut." Sierra Leonean girls of Foulah blood are liked for their delicate noses and Mende think the Mandingo nose "aristocratic."

Mouth

The mouth/lips, *nda*, of a woman must be clean and smooth, without any peeling skin or discolorations; the breath must be sweet and fresh. After these essentials, the beauty of the mouth and lips lies in their action—the mouth should be smiling. People love smiles and consider a frowning mouth, or closed or pursed lips, as "not beautiful." Size and shape are considered when judging between two *smiling* mouths. Mende like mouths a bit small, though full and rounded, with the lipline sharply defined, as though cut. They find large or blubbery lips repulsive; too thin lips are also bad, being regarded as a simian characteristic.

A mouth of naturally red color is desirable; it alludes to ripeness, something sweet and succulent. The red color refers to the vulva. In Mende, *nda* means mouth; *ndabu* (the same *nda* plus the adverb *bu* meaning bottom, underside, under, underneath) means the genitals (Innes, 1969:91), specifically, the vulva, "the mouth found underneath."[24] Female genitalia are red. As with the face mouth, then, the redder they are, the more attractive and alluring, possessing the red of ripeness, readiness.

Teeth

Teeth, *ngòngòlu*, should be small, the smaller the better, widely spaced, preferably with a gap, *sape*, between the two front teeth.[25] A pearly white-

ness is beautiful. To keep teeth immaculately clean, free from stain or decay, they are scoured at least once a day with an abrasive powder of salt and ashes, or with commercial tooth powders and pastes. The best cleansing, however, is obtained by rubbing the teeth with special sticks that remove all film and whiten the enamel. Small, widely spaced teeth are so attractive to Mende that in the past teeth were filed to reduce their size and open the spaces, a practice which has almost died out. Likewise, on a more modest scale, any woman not born with a middle gap would have the two upper incisors filed to open a space.

The small amount of flesh showing between the two front teeth is considered a beauty mark, a point of attention and admiration. Carrying further the punning interplay between mouth and genitals, the opening is seen as the vulva and the interaction between that space and the tongue as the act of sexual intercourse between male and female. The opening between the teeth suggests the opening between the legs—a girl with open teeth suggests easy seduction and a more passionate encounter. (For the same reason, a hissing noise made by sucking air through the teeth is abusive and offensive; it is a "fig" remark without words.)

Neck

A good neck, *mbolo,* is long, firm, and flexible; but "not too long, like a giraffe's or a camel's," and not too short, because then the person looks "like a tortoise." A truly beautiful neck should be ringed with indentations so that it appears segmented into rows; the deeper the indentations and the more distinct the rings, the better (fig. 37). It cannot be said that a girl *should* have a ringed neck, because ringed necks are the most special aspect of human appearance, not assumed within the merely nice, normal, and pretty. A ringed neck, *mbolo gènyè,* is a beauty in and of itself: it is *physical beauty incarnate.*[26] It has an identity and aura outside the person, but it does not make its owner beautiful. In fact, it is ludicrous to see this gorgeous neck on an otherwise unattractive girl; it becomes a caricature—the beauty of the neck mocks the plainness of her appearance.

BEAUTY OF THE BODY

Mende take note of the smallest variation in the features of the neck and head; but the human body, *kahu,* is by definition large, so our consideration of it involves larger areas with less fine distinctions. This discussion will concern itself with proportions, health, grooming, and praises; then will go beyond the physical to examine Mende notions about the parts of the body and the symbolic inferences of their morality and power.

Breasts

Young Mende girls are proud of their beautiful breasts, and justly so, for the breast, *nyini,* elicits the admiration of women and the adoration of

37

men. Looking at breasts, evaluating them, touching and fondling them are favorite Mende pastimes. On more than one occasion I have seen older men meet a young dancer for the first time and actually reach out and give her breasts a squeeze, murmuring admiringly, "you have nice breasts, huh," while the girl beamed. No amount of familiarity with the breast seems to diminish its appeal: all Mende infants are nursed for at least one, sometimes as long as three years; Mende girls and women go topless in the village and farmhouse. Even in urban areas, girls are bare-breasted in the house: schoolgirls take off their dresses when they come home, and boarding students are most comfortable around the dormitories wearing only a wrapped skirt. And yet, despite this constant and causal exposure, Mende people remain delighted at seeing breasts and always have an interest in judging their qualities. As each girl is growing up, the community observes to see "if the Breast has come," if, in her case, the idea of the breast will manifest itself.

Mende find the development of breasts, their "action," fascinating and significant. In general, it is a feminine characteristic to have more of everything,[27] and women have more breast than adult males and children of both sexes. The features of a healthy human body maintain their discrete structure, enlarging proportionally, retaining their relationship with the whole. But in the instance of the female chest, a flat area suddenly begins to swell and become round, changing the body's contours. Pregnancy is the only other occasion for such a dramatic change in a woman's body, as her abdomen rounds into a sphere, another marvelous female phenomenon. The chest of the prepubescent girl is of no interest because it is "just like a boy's or man's." But once her breasts bud and ripen, a girl is considered sexually mature, ready to enter into adult life. The swelling of her breasts foreshadows the capacity of her belly to expand and house and protect an unborn until its birth and her ability to nourish the baby after its birth.

Sometimes it seems that a girl is getting breasts "too soon," while she is still too young. Frequently in such cases the mother or an aunt will slap or punch down hard on the budding breasts or else hit them with the flat of a paddle—all in an effort to retard their development and make them "go back in." They say it works, but can only be a delaying device.[28] By the age of fourteen or fifteen the girl's breasts are full. She is now "complete" with all the necessary "parts," equipped by nature for full womanhood. The expression *nyini hu vendangò*, "the breast is full," praises breasts: "The breast is full up, it is fully ripe, the girl is in the bloom of youth, nubile, tender, yet mature." Now it is up to the Sande Society to take her, groom her, train her for her tasks, and place her in her proper position in the community (fig. 38).

For all that they are desired and worshiped, perfect breasts are rare in the world. A full, firm, wide breast is the Mende ideal. It should be low,

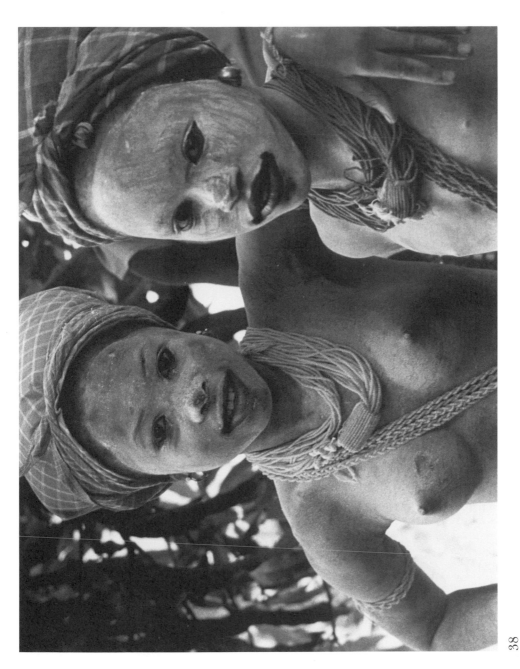

38

rounded, close to the chest, rather like a saucer; it should be thick, but not protruding or extended. It must be erect and solid in appearance, secure to the body, so that it does not jiggle or shake even when a girl dances or runs. Mende liken such breasts to a calabash, *tawa*, a witty simile for size, shape, hardness, and function.[29] The breast must be wide, covering the entire surface of the chest, from the sides across to the cleavage. Mende say in admiration: *Ngi nyini ngi yaka vendangò*—"her breast covers her chest (and sides)." Such erect round breasts are fully visible, there is no underside or underneath—the whole globe is seen at once. They are sculpted, clean-cut, sharply outlined. Speaking of such perfect young breasts, one elder mused, "The girl doesn't need any other decoration. She just stands there, and you see it."

Even at its best, in its ideal form, the beauty of the breasts is seen as a most transient thing: rarely occurring, it is also short-lived. The essence of its nature decrees that its beauty is fleeting. Once her breasts are developed, a girl is ready for initiation and marriage. She will become pregnant as soon as possible, nursing the newborn at these same young breasts and, in the process, ruining their shape. When her breasts have fallen or become flabby, a girl is dismissed as "ugly" by her peers.[30] An added distinction of the "calabash" breast, then, is its capacity to give suckle to a first and second child while maintaining its firmness. The ability of this breast is to do its job but not show the wear, to go into battle and come back unscarred: the fortunate owner will be considered ever after "truly beautiful."

In erotic play and love-making, the female's breasts are the focus of the couple's amorous attentions. Mende do not kiss on the mouth, and the vulva itself is so secret and sacred that few Mende women will allow even their husband to touch or probe them there, as he might wish to do; so fondling of the breasts is a major pleasure for both partners. The response of the breast to sexual excitation seems analogous to that of the penis—the nipple grows turgid and erect, while the entire breast becomes increasingly sensitive, aches for contact, and at the same time is receptive to harder, more insistent manipulation.

To name the nipple, Mende employ two different three-word phrases, whose elements indeed spring from other contexts and thus form a tableau of visible inference. One term alludes to the erotic and carnal nature of the breast, while the other delivers a poetic promise of youth and nubility, with both leading to concepts of fertility and nurturance. *Nyini la wondi*, nipple (Innes, 1969:119) is comprised of words for breast (loc. cit.), mouth/opening (ibid.:90), and foreskin (ibid.:119)—thereby designating the breast as an analogue of the penis. The breast has a mouth, opening at its tip as does the penis; and this orifice is covered by a prepuce, as in an uncircumcised penis. The other term, *nyini la bowa* (loc. cit.) is comprised of words for breast, mouth, and blossom (ibid.:126).[31] The words evoke a picture of a flower in a stem-vase, or a flower held over the mouth. Mende

see the little puckers of flesh which cover the opening of the breast as petals and so recall delicacy, prettiness, tenderness. When a tree produces flowers, Mende say, "*Nguli bowa,*" the tree has flowered, the tree is ready to bear. By the same association, "*Nyini la bowa,*" the mouth of the breast has flowered, celebrates at once the maturity of a young girl and the evidence of pregnancy in a young wife.

The word for breast itself is a compound word whose parts separate easily and if read together form a concept in a small phrase. *Nyi* means "bite," *ni* is an ideophone for "very sweet, very pleasant." Thus *nyini* means "bite the sweetness"—a reference to the infant's eating that which is the ultimate of sweetness and goodness, giving the ultimate in oceanic feelings of pleasure and satisfaction. It refers also to the erotic bites given the breasts by a lover. As in so many Mende words, the name of the thing is what you do with it or what its end product is. The breast is the sweetness that you bite, the sweetness there for you to take into your mouth for your sustenance and your pleasure.[32]

Lovers are not the only people who handle and caress the breasts—Mende babies are allowed to play with breasts to their little hearts' content. They are suckled on demand for the first year or two of life. Nursing babies is a public act, and the public jokingly envies the baby's access to cradling and physical gratification. At first the newborn searches for the food for survival; but in a few months the community sees him begin to take an interest in the breast for comfort and sensual pleasure. Before long, an older child, usually a girl, will be given the toddler to care for. It is a common sight to see a one- or two-year-old straddling the hip of his seven- or eight-year-old sister, the toddler continually groping for her nipple to pinch and pull. Most times the older child will bear nipple-teasing or even encourage it as a way of keeping the baby amused and quiet (fig. 39). Mende call this constant sucking and squeezing of the breast by the baby (and the lover) *nyivo,* "to trouble the breast," to worry it, to quarrel with it.[33]

There is still more about the deep meaning of the breast as part of the central mystery of woman. Let us return to the starting point of observing the beauty of the ripe breast, *nyini hu vendangò.* It is said to be "full," and the ideal breast is "like a calabash." Both these two constantly repeated comments are single words that encapsulate cosmic notions. The *ve* word stem refers to the flowing-in of bodies of water; when the tide rises, or when a waterfall fills a pool, a *ve* word is used. Using the same stem, *ve-nda* means "to be full," specifically with a liquid; thus a calabash can be *ve-nda* with water (*ve-nda-ngò a njei*) but not with stones. So, in using *ve-nda-ngò* to describe a ripe breast, Mende are referring to the idea that the breast is now full of liquid, since the word for mother's milk is *nyini ya,* the water of the breast.

Whenever we touch water of any kind we know that we are approaching

the spiritual essences of life. This swelling of the breast with life-nurturing liquid relates to the girl's ability to give birth; it presages the uterus filled with amniotic fluid, *ndo bòlòi ye kpulu hu yèi*. We just mentioned that Mende call the nipple the foreskin of the breast. The penis, the publicly analogous organ to the breast (the clitoris is never mentioned), also becomes swollen with fluids when erect. The sperm, *hindoi mayèi*, ejaculated through the tiny holes in the head of the penis, is a milky liquid that will water the ovum, the "baby seed," and nudge it into life. In the water of the womb, "under the water," the new life is forming; afterward the water of the breast will sustain it outside the mother's body. We are engendered by water, nurtured by water—water is mystical space because it is the medium of love and life before life.

Hands

Hands, *toko* (Innes, 1969:142–43) have a markedly dual nature in Mende thinking. Viewed as a pair, in other words, as a single entity, hands are a sense organ, an external one not situated in the head. As a sense organ, the hands extend out into the world, explore the environment, and through sensations report back on surrounding conditions. Hands also are seen as implements, a set of tools, instruments, an apparatus for performing tasks as ordered by the brain. The beauty of hands is judged by their size, texture, color, and movement. Lovely hands are slim and dainty with long tapering fingers. Fingernails are always cut very short; long nails are "foreign." A woman's hands must be soft and smooth, without the roughness characteristic of hard-working hands. The palm, *tokovèlè,* should be light in color even in the darkest person; a black palm is considered a simian attribute, ugly and coarse on a human being. Hands must be flexible in movement; any stiffness is arthritic and disfiguring.

Female hands, like those of the men, are working hands, and work is the toil of farming, fishing, and cooking (fig. 40). At the farm, women's hands do painstaking, tedious tasks which require considerable dexterity and strength. They handle growing plants, removing insect pests; at the same time, they pull out each weed individually at the roots. In fishing most women employ nets, but the champion fisherwomen can spear larger fish by hand with a hunting knife. When one dives for fish, her hands go where her body cannot. Using only her sense of touch, a fearless fisherwoman's hands probe behind rocks and into caves, grabbing at the fish who hide there, fish which are naturally considered the most meaty and succulent.

In her kitchen work a woman's hands again are her main tools. Proper preparation of Mende greens requires using a sharp paring knife to shave the leaves into fine slivers that will cook and blend well with other ingredients, a task requiring steadiness and precision; any error means injury. Most impressive is a woman's ability to handle very hot items, something men absolutely cannot do. Little girls have to learn early not to be afraid of

40

a boiling cauldron or a smouldering log. Using only a scrap of paper or a dry leaf to prevent actual contact between skin and object, a woman will handle very hot things with confident ease, and without harm.[34]

All Mende are right-handed, and giving and receiving is socially acceptable only with the right hand; to use the left hand in any exchange is a social crime. Whereas the right hand is used for public exchanges, the left is used for those that are private, or hidden. It is familiar information that in West Africa the left hand is used in personal hygiene. But in Mendeland, intimate ablutions are only a part of the work done by the left hand. For women, who are responsible for the cleanliness and health of the household, there is further ritual separation of the roles of each hand. A woman's part in love-making is taken by the left hand; once engaged in sexual contact, she can only handle the penis, and later tidy up the space, using her left. This division of activity is very seriously regarded as a social requirement; if a woman is not scrupulous in this matter, her husband can formally bring charges against her and have her haled before the chief's court.

Idiomatically, the hands represent the individual's participation and action; and a number of expressions depend on this association. *Nya toko wili lò hu*, "my hand is in with them," means "I will take part in the activities." *Toko fele kè koi fele*, "two hands and two feet," a statement of agreement, means "I am in it all the way." Hands indicate a person's intentions or interests; so when one says *loko wèè ngi ma*—"rest hand on it," it means accepting it in good faith, accepting completely. The hands are used in settling a dispute or misunderstanding: the touch of the hands, as in a handshake or a pat, is the true sign of forgiveness and reconciliation; without the contact of the hands, forgiveness is not truly given.[35]

Again, the left hand has a separate meaning. In these hard-working farming communities, each member of the body has laborious tasks to perform: the head, back, and shoulders bear the weight of loads, the feet and legs carry the body long distances; in a woman, the breasts and the buttocks nurture and support the young; and the right hand never ceases its manipulations and maneuvers. In all this industry the left hand is relatively inactive. Because it is such a nonparticipant, Mende accord the left hand the status of a witness, a silent observer of a person's actions. They swear an oath with the left hand, not the right; the left hand is subject to the ordeal because it stands detached from the individual's plans, and thus it is more likely to be honest and truthful.[36]

Hips/Buttocks

Mende are not much interested in waistlines as such. Secondary school girls do become inch-conscious and think 26" to 28" is a nice size; but most Mende say only that the midriff should be slim. The abdomen must be flat, or just a bit rounded, soft to the touch. *Tèvè lèvè* (Innes, 1969:140), thin,

flat, describes an attractive waist and stomach area; any protrusions or hardness of the mid-section are a sign of illness.

In any discussion of the body, longest and loudest appreciation is for buttocks, *ngoto*. If breasts are the high point of beauty of the front of the body, then the buttocks are the beauty of the back. In terms of the breast, beauty lasts at most five or six years for a village girl; beauty of the buttocks lasts a lifetime. Whereas breasts are exposed and familiar, from puberty buttocks are always covered. Perfect breasts are rare, but every woman seems to have a nice behind. And while breasts are more or less given by God, the buttocks are cultivated and developed.

Buttocks are judged by their size, shape, and movement. Even if the girl is otherwise slim, she must have bulging buttocks, of relatively greater mass. "The bigger it is, the more appreciated it is." "Each man has his own tastes, but everybody likes big buttocks."[37] The buttocks must be rounded and high on the body, protruding distinctly, then rounded down. Opinions differ on how high and protruding the behind should be. Urban folks and younger persons seem to prefer a very exaggerated size hip, so high that it forms a "shelf" in the back; to more traditional villagers such buttocks are "artificial" and make the body look "bent."

The insults are specific for any faults. A flat behind is derided as *Bi woti vėvė le ngoi bė fėlė*—"Your behind is as flat as a winnowing fan."[38] If the shape is not nice, people just say in contempt, *Ngoto gbi ngi ma*—"There are no buttocks on her; she has no buttocks." Of a small behind: *Bi wotoi bė hindo*—"Your behind is like a man's." Mende males are expected to be slim and strong of body, spare and angular. Most men do hard physical work and retain a military level of lean physical fitness all their lives; even the idle rich have no tendency toward a bay-window or body softness. Women, on the other hand, generally petite, are encouraged to be plumper. Again, women are thought to have a greater quantity of body flesh; so while a man's behind should be small and hard, a woman's should be ample (fig. 41).

The principal appeal of the behind is in the liveliness of its action. The buttocks must have strong movement; they must wriggle rhythmically as the woman walks, either alternately bumping up and down with each step, or swiveling in. A large or rounded backside that does not dance about when the girl walks is dismissed as a fraud. Because hips are always covered, it is possible for a woman to augment their size and round their shape secretly. But such artificial improvements are incapable of the desired movements. *Ngoto mayugbė* is the perfect behind, because the adjective includes the idea both of size and of motion. Another term is *ngoto tisėi*. The adjective and noun *tisa* refers to fruits in a bunch that are ripe and hanging, juicy and ready to be plucked. The two cheeks of the buttocks make this bunch with their motion resemble things that are suspended, capable of swaying and bobbing.[39] When a girl's buttocks are fleshy,

41

round, high, and active, she is in possession of an alluring physical asset. People praise her, saying: *Ngi wotongò*—literally, "she *is* Buttocks"; to see her is to see Buttocks, the incarnation of true buttocks.

Every woman desires attractive hips and, unlike some other aspects of beauty, mothers feel there is a good deal they can do to help them develop properly. Mothers are particular about this, and make a definite effort to shape the child's buttocks. As part of the baby's bath routine the mother will work on the buttocks every single day.[40] Women recall becoming conscious of their hips at around age eight or nine. A group of little friends begins to take an interest in the way older girls flaunt their big hips. In an effort to appear more grown-up, the little girls begin to strut around with their chests pushed forward and their behinds thrust back and up as far as they can manage. Their mothers, in annoyance, call out, *Ngalengò,* "crooked! bent!" and strike them on the back to make them straighten up. But once out of sight, the girls are at it again, imitating their elders, pulling their wrappers as tight as possible to emphasize the shape, and religiously practicing to gain control over the muscles so as to make them go up and down.[41] The reward of all these years of attention to the behind is that indeed nearly every Mende woman seems to have the kind of buttocks that the community considers so desirable.

Everyone, male and female, observes the buttocks of girls and women and is really excited when a good pair of hips goes by. Swaying from side to side with the cheeks rising and falling in rhythm, a prominent, lively behind is sexually enticing.[42] Women tie their lappas tight and deliberately twist and shake as they walk away from a man, knowing full well how provocative this is. There is a good deal of this hip "display" by a woman when she wants to attract sexual interest. As part of flirtation, the man may maneuver to brush by her quickly, or if they are married or not afraid of scandal, he will simply rest his hand on her behind. This gesture, called *ngoto lee,* is apart from words the most direct Mende statement of "I love you and I want you," and is the most public Mende sexual expression.[43] Because of the blatantly sexual nature of contact with a woman's buttocks, to be seen even looking at the behind of another man's wife can cause trouble. As part of the fun, the distracted young men devise ways of stealing quick looks at tantalizing behinds, adding the pleasure of the ruse to that of sexual excitement.

Good buttocks are beautiful in part because of their association with child-bearing and childcare; they are called in praise: *Ndo wopo woto*— "child-carrying buttocks." A Mende woman carries her baby on her back in a sling, *kula hakpa,* made of cloth wrappings (fig. 42). The baby is placed with its chest resting on the mother's back, its little behind nestled onto the upper curve of her buttocks. The baby's arms encircle her chest sides while the legs are open, one resting on each hip. Thus the buttock shelf is the

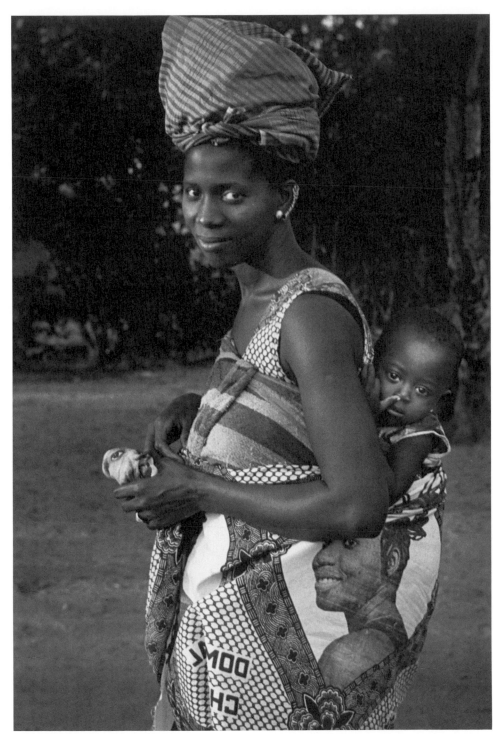

baby's "seat"; without this configuration the baby would slip down to injury and harm.[44]

In addition to its pronounced sexual associations, buttocks provide other reference points in Mende life. *Bi woto heimèi*—"your behind sitting place"—is figuratively "your headquarters," your permanent abode. As a gesture expressing high emotion about a matter a woman will strike her own hip; this is a gesture that only women make. In a high-spirited exchange among friends, when a woman comes to the best part of her story, to emphasize the favorable developments in the situation, she will strike her hip, giving the tale added emotion and expressing her good feelings. On the other hand, confronting another person with "hands on your hips" is extremely insulting in the Mende community. "It is not allowed"; "people don't do it"—it is a social crime for which there are no mitigating circumstances, and the offender will without fail be fined by the chief's court.[45]

Sande is gravely serious about fertility and nurturing; and no one knows better than Sowei that life begins with love, and that love between the sexes thrives in an atmosphere of exuberance and pleasure. Thus, it is not surprising that Sande is the major advertiser and promoter of women's buttocks. All Sande public dance groupings emphasize a display of hip size and flexibility. From their early initiation training, women dance with their hips more than with any other part of the body.[46] One dance that all initiates learn is called *mayugba*, a word defining a good behind as fleshy and flexible. The girls sing, "You are pretty and I am pretty, but I win all the admiration because I know how to display [*magè*] myself." At the refrain, each girl in turn steps out to do a dance of hip twisting and bobbing, making the strings of the skirt fly.[47] For the more expert and experienced dancer, the motion of the hips remains the test of her skill and talent. The Sande dance costume features several large bells hanging at the middle of the dancer's behind. The expert, *sowo-lolimò* (Sowo dancer) is the one whose hips toss the bells about wildly, making them clank and ring (fig. 43).

Genitals

Mende include the genitalia in their picture of feminine beauty and, as with other body parts, there are definite standards for evaluation of their quality. Despite the "private" nature of the sexual organs, in these close-knit communities a woman's sexual organs are subject to speculation and discussion; intimate information about their condition somehow manages to become public. *Kpota, mbòli,* and *tete* (Innes, 1969:62, 85, 139) are interchangeable words referring to the external portions of the female genital organs; internal areas combine one of these words with the noun meaning "inside," *hu* (ibid.:28). To be considered beautiful, the vulva should be small and neat, healthy and free of blemishes. The labia minora and other

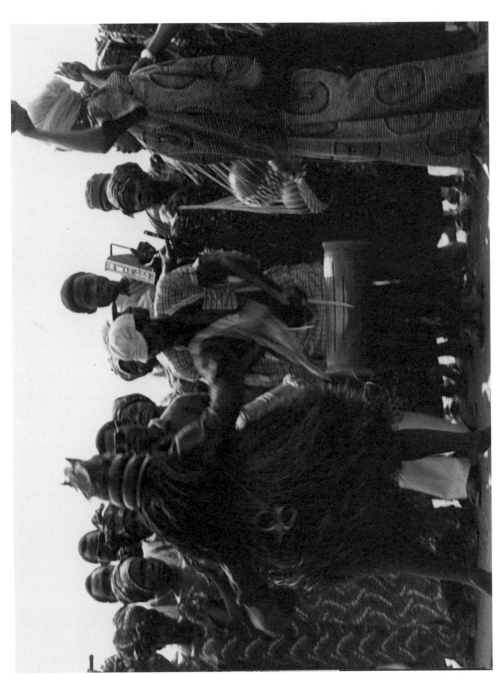

internal surfaces should be moist, free of blemish, and of a healthy red color. The vaginal tract itself should be small and tight.

The appearance of pubic hair, *ndega,* on a girl is a sure sign of female sexual maturity. A girl with budding breasts still plays freely about the village, wearing just a string of beads or a kerchief tied around her waist. But once the pubes appear, her nakedness becomes an embarrassment to adults. Father and grandmother will hear comments from neighbors: "That girl is growing up; isn't it time she went into Sande?" "She should put some clothes on; she looks shameful." "You shouldn't let her run around like that." It is certain that the girl will be initiated into the next Sande session.

Mende people detest pubic hair, and both men and women routinely shave their genitalia. Safety razors are popular now, but some people still use a straight razor made by a blacksmith. As in all matters of beauty and grooming, women are the more fastidious. Whether a girl going to her lover or a wife going to her husband—the vulva must be free of all traces of hair. If a woman should go to a man without shaving, she is indicating indifference and that she has no regard for his opinion of her. After giving birth, a young woman will wait out the year of sexual abstinence without shaving herself. Should she shave before then, she incurs her family's wrath because she is suspected of intending to resume her sex life and thus to neglect her baby.

A cleanly shaven vulva is a treat for a man; it shows that the girl is for him "heart, mind, and body" and that she cared enough to present herself as attractively as possible. Women of a harem will always polish up their appearance before their prescribed nights with their husband. But in a monogamous marriage or one in which there are only two wives, after a while the women may take less care. Some jealous husbands refuse to let their wives shave; while declaring that they get special pleasure from a bristly vulva, they have as an ulterior motive the prevention of the wife's going to a lover. The complications are easy to imagine. The wife who, after being careless, suddenly becomes fastidious about intimate matters, is announcing that she has a new love, for to make a good impression, it is necessary to shave. So for those who wish to be discreet about their infidelities, one cost is the tedium of constant attention to meticulous grooming.[48]

The vagina is meant for sexual intercourse, so by being small and tight it better grips the penis and provides greater contact and pleasure. If the vaginal wall has an independent rhythmic motion during coitus the organ is judged "the very best." But everywhere nature is coy, and it is hard to know, say the elders, where one will find the best vagina. A man can see by looking at his bride that she has nice breasts and nice hips, and a nice vulva; but he has no sign about the state of the vagina. It can happen that the vagina of a young girl will be big and slack, while that of an older woman

who has borne several children may still be in shape because "she knows how to arrange herself."

Mende men see this puzzle about the vagina as a "problem in the community" and a topic they return to often. They agree that the girls who are less attractive often have vaginas that are the "best ever," almost as a compensation for what they lack in looks. And a man is very lucky to find both internal and external desirability combined in one woman. The general community can be harsh and vocal in its judgments of a factor so intimate and supposedly secret. If a young woman is not sought after, it will be because word has gotten round that her vagina is not good. Women know about each other, and in any catty quarrel an unpopular girl is bound to be told that men do not want her because her vagina is too big. And vice versa, if a girl is popular with the opposite sex, her neighbors assume that she must have the most desirable type of organ.[49]

Added to the allure of the female genitalia is the Mende notion that it never ages: while the woman's other charms fade, the vagina is thought to remain young and fresh! One story about this comes from an interview with a popular singer. When I asked her how she got inspiration for her songs, she replied that she had plenty of material just from watching life around her. It happened that she was one of several junior wives to a chief who received a continuous stream of visitors. One day a woman in her sixties came to the chief to complain that her husband was ignoring her. The woman declared, "Yes, I know I am old now, but a woman never gets old down there." The young wives thought the incident hilarious and so the singer wrote a song detailing the ravages of time on the supplicant, from her grey hair to her withered behind, then adding loudly, "But my vagina is fine; I'm still young down there!"[50]

The whole genital area must be kept scrupulously clean, absolutely free of odors. A Sande *nyaha* washes herself constantly, and the first part of her body to be washed is the genitalia. A woman takes a bath after the day's work before the evening meal, and she washes again before going to her husband or to bed at night. In the morning she rises early, before the men, and before being seen again bathes thoroughly. A woman's menstrual period is a strictly private, hidden affair, with modesty preventing the slightest tell-tale signs.[51] All of this is part of the sexual etiquette a girl is taught during her Sande initiation.

For all their bathing and affinity with water, Mende women detest having water thrown or sprinkled on them by another person, taking it as an extreme insult. A Mende woman is of the water, is always in it, and is herself a source of water; so to put more water on her gratuitously is a grave affront interpreted as saying that she "needs water"—namely, that she is not clean, i.e., that her genitals are not clean. The cleanliness of a woman's genitalia is a serious and delicate issue in a Mende village or compound. A woman guards her reputation by scrupulous attention to

intimate hygiene; the slightest imputation that she exudes an offensive odor is a grievous insult, capable of involving a whole community in turmoil and bitter feelings. Women, Sande *nyaha*, are the cleanest people in the village, far outshining men, children, or animals, the house or the furnishings. A *nyaha*'s very function is to bring freshness and cleanliness into community life; so even a whisper that a woman is less than clean and trouble starts.

This "throwing water" needs a bit of explaining. It doesn't mean that one purposefully hurls or flicks water at a woman—that would be unspeakable. It is rather more complicated. Women are constantly handling water while in close proximity to other women of the family and community, but in no circumstance must a woman allow water to spill on another. So, if she is handing water to someone to drink and some drops fall on the other woman; or if she is emptying a basin just at a moment when another woman comes around the corner, and it splashes on her; or if she is carrying a bucket of water on her head and some of it spills on someone—if any of these things occurs (which an American would accept as a harmless accident)—in the Mende community a crime has been committed, and there will be controversy until matters are settled.

An even more serious situation arises in relation to the Sande Society. Certain Sowei are part of the noble elect of *water Sowei*. Introducing me to a group of Sande leaders, Chief Foday Kai indicated one as a "water Sowei" and said that on no account must water be sprinkled on her.[52] At a mere drop she falls into a faint or trance, so offended is her water spirit. Then the Sande *hale* seizes the offender, demanding expensive gifts and sacrifices as well as physical punishment in order to expiate the crime. It is a question of water and women, water and the spiritual, water and the female genitals, water as purity and life.

Thighs/Legs/Feet

Ideally, the legs, *gbaè*, of a Mende girl should be straight, full, and naturally close together. The thigh, *kpala*, should be round, a bit fleshy; the calf, *haka*, should be long, drawn out, and shapely. Legs that stand easily together from the knees to the groin are especially desirable. The ankles, *kpowo*, should be slim and flexible and the whole foot, *kòwò*, small and dainty with a high instep, both feet parallel, resting squarely on the ground. These considerations of the lower extremities bring into play the whole range of Mende beauty care and training. It is the duty of the mother to ensure that her child's legs are straight. Knock-knees, *wombi-la-wèlèngò*, and bowlegs, *gòwò-hu-heingò*, are faults considered preventable by conscientious shaping from earliest infancy. Standing or walking with the feet turned out, "pigeon toes," is considered just a habit that can be corrected if a child is nagged about it enough. Big feet, on the other hand, are just an unfortunate accident of nature for which a girl must continually endure teasing and taunts.

A major concern about a female's legs is their position—they should be as close together as possible, with no space between the thighs. The community requires this; whether she is sitting or standing, people hate to see a girl's legs apart. Before puberty, little Mende girls go about nearly naked, so they must learn to protect their modesty by keeping their thighs closed. Thus, as soon as a little girl is able to understand, she is constantly reminded by words, slaps, glances, and yells: *Bi gbaė gbėėma*—"Get your legs together!" Train almost any child from early childhood, as any ballet teacher knows, and gradually the legs will be shaped, the tone aligned, the sinews stretched, the balance weighed. As a result of her upbringing, by the time she is a teenager, every Mende girl has closed thighs that brush each other as she walks; and she can for hours effortlessly adopt the posture of the *mbogboni*—seated upright on the floor, legs together, stretched out straight on the floor, arms resting on the thigh.[53]

Mende traditionally are barefoot people and to them feet are almost devoid of distinction. They say, *Numu ėė numu gòò ngi gòò ma*—"A person will not know another person by his feet." Although most villagers do not use footwear, they still require that a person's feet must be clean underneath! Feet are the first to pick up dirt and dust so they are frequently splashed with water during the day; calluses are rubbed away by pumice stones so that the foot surface is free of rough skin in which dirt can lodge. Once smooth and dry, they are massaged with oil. Over the years of bathing, scrubbing, and oiling, well-cared for feet obtain the polished look of glossy parchment, an admired indication of careful grooming and attention to detail.[54]

Skin Color and Texture

Most Mende are dark brown in color, but skin either lighter or darker than the norm has great allure. A copper complexion, described as a point between the usual brown and a fair color, is unusual and very attractive; a copper-colored woman will always be considered beautiful and desirable. Very black skin, completely black, is the most desired and adored. In traditional society, a black person automatically was a celebrity. Mende expatiate, saying: "the blacker the better," "black people are *the* people," "jet black is the most beautiful." They describe the special glow of clean, jet black skin polished with oil, and they love the heightened visibility given to the whites of the eyes and the teeth as they contrast with the black of the skin. The very term for a "black person," *tėli-mò*, expresses this admiration: in Mende speech the word for person, *mò*, leads to the term for "beautifully black," *mòò*, giving a play on words of *tėlingò*, "it is shiny black, beautifully black" (Innes, 1969:88).[55] Black or copper-colored women are sought after by the wealthiest and most powerful men. One paramount chief told me that he always invites such unusually colored women to accompany him to important gatherings because they are a source of prestige and good fortune.[56]

Skin of whatever color must be soft and smooth to the touch, with an even, all-over color. It must be free of infections or eruptions, and have no discolored blotches or spots. In the difficult forest climate, six months of monsoon rain prompt the growth of skin fungus which can disfigure a girl with light-colored blotches. Year-round children especially are prey to irritating insect stings and bites which, when scratched, spread infection and often leave dark scars, a sadly common sight. A mother who wants to protect her daughter's looks must battle against this hostile environment, hoping to prevent these catastrophic threats to beauty. When I commented on one young woman's flawless skin, she replied, "It is thanks to my mother; she always washed me clean."

The Mende word for body hair is *njombo*; this includes any hair on the body surface, and underarm hair. The word also means fur, feathers, hide, any skin of animals. Women should not be hairy; they should have soft, smooth skin. Hair on a man's chest or body may be appreciated, but any body hair on a woman is an undesirable, masculine trait. Opinions are divided about underarm hair; half of the community seems to like it and find it attractive, while others want it shaved off. The choice is left to the woman; and if it grows out full, it will be considered a beauty point for her.

Overall Look

So far, we have evaluated one by one the physical characteristics of a woman. But in life, in person, the individual features are of course seen as an ensemble, with the separate elements coming together to form a whole. Mende are interested in the complete picture, in the proportions and the composition. Most important of all, everything about a girl must "fit together," *mbè-ma*, harmoniously with no jarring notes. Like grandfather's clock, a girl's parts should be about equal in quality; any gross imbalance is truly disturbing. If a girl is plain, let her be thoroughly plain. Should a homely girl somehow be born with a long, serrated neck or develop perfect calabash breasts, her whole look is upsetting. The beautiful thing "doesn't fit," it is "wasted on her." Rather than a bit of beauty improving its possessor, it is seen as a taunt from nature, a grotesquerie, making the girl embarrassingly ludicrous. Alternatively, if an otherwise lovely girl has scanty hair, squinty eyes, a flat behind or big feet, it is a disaster, a bad joke played on her by nature, to have one thing that "spoils" her.[57]

The term Mende use to express their ideal of size and proportion is *yèngèlè*, translated as "delicacy."[58] *Yèngèlè* relates to a small size that is complete and mature; it is a thing as small as it can be and yet "do the job." The *yèngèlè* girl is petite yet rounded and well-shaped. She is graceful, finely balanced, dainty, wispy—a breeze could waft her away (fig. 44). She is the little doll men just want to pick up and carry around; they want to baby her, play with her. She is like a jewel, a tiny thing that is delicate, beautiful, precious. She is adored, admired, and desired.

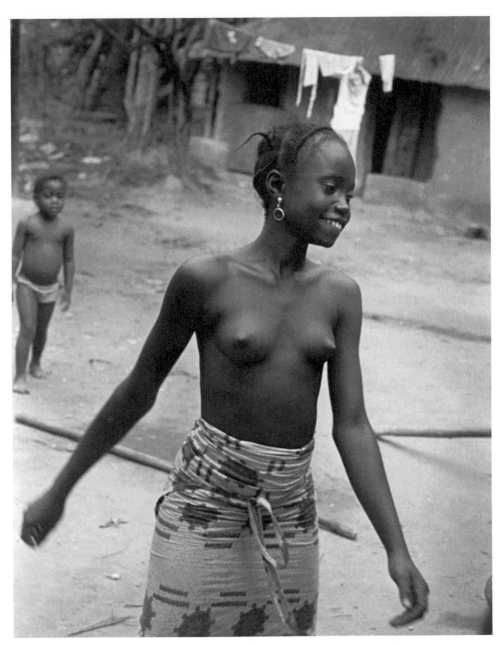

44

BEAUTY IN THE MANNER OF DOING THINGS[59]

Mende beauty is defined first in its physiological terms, in terms of objective reality. "The first fact is that formal beauty is based on a physico-mathematical structure: a measurement, a relationship, a proportion. Beauty as a quality seems to emerge from a certain quantitative threshold" (Memel-Fotê, 1968:52). It is first of all the material mass or volume—abundance of hair, fullness of calves, roundness of buttocks; then color, either of skin (black or copper), or of hair (black), or lips (red). It is also line and contour—flatness of stomach, tapering of fingers, parallel lines of legs and feet; it is relative size, sharpness of outline, all-over harmony of aspect. But beauty is *alive*, moving about in the community and interacting with the world. In many of the criteria of beauty for a particular part of the body, matters of motion were seen to be part of the basic essentials—a smiling mouth, bobbing buttocks, flexible hands. Beyond this, Mende are very alert to movement in everyday life and have clearly defined standards for what is the beautiful, elegant, graceful, pleasing way of performing even the most commonplace actions; pretty is as pretty does.

Standing

When a woman stands she takes care to keep her feet and legs together as much as possible; it is highly improper to hold them apart. Her shoulders should be back, her spine straight. Her hands should be together and the overall appearance should be relaxed yet contained, poised, and graceful (fig. 45). This "good posture," with the body erectly aligned and head held proudly high, is at once the platform, display, and posing-for-pictures position of Mende women. However, it is quite unseemly for a woman to be standing at all, especially in the company of men. Standing is a prominent position, and a woman should rather seek to lower herself when among men. Once a person stands up, all eyes are upon him or her, and it is thought that a woman should not advertise herself. To stand is to be exposed to the public and this is both immodest and dangerous; a woman should not be such an obvious target. If a woman must stand, then let it be behind the men, as unobtrusively as possible. The standing position has further implications in Mende social life. A visitor to a family is expected to sit down; not to do so indicates that one wants more people to come, wants strangers to come. It is considered a challenge and a provocative action if a man who comes with a subject for discussion stands while presenting it. Either of these two unfriendly aspects of standing are certainly to be avoided by women.[60]

Sitting

It follows, then, that a woman must always find a place to sit down in company. A woman will always be provided with a chair or bench; women

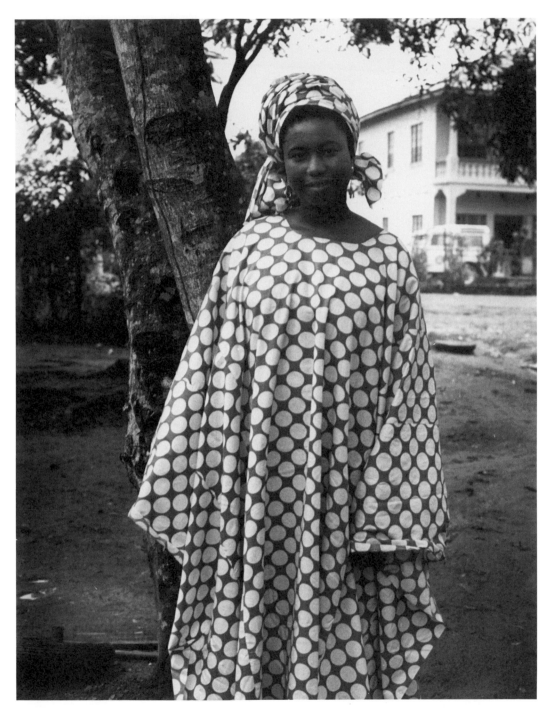

45

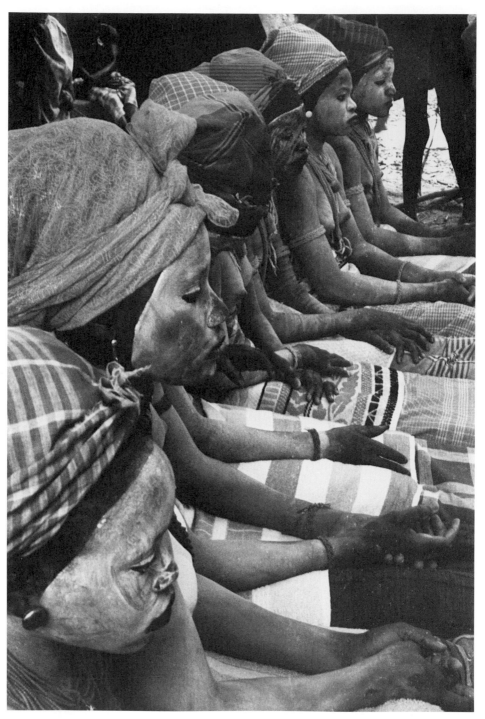

46

are thought to prefer sitting and are meant to sit down more quickly than men. From earliest childhood a girl learns to sit with her legs together, and by the time she reaches puberty she can sit with full feminine modesty. On a chair or bench, no matter how low, a woman sits with her knees and feet tight together. Seated at work, she will tuck her skirt between her legs, covering her thighs completely. On a mat on the ground, she adopts the *mbogboni* posture, a strict ninety-degree angle with her back vertical, legs together and stretched out straight in front of her on the floor (fig. 46).

This requirement that females always keep their legs together gives rise to a number of games and jokes. Little girls internalize all the admonitions of their elders. When they go bathing in a stream, girls vie to see who can sit in the water with legs so close together that water collects in little pools between the thighs and legs, with no space to allow water to flow or seep through. Also, when they play Sande Schools, the girls who imitate the initiates, *mbogboni,* are required to sit with their legs straight, while the girl who is "Sowei" chastises them if their legs should part.[61]

There is a weed that grows along the roadside which Mende have named *gbaa gbèmèi,* "leg closing," because it is thigmotropic. At the lightest touch the leaves close up, which is always a cause for mirth because of its association with the women of the community. A Mende woman reacts to the approach of an outsider by closing her legs. At home with husband or friends she can sit in a relaxed manner; her casual postures are a sign that she feels free with the company. So, to tease his wife a husband will say suddenly, "I see Mr. So-and-so coming up the path," and then laugh as she immediately claps her legs together into the required respectable posture.[62]

Kneeling

As further evidence of their modesty and self-effacement, females lower themselves by kneeling, bowing, or curtsying when approaching their seniors and superiors. These postures of fealty and respect are due every man from his wife and children, every senior wife from the junior wives, every mother from her child, every Sande Sowei from every *nyaha.* Kneeling, *ngombi-gbakpa,* is going down on hands and knees, a position not often seen by outsiders to the culture but still assumed in traditional rural compounds. As a token of their deference, and as a sign of their strict and refined upbringing, most wives will kneel when presenting an evening meal to their husbands or refreshments to a gathering of honored guests. Most often a woman bows down, *mawèlè,* by bending over from the waist and putting her hands on her knees. This is the "attendant" position for listening to an elder, awaiting instructions, receiving assignments and orders. Another kind of bowing resembles a stoop or deep curtsy. This is another posture for making presentations to a senior, whether of a mes-

sage, water, or food. The junior lowers herself at the side, makes the delivery, then remains in that position until told she is free to rise and go.[63]

Walking

A woman's walk should combine the majestic standing posture with a smooth slide from the hips. Legs together and thighs brushing, the foot touches the ground softly and the whole motion is graceful, flexible, but disciplined. A walk is a way of approach, of self-presentation, and thus is an expressive communication. Dragging the feet in the presence of any old person is an insolent act. Walking with legs apart is sluttish, as though one has just gotten up from bed after coitus. Pressing the heels into the ground is coarse.

Generally, however, when men criticize a girl's walk it is on the vaguer ground that "she is walking like a man"—that is, assertively, assuredly, energetically, rather than with feminine languor.[64] Far from wanting to walk "like men," most women use their style of walking as a major way of attracting male attention and admiration. Only in walking does a girl have the opportunity to display her figure fully for the delectation of men, and she makes the most of it. By the way she moves her legs, a girl can make her behind wriggle and bob up and down. The girls even get enjoyment out of it themselves, and are fond of walking while looking over their shoulders to observe their own buttock movements! Mothers complain, to no avail, that the girls are shaking their hips too much and tantalizing men. In this otherwise puritanical society, walking and walk-watching is a sport, a game in which all Mende delightedly participate.

Transporting

In Mendeland, women transport pans and buckets on their heads, babies and bird-cages on their backs. Fine form in head portage requires that the object be maintained in a state of equilibrium on the head of the person by itself, without the hands supporting it (Thompson, 1974:84). "Almost from the time she starts to walk a girl-child imitates the habits of the older children and women in carrying a bowl or piece of cloth on the head" (Little, 1967:115). The pride resides in having the load rest easily on the head with an insouciant countenance that reveals no sign of pressure or strain, then to walk gracefully, smoothly, with the arms swinging free. Indeed, as Thompson observes, "To move in perfect confidence with an object balanced on the head is one of the accomplishments of traditional life in Africa" (Thompson, 1974:96).

Facial Expression

Men adore a face displaying the clarity and shine of youth and health; they love to look at a woman and see a bright visage with sparkling eyes and a smiling mouth. Despite the physical and emotional rigors of compound

and farm life, a girl must always appear cheerful, optimistic, and uncomplaining. Whenever in the company of seniors, a feminine face projects calm, composure, and restraint. The object is to be seen but not heard or noticed, to seem serious but not gloomy or forbidding, sensitive but not demonstrative or vulnerable, sweetly appealing but not obvious.

Females are reminded all their lives to show the world a serene and happy countenance. Frowns, scowls, and pouts indicate a surly personality and are not allowed. Wide grins, laughter, and grimaces of shock or surprise are considered coarse and gauche. These negative facial expressions make even the prettiest face "ugly"; and Mende girls too are threatened that their faces will "freeze" in these distorting contortions, leaving them scarred for life. The girl who wins is the girl who pleases; the girl who pleases is the one able to appear gentle and submissive.[65] (How very different, then, is life in the *kpanguima,* how relaxing and how free! Indeed, Sande makes a special world where for a time women can ventilate their feelings, open up their personalities, take off their masks.)

Looking/Gazing

As Mende love eyes and consider them the most appealing and beautiful of human features, so too they articulate clear canons for the movement and comportment of the eyes. Much of the excitement about eyes is engendered by their action, all the nuances and extensions of the verb "to look," *kpe* (Innes, 1969:57). Through looking, one can touch another person, can project part of oneself onto the other. This ability of the eyes to pierce space and break through boundaries—in a society where rank and respect are of prime importance—calls for control of the way eyes are directed and disposed. Gazing at another person is a definite form of social intercourse and, as such, is subject to myriad conventions and standards.

The way in which a woman disposes her eyes, the way she looks at another, is certainly the single most important aspect of her overall manner. The general expression of a woman's eyes must be modest, restrained, and quiet (fig. 47). An eye that is alert, darting, piercing, is greatly condemned. The eyes should have a certain "innocence," as though they are "not able to read what is going on." A woman tries not to gaze at someone directly in the eyes; a straightforward look is considered belligerent, cheeky. With an elder or a senior person, one looks at the floor; even in a warm exchange, the junior keeps her eyes downcast a bit, open just enough to see the person before her, thereby indicating acquiescence to authority.

"Just looking" is a favorite Mende relaxation. Much of village visiting and socializing is based on simple looking. A man goes to visit his brothers; after exchanging salutations, they both sit and look at each other. He looks at the brother, the brother looks at him; they both look around, *yaun jia*— literally, their "eyes walk around" (ibid.:153). Then they glance back at

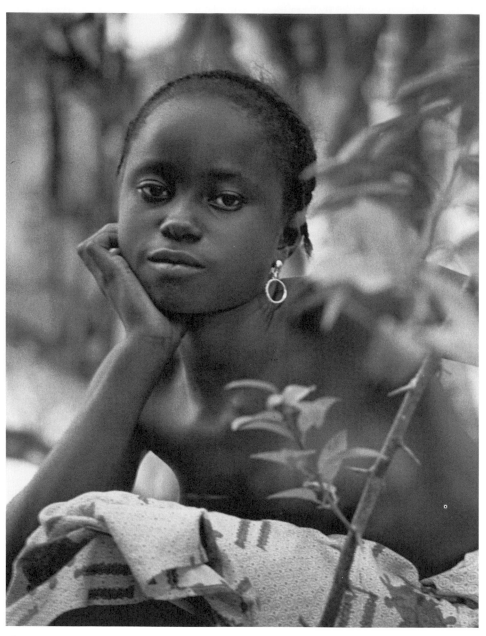

47

each other. There may be nothing for them to converse about, so they "just look." Mende never feel that talk has run out because they are not accustomed to chatting informally with each other. Conversation between people indicates an intimacy beyond the ordinary; they must share some secret and be in private before they can talk freely.[66]

Public "people-watching" is a major form of entertainment. In these stratified, secretive communities where no one dares ask a superior for an explanation, watching is also a principal source of news and information. Everyone in Mendeland watches everyone else; one is never alone and unobserved; there is always someone nearby taking note of one's behavior. Watching is done in public, but it is somewhat of an illicit act. Since looking forthrightly at another is a breach of etiquette, or even a social crime, every individual in the community adopts a personal set of dodges and ruses by which he or she can take in everything that is going on without appearing to do so. That is, he must observe all without being observed observing. This sounds complicated, and it is. It is also great fun and a real challenge. Children are allowed to be wide-eyed as long as they are closed-mouthed. Young bachelors, though, have to develop clever tactics if they are to feast their eyes on the women's charms without being caught doing so. Ah, Mendeland—place of peeking, peeping, prying, and spying; home of clandestine ogling, veiled observations, shifting focus, averted eyes, darting glares, shielded gazes, stolen glances, silent witness!

ASPECTS OF BEAUTY

Beauty as a concept in Mende thought operates on three planes of existence—in the world of spirit, in the world of nature, and in the life of humans. The spiritual and the natural are seen to establish the standards and values of the human experience. *Tingoi*, the spiritual notion, is the mystical ideal to be yearned for but never attained. *Nèku* is a description of the beauty of the natural world around us. *Haenjo* is the person who in her appearance most approximates the canons of perfection.

Beauty as an Ideal: *Tingoi*

Tingoi is a water spirit "which is said to assume the form of an exquisitely beautiful woman, and is therefore supposed to be a mermaid" (Harris and Sawyerr, 1969:41). There is no one more beautiful than *Tingoi;* rather, she is the starting point of beauty, and she is the standard. Her habitat is the holiest of domains, deep waters out at sea or in big rivers and ponds. *Tingoi* is a vision that appears dazzlingly and fleetingly to only a favored few. Those who claim to have seen her report that she has long, black, shining hair, a fair complexion, and a long, lined neck. Some say she has a pointed nose, small, sharply outlined lips, glistening, bright eyes, a smooth, glowing forehead, and succulent breasts.[67] The rest of

her body is in the form of a fish, or alternatively, of a python.[68] If a Mende woman has long, thick hair, people compliment her by saying, *Ngi wundei kè tingoi,* "she has hair like *Tingoi.*" If she has a long, segmented neck, they say, *Ngi gole kè tingoi.*[69] *Tingoi* is considered more beautiful even than Sowo, also a water deity. Hence, on the spiritual plane the dream fiction of *Tingoi* transcends in loveliness the man-made, thus limited, reality of Sowo.[70]

Tingoi as an image presents interesting problems to a student of Mende art and iconography. The mermaid is a popular subject for sculptors, yet images of it are almost completely ignored by art historians, researchers, and collectors.[71] Mende sculptors frequently carve statuettes of *Tingoi.* In my experience, if someone decides to commission a work, he will suggest a *Tingoi* figure because it is "beautiful." Further, in a land where almost all artistic expression is under the control of the *hale* associations, "*Tingoi* is free," Mende say; anybody may happen to see *Tingoi* and any artist can depict her whenever and however he likes. *Tingoi* is carved as a statuette in wood, standing about 18″ to 24″ from the base, dyed jet black and polished to a high gloss. *Tingoi* usually is portrayed as a creature female from the waist up, fish from the waist down; she has small, sharp, regular features, long flowing hair, a ringed neck, full shoulders and arms, and an ample bosom. The fish body is usually carefully incised to give the look of individual scales. In one hand she holds a mirror, in another a comb. Sometimes, instead of the mirror, she is holding a child or playing with snakes. *Tingoi* is in the public domain, a mystical being whose image circulates throughout the community, fulfilling its canons of beauty but flouting its moral strictures.

Kenneth Little in his ethnography of the Mende (1967) and Harris and Sawyerr in their work on Mende beliefs (1968) all tell about *Tingoi.* The basic tale explains the iconography of the representative *Tingoi* figure. It is agreed that *Tingoi* is a water spirit who appears in the form of a sublimely beautiful woman. She comes from the water's depths to sit on a rock and admire herself in the mirror as she combs her long, flowing hair.

> She is said to have a regular habitat and always appears on the same rock in the river. If however she takes a fancy to a man who surprises her, it is believed that she usually leaves her comb behind. The intruder may then pick up the comb, but on taking it home, must keep it out of everybody else's sight and reach. The spirit is then said to appear in a dream to the man who picked up the comb to plead for its return. The finder must, in response, strike as hard a bargain as possible, by demanding a rich ransom for the comb; but he must never return it. The spirit will then, it is claimed, bring the man concerned considerable wealth. As the comb is not returned, the visit is repeated several times, and a wise man must ask a bigger ransom each time; but equally he must never return the comb. It is claimed that if the comb ever happens to be returned, the man concerned might die or suffer extreme poverty for the rest of his life. [Harris and Sawyerr, 1968:40]

Expurgated from the text is *Tingoi's* sexuality. Her visitation in a dream is also occasion for coition. *Tingoi* is not limited by gender: as she appears to men and women alike in the day, so at night she fulfills the sleeper's erotic desires. Mende say there is no beauty without carnality; there is no beauty on a pedestal; there is no beauty which is unapproachable. One point about beauty is that it attracts, makes us desire closeness; and since beauty, like *Tingoi's*, is meant to bring joy not bitterness, it must somehow be an obtainable end. Equally earthy is the image of celestial beauty connected with notions of sudden riches. Not the slow, steady accumulation of assets and wealth earned through toil and stewardship; rather, this resembles a spin-of-the-wheel and then a rush of financial reward overnight—the insider's stocktip, the lottery, the sweepstakes, the bag of hundred-dollar bills accidentally found in the trash.

Tales of *Tingoi* abound in Mendeland; the mermaid is a figment of the imagination, "a story Mende like to tell." *Tingoi* acts in part as a parable in the Mende community to account for sudden good fortune: a windfall of unearned money needs to be explained to these sober, hard-working people. The answer is *Tingoi* coquettishly leaving her comb behind for a man who appeals to her and his skillfully manipulating her emotions to obtain for himself a "rich ransom." Alternatively, in the familiar chronicle of rags to rapid riches then back to rags—ah, well, the wretch mistakenly returned her comb. *Tingoi* is the stuff of dreams, beauty bringing fantasies of love and riches, of fortune and secret satisfactions.[72]

It is in water that Mende women seek beauty; *Tingoi*, the quintessence of beauty, is immersed in water and emerges from water. Queen of the deep, she is all that the mind can imagine as most beautiful; she has an ethereal, mystical aura of absolute beauty that no mortal can hope to obtain. Every human woman is compared to *Tingoi* and is found lacking. For *Tingoi* is all the beauty the human eye can see, extended by the imagination to supernatural dimensions, only realized in a water paradise of fulfilled ideals.

Beauty as a Process: *Nèku*

The sublimely beautiful mermaid *Tingoi* exists only in the spirit world, the world of the unseen; she can be imagined by the artist or glimpsed as a vision, but because of being etheric she cannot be held, contained, or referred to when needed. She is elusive, subject to hearsay and individual interpretation, and, as a figment of the Mende imagination, is essentially a human creation. So, Mende savants tell us, we need to look around within the culture's concrete environment to find an item of beauty that can serve as a tangible standard. Anything that is only man's creation is a copy of a more permanent thing in nature. There is a pattern somewhere which man tries to copy; that pattern is made by God and is a reflection of an eternal ideal.[73] We need to find that item which represents Beauty, which is the concept of Beauty made incarnate "dwelling amongst us," so that we

can see it, touch it, and so that it can inspire us to apply its lessons to our own lives.

Indeed, this encapsulation of Beauty does exist in the item called *nèku*. As a noun, *nèku* is a young shoot, a sprout; as an intransitive verb referring to plants, it means to sprout, to come up; about things, it means to be smooth, shining (Innes, 1969:99). A whole range of object, action, and state of being is expressed in this one word.[74] *Nèku* is the tiny shoot that pushes its way up through the soil as the first life of the plant. *Nèku* is the newest, tenderest young leaf that shows itself at the central growing point of the plant. *Nèku* is the flower, blooming in an efflorescence of life.

The *nèku* leaf attracts admiration and attention. When I asked, "What is beautiful among plants?" people answered *"nèku"*—not any particular plant, but that young, growing leaf that *all* plants have. There is beauty in the meadows: Mende love a flower or a field of blossoms; although they do not pick them or decorate their houses with them, they nonetheless cherish them as extreme beauty. Their softness and fragrance and color are delights that Mende like to see and walk among. There is beauty at the farm: when rice is young and the whole plant is delicate and a brilliant lime green, each leaf still fresh and shining—at that moment it presents a tableau Mende gaze at in loving satisfaction as the most pleasing of sights. Mende adore the *nèku*: "We like to see it; it gladdens the eye."

In a culture whose intellectual training revolves around botanical study, *nèku* is *tifei yee nèkui*—"the *new* leaf *of* the leaf." A plant with *nèku* quality is the most desirable/useful/beautiful; *nèku* is the part sought for any purpose whatsoever. The *nèku* leaf is young, so it has the most life. A tiny shoot of grass has the force to crack through a concrete sidewalk—a visible sign of the surging power of new life. As soon as the practical Mende see a new leaf, they think of two things: food and medicine. When women go to farms and forests every day to gather greens and herbs for cooking, they look for a *nèku* leaf, whether of cassava, potato, or other vegetable, thinking *nèku* tastiest and most nutritious. When herbalists and healers go into the forest "to bring leaves," *tifei gbua*, the leaves they are looking for are *nèku*, thought to have the greatest therapeutic properties. A *nèku* leaf has vitality flowing through every fiber, a youthful energy that the healer seeks for all the sick. This element of the concentration of the essence of life itself is a part of *nèku*. As life recedes so *nèku* fades, and the thing becomes *wova*, old, or *ndogbo*, withered.

The word *nèku* is confined to flora. To speak of human beings, Mende say, *ma-nèku-ngò*. By word division this is literally "on-*nèku*-it is," meaning to be shiny, to make shiny, to become shiny and smooth (Innes, 1967:79). The opposite of *manèkungò* is *ma-gole-ngò*, to be dusty, dull.[75] *Ma-gole* is dirty and drab, while *ma-nèku* is clean and bright. In the course of her daily work of farming, cleaning, and cooking, a woman becomes grimy and sweaty, *magolengò*. Then she goes to the stream to bathe, and she emerges

manèkungò. She may not know what makes the young leaf shine, but she uses oil on her clean skin to copy that youthful glow. The Mende woman will say, *Gbèè ngi nya yama nèku a ngulo wo*—"Let me put a little oil on my face to make myself *nèku.*" We put on clean clothes and jewelry to create *nèku* on ourselves. We paint the house, varnish the floors, polish the furniture and our shoes to make them *manèku,* to bring them up to the *nèku* standard. *Manèkungò* is the achievement of cleanliness, freshness, newness, youthfulness, with all its wholesomeness and vitality summed up in its brightness and shine.

Nèku is, emphatically, one of the core concepts of Mende aesthetic evaluations and strivings. The *nèku* leaf is bright and clean, fresh and new, its surface tender, smooth, and moist. It attracts us, makes us want to approach it, imitate it in our own experience, and try to recreate it all around us. Mende elders explain that we live by the eye, and that sight is the sense that first draws our attention to a thing. The eye quickly turns from a thing *magole* to a thing *manèku.* *Nèku* "satisfies the sight"; it is essential to sight; we notice the flower and the jewel.[76] Mende want this brightness and heightened visibility, this "eye-attractingness," so they strive to make themselves and their surroundings *manèkungò.* *Manèkungò* is the *process* and the *accomplishment* of approaching in human experience the qualities of wholesomeness and beauty incarnate in the *nèku* leaf: rejuvenation, repristination. *The* nèku *leaf is the thing which God has put in the world for us to see and admire and emulate.* Its great worth and usefulness shine forth in beauty.

Beauty as a Person: *Haenjo*

Beauty in Mende thought is found in the feminine. Being beautiful is part of the definition of what it means to be a Mende woman, and we have surveyed the woman's lifelong preoccupation with creating beauty in her person and in her surroundings. The female human being who epitomizes all that a person can achieve in beauty is *haenjo,* the Mende girl at the completion of her initiation into Sande. Just as *nèku* is not a particular plant but the most beautiful moment in the cycle of the plants' life, so *haenjo* is not a particular young woman but is the most beautiful moment in the cycle of a woman's life (fig. 48).

"If you are not beautiful on the day you are *haenjo,* you will never be beautiful." On the day she is presented to the community as a polished young lady, a Mende girl is as lovely as nature and art can make her. Queen-for-a-day, the most-beautiful-girl-in-the-world, the bride-on-her-wedding-day—all eyes are on her, and all the yearnings of her people. The *kpanguima* is a kind of finishing school, and the result of the months of nurturing and training is a belle round and sturdy yet graceful and poised. She has learned to sing and to dance and to cook; she has learned etiquette and proper comportment. She is congenial, charming, knowl-

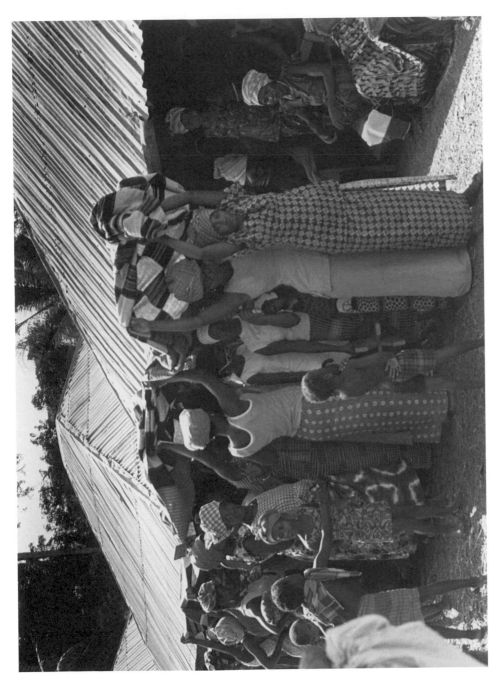

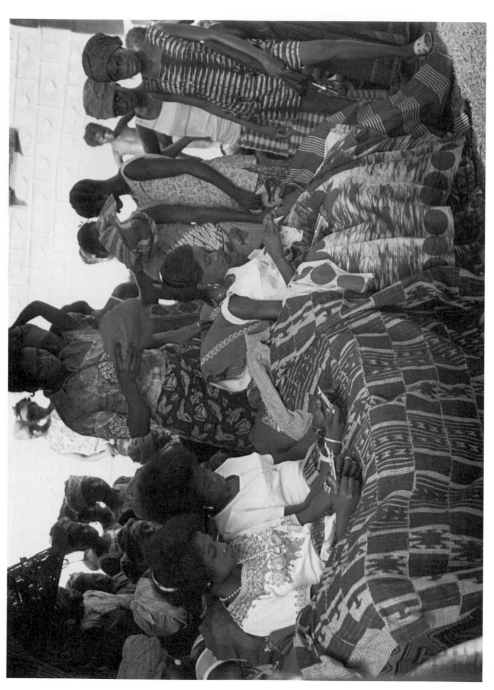

edgeable; she now ranks among the *nyaha,* and for the days of her coming-out celebrations she is treated like a chief (figs. 49 and 50).

Little describes the ceremony:

> The day on which the newly graduated members return to daily life is one of great rejoicing, which parents and relatives and all concerned share and celebrate. This also marks the final transition of the girls into full womanhood. They move in procession from their temporary camp, headed by the officials. The whole row of girls is covered by a canopy of large, good-quality country cloths which are held high over them by parents and older members of the society. In the old days, the girls would have been profusely decorated with jewelry and smothered in oil to make their skin glisten. Nowadays, as already mentioned, it is a point of honour for a mother to turn out her daughter in the latest modern style. Alongside the procession dance various "spirits" of the society impersonated by officials wearing masks. When the town is reached the girls remain for a time in the town *barri* receiving the gifts which their friends and suitors bring them. Afterwards, each girl goes to her mother's house where a large chair has been placed like a throne for her, and there she sits in state for a time in all her finery. [1967:128]

Haenjo is every girl's attempt to fashion herself into loveliness. Recall that Mende hold clear ideals of beauty. If we go back to *Tingoi*, the mermaid, she is imagined as possessing and displaying the most exquisite female looks. Through this story Mende affirm that they do not expect perfect female beauty in this human life on earth, that perfect beauty is divine, unearthly, from paradise, and thus can only be imagined.

But Mende still long for the ideal, even just some piece of perfection, some small part. Consider one feature of feminine form—the hair, *ngundia.* We have said that judgments of hair are voiced in terms of quantity. When I asked Sowei Z. L. to tell me the properties of good hair, she called over a young girl with a luxurious head of hair and asserted, *ngundingò*—literally, "it is hair," *that* is hair.[77] The statement "it is hair" means that it has the ideal qualities of hair. Mende say hair should not be "dry" (short or thin) and it should not be limp or too fine. When hair is the way it *should* be, long and strong and thick, it is simply *hair.* The Platonic tone of Mende aesthetic thought is evident here.[78] An idea, a mental picture of what hair should be like, exists. This *ideal* is regarded as the *real thing,* while any hair that does not come up to the ideal is considered an aberration, a poor substitute, a failed attempt at materialization of the concept of Hair. Thus, when hair does meet the criteria, it is simply the thing itself manifested and made visible.

Of a woman's hair Mende also say, *Ngi ngundingò*—literally, "*she* is hair." This means that she has managed to manifest the idea of hair and make it visible. Her hair meets all the criteria so *when you have seen her you have seen hair.* As the girl develops in adolescence, she is scrutinized by the community to see if she will make the ideal materialize for its delectation. When

this happens, there are ripples of pleasure in the community. A beautiful head of hair can make a girl famous and earns her the name of *Ma Ngundia* —"Miss Hair." In recognition and appreciation of their gifts, it follows that in the village there are young women called "Miss Eyes," "Miss Breast," "Miss Buttocks."

Again on the subject of hair, Mende only use *ngundingò* in reference to a woman. Because a man's hair is shaven or cut close to the scalp, people say that "men don't have hair." Beautiful hair thus is a distinctly female trait; the more of it, the more feminine the woman. This polarization of attributes by sexual label is at the core of Mende aesthetic evaluation. In a way, the "further away from" a man's appearance a woman is, the more beautiful she is considered. So, while a man's hands are tough and strong, a woman's should be soft and dainty; a man's eyes are red and quick, a women's clear and slumberous; a man's walk is firm and fast, a woman's saucy and sinuous. A man must look aggressive and fierce, while a woman's countenance should be smiling and sweet.

The lessons the initiate has learned in the *kpanguima* are lessons for life; they are Sande instructions on how to find joy and fulfillment in her role as a woman. The highest lesson in beauty is the final ritual bath when the girl washes off her body the clay dust of her seclusion and ordeal and then massages herself all over with perfumed oils. This bath is performed in common with her sodality sisters and the senior women of Sande; from the waters like Sowo, like *Tingoi*, she arises in full glory finally transformed into a beautiful *nyaha*. Later, for the rest of her life, she will perform the same ritual personally, daily going to the stream after the day's labors to wash away the traces of toil, to put on herself *nèku*, freshness, cleanliness, to make herself anew in the image of *haenjo*.

Beauty and Goodness

Mende expect women to be beautiful, graceful, delicate, curvaceous, pretty, clean, fresh, perfumed, groomed, adorned. And Mende expect women to be good, kind, sweet, patient, gentle, modest, loving, helpful, cheerful, honest, understanding. A beautiful girl must be a good girl, and goodness alone can make a girl beautiful. The Mende word *nyande* means both to be good and to be beautiful, to be nice—character, looks, and comportment refracting and overlapping. In any discussion of the physical aspects of beauty, before very long somebody would say: "but no one can be beautiful if she doesn't have a fine character." If I could make any distinction in the answers it would be that older men were the most precise and detailed in their descriptions of the physical, while older women held that comportment and character are more important. And so the Mende community, like all human societies, struggles to harmonize the short-term physical desires of the men for sexual contact with the longer-range goals of the women for family life, and with the sustained goals of the community for progeny and prosperity (fig. 51).

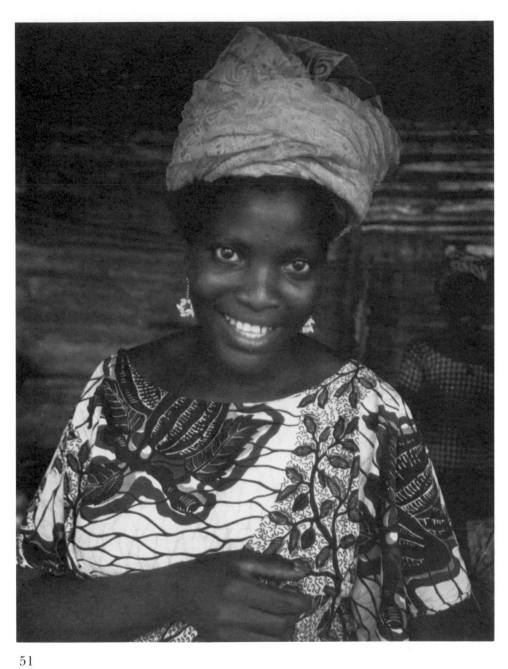

51

Toward these wider ends, older women train young girls in good behavior, discipline young women to their serious responsibilities, and themselves serve as examples of high morals and ethical behavior. In the larger sense, the mind of the Mende is concerned with questions of ethics and morality; the guiding ideology is moral rather than religious or scientific. The *hale* formed by the Mende all have in part or full the intention of upholding the moral standards of the community. Considering this overwhelmingly moralistic cast to Mende thought, it is no surprise that beauty, too, is judged for its goodness.

The dangers of beauty are an outcome of its extraordinary impact and power; a beautiful girl can become arrogant, her pride turn to narcissism. One oft-told tale on the subject of beauty concerns a chief's daughter who is the most beautiful girl in the land.[79] When it comes time for her to marry, she declares she will marry only the most handsome man, one as good-looking as herself. Her father brings her proposals from wealthy, important men of the area, but she refuses them all. Then a most handsome man, resplendently dressed, presents himself at the chief's court. After inspection he is found to be perfect in every detail, without scar or flaw. The girl welcomes him as her husband, only to discover in the marriage chamber that he has removed his disguise of physical perfection and has resumed his true form of an *ndili*-python.[80] She cries out for help but is ignored, as the serpent swallows her whole. Here, the perils of youthful willfulness and the misuse of attractiveness conferred by beauty connect with implications of nonproductive autoeroticism.[81] The punishment for such social crimes is violent death, the python doing the job of removing the offender from the community.

Beauty is closely inspected all the time to make sure it is good. Mende fear that beauty will blind the eye to some evil that hides within. Many beautiful women resent the fuss made about them and feel they are unjustly harassed and harshly treated. Their beauty serves to draw attention to them and excite added criticism from their superiors. People seem to expect the best but fear the worst. Lovers may be tough with her, declaring that the girl may have used her looks to impress other men, but that *he* is not going to be taken in. Others feel bothered for minor infractions interpreted by their families as signs that they may become lazy or irresponsible and try to slide by on looks alone. One woman expressed bitterness about all this. She was nagged and punished all her life, she complained. Though she lived in town and was a bright pupil interested in a career in nursing, missionary teachers made her marry very young for fear that she could not resist urban pressures and would become a concubine or a prostitute. "This beauty, this beauty, what did all this beauty ever get me!"

A more positive illustration of Mende reflections on beauty lies in their interest in transcendence of the physical to an even greater *nyande* through art. Mende declare that any girl with a beautiful voice is a beautiful girl: she

may be quite ordinary to look at, but if she can sing well she will be considered lovely by any man in town. As we have already observed, "Beauty as a quality seems to emerge from a certain quantitative threshold" (Memel-Fotê, 1968:52). We have seen how it works in physiological terms, but it also seems to apply to what Mende call delicate, *yèngèlè*, performances: artistic activities depending on wit, skill, talent, dedication, practice. Everybody in a Mende community is taught the rudiments of musical performance, singing, dancing, playing an instrument. But when a woman goes beyond the ordinary to become the soloist, not the chorus, this transcendence of the ordinary is called Beauty, and transfigures its owner into an Object of Beauty, a beauty that has all the allure and impact of physical beauty, and is even on a higher plane because it is derived from the "goodness"—pleasure-giving, group-forming—of fine performance.

Mende assume that a beautiful exterior enshrines the most useful something. It is a big disappointment for something to be beautiful to look at but not good, not useful, not fine. A "good thing" must be efficacious, do its job well. Part of the goodness can only be judged in its performance of the task for which it was created or fashioned. A good thing is utilitarian and is well-suited to fulfilling a useful purpose. In almost every discussion of beauty, someone would say how awful it is if a pretty girl is lazy or does not have a fine character. Mende call this *nyande gbama*, empty beauty, *gbama* meaning "for nothing, in vain" (Innes, 1969:17). *Nyande gbama* refers to many of the functional and moral issues. It is *gbama* for a good-looking girl to be rude, insolent, disrespectful. It is *gbama* for her to be nonfunctional in the community: "She can't work, can't cook, can't dance, can't sing—of what use is she?" It is *gbama* to be poor, of low status, living in coarse company although because of your looks you would be welcomed among those of refinement and prestige. It is beauty wasted. Beauty without a dimension of goodness is hollow, without substance, a deception.

Certainly the most serious *gbama* is barrenness. There can be no more horrible deception than that the beautiful girl—so sought after since childhood, so fought over by relatives, Sande, and suitors—should, finally married, prove incapable of having children. It is a blow to the community, a vile mockery of all that they hold sacred. Beauty, in Mende thought, "is required to aid, it is called upon to participate and is a participant in the efficacy of the object.... The more beautiful the object, the better it accomplishes its affectively desired, imaginatively dreamed, technically hoped-for effect" (Memel-Fotê, 1968:57). The irreducible, primary function of a woman is to bear children (fig. 52). For beauty to be associated with sterility brings sad musings of "how can beautiful people not be good."[82]

If we look closely at the Mende words for beauty and goodness, we will see them overlapping, intersecting, and blending into a Möbius strip of meanings. *Nyande* is the word for beauty and *kpekpe* is the word for good-

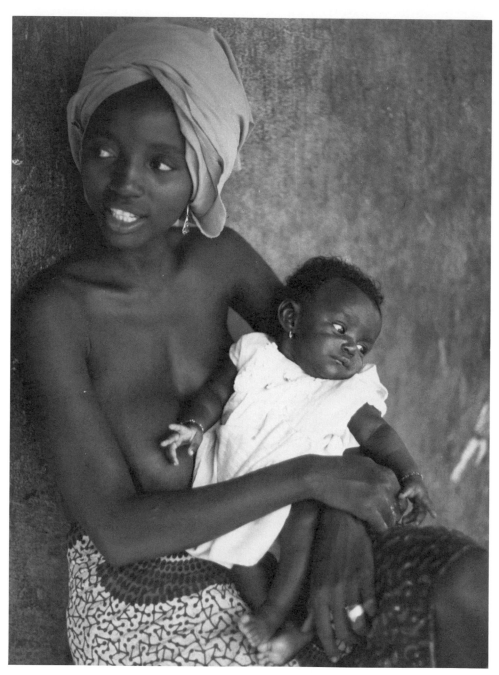

52

ness.[83] *Nyande* can go off in the direction of describing the physical, the external, so it relates to prettiness, desirable body shape, admirable skin, hair, or eyes, and other physical attributes. In speaking of any one of these features for each of which there is a definite canon of beauty, *nyande* stands for the fulfillment of that canon. Thus *nyande yama*, "beautiful eyes," means the eyes are big, round, prominent, bright, and expressive. *Nyande nyini*, "beautiful breasts," means the breasts are low, firm, thick, covering the entire chest area; and so on.

Kpekpe relates to worth in the utility of objects and the behavior of human beings. For instance, *kpatoi kpekpe-ngò*, "the cutlass is good," means that it is comfortable to hold, useful to work with, performs well the job for which a cutlass is designed. Also, though, it is nothing else but a cutlass, doing the cutlass job.[84] When referring to people, the goodness of *kpekpe* means a person is kind-hearted, helps you, gives you gifts. As with objects, this is an appreciation based on the disposal of the object or the person to offer its services for your benefit.

In talking of objects, *nyande* can also express utility. However ugly-looking a cutlass may be, Mende can also say, *Kpatoi nyande-ngò*," meaning that the cutlass is beautiful because it is indeed a cutlass, a functional object, and not just a piece of useless, worthless junk. In a way, the two words are interchangeable; however, *nyande-ngò* is a more gentle use of the language. *Nyande* is also broader, implying that the thing in question is comprehensively good, and includes a positive evaluation of both its looks and its usefulness.

When describing human beings, at a more abstract level, the two words converge at a point—the point of kindness and generosity. *Ngi kpekpe-ngò* —"He is good, he is *kind*, he is *generous*." *Ngi hinda nyande-ngò*—"His ways are fine, he is *kind*, he is *generous*." At the highest level of Mende conceptualization, beauty and goodness meet to express a sympathetic interest in the welfare of others and a warm-hearted readiness to give.[85]

Beauty as a Historical Fact

As beauty is physical and metaphysical, it is also "an historical fact."[86] By interviewing some thirty persons over the age of sixty-five, each of whom had been trained by an old grandmother or aunt, I was able to obtain information about beauty in a time span of about one hundred and twenty-five years. It was quickly evident that a young girl in 1885 was judged by the same standards as her counterpart in 1985! If Mende canons appear to have been so static for such a long time, I do not believe it is due to isolation or xenophobia. Although Mende culture has matured in small rural farming communities, like all West African peoples, Mende have extensive contact with neighboring groups. Since the people with whom Mende have mingled hold to similar views, ethnic interaction has probably served only to reinforce the existing Mende standards.[87] And, since beauty is

body-based, and since all bodies resemble each other and the same features constantly recur over time, they are seen to have the permanence of nature itself as a manifestation of God.

Properly speaking, Mende people were never colonized (they were governed by the British as a protectorate), and they do not feel themselves the victims of cultural rape. The British colonial presence and its exploitation of mineral and farming resources served in part to introduce a number of innovations into Mende life that offered a new set of opportunities and challenges. Through it all, beauty, as an aspect of the "absorptive" Mende culture, managed to pick out what it needed and thus enhance the aesthetic qualities that are valued. So now for the first time beauty can be faked by makeup or flattering clothes. Short, thin hair can be augmented by hairpieces and covered by wigs, a flat chest enlarged by falsies, a fallen bust line uplifted by a brassiere, brows thickened with a pencil, and a healthy glow applied with makeup. Islamic styles for women made popular by *haja* has meant a beauty of clothing and adornment rather than of face and body; these voluminous robes, veils, and jewelry give older women more opportunity for glamor and elegance.

When Mende say that "before" beauty was "natural," they are saying several things. The remark goes back to a time when a virgin stood naked before the criticisms of the community, then the sole arbiter of taste but now only one of several. The release of many girls from this evaluation marks the outside influences that have brought upset to all sectors of Mende life. The vast majority of Mende girls who live in the villages still maintain the same life-styles, but town girls, schoolgirls, and the chiefs' daughters are freer, less subject to the decisions of elders. Among the elders themselves, before, a woman in her fifties or sixties was sought after as a love-partner only if she had the prestige of being an artist or a Sowei. Now another group of mature women has attained social prominence and sexual desirability: the rich wives and mothers of the new political and governmental elite, whose prestige is based on money rather than, as it had been for women before, on service to the community (fig. 53). In Mendeland, as elsewhere in the world, "beauty changes."

Notes

1 Stendhal [Marie Henri Beyle], *On Love* (Garden City, N.Y.: Doubleday & Co., 1947), p. 82.

2 In the West, only the beauty of flowers is absolute and incontestable; people, on the other hand, are too flawed. Enjoying a "botanizing" stroll through the galleries of the Metropolitan Museum of Art in New York City, A. Hyatt Major stated: "Flowers, you will find, are the only subject for art that people have always thought beautiful. In contrast, men and women, art's most frequent subject, seem masterful, seductive, demented, majestic, beaten or sparkling, but rarely beautiful" (see his "Introduction" to the Museum's 1978 datebook).

3 Advertisement for the Allentown Furniture Company, Sierra Leone Broadcasting System, April 1977.

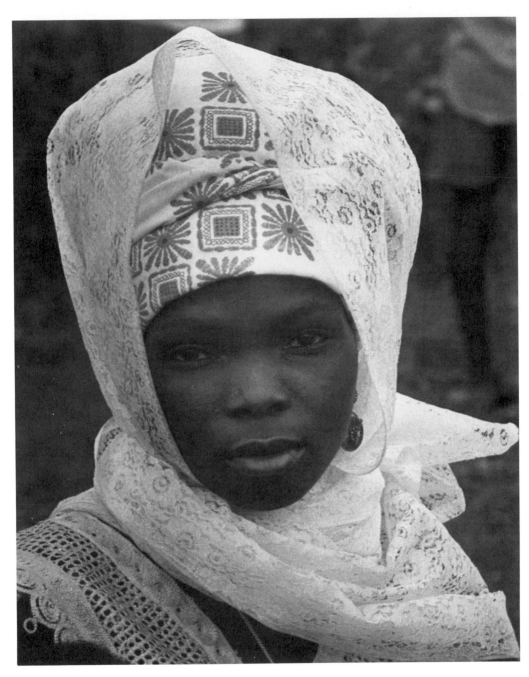

53

4 The keyholders of the luxurious Cape Sierra Hotel were in the form of a woman's head, rather like the Sande mask but more naturalistic. The carver, Patrick Foray, explained he made them thus so they would be "nice" (Freetown, July 1977).

5 Telu preceptor, February 1977.

6 Discussion by Bo preceptor, March 1977.

7 Based on interviews with eight women considered by Mende as extraordinarily beautiful; interviews conducted in Freetown, Bo, Njala, Telu, and Lungi, over the year February 1976 through February 1977.

8 Telu preceptor, February 1977.

9 Mme. K.D., Freetown, March 1976. Outsiders are astonished to see even a four-month-old baby "dolled up," with powder, eyebrow pencil and eyeliner, lipstick, and nail polish, wearing earrings, bracelets, necklaces, and ribbons.

10 This ability of a mother to cash in on the male weakness for beautiful female children prompted a "secret/trick" true story from my bawdy friend from Njala, Mme. Boi. Desiring some extra income but having no little girl around to use as bait, she decided to disguise her baby son. With his hair braided and his face made up, he was so cute that Mme. Boi was able to convince a generous farmer from a neighboring village that this darling infant was a girl. Every month or so the unsuspecting man would send her some nice token present. To the response of gales of laughter from the crowd, Mme. Boi ends the story by imitating his amazement and horror when, on a visit one day, juggling and petting his baby-bride-to-be, he chanced to feel its male genitalia (May 1977).

11 See the Sierra Leone historian, M. C. F. Easmon, "Madame Yoko, Ruler of the Mendi Confederacy," *Sierra Leone Studies* (December 1958), pp. 166–67. Madame Yoko ruled as a supreme paramount chief of the Mende from 1885 to 1905. Easmon recounts that she "started her own *Sandi Bush* [school] and it became famous in Mendiland, so much so that mothers strove to get their daughters admitted to Yoko's bush, and, at the height of her fame when she ruled all the Kpa [Southern] Mende, to enter her Bush was locally the equivalent of being 'Presented at Court.' She selected all the best young girls for her Bush and then disposed of them in marriage to the leading men who would help her own advancement" (pp. 166–67). After the death of her husband she was appointed ruler. Madam Yoko "steadily enlarged the extent of the territory she ruled, so that after her death the unwieldly Kpa Mendi Confederacy had to be broken up into its original fifteen separate chiefdoms" (p. 167). For further discussion of Mende female rulers in relation to the Sande Society, see Carol P. Hoffer, "Mende and Sherbro Women in High Office," *Canadian Journal of African Studies* 4, no. 2 (1972):151–64. Mme. Gulama's story has yet to be recounted. She has been a prominent and controversial figure in Mende chieftancy and Sierra Leone national affairs since the 1960s. She is mentioned in Hoffer (1972), pp. 152, 157.

12 Diamonds are the principal export of Sierra Leone, accounting for 62 percent of its foreign earnings. A considerable portion of Sierra Leone diamonds are of gem quality: the huge stone in the scepter of the Queen of England is a Sierra Leone diamond, and the "Star of Sierra Leone" is on display at the Smithsonian Institution in Washington, D.C. A large part of Mendeland is diamondiferous, and since the gems are found in alluvial (not deep mine) deposits, it requires only a minimum of investment in equipment to pan for diamonds. For the history of the Sierra Leone diamond rush, still going on today, see H. L. van der Laan, *The Sierra Leone Diamonds: An Economic Study Covering the Years 1952–1961* (London: Oxford University Press, 1965).

13 Sierra Leone farmers grow profitable quantities of high-quality, high-priced, flavor-bean cocoa and coffee.

14 "This is one of the main reasons why chiefs and other big men in Mende society usually have more wives than have commoners. It is the custom for persons who hope to gain

the chief's favour or to have a grandchild eligible for the chiefdom, to present a daughter to him. If he refused the offer, or did not add to his household from other sources, a chief would gain the reputation of being either a very mean or a very poor man. His political prestige would suffer and he would run the risk of losing the respect of his followers" (Little 1967:141). For an earlier reference, see William Vivian, "The Mendi Country and Some of the Customs and Characteristics of Its People," *Journal of the Manchester Geographical Society* 12, nos. 1–3 (1896):1–34. "I have heard the young [Mende] Romeo chanting aloud the charms of his Juliet, and making his clearing ring with the description of her beauty . . . but their tender yearnings will be utterly disregarded if it be thought that in the family interest 'my lady fair' should be wedded to another. Powerful chiefs have a practical monopoly of the youth and beauty of the country; in the turbulence and uncertainty of their life, the timid and poor have no surer way to bid for the protection of the strong chief than by spontaneously presenting to him the flower of the family to wife. There appears to be no regulation as to the number of wives a man shall possess" (p. 25).

15 I also asked what is considered beautiful among birds, trees, animals, plants, and such. The answers were decidedly dull (my Bo preceptor suggested testily that I ask at the Ministry of Agriculture!); so I asked my assistants to enquire in their communities; but again, no really exciting information. In fact, it would appear that the only nonhuman female "thing" which Mende exultantly find beautiful is the young rice farm at the time when the plants are strong and growing high but still of an extraordinary acid/lime green color. Then it is the epitome of *nèku*, natural beauty, to be discussed later.

16 In this discussion I refer to girls, though much the same care is given to boy babies. It was continually explained to me that treatment was the same "except more so for girls."

17 Comments on the physiognomy of a child's head are common. Even to point out a lump or say the ears are a funny shape causes hurt feelings, and if the remark passes between male child peers, it leads to fisticuffs. A West African, Bernard Sacré, told me "philosophically" of the many times a cranial bump had caused him to have a fight "to defend his head" (New Haven, April 1975).

18 I am grateful to the painter and sculptor Tom Feelings for sharing this observation with me.

19 Telu preceptor, Bo preceptor, and numerous informants.

20 Mr. J. B.-G., Freetown, February 1976.

21 I am grateful to Susan Vogel, Director of the Center for African Art, New York City, for making this observation in relation to the Baule people of the Ivory Coast. Mende people experience the same enjoyment of the bath.

22 Discussion by Bo preceptor, June 1977.

23 Moyamba assistants, May 1976.

24 The Latin *labium*, meaning lip, with the plural *labia* referring to the outer (*majora*) and inner (*minora*) integument folds of the vulva, all show a point of view similar to the Mende.

25 Mende notions about *sape* evoke the memory of the Wife of Bath in Chaucer's *Canterbury Tales*. She was 'gat-toothed," an indication of her warm-blooded, sexy disposition. I have always thought of the Wife of Bath when looking at subway posters of smiling people on which the teeth are carefully blacked out to make a gap.

26 The ringed neck is so beautiful that informants seemed to gain pleasure even from thinking about it, visualizing it, and describing it. I have more than fourteen different interpretive references to neck beauty in my notes, in addition to regular short answers.

27 Bo preceptor, March 1978.

28 Moyamba assistants, May 1976.
29 The likening of the ripe breast to a calabash recalls a frequent theme in Mende folktales. "One theme with wide distribution in West Africa is that of the magic food-producing object and the magic beater (usually a whip) which protects it. In a Mende version of this story, *calabashes filled with rice* grow on a tree, on which are also whips which beat anyone who removes the rice" (Innes 1964:15; italics mine). Rice, like milk, is white (in Mende color designations) and, like milk for babies, is the basic nurturing substance for adults. Calabashes/breasts relate in ways that suggest they can be seen as receptacles of life-support foods and liquids.
30 Freetown assistant, September 1976.
31 These words are from my Njala and Bo preceptors. Innes has *nyini la bowa*, "the skin of the breasts mouth" (1969:119). Though not quite the same, both meanings retain the Mende idea of the breast as a kind of "mouth," with mouth as a metaphor for in-gesting.
32 This explanation is from the Bo preceptor, June 1977. Victor Turner, I fear, would deem it "folk etymologizing" (1969:11). Speaking of words in Ndembu rituals, he states:

The meaning of a given symbol is often, though by no means invariably, derived by Ndembu from the name assigned to it, the sense of which is traced from some primary word, or etymon, often a verb. Scholars have shown that in other Bantu societies this is often a process of fictitious etymologizing, dependent on similarity of sound rather than upon derivation from a common source. Nevertheless, for the people themselves it constitutes part of the 'explanation' of a ritual symbol; and we are here trying to discover 'the Ndembu inside view,' how the Ndembu themselves felt and thought about their own ritual.

M. J. Field, using data from her thirty-five years of field research in West Africa, discusses a popular pastime, "the game of speculating on the meanings of proper names (place-names, however, being commoner topics of discussion than personal names) . . . [This] is exemplified by the new meaning for the place name Legon invented by the students of the Ghanaian university now on that site. They believe that it means 'the Hill of Knowledge' (from the Ga *le* to know, and *gon*, a hill). But the name in fact dates from a time when the tribe called the Le, whose better-informed descendants still exist elsewhere, lived on the hill" (1971:127–28). I have heard this approach applied to the word *Mende*. The *nde* part is easy, meaning "tell, say; give birth to, bear, beget" (Innes 1969:92). *Me* is more difficult since it means "eat; cheat some one of his money, misappropriate" (ibid.:86). One notion is that *Mende* means "Eat before you speak"—that is, the Mende are a practical people not given to philosophizing, and they put earning a good living before time-wasting talk or, alternatively, that Mende *should* remember, in fact are being instructed by their very name to remember what they can reasonably afford before embarking on litigation or hoping for a big family. And a third meaning is based on *me* as an ideophone for "drawing back the arm without striking," in which case *Mende* means "Draw back before speaking"—consider the consequences of your words, think again. In all this theorizing there is no mention of the historical connections of *Mende* with Mande, Mani, and other nation names of the Upper Guinea Coast.

33 Mme. K. compound, Bo, April 1977.
34 Ibid.
35 Discussion by Bo preceptor, March 1978.
36 Discussion by Bo preceptor, October 1977.
37 Freetown, February 1976.

38 A flat-bottomed basket about 1 inch deep used to spread out rice for drying, picking, or winnowing.

39 Discussion of *tisa* by Telu preceptor, February 1977.

40 Mme. K. compound, March 1977. The details of the bath routine practiced by the mother to build her baby's buttocks are given in the section above, "Shaping a Girl's Beauty."

41 Mme. Z. K. of Freetown, along with three of her neighbors, first told me about their growing up experiences, February 1976.

42 Children in Mende communities wear scant clothing. Before they are initiated, girls wear only beads or a square kerchief tied at the side. Once a girl has experienced sexual relations, she begins to wear a large cloth (*kula* or lappa) extending from her waist to just above her ankles. The traditional Mende term for sexual intercourse is *nya gulëi yili*, "tie my lappa on." Her husband is said to have tied the lappa on her and, no longer a virgin, she is *kula hu nyaha*, "a woman in a cloth, a woman wearing a lappa" (Innes, 1969:67 and 1971:64). So by definition any female wearing a waist cloth is sexually mature.

43 Kenema assistants, October 1976.

44 Freetown, March 1976.

45 Discussion by Telu preceptor, July 1977.

46 Njala preceptor, December 1976.

47 Innes has an item on *jajo*, giving its meaning as "a small tree from which ornaments worn around the waist by [Sande initiates] are made; a dance for [Sande] girls" (1969:34). In my notes I have *jajo* as a dance where the dancers wear tinkling bells around their hips. Mainly bells and twigs (like raffia) are strung so that the movement of hips sends them "up and down, and all around." The name of the dance itself seems to be *ja* (or *jaa* in Innes 1969:34), and *jo* is the familiar *Jowo/Sowo* meaning "expert," so *jajo* probably means to be accomplished in doing the Sande hip dances; but this is conjecture, not a Mende explanation of the term.

48 Discussions of personal hygiene are from Kenema and Bo assistants, and Mme. K. compound, Bo, November 1976.

49 Discussion by Telu preceptor, February 1977.

50 Kenema, October 1976.

51 Mme. K. compound, Bo, January 1977.

52 Meeting of Sowei, Telu, February 1977.

53 Njala preceptor, March 1977.

54 Moyamba assistants, April 1976.

55 Discussion by Bo preceptor, August 1977.

56 Chief B. A. Foday-Kai, February 1977.

57 Moyamba assistants, March 1976.

58 Innes has the mundane definition: "unstable, precarious, likely to fall" (1969:154). The "unstable" part of his definition is extended in aesthetic judgment to mean finely balanced, delicately composed and poised.

59 This title comes from the book on Ghanaian aesthetic ideals and their practical application in everyday life, *Ghana's Heritage of Culture* (Leipzig: Koehler and Amelang, 1963), by the Ghanaian artist Kofi Antubam. Employing Akan terminology, Antubam writes of *Adefeye*—"Beauty in the Manner of Doing Things." He says: "Ideas of beauty reveal themselves in a people's manner and rules of doing things" (p. 113). Antubam then describes the five rules for sitting, speaking in public, bathing, and eating.

60 Mme K. compound, Bo, July 1977.

61 Njala preceptor, June 1977.

62 Telu-Bongor, April 1977.

63 Discussion by Bo preceptor, October 1976.

64 This is another of those points that is difficult for an outsider to understand. One of my friends, Miss M.D., is acknowledged as one of the beauties of Freetown and Sierra Leone. I learned a great deal about the excited public reaction to beauty by being in her presence socially. However, whenever I would say of her, "Oh, isn't M. beautiful!" almost automatically the Sierra Leonean would reply, "But she walks like a man." One of her male admirers went so far as to ask me to speak to her about it for her own benefit because it "spoiled" her. When I did, M. patiently explained that she knew about her walk, that entering a gathering she could remember to walk "right," but as a student, researcher, and surrogate head of family, she was often so busy that she forgot. Rather than being annoyed about people's comments, she agreed that they were right, that she had tried to change, but somehow she always walked "too firmly."

65 The Telu preceptor was very precise in descriptions of the disposition of the eyes and the arrangement of the face. He certainly feels that even the plainest girl can be endearing if she maintains a sweet countenance, while nothing spoils a pretty one more than frowns.

66 Discussion by Bo preceptor, October 1976.

67 I interviewed one middle-aged woman, Mme. C. of Njala (friend of my Njala preceptor), who claimed to have seen *Tingoi.* She added that, although the mermaid's face was alluring, she exuded a strong "rotten fish" odor which was revolting. Mme. C. had heard, however, that the bad smell was a test of one's determination to know her; and that later on *Tingoi* was perfumed. The vile part of the story fits into the Mende notion that perfect beauties always have a flaw that is not visible to the eye.

68 Because *Tingoi* slips into the water so fast, it is difficult to be sure of her body. In Mendeland, the python, an amphibious creature, is associated with women, spirits, and cults.

69 "A Mende woman with beautiful long hair is generally described as possessing hair like that of *tingoi*" (Harris and Sawyerr 1968:41). A quick Mende response to any question about feminine beauty of head and face is "*kè Tingoi*"—like the mermaid, as though that said it all. In every beginning interview it became necessary to explain to informants and assistants that *Tingoi* is only meaningful to Mende and that more specific details were needed for outsiders.

70 Remark from Sowei Y.V., Lumley, June 1976. Comparison to Sowo would seem to make it clear that only physical beauty, not character, behavior, or influence, was the factor under discussion, and that in *beauty, Tingoi* is the very best. This is an interesting remark for two reasons: it gives us a feeling for the way Mende evaluate and discuss beauty for the sheer delight of it, and also shows that Sowo can be inadvertently appraised and compared to other divine beings, like talking about the qualities of angels.

71 William Hommel (1974) made an effort to illustrate an example of every object in Mende art, but there is no picture of a *Tingoi* figure. This situation appears generally in West African art. See Jill Salmons, "Mammy Wata," *African Arts* 10, no. 3 (April 1977).

72 Discussion by the Bo preceptor, June 1977.

73 "God is nevertheless the primordial artist who founded in his creative gesture all the future branches of art. . . . The human artist has obtained from life the gift of creating, of awakening and of constantly and collectively bringing up to date God's gesture" (Memel-Fotê 1968:63). This is the sense of inspiration expressed by so many creative people, a sense that "God was the first physicist," which is less a worshipful stance than one that searches for the thought behind manifestations.

74 Inspiration from the Bo preceptor; discussions with Bo, Njala, and Telu assistants; January to August 1977.

75 This term is not in Innes's dictionary. The stem word *kole* means "to be white" or "to whiten," "to clean" or "clear" (1969:47), contrary to our meaning of *ma-gole-ngò.*

Under *magole*, however, Innes picks up the alternate, opposite meaning of the same word—"to smear a child with mud" (p. 75). The explanation seems to be that Mende whiten things with *hojo*, which is a kind of clay earth. This *hojo/magole* applied to *things* makes them white and clean, but on *people* it makes them dusty and dirty, "smeared with mud." As we have discussed earlier, the Sande *mbogboni* are *magole*, painted with kaolin.

76 *Nèku* relates again to Mende appreciation of both shiny blackness and fairness in coloring; both are bright. Memel-Fotê, discussing a cross-section of subsaharan cultures, states after evaluating aesthetic criteria in a wide cross-section that "every major exhibition of beauty comes forth in terms of lightness. . . . [This shows] the eminence of light in the conception of philosophical values and especially the privileged position of the eye in aesthetic perception. For the Bete [an Ivorian society], beauty is a visual magnificence. Even beautiful music is described by the eye as though beauty could only be conceived by reinterpretation into visual terms" (1968:59).

77 Freetown, March 1976.

78 George M. Carew, a lecturer in Philosophy at Fourah Bay College and himself a Mende, has commented on the Platonic cast of Mende thought: "In both ontology and epistemology, the Mende view approximates some form of platonic idealism. Plato postulated two worlds: the real world and the world of mere appearances. According to Mende belief, true knowledge is unattainable in the physical world of mere appearances. Knowledge of the nature of things is possessed only by God and the Spirits which populate his spiritual republic." See his "The Underlying Philosophical Connotations of Some Mende Proverbs," Seminar on Black Civilization and Education, University of Sierra Leone, 14–15 March 1975, unpublished MS, p. 3.

79 I term "oft-told-tales" those stories I was told repeatedly by Mende who liked me and wanted to help me understand Mende ways. They are all tales of supernatural, mysterious happenings that are said to happen in different places at different times. Among them: (1) The Sande initiates turned to stone; (2) The relative who visits from afar and then you hear the next day that he died last week; (3) The orphan girl whose Sande tuition is mysteriously paid and she graduates and marries the president; (4) The beautiful girl who is a bed-wetter; (5) The pond you drink from which makes you return to that spot; (6) The *Tingoi* who brings a particular man great riches. These stories never appear in collections of folktales, and they do not seem to fit into any standard form. "Mende literature comprises many forms including prayers to the dead (*ngo gbia*), ritual slogans addressed to dancing spirits, dream (*kibalo*) narrations, fictitious tales (*dòmè; njele*), myths and legends (*njia wova; njepe wova*), place puzzles (*hoboi*), proverbs and riddles (*sale*), and songs (*ngule*)." They are perhaps closest to *njia wova*, since such a narrative "recounts actual events, . . . may be told to an individual" (Kilson 1976:17). The question is whether or not they "recount actual events." Under the guidance of my preceptors I have come to see that they encapsulate Mende thought and, like moral tales, "are used for the socialization of the young, and therefore embody the mores of the society" (Innes 1964:15). Mende kindly saw me as a "child Mende" who needed to be socialized. The lessons these "oft-told-tales" teach and the way they function in the life of the community would be the topic of an interesting paper.

80 This is not the natural python so revered by Mende cultists, but the vampire *ndili*, "a mythical creature in the shape of a python that is believed to attack children at night" (Innes 1969:95). The *ndili* is a complicated notion of evil; discussed by Harris and Sawyerr 1968:77–79, 118, 122; and by Little 1967:231.

81 The very perfection of her suitor should have warned the girl that he was not a normal human being, but a monster. This tale is an admonition to be suspicious of perfect beauty; Mende are sure that the very loveliest girls, for example, have serious, secret

physical flaws. There is a prevalent notion that what can be seen may be fine, but what is completely hidden, the genitals, may be amiss in some way. Or a girl may have scars from infections that are covered by the long lappa. Three different men told me of encountering girls whose public and private parts were all exquisite, only to find that they were bed-wetters.

82 This is a real dilemma to Mende, rather like a western Christian brought up with a sense of guilt and retribution who questions "why innocent babies die." Both sets of speculations are unanswerable and express the layman's confusion about the ethical bases of the world he lives in.

83 In Innes: "*Kpekpe*—goodness, generosity; be good, be generous" (1969:57). "*Nyande* —be nice, be good looking, good, beauty, good looks . . . *Ngi wie hinda nyandengò*—he is good, kind" (p. 118).

84 "No matter how important its aristic content may be, the making of a garment, a uniform, an ornament, a piece of jewelry, or a tool is subordinated to its function, its efficacy. Any adjunctions whose only purpose would be beauty [ornament] are excluded insofar as it would overburden or hamper proper utilization of the object" (Memel-Fotê 1968:57).

85 Again, I am grateful especially to the Bo preceptor and to the Mme. K. compound for their patient and lucid explanations of Mende aesthetic and moral concepts.

86 Susan Sontag, "Beauty, How Will It Change Next?" *Beauty in Vogue* (London), Autumn/Winter, 1975, p. 86.

87 The comparisons Memel-Fotê has made of fourteen different cultures indicates their considerable agreement in aesthetic matters (1968:47–56).

5

Sowo: The Good
Made Visible

The Sande Society is a concept, an ideal, an organization, a body of knowledge, a collection of objects, a fellowship of women. The society is sacred, and its communion is secret. Sowo, the classical Sande Society mask, is the embodiment of the society, a presentation which Sande has designed to ennoble its members and strengthen the larger community. In Sowo the world can see what canons Sande cherishes, what values it upholds. Sowo is an exemplar, a water deity, a goddess, a Mende metaphor in motion.

This study takes a single archetypical object, Sowo, from a single culture, Mende, and then analyzes that object's basic elements of form so as to discover the rules of their combination and apposition (fig. 54). As Sande standard bearer and symbol, Sowo is presented to the public as a fully costumed being; the basic personage is composed of a black, wooden, sculpted helmet mask, *sowo-wui*, combined with a black raffia-and-cloth costume, *sowoi-malomei*. Each element assembled to make up Sowo has its own references in Mende thought and conduct, and each augments and extends the meaning of the whole. For us to understand all this will require no less than a study of the natural and metaphysical background from which the forms emerge, forms which we shall unveil, part by part, meaning by meaning.

Sowo has remained throughout the generations as a focus of Mende life because of its beauty and lofty meanings, and *Sowo has this beauty and nobility because the Mende mind puts them there*. The mask is, after all, mere wood and fibre fashioned by ordinary human beings. Any significance it may have—any power or majesty it may possess—has been projected onto it by the designs and desires of the wisest Mende elders as part of their plans and feelings of responsibility for the development and enlightenment of Mende people. Sowo is an alluring portrayal to which Mende are always attracted. They say, "It awakens in us love, so we desire closeness and move

153

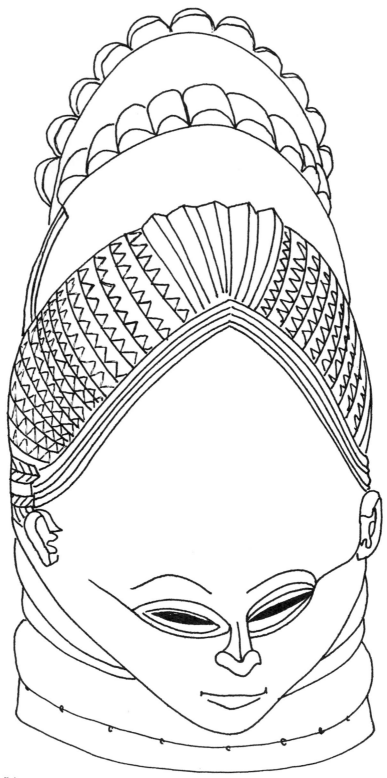

54

nearer." The truth of Sowo exists on a metaphysical plane; but, if we humans are to learn from Sowo, we must be able to *see* it; it must appear on the material plane. Visible, tangible Sowo becomes a gateway to the spiritual. It is the form that pulls you toward the formless. It is the finite that leads you toward the infinite.

The fully robed Sowo mask, a powerful presence in Mende life, comes dancing or parading only some four or five times in the year; the rest of the time it is hidden from sight.[1] Sowo is the single favorite subject for Sierra Leonean artists, and its image shows up in all manner of secular visual arts—paintings, prints, drawings, photographs, greeting cards, calendars, and holiday floats. However, although it is difficult to obtain a Sowo costume, examples of the sculpted head of Sowo, the *sowo-wui,* are easily viewed, bought, sold, and collected.[2] Sprinkled liberally through Sierra Leonean life, the mask head may be seen at local museums, craft shows, and exhibitions; in salons of chiefs and other dignitaries; in the homes both of nationals and expatriates.[3]

The Sowo head, *sowo-wui,* is a wooden, monoxyl helmet designed to completely encase the wearer's head and rest on her shoulders. Made of lightweight bombax (*kpòyò* or *kalo wulu* in Mende) wood, it is solid and bulky in appearance but not heavy to wear. The head is sculpted to represent a female image, then finished in a monochrome black, with the smooth areas of the face and neck raised to a high polish.[4] Every *sowo-wui* mask has features common to all.[5] There are three major divisions of the form of the Sowo head: (1) the neck, with thick rings of circumambient flesh; (2) the face; (3) the coiffure—as seen in a fine example, figure 55. The neck forms the base of the mask and the lower half of the frame for the face. It is the solid base of the high dome of the total head. The neck is composed of three or four solid rolls of flesh, carved into the wood, which encircle the head, usually rising four to five inches up the back of the head, then sloping down and compressed into a narrow space in the front where they fit into a rounded point under the chin. The neck rings, roughly parallel at the back of the head, slope forward from the ears to cradle the lower half of the face in a V. The bottom of the neck is evenly finished with a flat edge so that the mask head can stand firmly upright.

The actual face of the *sowo-wui* divides usually into two parts, along an imaginary horizontal line running from the center of the ears at the side, through the centers of the eyes on the face. If the face were flattened out for schematic viewing, it would take an approximate diamond shape with points at the tip of the chin and the top of the forehead and the ears. The smooth, unmarked expanse of the forehead occupies the top half of the face (with a bit of the eyes and occasionally eyebrows taking up a small space). The eyes, broad but usually slitted as if almost closed, dominate the bottom half along the horizontal line. Below them are carved compactly into a small space, the nose, mouth, and the chin resting on the neck rings.

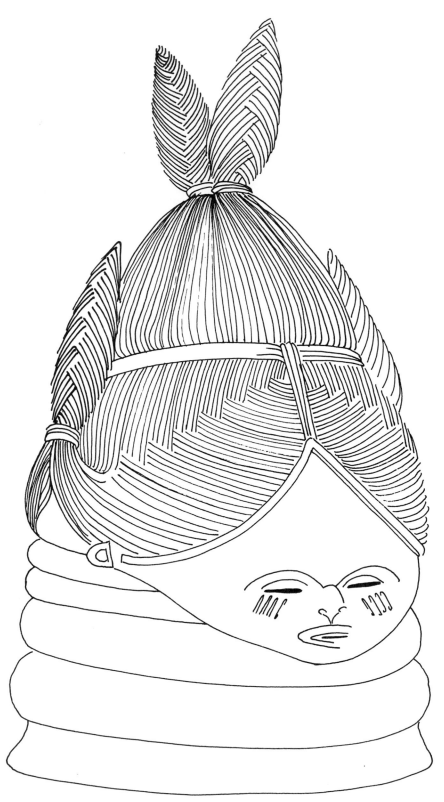

55

The coiffure is both the largest portion of the mask detail and its most richly decorated element. Starting above the forehead at the hairline, it covers the round of the head and meets the neck rings at the back along an extension of that same horizontal line that divided the front. So, if the *sowo-wui* were rounded into a ball, the top of the hemisphere would hold the forehead and coiffure; the bottom the face and neck rings.[6] Two aspects of the coiffure can be distinguished: (1) the hair itself; and (2) symbolic additions and embellishments. A *sowo-wui* is always carved with an elaborate hairdo, *ngu-felè*—braiding and plaiting of all kinds, tufts, curls, and buns. The embellishments are of several types: crown shapes and crests are striking for their grandeur; representations of birds and snakes frequently surmount the head, as do the forms of a variety of horns, pots, shells, beads, and amulet packets.

THE BEAUTY OF THE *SOWO-WUI*

For a mask to be accepted by the Sande Society, it must first and foremost be beautiful, enchantingly beautiful in Sande eyes. The leaders of Sande have established the rules for fine form, and they insist that every mask used by the society meet its high standards.[7] Sowo must be a pleasure to look at and awe-inspiring to approach. Truly a glamorous being, the mask joins the community together in the experience of its beauty and allure. So beauty is required of Sowo, and the Sande elders ensure that its aesthetic canons are upheld.[8] For the sculptor, creation of the mask top, the *sowo-wui,* is a masterwork requiring all his skill and imagination. And for all cultivated Mende, the Sande head is a clear expression of all that is desirable and fine in the Mende world.

A mask head must be complete and correct, Ngakpangò-jo.

A good Sowo head must be recognizable as a Sowo head and as nothing else but that. Thus, it must be complete and correct in all its parts: full, striated neck, small face with closed mouth, lowered eyes, large forehead, plaited hairdo—all symmetrical and balanced, carved in wood, and dyed deep black. These are the basic—fundamental and irreducible—requirements. An incomplete mask cannot properly "perform" in the society, for each of its particular features is a component in the formula required for transmitting Sande precepts. If something is going to be a *sowo-wui,* it must be a *sowo-wui* definitely; and it is a *sowo-wui* by having all that is necessary to its definition.[9] An object whose features deviate from the formula is still a piece of sculpture all right, but it simply is not a *sowo-wui.* Mende are good at stating negatives and at noticing details that fall short of the ideal; so a mask that fails to meet exact standards will be rejected outright.

A sowo-wui must be comfortable to wear, A gulo nya ma leke kineiñ.

A beautiful thing must perform well, and a *sowo-wui* is made to be worn for dancing. No matter how glorious its appearance otherwise, a mask that cannot be used in the dance is a piece of furniture, or a *kpowa jowui*, a mask only fit for the uninitiated. Like a pretty woman with the misfortune to be barren, it is considered *nyande gbamëi*—useless, empty beauty. For the dancer, the mask must be comfortable to wear—quick to slip on, light in weight, with holes giving sufficient eye visibility, smoothly finished within, resting easily on the shoulders.[10] For the audience, it must be seen to cover the dancer's head and sit evenly, its horizontal planes level, not askew. A light-weight mask is highly prized. Richards mentions that hollowing out the log to a thickness of no more than three-quarters of an inch is a "particularly energy- and time-consuming" procedure, "but it is nonetheless assiduously pursued because in many Sande camps one of the ways by which the technical competence of the artist is judged is by the weight of the mask; the lighter it is, the more capable the artist" (1974:48).

A sowo-wui must be shiny black, Mòò-mòò.

The *sowo-wui* is the incarnation of all the aesthetic and moral excellence of "shiny blackness." Among Sowo's names is *mòò mòò*, "the shiny jet black thing," "the beautifully black thing." Shiny blackness is the image's name, description, and identity. The sculptor who creates the *sowo-wui* paints it repeatedly with the dye until the hue has soaked deep into the wood and the color is a deep, even black. Then the mask is rubbed with palm oil or shoe polish until the surface is sleek and luminous. Thereafter the owners will frequently apply palm oil to maintain the gloss and intensify the blackness. A cherished mask gradually takes on a glow as if from an inner light of life.

A sowo-wui must be smooth, Ma gbongbongò-bòwòbòwò.

The surface of the mask must be perfectly smooth, without any bumps or rough spots. The test of the carver's devotion is the expanse of the forehead and the curves of the neck—these must be sanded to perfection with no trace of knife chip marks remaining. As in the example in figure 56, the sculptor has achieved the smooth, open sweep which Mende adore. The absolutely smooth forehead is able to swirl in the raking glare of the sun and glitter back a mirror surface of brilliant light.

A sowo-wui must be balanced and symmetrical, Mbè-ma.

A *sowo-wui* is balanced and symmetrical; it sits flat on its neck base, and all horizontal or vertical planes must be relatively straight. Of the vertical hemispheres, one side of the head duplicates the other. If there is a single feature, say, a bird adornment, it will appear in the middle of the

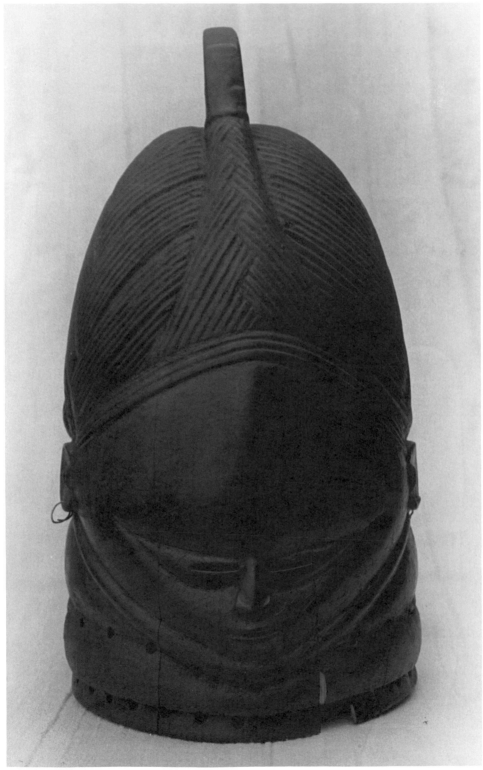

56

coiffure; if the mask features crests there will be one extension in the center, flanked by one or two others on each side. "Mende carvers strive for symmetry, and even when iconographic elements do not allow perfect symmetry (as, for example, snakes in the headdresses) the best possible balance is sought" (Reinhardt, 1975:145).

Sowo-wui features must be clearly visible, Ma ya-sahëïn.

It is important that each part of the mask be clearly defined by being sharply cut. Features must be readable; if they are blurred, fuzzy, muddled, or otherwise indistinct, the mask is unacceptable. Adornments, hairstyles, or whatever must all and each be visible and clearly delineated. One must be able to *see* everything easily. Shiny blackness and smoothness both relate to visibility and clarity, which appeals to the Mende love of brightness and radiance, and serves to again emphasize "the privileged position of the eye in aesthetic perception" (Memel-Fotê, 1968:59).

A sowo-wui must appear fresh and new, Nëku.

As the Sande Society seeks to refresh and rejuvenate the Mende woman and her surroundings, so the mask must display freshness, *nëku,* confirming cleanliness, crispness, newness, youthfulness, and, again, shininess. The head itself must be new in appearance, free of dust or any signs of wear or deterioration. The carver gives a new *sowo-wui* its original look of fullness and amplitude, but only the owners can proudly maintain the head pristine. It is a gift from God that we must preserve in all its newness, at its very best.

Sowo-wui features must be delicate, dainty, Yëngëlë.

Delicacy is the most highly prized attribute of the carving; the manner in which the mask is incised is closely scrutinized. Delicacy involves not so much the shaping but the fine detailing, the minute incisions. Reinhardt in her researches found that "delicacy in rendering line was praised by all speakers." Marks (scarification and hair) should be "small, fine and regular" (1975:135). This reaching for delicacy, *yëngëlë,* is almost synonymous with what it means to carve, *hawa*—"to cut something but not cut it through."

Mende evaluation of the quality of a *sowo-wui* extends from the quality of *yëngëlë:* fineness of detail, painstaking rendering of line, exquisite incising, with clear delineation of hue. Mende recognize three ascending levels of quality, but express their evaluations in a mystery language of parables concerning the object's reputed creator. A mask of no special distinction is known to be made by a man, a human being, a part-time carver, a farmer by profession. He can be seen in his workshop in the village or town, working wood with his tools. The carver is only capable of making an ordinary object because his hands are rough and his motions coarse. Male

Mende work motions are broad and large, with no finger articulation or dexterity; Mende farming implements, the hoe and the machete, chop and slash. So the community reasons that the carver/farmer is limited in his ability to fashion elegant renderings.

A better quality of mask is more delicate, more subtle (fig. 57). Mende attribute these finer pieces to the *tèmui,* elves, little people who live in the woods. Deep in the forest, far away from other people, the carver goes and enlists the aid of the elves. The carver can make the general outlines of the head, but only the elves with their tiny hands and miniature tools are capable of doing the exacting work of making the dainty little incisions.[11] At the top level, the very best pieces are said to be sculpted with exquisite detail by water spirits. Mende say that the abode of heaven is to be found under the water; in the underwater paradise such miracles of delicacy are the norm. The telling indication that the *sowo-wui* has an extraterrestrial provenance is to be seen only on the inner surface—there can be absolutely no drop of black inside the mask; it must be unblemished white. Such perfection is unearthly; again, it is thought that human carvers will always, no matter how hard they try to be careful, spill some of the dye and mar the interior of the mask; only the work of the water deities will be faultless. Water once more as origin of the sublime, the highest ideals materializing from the depths.

THE MEANING OF THE *SOWO-WUI*

The *sowo-wui* awes the Mende community. Any mask, regardless of quality or condition and wherever found, excites the onlooker and precipitates comment and action. There is an etiquette for viewing and handling the *sowo-wui.* To view it, we can approach the mask because it is alluring but not draw too close because it demands our respect. One may stroke it in a cult house, but never casually pick it up, turn it over or look into its hollow portion, or handle it in any other disrespectful manner.[12] Because the head can be appreciated by every age and social group, and appears to be endlessly fascinating from any perspective, we can assume that such universal appeal rests on myriad interpretations which multiply and deepen with the wit, knowledge, and life experiences of the observer.

The mask is a head of a woman, and every element of the mask's form corresponds to some identifiable natural object. But the siting of the features and their size and relative proportions respond, as we shall see, to metaphysically elaborated "image demands." Sacred objects are rarely discussed with researchers, but the Bo preceptor continually teaches that the data we seek are out in the open. Nonetheless, without the connections explained it is impossible to know the meanings of things right before one's eyes; we are *kpowa,* uninitiates who cannot see through the mists. The smallest details of the *sowo-wui* resonate with meaning; their multivocal

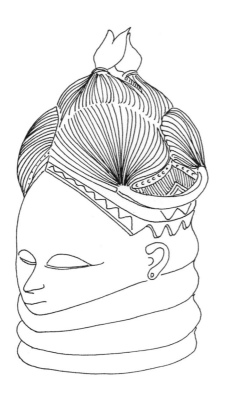

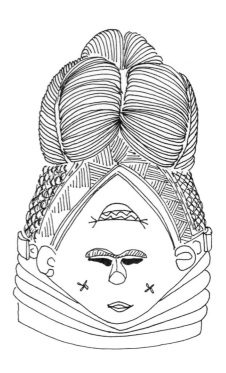

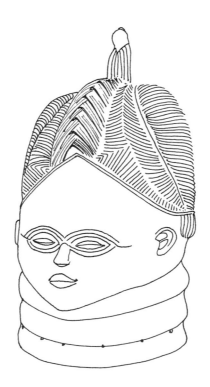

57

symbolic power enhances "the impact of art and its effectiveness as communication." Anthony Forge suggests that artistic communication depends precisely on ambiguity: "The power of the symbols or groups of symbols to make reference to contexts and rituals other than the one in which they are presently appearing is perhaps the most vital part of their effectiveness, especially when reinforced by beauty and mystery."[13]

HIERARCHY OF MASKS

Mende recognize two types of *sowo-wui* heads: one is the pure classical form, complete and correct, whose origins are divine and whose use is restricted to the highest, *sowo,* level of the Sande Society; the other is an ornamented mask commissioned and used by specialist dancers at the middle, *ligba,* level. The first is of supernatural provenance representing the sacred Sande spirit, while the other is made to the fancy of an individual Sowo-dancer as her private choice and property. This is the first time in the literature that any observer has noted the difference in the masks. The distinguishing feature is the coiffure: classical, upper-level masks appear to have only a hairdo in a style called *Sowo-bòlò,* "Sowo's cap," while the dancers' masks display a variety of hairstyles and adornments. As an additional sign, the classical masks are tied with a white cloth at the top, the ends falling down in streamers.

A field photograph will illustrate the two types. Figure 58, taken from W. L. Hommel's *Art of the Mende* (1974), shows a procession of masks in Kenema, Eastern Province. The two Sowo leading each have a coiffure of the *Sowo-bòlò* hairstyle, wrapped with a white headtie. Walking behind can be seen a third mask of elaborate coiffure, with no white scarf. A quotation from Hommel's informants offers important background:

> When a woman reaches the middle [*ligba*] level of the Sande society she commissions a mask which will be hers alone, and will project the personality of a particular spirit. She is the only person who evokes the spirit of the mask, so when she retires or moves upward in the society, it becomes valueless, and is either retired, transformed to represent the comedian, Gonde, or presented to a chief as a prestige gift. It is extremely important that a new mask be attractive to the spirit, otherwise it will not choose to enter and the helmet is useless. On attaining the middle level of the Sande society a woman seeks out a carver who, because of his profession, has more familiarity with the rituals and the society than other men. She need tell him only the name it will bear before he secludes himself in the bush to visualize the personality of the spirit which will eventually inhabit it. [n.p.]

L. Reinhardt remarked that certain masks are topped with white kerchiefs:

> Senior members of the society, Sowoisia, are distinguished by wearing white head-ties on ceremonial occasions. So, too, do some of the spirits when they

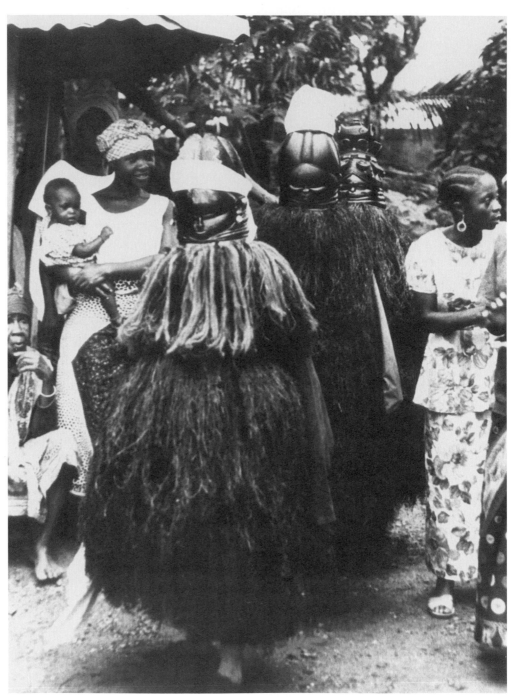

dance. Thus it may be that levels are designated in this manner when they dance: a *Sowo* will have a head-tie wrapped around the upper part of the mask. . . . This view is supported by statements averring that the head-ties designate "older," and "more important masks" which take precedence over the others. [1976:49]

Early observations of Sande further establish the idea of a hierarchy of masks: one of *sowo* level, the other of middle level. T. J. Alldridge, the British Travelling Commissioner in Sierra Leone at the beginning of the century, notes that the "Sowehs, or women of the highest degree in the order [are] readily distinguished by their having white cloth wound turban fashion around their heads" (1910:223). In an earlier book he describes an arrest by Sowo of a man who has committed crimes against Sande (1901: 142). Alldridge comments dryly that when Sowo "comes out to arrest a person, she does not bring any music with her" (1901:143), i.e., this is not one of the middle level, entertaining *Ndoli Jowei*. In his photograph of the avenging Sowo, she has a plain hairdo and is wearing a white headtie.

In sum, in any Mende community there are two classes of masks: a select few are for the use of Sowei and the Sande shrine, and a larger group is held privately by individual specialist dancers. We have shown that the highest-level masks are topped only by a beautiful hairstyle, but the dancers' masks feature in addition a variety of adornments. Understanding this distinction leads us to a perception of the essentials of Sowo mask form. Our research indicates that *the unadorned is the true,* "complete and correct," *pure archetypal image;* while the adorned masks are idiosyncratic variations, often exciting to look at but not representative of the essence of Sowo (fig. 59).

SOWEI'S MASK, THE SACRED *SOWO-WUI*

The distinction between and among masks revolves around the diversity of coiffure. Other features of the mask are held to a standard and a sameness; however, like a human head whose basic features are fixed but whose hair can easily be changed and rearranged, the *sowo-wui* coiffure also varies over fixed features. By coiffure the masks are divided into two groups—those which portray a soft hairdo of the older woman, usually with little ornamentation, and those which have intricate styles and varied embellishments. The vast majority of *sowo-wui* collected show an elaborate coiffure, while it is rare to see a mask of classical hair motif outside of Sande hands. I suggest that among the soft hair motif masks are certain ones which are sacred *sowo-wui,* senior masks controlled by the Sowei, or ruling, level of the Sande Society; and furthermore, that the more elaborate, adorned masks are junior, as their "young," intricate hair designs indicate, and that these fancier masks relate to the lower, *ligba wulo* (junior *ligba*), middle level of the Sande Society. To recapitulate, Sande masks are

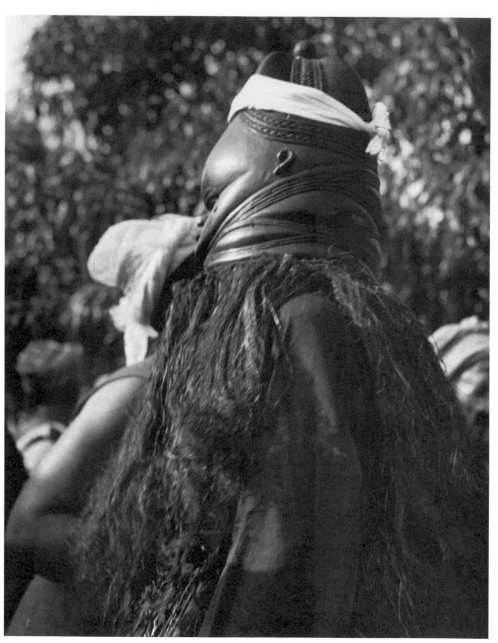

59

part of the Sande Society, and the Sande Society is part of Mende culture. Mende life is stratified on the basis of authority over institutions. Thus, this allocation of distinctly different masks to the different strata within the Sande organization is "natural" to Mende, at once reflecting and reinforcing Mende social values.

Our study proceeds with an examination of the sacred *sowo-wui*. In chapter 4 the physical aspects of the face and head were discussed; let us now examine the forms for their richly interlocking meanings in Mende social and religious thought. These aspects of *sowo-wui* form attain "intensification of iconic resonance by simplification of expressive means" (Thompson, 1974:47), so we shall observe each detail, knowing it will yield profound material. *Sowo-wui* features are both illustration and abstraction, both derivative and primary: derivative because the form recalls an occurrence in nature; primary because it is not a picture of a thing, but is rather a materialization of concepts and dogma.

Neck, *mbolo*

The dramatic coils of flesh circling the *sowo-wui* neck are an obligatory form (fig. 60). Paramount Chief Foday Kai, a recognized authority on Mende culture, asserted that "A *sowo-wui* without neck rings is not a *sowo-wui*" (February 1977). *Sowo-wui* neck rings are an exaggeration of the actual creases on the necks of some Africans—to outsiders hardly discernible, to Mende enormously important. A beautiful neck is ringed. Children wish for neck rings. Adults try to cultivate neck rings. Because they simultaneously suggest wealth, high status, and vitality, they are considered a "sign of beauty," sexually attractive to both men and women. These rings guarantee attention. Those who have them attract others as friends and lovers automatically, effortlessly: "People like you just because you have that neck." Since there is nothing more highly esteemed by Mende than the capacity to attract others, this magnetic quality of the neck rings endows them with remarkable significance.

In considering a person's beauty, the neck is evaluated as a piece apart. If it is ringed, it is a beauty in itself, which a person or object can possess as a "thing." A ringed neck is "beauty incarnate," beyond discussion or debate. A Mende saying restates the linkage of ringed neck with beauty: *Numu wova yaa yè tia wòò ti nyandema ngi bolo woma gbee*—"If an old woman tells you she was beautiful in her youth, ask to see the back of her neck." When all other charms have faded, it is thought that a crease will remain at the back of the neck where it joins the collarbone, an indelible proof of past glories. The rings, therefore, have to Mende an almost Proustian permanence. Regardless of what else may occur, they remain to proclaim the body's lost loveliness.

Neck rings are most pronounced in those who are well fed and comfortably situated. In those rural farming communities that know seasonal

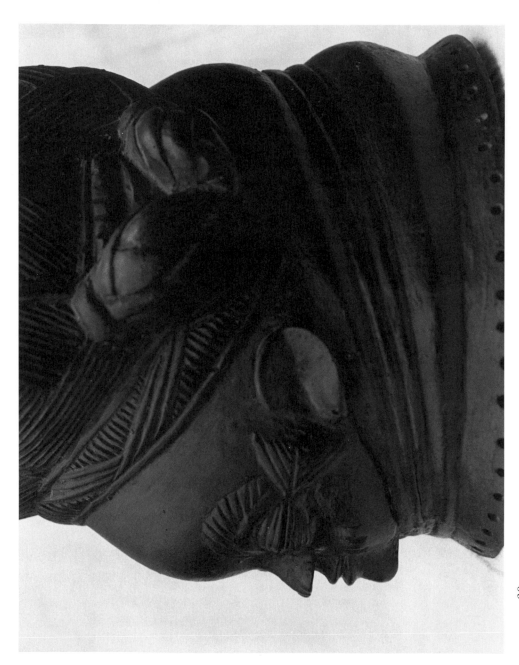

hunger, only the most affluent always have enough to eat. Mende definitely relate blessings to virtue. A bountiful harvest comes through health, physical vigor, capable organization of many people working cooperatively, good luck in agricultural and climatic conditions. So the rounded rings indicate full-bodied good health and good living, the result of intelligent planning and beneficent fortune.

Sowei, the head of the Sande Society, and *sowo-wui,* the head of the Sande mask, both have all desirable attributes. Though she may be old in years, a Sowei's prestige as the most important female in the town gives her a definite sexual allure that other mature women simply cannot have. Moreover, Sowei is *in charge* of fertility, *bestows* nubility, is *protector* of all the women and children. She presides over weeks of continuous feasting in the *kpanguima* of which every woman is welcome to take her fill. The opulent neck of the mask, therefore, is in keeping with this spirit of generosity. These, then, are the physical associations of the rings: health, wealth, and generousness of station. But we must go deeper. We must find references explaining why these notions tend to cluster around the neck rings in the first place.

One important insight can be found in the Krio word describing the good luck of having a ringed neck—*bonya. Bonya,* a word from the marketplace, means "dash"—gratuity, present, gift. In trade, after haggling is over and a price is set, the buyer or seller (usually the seller) adds a bit more as a gesture of goodwill.[14] This little extra is the *bonya.* By definition, *bonya* cannot be bought or coerced—it can only be freely given. It is the essence of balanced generosity: after the hard bargaining, a sweetening *bonya* is a way of saying, "What went before was business, but this extra lets you know that I like you and value you beyond your money." *Bonya* is a love-gift, a token of friendship. A ringed neck is God's *bonya* to those whom He has selected for special blessings and favors. That is, God gives everyone a regular neck that works well enough; but a ringed neck has something extra, beyond the ordinary. God put the rings there as a way of letting the world know of His affection for a fortunate few. It follows that the example of divine gifts evokes a lifetime of outpourings from men.

To understand the significance of the ringed-neck image, we must discard western phrasing—"rings" (Innes, 1969:44), "fat lobes" (Richards, 1974:49), "neck coils" (Dubinskas, 1972:34), "wrinkles" (Innes, 1969:84; d'Azevedo, 1973:147), "creases," "lines" (Innes, 1969:44)—and return to vernacular foundations. In Krio (the Creole language of coastal Sierra Leone), it is "cut-neck"—a translation that caused me to look further. The Mende term for the neck is *mbolo gènyèngò* (Innes, 1969:34), "the-neck-is-cut." *Gènyè* is a creative cut made around something, an incision that does not cut through or off. The tool is applied deeply, leaving the thing delicately poised though still attached. *Gènyè* indicates care and artistry: it is easy to slice or cut something off; but to notch around something requires

skill, a sharp tool, a strong hand, and a delicate feel. In making a person with a ringed neck, God took the time to design and carve something special. *Gènyè* recalls Mende esteem for civilizing cuts on the earth and the human body. On the neck-that-is-cut, God the Artist has already made lines bestowing delicacy, grace, refinement. Mende say of it: *Ngewò bi goilò,* "God gave it to you." This luxury and elegance are a heavenly touch, a mark of beauty that does not fade with the passing years but remains as a manifestation of God's loving attention.

Mende mythology endows the neck coils with still more meaning; the coils connect the mask with the spiritual realm of rivers. As shown earlier in this work, Sande women are water people, and the Sande initiation camp itself is not of this world but is spiritually envisioned as being located under the water. The robed mask is a "dancing stone," *ngafagòtu,* and the *sowo-wui* is a mere paltry human attempt to mirror glories of the divinely sculpted founding stone which Sande Jo took from the river. The sacred masks of *sowo* standing are thought to be fashioned by the deity personages of the heavenly towns under the water. Or, alternatively, Sowo itself is a deity from the waters. "The neck rings are an extension of the concentric waves which are formed on still water by Sowo's head breaking the surface" (Dubinskas, 1972:39). As we have just said, the *kpanguima* is under water. When the Sowo leaves the camp to dance for the public, it is said to be emerging from the water—a reenactment of its original arrival and an extension of the symbolism of the neck rings. It is these circles in the water which the neck rings represent: "they are due to the resemblance to the spirit coming from the water."

Some Mende relate the neck rings to *Tingoi,* the mermaid. *Tingoi* reigns through love and beauty. Thus, when Mende see the *sowo-wui* has a neck like *Tingoi*'s—*mbolo kia tingoi*—they relate the icon through the lines to supernatural, sumptuous images of love and power. The ringed neck on Sowo, like that on *Tingoi,* is of such distinction that it transports the image from the human to the divine. No flesh-and-blood woman has such a neck. The "cut-neck" element in Mende art, in sum, functions the way a halo does in western painting, signifying that what the eye sees is human in form but divine in essence.

Mouth, nda

Mende elders are certain that most human suffering stems from loose, malicious talk. Carping, complaints, gossip, and innuendo are bad enough; but aspersions, curses, lies, slander, and false witness can cause a victim great anguish and wreak havoc in small, close-knit communities. One person, an elder of Kagboro chiefdom, told me that people talk a lot about "witches" when in fact they are of no importance. Most personal pain and community strife, she stressed, are caused by "day witchery"— backbiting, false witness, hypocrisy (March 1976). Silence, an indication of

composure and sound judgment, is in short supply. Mende are not supposed to talk easily about anything; everything is a secret to one society or another; still everyone knows "dirt" about everybody else. Sooner or later (usually at a trial) every scandal will be brought to light.

Mende are not casually loquacious people. They do not mind discussing the practicalities of making a living or performing a task (Little, 1962:112), but they refrain from unconsidered chattiness. Unless carefully restrained, "Talk makes palaver." Only in the most intimate, secure circumstances do people chat freely. Consequently, the mouth of the mask is deliberately deemphasized. Sowo's mouth is small, pursed, inalterably shut. The sculptors told Dubinskas in 1972 that the mouth should be "closed and solemn, not angry or laughing." The Sowo, like Sowei, is a conservative, serious person; laughing would be out of character. A woman of prestige opens her mouth only in the proper place. The mouth on the *sowo-wui* head is what a mouth should be: an image of ideal, perfect silence.

A Mende woman's anger is usually expressed in the criticism and striking of her children. She is prevented by village mores from expressing discontent with the adults around her because—as husband, senior wife, mother-in-law, chief—they are her superiors. The community understands that much of the abuse rained on children is caused by a mother's frustrations with her husband. A saintly mother accepts her troubles stoically and treats her child with kindness; her forebearance is a blessing to her child and is the assurance of a good future in life. Other women, overwhelmed by disappointments, lash out in their agony at the only possible victims, their children. In a spasm of fury a woman may curse her child, declaring he will never succeed, will never amount to anything. This "mother's curse," *njei jondu,* is dreaded.[15] Nothing is considered more harmful to a person than his or her mother's curse; it is sure to ruin a person's life. It is irrevocable and one hundred percent effective. When Mende observe a person who is a drunk, a brawler, or a thief, they conclude that the wretch was at one time cursed by his mother. No good can ever come of him. The community writes him off as a loss. Sowo is above such levels of frustration. Her opinions and decisions are clearly known and all her children honor and serve her. She has no need for displaced temper. She blesses and brings goodness to all her children.

The way to say "my lover" in Mende is *nya jali gulamò,*—literally "the person who makes me laugh." The one element of that sentence, *jali gula* is a mutation of *sali gbua,* to play jokes (Innes, 1969:129), to crack jokes, have fun, play. Lovers are people who chat freely and gaily with each other and make each other laugh. *Mua ta ma yèlè luahu,* "we laugh together," thus "we are lovers." The actual sexual union is private, secret; what the public spies is the couple's easy joviality. Returning to the mask, the closed mouth of Sowo confirms that it is aloof and sovereign, not a plaything, not an object

of male whims. A smiling girl invites flirtation, but the closed mouth of the Sowo forbids any such casual sexual designs. Hence, there is no joking or laughing with a Sowo; nor does she allow herself a smiling mien. In real life, Sowei is also difficult to approach: "You go a long way and pay a whole lot to get her to smile at you."[16]

Sowo is a goddess, a spirit. She is complete, self-contained, above desire, beyond flesh. Her silence is part of her power of exaltation, above desire and laughter. She listens, she looks, but does not speak. Her small, pursed lips rephrase, time and again, that Sowo knows all the secrets of the female body and the female heart but reveal nothing. She has heard all the confessions, judged all the crimes, but her mouth is sealed. Consonant with such beliefs, no being of Sowo's exalted rank would ever open her mouth in public. Important persons and supernatural beings never speak, nor are they spoken to directly; the communicate only through intermediaries.

In official town and village affairs, the chief does not speak with the citizens; rather, his *lavale,* "spokesman," conveys his comments and decisions (Harris and Sawyerr, 1968:134–135). Likewise, in divination, the oracle stones do not, cannot, speak. Whatever their patterns reveal must be read by the *tòtò gbèmò,* and it is he who will interpret the signs, chanting "the stones say. . . ." Serene Sowo, too, never walks amongst us without her attendant, *Klèi,* who talks on her behalf. So the closed mouth is further proof of Sowo's eminence and spirituality, a mystical mirror in silence and in glory, of the speaking persons below.

Nose, *hokpa*

The nose is, in Mende terms, a "mouth" for the absorption of nonmaterial things into one's system. Women are supposed to have a keener sense of smell than men, and they are considered generally more sensitive to the environment. Mende loathe bad smells and relate them to disease and the forces of disruption. In the Mende quest to identify and eliminate the harmful and negative, a woman is most likely to declare a smell bad and, in the interest of her family's well-being, set out to discover its cause. A place that is not clean-smelling is not fit for human beings. Women, as keepers of the homestead, have special responsibility for keeping the living areas fresh and clean.[17]

Mende consider smell as the lowest of the senses and the closest to the animal. Mende—who have such well-articulated standards for all aspects of appearance and behavior—find smells baffling, too instinctual for rational discourse. Everyone is sure that excrement and filth are foul, that spices and perfumes are "sweet"; but in between are phenomena defying easy characterization.[18] A scent that repels one person may attract another; a whiff of a certain odor can be erotic, too much may stink. So, in this one instance the Mende admit of an individual evaluation. They agree that persons who love each other find pleasure in each other's body aro-

mas. The smell of the person is the person's presence, and is liked by all those who like him or her. So, if a person feels disliked by another he says: *Nya magu ii nėeni ngi wė*, "my smell is not sweet to him."[19] All of this lends resonance to the fact that Sowo's nose is sharp and delicate and, like the mouth, small and nonfunctional. Above all speech and sexual provocation, she is discreet in a fundamental olfactory sense as well. The *sowo-wui* nose is sufficient to establish its reality and facial orientation but never large or gross or in any way suggestive of coarse appetites or powers of olfactory perception.

Ears, *ngoli*

The *sowo-wui* has well-shaped ears that fit into the area between the front and the back of the mask, the upper portion and the lower. As with other elements of its design, they are not natural in size or shape, but are elegant approximations. In contrast to the proportionally deemphasized nose and mouth in *sowo-wui* sculpture, the eyes and the ears are accentuated and glorified. Eyes are accented by length and slitting, whereas ears are accented by projecting powers of the Mende cursive scheme in relief which usually represents them. Mende people regard the ear as a marvel and have given it much attention. The ear stands for hearing in the Mende language; *ngoli ve* means "to give ear," to listen. In everyday life, the ears (along with the eyes) are the instruments of learning, and are expected to be sensitive and acute. More profoundly, however, Mende ideas about the ear relate to sexual eroticism, to the dual nature of human beings, and to concepts about the continuum of life (fig. 61).

At an early age, a Mende child begins to fuss with his or her ears. Parental admonitions to wash inside, around, and behind the ear, and fears that something will "get into" the ear, all tip off the child that, like the mouth and the genitals, ears are something special, with a prohibited dimension. Adolescents learn to play with the ear, tickling themselves or friends of the same gender, with a feather or a leaf. The community notes a teenager's flushed pleasure as another sign of developing sexual maturity and loss of childhood innocence. Later, as lovers, in foreplay couples will tease and caress the ear as a way of arousing desire. Later still, as older persons, an individual will absentmindedly toy with his ear in public, and is excused now for this harmless self-indulgence.[20]

Although a newborn's capacities for seeing, smelling, and tasting are not fully functional at birth, it already can hear perfectly well. And though it may be years before the baby can stand, talk, or walk, and fourteen to sixteen years before its body is fully matured—still at birth the ear is *all* that it will ever be; it is the one thing that a human being comes into the world with that is optimally functional. Not only is his prenatal hearing mechanism fully functional, but also the baby has had round-the-clock practice using this one, particular, sense. Western science has learned that

61

the ear of a human fetus is fully developed and operational by the sixth month after conception. For the last twelve weeks of its intrauterine existence, the embryo, floating in its liquid universe, has been rocked by the loud, rhythmic, nonstop beat of the mother's heart.[21] Frequently, the fetus reacts strongly to certain external sounds, moving and kicking in response to a sharp noise or throbbing music. Because a mother knows that the unborn can hear, Mende women talk and sing to the child while it is still in the womb.

At birth an infant responds to sound in a way that is visible to its parents. The newborn can distinguish the mother/food supply sounds from others and in general shows little interest in any other noises unless they are too close and threatening. Harsh sounds irritate or frighten infants, making them freeze or cry. Soothing sounds elicit coos, reaching-out, and, in a few weeks, smiles. Mothers are convinced by a baby's gurgles that it understands what is being said, so into the infant's ear she pours her heart. The newborn is her confidant, the keeper of all her secrets. The mother will tell him or her of her loves and hurts and dreams—she is greatly attached to the infant as a friend, and the infant in turn is constantly stimulated by the music of the human voice. Babies are born with acute musical sense: they can distinguish tone, rhythm, pitch, direction, and intensity, and react to musical changes. The rhythmic beat it remembers is now joined to the mother's loving voice as the sweetest and most satisfying sounds to its ear, a taste which the Mende (and most other people in the world) will cultivate and retain throughout their lives.

These physiological facts influence Mende thought, and the latter system is in turn reflected in the Mende handling of this key aspect of gross somatic structure in sculptural form. Mende believe an individual is part of a chain of being that links the dead, the living, and the not-yet-born. These concepts are made concrete in the entity of the ear. This is how the thesis develops. First, before a baby is born—while it is "still a stone in the water,"[22] Mende believe it can hear and *respond* to what it hears. Response in the fetus indicates that the ears are *alive* before the baby is born, before the other senses take on life and responsiveness. Then, Mende say the ear maintains integrity of design throughout a person's life. The rest of the body will change dramatically but the ear remains as it is. This permanence of its shape is correlated with mythic continuity of function; for example, at death, when functioning of the body ceases, Mende think that the ear *remains alive*. All other parts of the body show signs of death and are observed to decompose rapidly; the ear, always cool to the touch and bloodless in most persons, seems to resist corruption.

Mende say: *Ngoli nda ii haa ma,* "There is no death [within] the ear," the ear never dies. As an outcome of this belief, relatives of a deceased person visit the corpse and talk into its ear, giving it messages to carry to the spirit world.[23] Hearing, understanding, signified by the ear, is the one faculty we

bring with us mature from the place and time before birth, the spirit water world from which we come. Since the ear is not corrupted by death, we still have hearing after our life is over. The ear alone has the capacity to span the whole of a human experience, and by functioning in both the physical and the spiritual world, it can be seen as an icon for the metaphysical, supernatural dimension of existence.

Sculpturally, these powerfully allusive qualities converge in the graphic suggestion of a chaste and spiritualized closing down or diminution of the senses. Mende have a notion that we "see" with our ears and that our ears are organs of perception for seeing the invisible and what is wrapped in darkness. This may possibly explain at a purely intuitive level the cut which on some masks unites the slit of the eye with the center of the ear. More-over, just as the eyes are closed, so Sowo's ears are literally, plastically sealed. She is not open to spoken blandishments, flirtation, enticement, seduction, persuasion. The ears are another sign of Sande immutability—implacable judge that cannot be influenced, chief that cannot be swayed, witness that cannot be bribed. The ears are a mark of the sovereignty of Sowo; it presents the blank stare that all high ritual objects in Mendeland present. There is no way to fondle or cajole your way into Sowo's graces. It is not a casually hearing person; it is a piece of wood representing a stone that is cool, detached, not moved by pain or pleasure, operating at the level of essence and truth.

Eyes, *ngama galè*

Mende consider the eye the supreme element of the body. Eyes are the most important of the sense organs, the most interesting component of the head, the most useful human resources, and the most beautiful physical attribute. The light of human life gleams through the windows of the eyes; bright eyes show the vitality of life itself. In illness and old age, with any waning of life force, the eyes dim; in death they are closed and dark. Eyes mirror the mind and heart; they sparkle with intelligence and joy. To the moralistic Mende, eyes are goodness, because although the rest of the face and body can be controlled, the eyes always reveal genuine feelings and tell the truth. Mende share this preoccupation with eyes with the rest of man-kind, of course; but Mende are unusually articulate in their observations of the eye. What interests us here is what specific ideas about the eyes find expression in the characteristic *sowo-wui* slitted eye.

Many *sowo-wui* have cicatrization marks at the corner of the eyes, or just below or above them. Enquiries about their meanings bring conflicting views. Short lines at the corner may show that the mask is from Mende/Sherbro coastal areas, but some folks say that such lines are adopted by the carvers to focus more attention on the eyes. Short parallel lines under the eyes may be in imitation of identity marks formerly favored by the eastern Mende, although today it is rare to see scars on a Mende's face. Other

informants suggested that these short parallel lines may be above or below the eyes to recall the scars given in rituals to strengthen fearful persons who desire protection against illness, rivals, snakebites, and other daily dangers. Cicatrization, then, seems a minor feature of the *sowo-wui* face.

An indication of the importance Mende accord the eye is to be found in the word itself: *ngama* means both face and eye (Innes, 1969:102); the essential fact of the face is that it contains the eyes, and the eyes in turn *are* the face. When wanting to refer specifically to eyes themselves, Mende say *ngama galè,*—literally, "the seed of the head." The *galè* type of seed is usually a pit in a piece of fruit (*kalè,* ibid.:39); the image of a peach, for example—flesh around the core of a seed that germinates the tree itself— gives a fuller feeling for this idea of the seed and the eye.

Ordinary people have two eyes, the pair counted as "one eye"; but those with supernatural powers have two pairs: one for seeing the mundane world, the other for seeing into the spiritual domain. A Mende will say of a divine that he has "two eyes," *ngama fele,* or is "twin-eyed."[24] "Two-eyed" persons are part of that class in the Mende community who provide the tools or conditions for the success of others but who are themselves poor and rejected. Someone who sees spirits or who can divine is usually relegated to the fringes of respectable society and is only approached in times of trouble. Should parents suspect their child of "having eyes," they will anxiously implore the *mòri* men to restore her to normal so that she will not suffer a life of misery.[25] To remove the trait requires a ritual called *ngama lufe. Lufe* (from *ndufe*) means "to extinguish the eye," "to blind someone" (Innes, 1969:98). The object is to destroy the sight of the second pair of eyes so that the child only has use of the earthly eyes. In more traditional practice, the Sowei or other Mende specialist will deal with the problem in a healing called *ngama wua,* to wash the eyes. Using a decoction of leaves and herbs known as a *sawa* (ibid.: 110), the Sowei will wash away the second eye and restore the person to normal.

But in the village there are some other persons who long for extra capacities, whatever the psychic or social cost. For them there is another kind of *ngama wua* ritual, a wash to attempt to endow them with "two-eyes," with all the concomitant advantages and dangers to all.[26] Sowei herself, as head of the Sande Society, has all the powers of double vision, tempered for the benefit of the community. When the carved eyes of the wooden mask are allied to the eyes of the dancer, a Sowo becomes a "two-eyed" creature with all the attendant mystical powers; the mask-head forms a Janus with the head of the human being inside; she, with her human eyes, has added to her all the power of the mask's eyes to see inside the spirit world.[27] So one other element in a Sowei's authority comes from her having the mask in her possession; hence the capacity to acquire knowledge through supernatural sight.[28]

As a necessity of the form, eyes of the *sowo-wui,* mask-head, are always

heavy-lidded, downcast, the opening the merest slit. The shaded eye appears often in certain modes of West African sculpture as a feature of masks described as serene, beautiful, inward, contemplative, feminine, all-knowing, powerful but restrained. Now we are able to give direct interpretation of the *sowo-wui* slitted eye based on Sande and Mende concepts. The complexity of the slitted eye as an icon in its own right is demonstrated in part by the fact that there are no less than six separate meanings, some mundane, others metaphysical, that relate to the narrow opening of the *sowo-wui* eye.

1. The slitted eye conceals the personal identity of the *sowo-lolimò*, masked dancer. To Mende, eyes are the most distinctive feature of a person. (Feet, on the other hand, are anonymous, and traditionally Sowo was danced barefoot with no loss of secrecy.) The slitted eye effectively prevents the audience from ascertaining which individual is dancing inside the costume. Some masks have no openings at all in the eye spots, guaranteeing secrecy (fig. 62). One of the carvers now at work, Moussa Kanu, from Bonthe-Sherbro in southern Sierra Leone, has made the closed eye-hole a mark of his particular style; dancers see through two slits concealed among the neck ring incisions.[29]

2. The slitted eye is a ritual screen; it prevents any person from looking directly into the Sowo's eyes. For both social and religious reasons, a Mende dare not look at Sowo directly; Sowo is too exalted a personage. The eye-to-eye gaze that a westerner considers forthright and honest, a Mende finds exceedingly rude and disrespectful. Further, Mende believe that denizens of the spirit world have distinctive eyes; living in the spirit world marks the eyes—they lose their clarity, and the iris appears to be covered by a milky film. Hence, the Sowo eye should not be a clear, human eye, but a veiled, supernatural one. Thus, no one is allowed to look closely at the mask's portals of perception. The slitted-eye motif precludes it.

3. The slitted eye is calm and inviting. In ordinary circumstances, a Mende's eyes are wide, bright, and darting about. Fast-moving, open eyes indicate mental nimbleness and a wary alertness. The slitted eye, on the other hand, is "dulled," the brightness dimmed a bit, the activity slowed down. "The eye is sleeping in the head"—that is, it is relaxed, secure.[30] The gentleness of the sleepy eye attracts both men and women; it is uncritical, unthreatening, and thus comforting and receptive, making one desire closeness.

4. The slitted eye is alluring, flirtatious, sultry, quickening the blood of sexual desire. Many Mende women cultivate this "dreamy look" because men find it ravishing. When an eye is slitted it can only look a short distance straight ahead; by shutting out everyone and everything else and then focusing her gaze exclusively on her beloved, the woman invites dalliance and promises a warm response. An air of romantic privacy encloses the couple and assures intimate exchanges. One of my preceptors explained

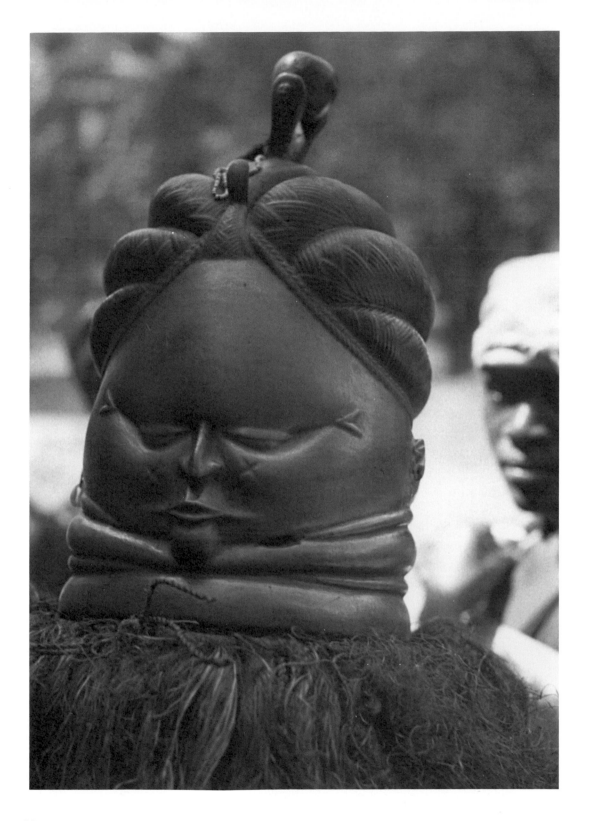

that Mende know passion narrows the vision and blinds one both to one's surroundings and to the implications of one's actions. In making eyes at the opposite sex, in fondling and petting, we all "lose sight" of the larger world and matters of prudence and practicality. "I don't know if its cloudy or bright; I only have eyes for you."

5. A slitted eye is the sign of a chaste woman. Paradoxically, the same lidded look that excites a lover reassures a husband. A husband watches his wife's eyes when there are young men around; a modest, virtuous woman keeps her eyes to herself, obviating even chance eye contact with the men of the town. The association with slitted eyes reflects the community opinion of Sowei themselves. The message of the closed, unsmiling mouth is mirrored or amplified by the narrowed eyes: this is a serious woman, above the usual amorous games and intrigues.

6. The slitted eye reinforces the silence of Sowo's presence by effectively preventing the dancer within from communicating through Sowo's eyes. Mende eyes "talk," speaking through a repetoire of barely discernible, but powerfully significant, movements of the balls, lids, and brows. These are codes of gesture, particular to couples and small groups, agreements of secret meanings, linking close kin, friends, or society members. The "language of the eyes" is well known the breadth of Mendeland; to a Mende, eyes, not actions, speak louder than words. For Sowo to be correctly silent, not only must her mouth be closed, but her eyes also.

In conclusion, ear and eye, like mouth, are materially "blind" to indicate, in subtle equilibrations of silence, shade, and calm, an inner force beyond measure or conventional belief.

Forehead, *tawa*

As Sowo dances, her generously endowed forehead glints in the light. The forehead is pure sweep and space amidst compacted detail; it is clear and open while the rest of the head is closed and guarded. By its mass and volume we know that the brow is meant to be the outstanding iconological feature of the mask—a vision of clarity, smoothness, and illumination. Memel-Fotê offers an approach to interpreting the Sowo forehead: "When the Negro artist accentuates, gives prominence, hypertrophizes some part of his plastic art, literature, or music, one would say it is precisely to reveal the significance of that particular aspect and to impose it. Inequality of significance explains and justifies the characteristic and notorious disproportion of work of African art" (1968:56).

The fine forehead alludes to Sowo's womanly beauty, nobility, sensitivity, and purity. The *sowo-wui* is described as *gbɛlɛ̀n* (literally, "gently"), a word that leads to associations of beauty with patrician personality. *Gbɛlɛ̀n* is a way of doing things in a well-born manner that bespeaks privilege and high social position. Mende say, when admiring a graceful, elegant young lady, *Ngi jia yii yaa gbɛlɛ̀n*, "She carries herself in a refined manner, in a

noble manner." *Gbèlèṅ* is not rough; it is soft and soothing; it expresses delicate sensibilities, gentle feminine feelings.[31] The *sowo-wui*'s fine-textured forehead indicates freedom from toil in the sun which thickens and toughens the skin, while a leathery forehead is thought to indicate a coarse makeup and low community status. A forehead without wrinkles symbolizes youthfulness, *foninge*, soft, smooth, prime well-being. Without blemish, shining in the light, a *sowo-wui* reflects an image of purity coming from water cleanliness and renewal.

But the sheer size of the brow is striking; it is so exaggerated that we must take its message to be of prime importance (fig. 63). There seem to be two associations to the brow, and both relate to the whole of the personality. The broad forehead, we shall see, is an icon of poise and success, the readiness to cope with life's challenges and the ability to triumph over them. Character and personality reside on the forehead, and it is very much a window into a person. "The brow is the parlor by which you enter into relationship with another person." In sincere and earnest conversation with an equal, a Mende will fix his gaze on the other's forehead. Even when addressing a superior, especially when answering questions, he is permitted to look at the senior's forehead and thereby to give a full view of his own face and eyes.

A person whose brow is in full view is considered strong or sound of character and ready to meet society's challenges. When the brow is covered, Mende question what is wrong with the person. It is considered a way of declaring that all is not well, of excusing oneself from social participation. A woman's brow is more expressive and important than a man's because most men go about with their heads fully exposed, while a woman can use a kerchief to cover parts of her brow. When she is ill, grief-stricken, or sorrowful, a woman will pull her headtie down to cover her eyes. By this action she coddles herself and tells the world she would like to be left alone for a while.[32] Sowo rejoices in undertaking full adult, female responsibilities, is free of physical or emotional indisposition. The broad expanse of Sowo's brow proclaims, in Sande terms, the ideal poise founded on self-confidence and inner security.

A very old and elegant blessing, *Ṅgewò a bi lawa wòlò*, "May God make your forehead big" (Harris and Sawyerr, 1968:126), makes clear the connection between an augmented forehead and success (fig. 64). To Mende, as to many other West African peoples, the forehead is the "lucky spot," the point on the body that received good fortune. The good that is coming to a person actually arrives upon his forehead. It is where prosperity enters a person's life. When prosperity is within a person's grasp, Mende comment, *Hani na ngi lawa*, "It is there now on her forehead." When your ship comes in, it will dock on your forehead.[33]

As among Yoruba and Igbo, when a Mende spectator wishes to reward an entertainer he presses a coin onto the person's forehead to show his

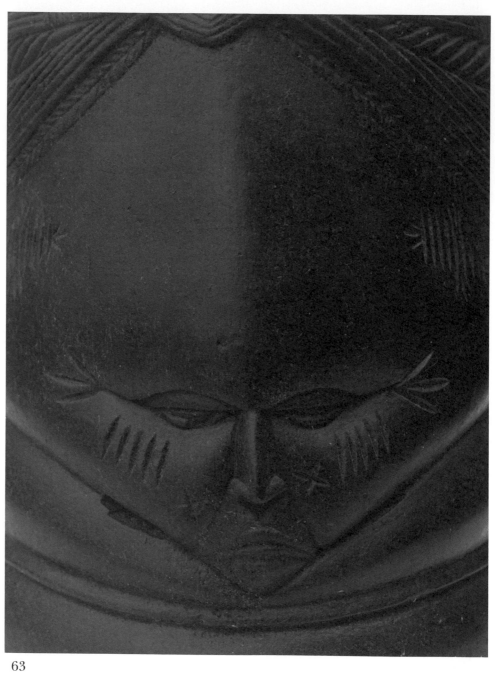

63

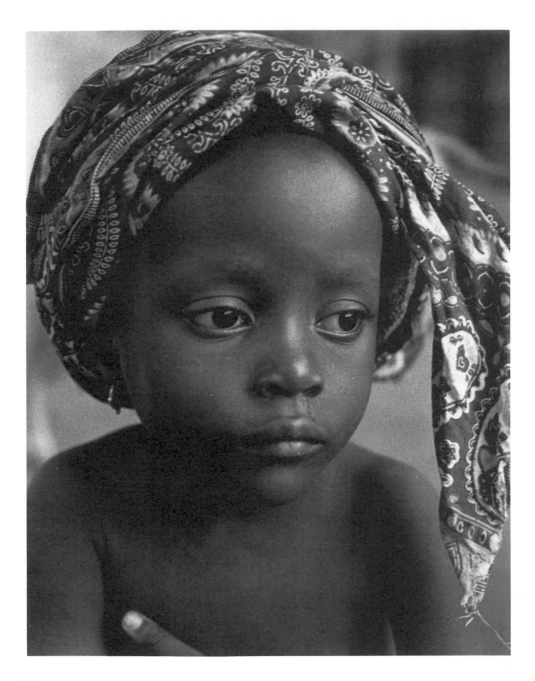

64

pleasure. And, even more profound, when a newborn Mende baby is strong enough to be presented as a new member of the community, the ritual involves blessing his forehead: "The one after whom the child is to be named carries the baby outside the house, announces the name, pronounces blessings, and then spits three or four times as appropriate on the child's forehead" (Sawyerr and Todd, 1970:30).

A relatively large forehead on a child predicts a future of fame and riches. Alternatively, when an adult is successful and prosperous in his affairs, it is thought that his forehead grows bigger! Prominent persons, wealthy and respected persons, famous and powerful persons—of all of them it is said, "He has a big forehead." The reasoning: good fortune comes to the forehead; thus the person whose forehead is broad has a larger space for a greater portion of prosperity; the wider the forehead, the more good can come to him. The *sowo-wui* forehead is thus the biggest one ever seen. On that vast brow rest the riches of this world, and all the treasures of the next.

Coiffure, *ngufèlè*

The top of every Sowo mask is carved to represent braided hair, and the style of hair braiding is one of the mask's most individualized features. The hair crest always displays axial symmetry around the facial vertical line, maintaining the mask's harmony and balance. Though *sowo-wui* hair may bear some resemblance to the way Mende women actually wear their hair, the mask's hairstyle is always grander and more distinctive. The coiffure must be elaborate and pleasing, crowning the head of Sowo with elegance and wealth. Every *sowo-wui* displays a full head of hair plaited into a design, so both the quantity of hair and the hairdo pattern are significant for us. A woman's hair should be thick and full; on a *sowo-wui* this long, thick hair is the first exclusively female characteristic that we have so far considered. This discussion reviews some of the material on hair presented in chapter 4 in order to extend it further.

"Big hair," "plenty of hair," "much hair"—West African communities, including Mende, admire a fine head of long, thick hair on a woman. Both these elements are crucial: thickness and length. Thickness equals increase in the number of individual strands, and the length is proof of strength. Growing such luxuriant hair requires a Mende woman's patience and care. Because a man's hair is kept shaved or cut close to the scalp, people say that "men don't have hair." Beautiful hair thus is a distinctly female trait; the more of it, the more feminine the woman (fig. 65).

Great hair is praised as *kpotongò*,—literally, "it is much, abundant, plentiful" (Innes, 1969:62). The root word, *kpoto*, is most often said about fruits on a tree, rice, and other growing things, and about things of a kind that can be pulled together and tied. When referring to hair, *kpoto* means long and thick; Mende think the salient quality of hair is that it grows, and *kpoto*

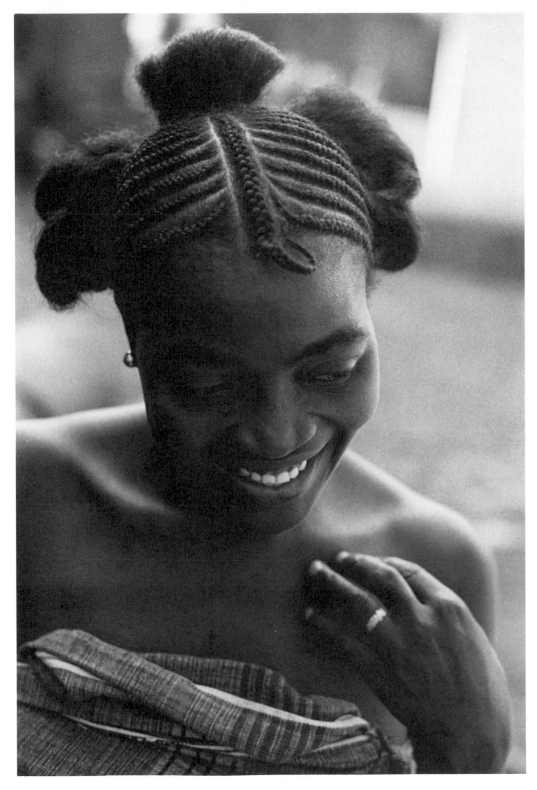

denotes an abundant, numerous quality of growing things. *Kpoto* objects can be tied together, inferring the way hair is styled, using threads to hold it together, and the way the hair is woven together in plaits and tied at the ends. Other hair words play on this analogy between hair and flora, one growing on a woman's head, the other on the earth's surface. *Kpèndèngò* is a word meaning "stunted, not growing robustly"; it describes hair that is short or thin (ibid.:60). The opposite term, *pòpòòngò,* indicates thick growth, luxuriance like a farm or forest (ibid.:126). Hair that is *pòpòòngò* is growing in abundance as it should.[34]

These ideas about hair reinforce Mende identification of women with *Maa-Ndòò,* the Great Mother Earth, the female principle of God Almighty.[35] Trees, plants, scrubs, vines, bushes, flowers, herbs—verdure is "hair" on the head of Earth Mother, just as the hair on the head of a woman is her flora, her foliage (fig. 66). Plants and human hair have, in essence, the capacity for growth and increase. A woman with long, thick hair demonstrates the life-force, the multiplying power of profusion, prosperity, a "green thumb" for raising bountiful farms and many healthy children. Coiffure, therefore, encodes yet another prayer for life, more abundantly.

As westerners, it is difficult for us to appreciate the communicative power Mende attribute to women's hair. The hair must be well-groomed; merely to be presentable, a woman's hair must be clean, oiled, and plaited. For the sake of elegance and sexual appeal, hair must be shaped into beautiful and complicated styles (fig. 67). Without exception, the hair of a *sowo-wui* displays a neat, beautiful hairstyle. The entire hair area, like the very best human hair, is smooth, shiny, with a well-ordered appearance. Hair, to remain well-groomed, demands constant attention. Black hair is easily mussed, and if not cared for consistently, it quickly mats into knotted hangings difficult to comb. The opposite of well-groomed hair is *yivi-yivi*—untidy, unkempt, messy, without shape (ibid.:154). Dirty, disorderly homes are *yivi,* chicken coops are *yivi,* political chicanery is *yivi.*[36] Such disheveled, neglected hair is anathema to Mende. It signifies insanity. Those few who buckle under the strains of everyday life, retreating into madness, signal their illness graphically by no longer grooming their hair, thus abandoning the community's standards of behavior.

Only in bereavement may a woman leave her hair loose; otherwise, it must be tied or plaited, "under strict control." Mende culture finds it morally unfitting to leave the hair unarranged and equates wild hair with wild behavior. *Ngufulo,* "unplaited hair," has an extended meaning. *Ngufulo-mò* is literally "a person with unplaited hair," but its idiomatic meaning is "a woman of loose morals" (ibid.:110). When a woman's hair is loose, people assume that she began the day groomed but her hair became undone during love affairs. Playing with the hair is one of the pleasures of sexual intimacy. A Mende woman shows her acceptance of a man by letting

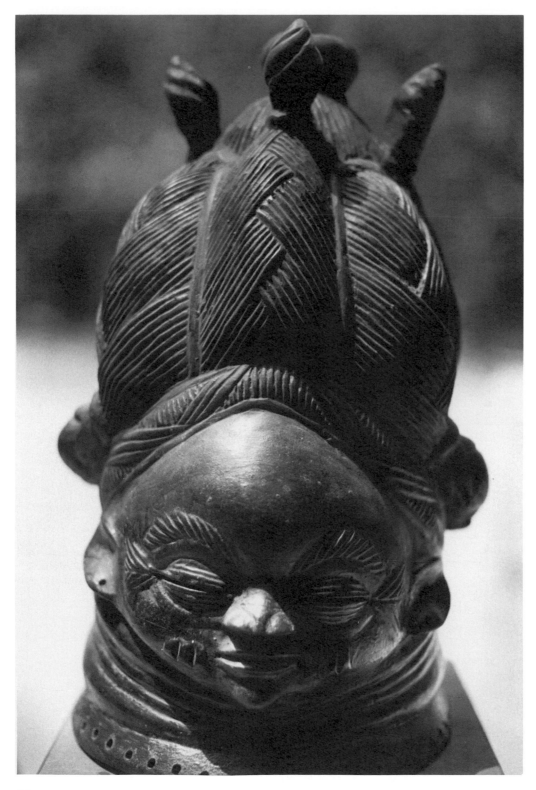

66

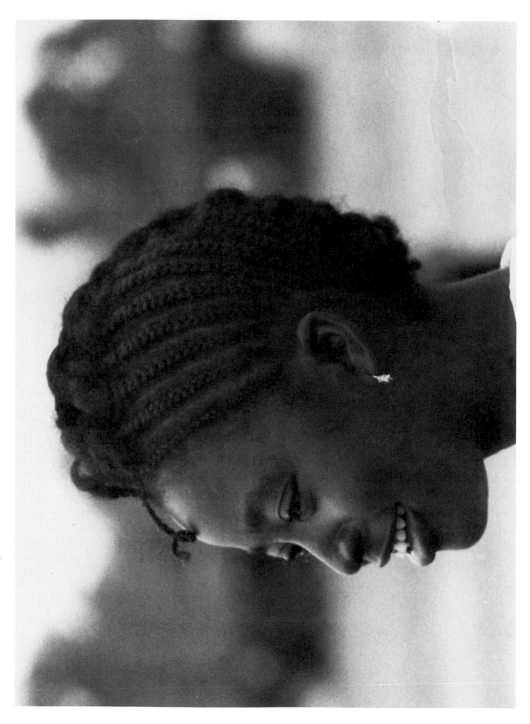

him do what he likes with her hair. A man will be "touched and moved all over" if he can put his hands through a woman's hair and rub and tease the scalp.[37] Mende men love to undo the woman's hair arrangements; it gives them feelings of great privilege and mastery.

Men find hair sexually seductive, and well-braided hair pleasing and attractive. Whether in a romance or a marriage, a woman always goes to a man's room with her hair neat; and if she wants to make a special impression, she will sport a new and elegant style well done. Since the woman would have left her quarters with her head under wraps so that others will not see her hair, the man will have the flattering feeling that she went through so much time and trouble to fashion herself for his eyes alone. Even in the *mawè* compound, when a wife has only to walk a few yards to her husband, she will follow the rituals of "going to a man's room" and arrive in a headtie covering her coiffure (fig. 68). In turn, as a love token, a man will gladly pay the person who creates a pretty style for his girl friend.[38]

Elaborate hairdos are the result of patient hours women spend in braiding, threading, twisting, and shaping each other's hair. The one woman must be willing to do her hair, and the other must trust her enough to let her handle her head. Their hair-braiding sessions are a time of shared confidences and laughter; the circle of women who do each other's hair are friends bound together in a fellowship. For the hairdo to be successful—crisp, every strand in place, symmetrical—Mende say the particular working space must be cleared of animosities and be full of goodwill and harmony.

Offering to plait another woman's hair is a way of asking her to become your friend. A beautiful, distinctive style is considered a gift of love. The informants suggest, and field participations confirm, that it is one woman saying to another: "I like you. I appreciate you. I have thought about you enough to imagine a style that will suit and enhance your features. I am not jealous of you. I *want* you to look beautiful so that you will attract love, admiration, and all the good that these bring. I am willing to stand or bend for several hours, working on your hair, expecting no remuneration. My sacrifice proves that I want only the best for you." Thus, braiding someone's hair is indicative of ideal care and love, the concrete contribution of one woman to the success of another.[39] The excellence of the Sowo coiffure connotes excellence of social relations and perfected modes of human discourse and dialogue in patient communal effort (fig. 69).

One of the mask's most individualized features is the style of hair braiding. Many masks display reproductions of standard styles worn by Mende women. These hairstyles change constantly according to innovations and elegance. Mende connoisseurs divide the styles into categories of "loose" and "tight" and identify the loose with old women and tight with young. Loose styles, not at all elaborate, feature four or six bulky plaits made to

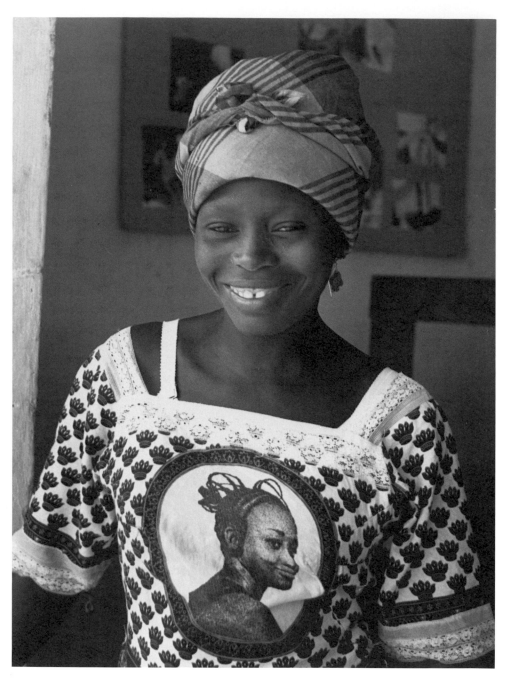

68

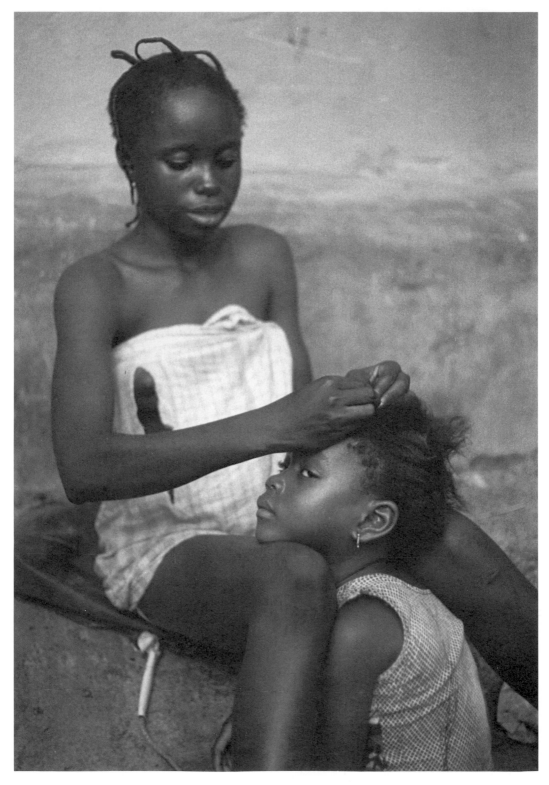

69

look soft on the scalp. Old women are past being willing to endure discomfort for the sake of fashion. They lack the patience to sit for long hours to have their hair done, and they find a tight pull on the scalp irritating. Younger women, keenly concerned with making a good impression, are not bothered by such things. Consequently, the masks with intricate hair designs are considered to represent young Sowo, and may be carved in honor of a precocious Sowei, a young dancer, or an image of a chief as a young woman.

The permanence of the perfection of the *sowo-wui* coiffure is a mark of its supernatural status (fig. 70). In contrast to Sowo's raffia costume where "hairs" are always getting tangled, the mask-head, where the elegance of an icon's hair is most evident, preserves a pristine, ageless immunity to the vicissitudes of life. Further, gloriously "cut" hair, like neck rings, has shades of meaning that recall the mask's emergence from sacred waters. It is known among Mende that all the "water people," angels, have marvelous hair. The mermaid *Tingoi* is known by her long, wavy hair and her glamorous habit of dressing it with a golden comb while seated on a rock. A little girl with especially long hair is feared to be in danger of drowning because she will be very attractive to the "water people," who may think she is one of them and wish her to join them. Mende people believe that the "water people" crown any woman who visits them beneath the rivers with a beautiful hairdo. Thus, according to informants from Bagbe Chiefdom, Bo District, a diver who retrieves blessed *sowo-wui* from under water goes under the currents with hair unkempt. When she returns, triumphant, bringing masks and Sande ritual objects, her hair is braided elaborately, a miracle proving that her feat was genuine, that she was indeed entertained by the divine ones of the deep.[40] And the most telling example: during the Sande initiation session, the girls are believed to reside under water. When they are ready to rejoin the community, they rise from the waters, displaying magnificent hairstyles more dazzling than any that could be "done by human hands," a beautiful sign of their favor with the heavenly.

All this links up easily with the popular assumption that the best *sowo-wui* are supernaturally created. As proof of this contention, Sande points to the coiffure: it is so smooth, so delicately carved, so finely fashioned, so intricate and elaborate. Surely such results are beyond an earthly woman's capabilities and prove that the mask beckons from a better world.

The ruling mask, the sacred sowo-wui, is the essential, pure form and the superior object.

Sacred *sowo-wui* are taken from the water in a reenactment of mystical origins; they seem to possess a special aura of mystery and power and engender awe and holy dread in the spectator. By definition, masks wrested from rivers are fashioned supernaturally and come to earth from paradise. The community regards these masks as the finest, the most

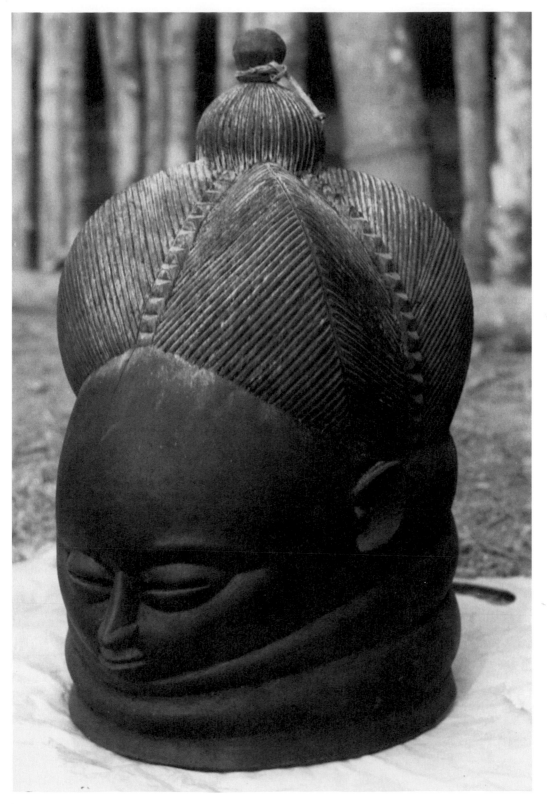

70

beautiful, and the most cherished. It stands to reason that, since these heads come from the water, from the Holy Source of all Beauty and Life, then *they must be complete*, must be the entirety, the pure, the whole. They are the divine summation of Sande and thus cannot be imagined to lack anything.

On parade these mystical masks lead the others; upon seeing them, informants report being awe-struck, overwhelmed, overcome: *Muamua nya huveilò*, "I was filled from within with awe." And, *Muamua a lelo a bia,* "Awe and dread have overcome us." They feel they are in the presence of something wonderful and holy. The descriptive word for such masks is *muamua*, translated by Innes as "sudden fright, panic, terror, fear, a feeling of being in the presence of the supernatural" (1969:88). A young nurse from Bo said *muamua* is the sensation of "seeing something super, strange, surprising, a bit frightening." To the Njala preceptor, *muamua* is "thrilling, has to do with fear, like when seeing a dead body, or a ghost." To the Bo preceptor, *muamua* is the "feeling of awe, of being overwhelmed with the power of the spiritual world."

An interview with a carver, B. K. of Maleu Chiefdom, is a clear statement of the difference in masks that I had conjectured. "Some masks are found in rivers by a special set of women called *Sande wumbubla*. These masks are made by the underwater spirits, especially those connected with the Sande Society. The underwater masks are black just like the ones we carve here. They have the tear marks in the corners of their eyes. Their necks are segmented. The only difference is that their hair is plaited in bundles, in thick handfuls: *Ti wundièi houhoungò ngili ngilingò*" (August 1977). People of the community can distinguish these special masks and,— as Chief Foday Kai indicated to me which among a gathering of Sowei was a "water Sowei"—will reveal them to uninformed visitors. But there is very strong evidence that the hairstyle and the white headtie clearly identify these masks, so there is no confusion. All the mystical masks I have seen, and photographs of masks with white headties, feature a hairstyle of full plaits in a style called "Sowo's cap." If we follow Sande logic, then we see that this mask with its full, thick hair arranged in a style for older women represents the complete, the pure, the essential, the essence (fig. 71).

The culminating stage of the Sande initiation ritual confirms all that we have learned about a sacred *sowo-wui*, recognizable by its grand, dignified coiffure of thick hair. At the end of the novices' training period, and immediately before they are released from the session, they are led to a stream for a ritual bath. Mende from the eastern region call this ceremony *Ti bòlòi wèè*, "put on their cap." First the girls are washed clean of the *hojo* clay. Then their hair is lathered with soap, making it thick and malleable, able to hold a style. Now sudsy and *white*, the hair is shaped into soft coils and pulled up on the head to make a small topknot. This is "to make a headdress like the mask," and "to make the girls look like the cap." "It imitates the Sowo head and shows that the girls are part of the Society."[41]

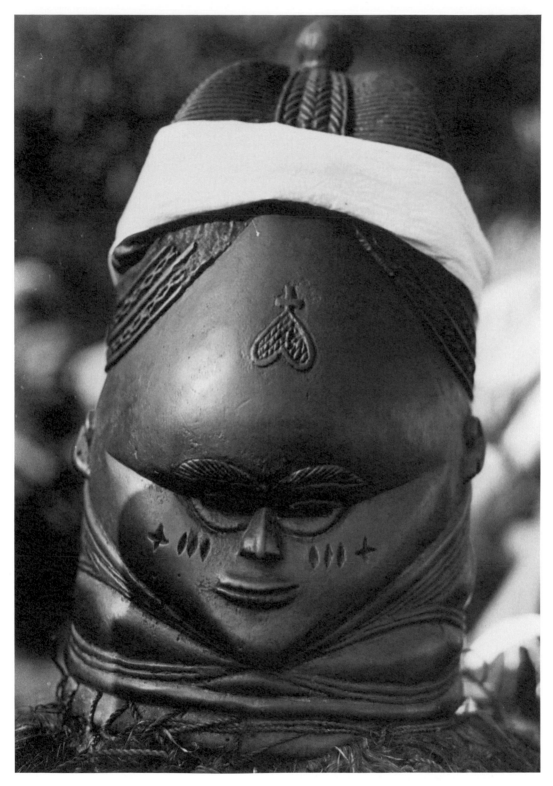

Alternately, in the southern region, the final day of the initiation cere-
monies is called *Sowo gbuaye le voloi ma,* "day of putting on Sowo likeness,
the day on which the likeness, true image, of Sowo is born, given birth
to."[42] These images from deep Sande ritual inside the *kpanguima* give us
the evidence we need for finally deciphering the crucial meanings of the
sowo-wui. To make a "likeness of Sowo," the girls are first coated com-
pletely in *hojo* clay so that they are chalk white all over (except for the
hands); then they are dressed in white clothes and adorned with white
beads. On their heads they wear "Sowo's crown," a crocheted black cap
bolstered from underneath with cotton wool to give the appearance of a
pile of long thick hair that is drawn up into coils, not plaited into a style (fig.
72). This is "a way to make them more beautiful," "to make them look like
Sowo." When I asked for a translation of *Sowo gbuaye,* I was told "Sowo's
cap," or "Sowo's crown." Only after I had countered that the Mende word
for cap is *bolo* did they say that *what causes the resemblance to Sowo is the
headgear,* so in this context the meaning of *gbuaye* is "crown" or "cap."[43]

While wearing "Sowo's crown" the girls are now *Poma Jowei,* "future
Sowei," "the Sowei of posterity." The girls experience in this ritual mo-
ment the future time when they will be older and wiser, when they will be
ngumò,—"a person with a head," a person with a discerning mind, a per-
son capable of drawing correct conclusions from her observation of things
and events. The pictures show the girls solemn, of serious mien, eyes half
closed, not laughing or smiling, or girlishly giggling. They are aloof and
quiet, "like the mask." To further relate these crowns to the sacred marks,
the *Sowo-bolo* are decorated with white ribbons,—ribbons that recall the
white headtie of the Sowei and the white streamers attached to the Sowo
mask-head when it is the sacred *sowo-wui.* The cutouts of flowers on the
head and at the ear give a decorative *nèku* touch of sweetness.

These rituals in which the new initiates show their enlightenment by
appearing in the image of Sowo's head, reinforce other data, making it
certain that these *sowo-bòlò* masks are sacred. Initiates and masks are born
of the water, the initiates come from the *kpanguima,* spiritual waters, the
mask from the depths of the river. The girls are presented ceremoniously,
newly created by the Society as ready for the highest responsibilities of
womanhood, their heads adorned to resemble Sowo, in the *sowo-bòlò*
hairstyle of the mask, taken ritually from the water. As women and water
interact in cleanliness and fertility, proclaiming richness and order, so
water shapes hair into a crown of spirituality, wisdom, and calm.

*The dancer's mask, the adorned sowo-wui, is also beautiful and symbolic, but is
idiosyncratic and of lower rank.*

Adorned masks claim no mystical provenance. They are known to be the
product of carvers made on commission by the *sowo-lolimò,* women who
dance publicly in the Sowo costume. Every specialist dancer has a head and
costume that belongs to her privately and is kept under her strict control.

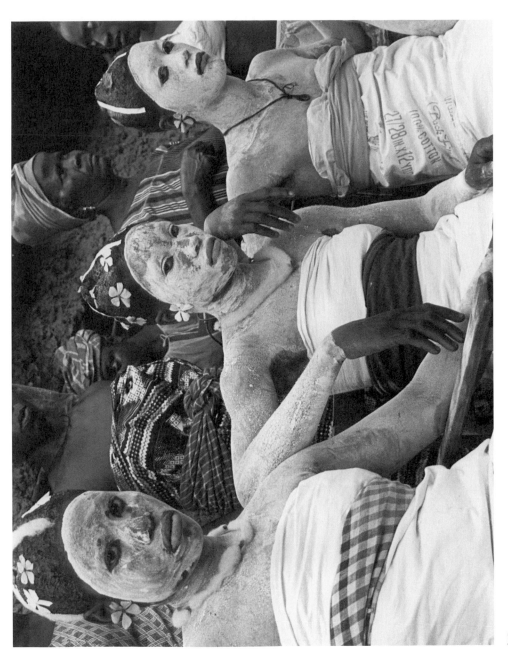

The mask is made at her request, is her personal property, and reflects her individuality. The community admires these fanciful creations. They think the adornments add "personality" and identity to the mask. In the most practical sense (always important to Mende), the differences of adornment serve to distinguish the masks: "If all the masks were of the same model it would hardly be possible to tell one from another."[44]

Over the years, in any Mende community women emerge who are gifted, serious dancers—*Ndoli Jowei,* "experts in dancing." For the pleasure of self-expression, they spend their leisure time furthering dance pursuits: teaching rudiments of Sande dance to new initiates, training *Sande yo* dancers, and choreographing Sande public presentations (fig. 73). Most importantly, they themselves are dedicated solo dancers who organize community parties and perform at various civic, lodge, and social events. The most exalted appearance for any woman dancer is her performance as a *sowo-lolimò,* a Sowo dancer, wearing the full Sowo outfit. Her particular *sowo-wui* mask is especially made for her in a size which is comfortable, and with adornments on the coiffure which are her individual choice.

The adornments all serve to enhance the fame of the dancer and help uphold her status. In Mendeland a *sowo-lolimò* is in a hazardous position. Anyone so superior to the average person and so admired for extraordinary performance immediately becomes a target of the envious and the spiteful. A woman who steps forward to dance solo is declaring her mastery and is challenging the community and the other dancers to acknowledge her claim to fame. To be so bold and so confident, a dancer must enjoy supernatural assistance and protection. This assistance must first work to make the woman prominent and then must fortify her so that she can maintain her status despite the efforts of enemies and rivals to unsettle or destroy her. Without mystical safeguards, any number of catastrophes might occur: the mask might tighten on her skull and asphyxiate her; the costume (highly flammable, of oil palm fibers) might catch on fire and cremate her; she might find her legs hobbled or paralyzed; or she might be tripped into a crippling fall. Out on stage alone, only supernatural intervention can assure her safety from satanic forces.[45]

The adornments on a *sowo-lolimò's* mask are particular, individual presentations of personally meaningful items. Supernatural assistance is perforce personal and individual—inspiration from a dream or power from a guardian angel. These invisible forces must be symbolized by concrete, visible forms. Thus, these symbolic objects allude to the power but are not the power themselves. For example, a mask with amulets probably means that its owner feels the source of her strength is a special talisman. Upon being elevated to *sowo-lolimò,* she will have been instructed (usually through a dream) to have the amulet emblazoned on the mask's coiffure,

both in recognition and appreciation of its powers, and as a warning to her rivals that she has something strong aiding and defending her. As one informant told me: "the representations on the mask are very 'useful'; they help the dancer."

In fashioning these special coiffures, the sculptor usually can exercise a bit of creativity, so the adornments may be a mixture of both the patron's wishes and his own. Thus, of a mask showing a snake and beads the snake may be the emblem of the owner, while the beads are a fancy of the sculptor. There is another interesting variation here. Sometimes the carver may be asked to depict a particular concept that the dancer feels is a central theme of her life—perhaps "perseverance" or "honesty." Then the carver is free to use his imagination to show objects or creatures to which that quality can be ascribed, again forming a kind of private symbolism, whose meaning may be known only to him and the woman until she decides to tell further someone else.[46] Not all dancers' masks are individually commissioned; rather, the carver may make several at a time and then try to sell them. Since the masks are traded over a wide area, the sculptors find it safe to include on the masks a pleasing arrangement of common occult objects, knowing full well that they have broad appeal.

From this discussion it is clear that Mende recognize two categories of Sowo masks. One is the sacred *sowo-wui,* an image composed of the essentials, for which the Sande Society claims a divine provenance. The dancer's mask is less holy; it sports a coiffure adorned with idiosyncratic allusions to cultic items and is made especially to please the individual dancer. Sande elders conceive the prototypical sacred *sowo-wui* in the classical mold, a dignified image of its awe-inspiring authority. Depiction of occult additions would be an admission of insecurities arising from earthly, daily life. Since the society is all power and knows no fears, such adornments have no place on the true, divine mask. The round, ringed neck, the serious feminine face, the magnificent forehead, the crown of thick, soft hair—limitation to these pure features serves to maintain Sande immortal above the individual, the mundane, and the transient. Sande is as eternal as a rock; Sowo is as perennial as the rivers.

ADORNMENTS

To the western eye, a *sowo-wui* with elaborate coiffure adornments is especially attractive. These embellishments animate the mask and bring some charm to lighten its austere dignity; they give play to the imagination and exhibit a pleasant individuality. Most objects surmounting the represented coiffure fall into one of five categories: (1) animals; (2) cooking pots; (3) shells and beads; (4) amulets and charms; (5) crests and crowns. In

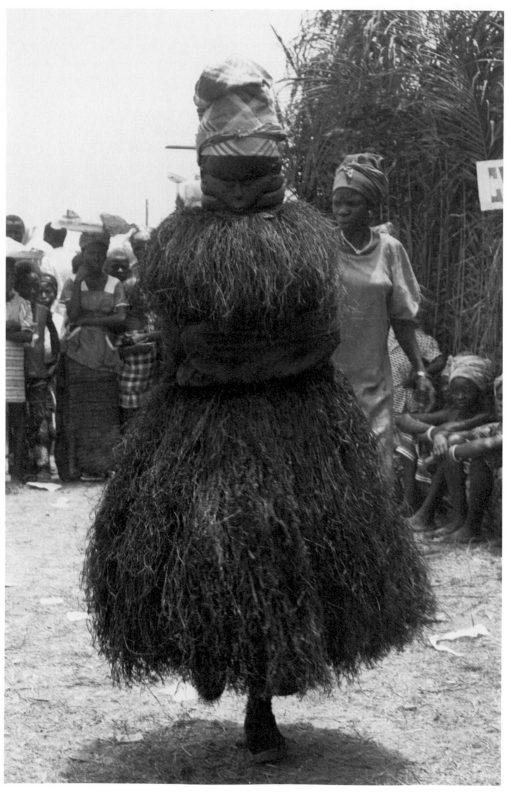

Mendeland all these items carry a mystic aura and can function on a plane of magical assertion.

Animals, *huanga*

The two animals that appear most frequently on Mende Sande masks are snakes and birds. Their inherent qualities of presentation are powerfully projected: the snake, *kali,* is coiled or winding; the bird, *ngoni,* stands upright, facing to the front, looking straight ahead. Often snake and bird appear together; here pattern emphasizes the slow, sinuous movement of the snake, the sharp quickness of its companion. Snakes and birds are distinguished in Mende lore by their connections with the supernatural. Both are liminal creatures *extraordinaire,* snakes operating between earth and water, birds between earth and air. Snakes slither on the ground, burrow into the soil, and swim beneath the waters; birds walk on the ground, perch in the trees, and fly into the wind. In their position at the edges of the elements, these animals can be intermediaries between man and the divinities. They are metaphysical messengers, actors in truth, travelers between worlds.[47] Hence snake and bird crown the crest with powers of mystic mediation (fig. 74).

The animalizing factor in Sande mystic terminology also rests on birds and snakes as creatures special to the powers of initiated women. Birds and snakes are deliberately contrasted for their high-affect powers of symbolic abatement.[48] Birds are friends; snakes are enemies. Birds are bright and visible; snakes are dark and hidden. Birds are light and life; snakes are night and sudden death. Birds are melody and sweetness; snakes are silence and poison. Birds help bring babies; snakes steal them away. A bird and a snake together suggest internecine strife; they are natural enemies—when they meet they fight. The snake bites the chicken's legs; the chicken pecks at the snake's head and eyes. Together they depict life as a battle.[49]

This makes the snake and bird motif something of a visual parable or proverb, the concretization of the idea of inevitable struggle. A Mende person looking at a picture of a bird and snake together can only come to one conclusion based on knowledge of the living animals' habits and interaction. Thus the snake-bird image is what J. Flam says might "not illustrate a literary concept but be in itself the primary embodiment in solely visual terms of a series of ideas" (1970:138). There is no way to avoid living with your enemy; he is right there in your compound, even sometimes of the same blood. And so you must be observant, wary, ready to do battle to protect yourself and those in your care. But, more important, to lift these avatars of flight and poison and to combine them quite deliberately on your head means you carry a supremely balanced load, a simultaneous submission to and control over deadly forces of war and murderous and spasmodic action.

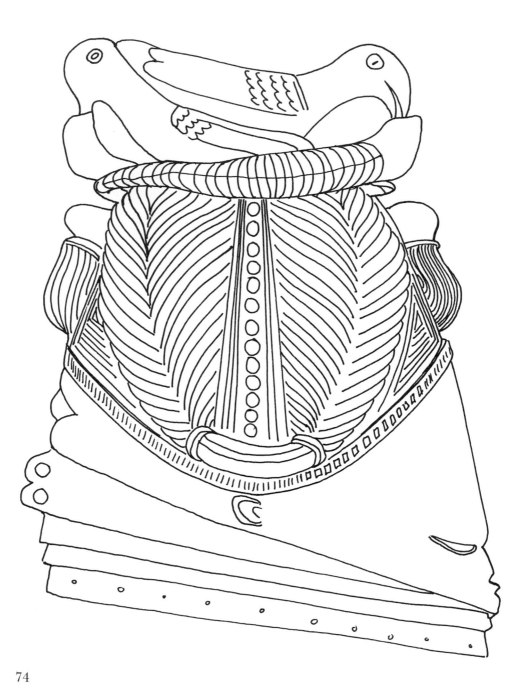

74

Snakes

Mendeland is infested with every variety of benign and viperous snake, *kali,* known to West Africa. Because of the farming rotation cycle, at any one time only about one-seventh of the land is cleared and under cultivation, while the other six-sevenths remain bush or forest, the habitat in which serpents thrive (Hofstra, 1937:106). But snakes do not remain in the forest; rather, they are part and parcel of the domestic environment. During monsoon rains, snakes come into the village seeking dry shelter because their holes are flooded. During the dry season, they come into the village in search of coolness and moisture near wells and bathhouses. In any season they come food-hunting for fowls and eggs.

Mende people live among serpents and go about their daily affairs knowing that vipers are lurking, ready to strike. Whether in the village compound or at the farmhouse, a snake is surely nearby. Every Mende must be on the alert against hidden, rogue snakes—under the bed, in a corner of the latrine, coiled around rafters, or swinging from the mango trees above. For a Mende to be able to walk about and live a normal life, he must conquer any fear of snakes. Children naturally are terrified of them, and so as part of preparing young people to be active citizens of the community, both Sande and Poro teach their initiates how to recognize different snakes, their potential for harm, and how to avoid them. It is understood that both societies give their members knowledge of the herbs which insure "against" snakebite. Such society medications are sufficient protection against serpents for everyday functioning.

Generally, snakes are considered to be weaker than man and, in a way, under man's control. Since snakes usually run from people, they are not considered fierce; and since they usually appear only one at a time, they can be killed without much difficulty. Nevertheless, at the sighting of a snake in a town or village, a frenzied alarm goes up, everybody rushes to the spot, and there is no peace until the snake has been beaten to death. This frailty of even the deadliest serpent gives rise to a proverb: *Ngela jia mia abaa gbua kali ma*—"A snake walking by itself has no respect." As dangerous as a single snake is, a human being will attack and kill it; but if there are several snakes together he will flee. So, grouping gives the individual power and respect. Alone, you are vulnerable, easily destroyed by adversaries and natural environment; but in the solidarity of the family or the *hale,* you are protected, confident.[50] It may be that this mask with its minor snake form alludes to the weakness of an isolated enemy. By extention, Sande promises that a *nyaha* can enjoy her world without fear, strengthened by the calm and courage to be gained through Sande fellowship (fig. 75).

In the rural areas where Mende live, snakes are one of the few causes of

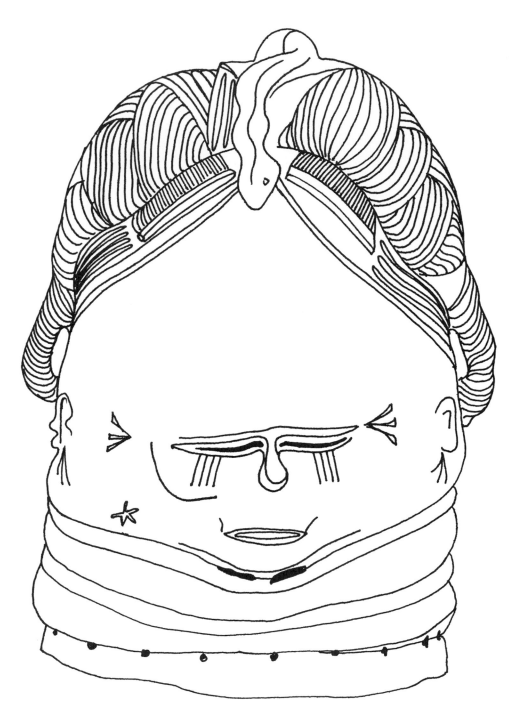

75

sudden death. Since snakes are not "supposed to" bite people, when one does and the bite is fatal, Mende think the death is the result of malevolent forces, a clear-cut case of murder. In fact, Mende tend to speak of *any* mysterious, violent end as caused by "snakebite"; and whenever a wicked, ambitious person contracts to have a rival killed, it is assumed that a snake will be sent to do the actual job. Thus, an attacking viper is regarded as an emissary of death dispatched through supernatural means on command of a human decision to destroy another human beings's life. Since this control of snakes for evil ends is transmitted through the spirit world, then it is there, as well as on earth, that the evil has to be combatted. So in any Mende community there will be several adepts in the societies who can handle snakes and by doing so show their *hale* power over unseen forces, on the side of good.

One secret group, the Yambo Society (Innes, 1969:152), has domination of snakes as one of its primary objectives. On many practical matters, Yambo members are appealed to when expert help is needed. If the number of snakes around a village gets out of hand, Yambo people can be called in as exterminators. They prepare serums for use against snakebite and will do their best to save a victim. When there is thick forest land to be cleared and the certainty of encounters with deadly serpents, a Yambo man will be the one to lead the work crew in battle against them.

Mende are not the first people to externalize their anxieties by turning them into public spectacles, so we find that from the ranks of the Yambo Society comes an entertainer—the snake charmer, *kali-lolimò*, literally, the "snake-dancer." Dressed in a sombre costume of black with leg rattles around his calves, and accompanied by an instrumental ensemble, the snake-dancer plays with his pet snakes, letting them wind around his neck and torso. In an unnerving performance that has the crowd shrieking in horror, he struts and leaps with the snakes in his hand, putting their heads into his mouth or swinging them by the tail. Snake-dancers are thought to be peculiar and unpleasant persons who, like doctors who cannot cure themselves, are doomed to die from snakebite.[51]

In Mende belief and in Sande Society mysteries there is a decided, special connection between women and snakes. Mende women are considered to be more afraid of snakes, more disturbed upon seeing one. A snake phobia is thought only to afflict women, while men are supposed to face snakes bravely. A woman relies on her little pet chicken to watch for snakes around the compound and farmhouse; its squawks will alert her to danger. Women are also thought to dream of snakes; Mende "maintain that when a woman dreams of a snake, she will get a child" (Sawyerr, 1970:78).

The association between snakes and pregnancy leads right into the inner circles of the Sande Society with its overriding concern for conception and birth. The snake of the society is the python, a huge, docile, nonpoisonous snake whose cultic worship is found throughout West Af-

rica. The African python is aquatic, living near water and habitually slip-
ping into rivers or streams, where women encounter it as they bathe, wash
clothes, or fish. As Sande women are always "in water," they need to be
taught by the society to come to terms with the python; the python is part
of a woman's environment; as beings in nature they must coexist. The
python, like other snakes, regenerates by casting off its skin; this skin, with
its "Sande markings" of black and white, is regarded as one of the secret
Sande objects, and is collected and maintained as a partaking of the prima-
ry powers of life.[52]

Birds

To the Mende, birds are fascinating. They are the magnet for more lore
and supposition than any other creature in the Mende environment. Birds
are perceived as being "just like people." In America we tend to anthropo-
morphize our "four-legged friends," especially dogs and cats, see their
cute ways as indications of their being "almost human," and allow animal
characters to occupy "human" roles in much of our popular art. Mende,
however, do not find furry creatures at all endearing. Rather, they reserve
their affection for birds, and it is ordinary bird behavior that they regard
as "almost human." Mende see definite similarities between birds and
humans. They stress that birds walk upright on two hind legs, "like peo-
ple," and use their arms/wings for work. Like people, birds eat cereals and
greens, with an occasional treat of animal protein. Birds build homes and
live in them with their mates, and as a couple together they shelter and
protect their young. Most important are their voices—birds chatter back
and forth, sing beautifully, and some can even be taught to imitate human
speech, just as humans, by whistling, can in turn imitate bird songs.

Birds have enormous significance both in daily, mundane routine and
in the ritualistic and spiritual realms of life. Mende regard birds as nature's
oracles; they believe that birds can see everything everywhere—even into
the future and into the human heart. Ordinary Mende folk who put store
in omens observe bird behavior for hints of what the day holds: a bird
standing in front of one's door "means" this; a bird crossing one's path
"means" that. Divining experts frequently claim the gift of hearing a bird's
song and interpreting the message of the notes. The idea that birds are
speaking is reasonable to a Mende; Mende speech, being tonemic in its
structure, resembles, in a layman's view, the rise and fall of notes charac-
teristic of a bird cry. Senior Sande women are believed to know the secrets
of bird language. Some Sowei know the herbs which, when rubbed on the
ear, allow her to know the significance of a bird's own sounds. To a woman
who can interpret their speech, birds can foretell good fortune or danger,
warn of arrivals or departure, predict death or adversity (fig. 76).

Mende are convinced that birds can see into the future. What appears to
be metaphysical conjecture has a beginning element of physical fact; every

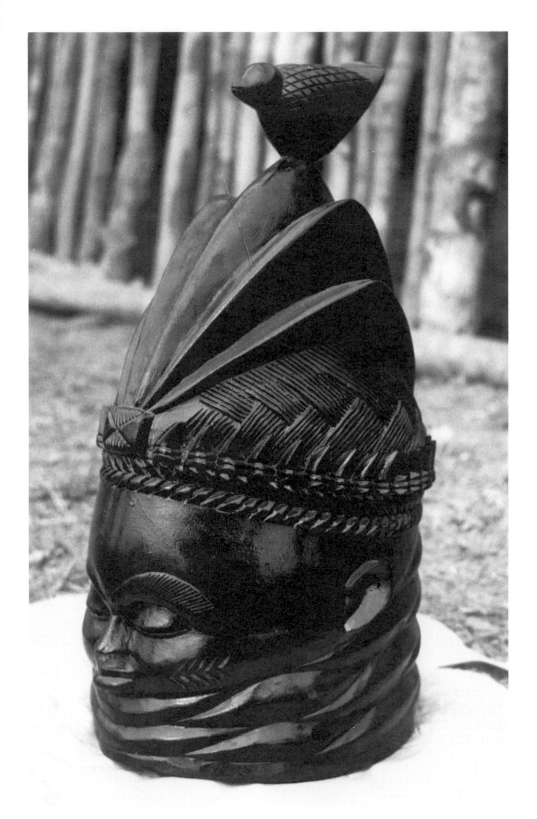

aspect of Mende thought with a supernatural dimension must touch the concrete world at some "point." A narrative will illustrate how the process unfolds. In Mende thought human activities create events, and events together make up time. Also, Mende view their world as criss-crossed by pathways, *kpambi,* each pathway special to an individual species. Human beings move from one place to another along specific, determined routes, whether highways, roads, or footpaths. A town woman is on her way to visit her mother in the village. Walking along the road, she is more than a mile away; it will be another twenty minutes before her waiting mother will get a glimpse of her. As yet the woman's presence is not known in the village; her arrival is a future event. Birds, from their vantage points high in trees, can see down the road and survey all the distant paths, therein their power to foretell the destinies of the village. The bird sees the event (the visitor approaching) "before it happens," before the earth-bound human can. Explaining birds' special gifts, Mende say: *Nòninga ta kulò lòlò* —"Birds see far." Thus, from their perches, birds can see into the future; and to a person who understands their language and signs, they will communicate future events.[53] Forewarned, she is forearmed. One word sums up the reason for their embeddedness in Sande coiffure: clairvoyance.[54]

Birds of the forest have an aura of mystery and strangeness; since they live along the roads and in the bush, they survey a different, wider terrain. They have other tales to tell (fig. 77). Mende believe that some birds "impersonate the ancestral spirits and transmit messages from them." Harris and Sawyerr report:

> The most widely known of these is the traveller's bird, *gbofio. Gbofio* is said by some "to receive messages from the spirits"; and by others, "to travel with the spirits." Travellers going along forest paths often hear it calling and calling persistently. Naturally they tend to take the view that it must be to them. . . . A lone traveller, in particular, tends to look upon the noticeably persistent call of the bird as providing him company. In view of the universally held belief that the ancestors are always close to a dear relative, the persistent call of the bird is interpreted as an indication that the bird travels along with the spirits which accompany the traveller. The call is also interpreted as oracular, indicating to the traveller what good fortune or ill-fate awaits him at his destination. [1968:51]

The supreme bird of the Mende community is the chicken. For westerners, chickens are hardly heroic. Not so for Mende; they see chickens as an exquisitely symbolic species. They are true birds, possessing all the mystical power of birds yet conveniently available and cooperative. A chicken is the proverbial "bird-in-hand." With its humanlike habits, the chicken melds into the fabric of family and community. Chickens live in a domestic life in the household, pecking about the compound, venturing into the rooms. They are cheerfully busy around the village all day, sleep in their

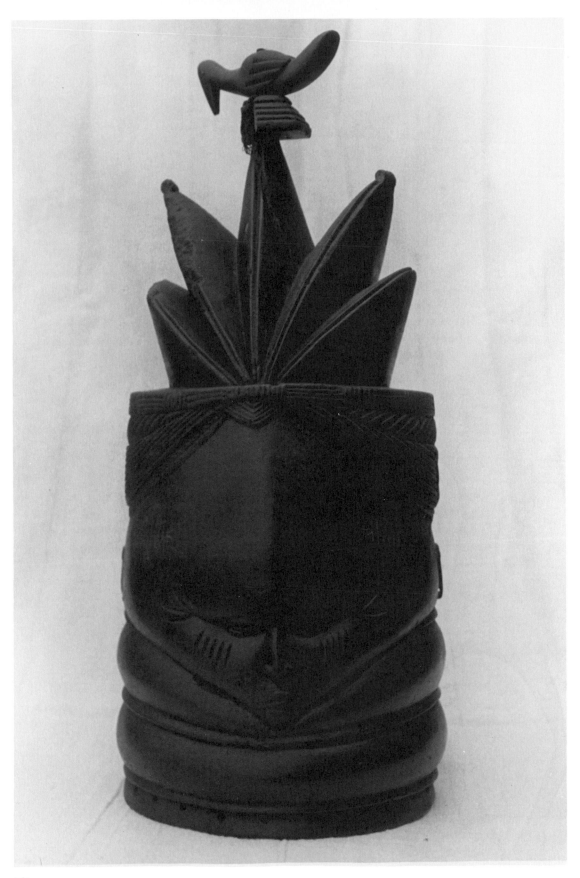

home coops at night, and are amusing pets, entertaining to have around.

The Mende word for chickens, *te*, and the word for town, *ta*, are the same in the definite, *tèi* for both (Innes, 1969:139, 137). This binds together the two concepts in a fluently continuous pun. The first sign of human habitation is the presence of chickens. They, in turn, are the first to see the strangers, and their agitated squawks alert their owners in advance to new arrivals. Moreover, chickens are the village time-keepers. A rooster marks the beginning of the Mende day: his first crow, about 4:00 A.M., warns that day is approaching; the second, around 6:00 A.M., signals the start of human acitvity. In the evenings when chickens come to roost, this indicates the time when people gather together in the after-labor hours of relaxation. Bird surmounted *sowo-wui* consequently are radiant with symbolic circumspection—an eye on the parameters of the village and all that passes there. Birds are icons of mystic surveillance and the passage of time, hence their plenitude in Sande symbolism.

There are additional powers attributed to chickens which suggest by symbolic force important elements of *sowo-wui* bird iconography. As they view the future and survey the passage of time, so too are chickens able to see into the human heart, and to discern and so attest to the truth of a person's statements at ritual confessions or at reconciliations between two contending persons. "The chicken, it is believed, is the great arbiter of truth and the genuineness of one's motives and intentions, with special reference to the maintenance of good relations between friends or relations. So when a friend or relation, once estranged from another through some earlier misunderstanding, agrees to settle the difference and declares that the offence has been overlooked, grains of rice are placed on the palm of his hand and a chicken is brought up to it. If it pecks avidly at the rice, the onlookers will be convinced that the quarrel has been fully settled. This arbitration rite is known as *tèi i mbèi jongba*—'let-the-chicken-peck-at-the-rice'" (Harris and Sawyerr, 1968:135–36).

Harris and Sawyerr recount a Mende creation myth that "tries to account for the origin of the sacrifice of a chicken which is, for all practical purposes, essential in the Mende sacrificial system" (1968:6–7). Mende believe that in the Beginning two chickens were given to the first man and the first woman as gifts from the great Creator God. "When *Ngewò* created mankind, He also created the chicken which He gave one each, to the first man and woman, as the medium of invoking His presence whenever he was needed" (ibid.:120). So, from this divine precedent, when approaching ancestors or in-laws, honored guests, or God himself, the appropriate gift a Mende brings is a chicken—often white, live, or cooked in a stew (ibid.:26, 27). I was told in Telu that chickens die for the sacrificial purpose of binding Mende families together; "they give their lives to make other lives abundant and happy" (March 1978).

Birds and Sande are strongly interwoven forces; birds are frequently

referred to in Sande songs and are symbolic of the society's deepest mysteries. During Sande sessions, Sowei notables are seen going to and fro carrying fowl or bunches of eagle feathers. Sande *nyaha,* initiated women, live intimately with birds, keeping them as amusing mascots, playing with them, drawing on their special bird qualities to protect their own well-being and increase life's enjoyment (fig. 78). The clearest public sign of the Sande woman's involvement with birds is the special affection she has for her pet chickens. When going to the farm plot in the morning, she carries her chickens along in a bird-cage for company during the lonely day, and returns with them in the evening. Romance is another factor in the studding of *sowo-wui* hair with bird-shaped forms. A woman's lover is her *ǹoni woi njei ma*—"small bird by the water that I call with song." The scene is a spot outside the village, near the riverside, the favorite trysting place for clandestine lovers. She comes smiling and excited, hoping that her lover will keep their assignation and be waiting for her, hidden. She sings a bird song to call him to her side.[55]

Drawing again on the symbolic communicative networks of the Sande *kpanguima* enclosure, we find that birds are intricately involved with successful child-bearing. Sande elders organize the young *nyaha* into a group known to the community as a "bird-society." Members pledge to cherish birds and keep the "bird-laws," *ǹoni jae;* in return they are assured of fertility. Sowei make expectant mothers join a special unit within the bird society devoted to prenatal instruction and care.[56] And although Mende consider fowl and game-birds delicious and choice fare—literally, "good for the gods"—during pregnancy the eating of bird flesh or bird eggs is strictly forbidden, except in Sande ritual. Chickens and hens are helpful friends and companions; to eat them would be perfidy.[57] Sowei have observed the brooding hens' selection of leaves, believing them to have special properties that aid pregnancy; they pluck and use such leaves in prenatal medications. These herbal mixtures have in fact been highly effective, so woman regard their revelation as a gift of the birds to the world of women.[58]

Pregnant girls learn to regard the hen as a guide and model. A proverb uses the brooding hen as an example of self-sacrificial, single-minded devotion to a life-or-death obligation: *Kpee jebulee ee te gbua ngalu ma*—"Looking with displeasure at a hen will not remove her from her egg." No amount of ugly looks or bad words will drive a brooding hen off her eggs. She has her task and her own program and she will stick to it for the good of her chicks. Someone really determined to pursue a course will see it to the end. A goal must be as dear to a person as her incubating eggs are to the hen.

As hens relate to pregnancy, so the actions of another bird, *sokele,* are Sande lessons to young nursing mothers: *Selesele mia lini a sokele kawo ma*—"Small hops take *sokele* onto the rubbish heap." *Sokele,* a tiny rice bird of

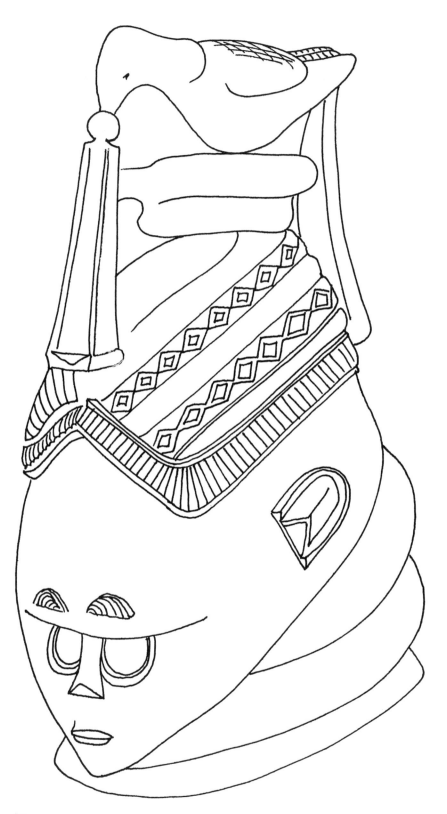

black and white coloring, flies from its nest every day and joins the human domestic scene. Every compound has a spot where the kitchen trash is thrown, and *sokele* comes to eat the good scraps. It hops nervously onto the heap, only to be caught in a trap placed there by the village boys. The proverb warns young mothers who have not yet weaned their children to venture out slowly, not to play, to be prudent; not to be trapped by men, but to be alert and cautious, mindful of their obligations.[59]

Birds, then, are living metaphors for the instruction of the *nyaha* in their basic responsibilities of childbearing and child-nurturing; there is nothing else more important to the race. Sande uses *sowo-wui* imagery to reinforce and reaffirm its sacred trust of ensuring the continuation of life. The bird figures atop the mask are indefinite, often seeming to represent the notion of a bird but not one kind in particular. In their ambiguity, these images have a hundred didactic associations and relate to a myriad of matters— love, fertility, domesticity, power, danger, discipline, prudence, laughter, special magnified sight, and clear hearing. Birds communicate across the barriers of time and space, between realms of the human and the divine.

Other Animals

Only a small selection of animals is represented as part of the Sowo coiffure. Common barnyard animals—pigs, sheep, goats, buffalo—are considered vulgar and utilitarian in nature; these animals are destined to be bought and sold, killed and eaten, and as such, they lack a spiritual dimension. Grander and wilder creatures, such as antelope, horses, elephants, and leopards, are admired for their strength and beauty; but they seem to belong in the masculine domain. Occasionally, a fish, crocodile, toad, or rodent will appear on a mask. The first three continue the Sande emphasis on creatures associated with water or the riverside. The crocodile is a dangerous aquatic reptile that maims and kills; like the snake, it is a reminder of evil and death (fig. 79).

The lowly toad turns out to have very lofty associations. A venerable Sowei explained that a toad represents a supernatural good come to earth. She held that toads, unlike other animals, do not rot when they die but dry up cleanly without smell or residue. Even in the season of heavy rains, the toad is not corrupted by damp but, rather, always becomes dry. Because of its triumph over the physical corruption of death, it is thought to have knowledge which other creatures lack. That is, nothing wants to rot and decay. But since God only gave this power of cleanliness in death to toads, then toads must have a special mystical good.[60]

She showed us a mask featuring toads swallowing snakes. In life, snakes swallow toads; on her mask, this process is reversed. From our understanding of the meaning of snakes and toads, we see this as a tableau of good triumphing over evil. In the bird-and-snake ensemble the theme seems to be the certainty and inevitability of struggle, and the probability

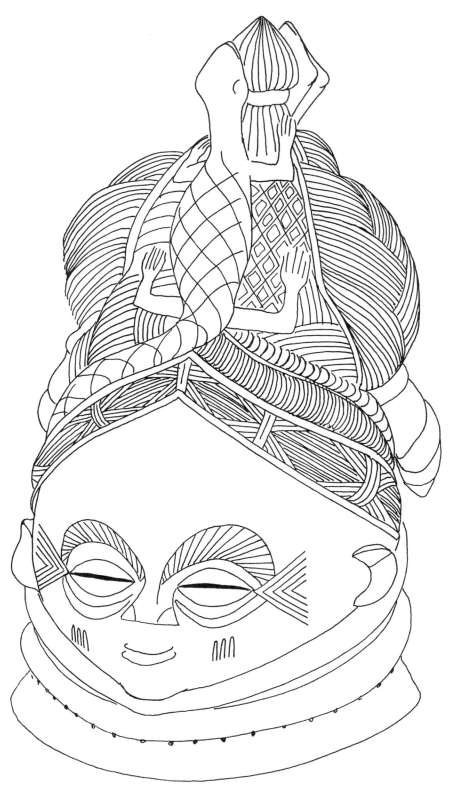

79

of a stalemate at best. But in this toad-and-snake combination there is a picturing of the ascendance of good in defiance of the natural order, making something new and hitherto unseen in the world—not an earthly scene, but a heavenly one.

Horns from sheep, goats, bulls, buffalo, and antelope are in regular use in Mendeland. They can be fashioned into rings and bracelets and worn as jewelry. In chiefly households, some horns are carved and decorated for display, while larger horns are made into musical instruments in the ensemble that accompanies the public appearances of a chief and his entourage. Smaller horns are popular as containers and drinking vessels. Horns are widely used in rituals because they are a basic, natural thing known to the ancestors. They have some of the aura of the animal that grew them so they are a fine holder of magical substances (fig. 80). Horns frequently appear on Sande masks; I was told that masks with horns were "evil" and "very dangerous," but I could get no further explanation. Another suggestion was that the owner had magical protection concealed in horns. One woman told me that those on her mask represented antelope horns; she added that the antelope is a nimble, swift-footed animal so the horns were there to impart these qualities to her dancing.

Cooking Pots

A three-legged, covered iron cooking pot, *kòluvèi,* often crowns a Sande mask, so we shall look at common experiences to understand the pot's significance in Mende life. All that is hearth and home is summed up in the three stones of the *ngunde,* or cooking area. The iron stewing kettle is an integral part of the hearth scene and can be a symbol of the warmth and security of this center of family life (fig. 81). Certainly every woman owns a cooking pot as part of her basic household equipment, and her ability to prepare the food is, along with childbearing, her irreducible responsibility to the human community; a *kòluvèi* may be in praise of womanly home-making. There are other possible interpretations, however. The kettle is portable, and it shows up in other contexts. Not only is food cooked in it, a kettle is also standard equipment for the herbalist and the sorcerer, for anyone who brews and concocts mixtures mundane or magical. As a traditional receptacle for any kind of liquid or anything in a fluid medium, a kettle lends itself to ritual occasions. Finally, many rural people still conceal their values in an iron pot.

Thus the *kòluvèi* image on a mask can evoke several situations and tableaux of Mende life. It may mean that the owner is a senior wife, in charge of the *ngunde* hearth. It could mean that she has made a sacrificial prayer of stones in water in a pot, and her request was granted. Perhaps she herself is a herbalist who uses a pot for cooking up her portions. It could be a reminder of her wifely chastity, or it might even signify her skill in deception. In his field research, Richards was told that the *kòluvèi* is a

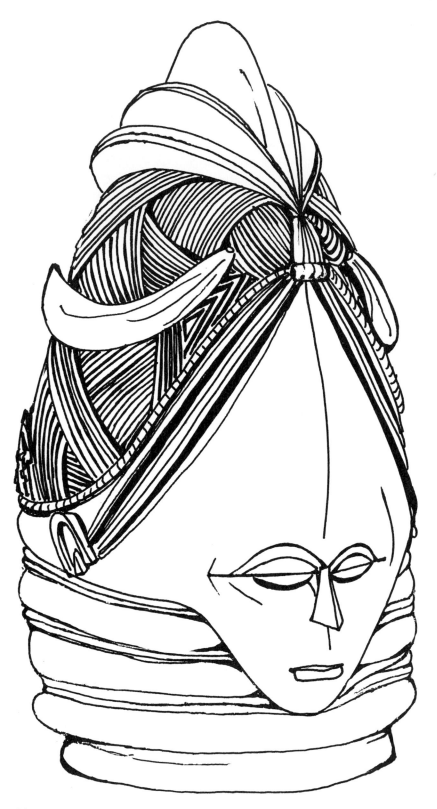

80

container for money collected by a *sowo-lolimò* for her dancing (1974:49). This explains the use of the pot as the improvised bank of the provinces.

Shells and Beads

The cowrie shell was an early medium of exchange in West Africa and is still in use today as a traditional form of money.[61] It has monetary value for Mende people and is also charged with a variety of secular and spiritual meanings. For daily commerce, the set price of cowries (at this writing) is five to a Sierra Leonean penny. In many subsistence economy areas, the nationally-minted penny has too much purchasing power to function as the smallest unit of money; so villagers still routinely use the cowrie for many small, informal transactions. Cowries also often serve as "men" and pieces in board games; and when folks gamble and play games of chance, cowries are used as chips.

The cowrie is mystical money, a form of coinage that can circulate on the supernatural plane; it is the only currency which the ancestors recognize and accept. Mende consider the cowrie an "ancient thing" passed down from *Leve-Njeini*, God-and-the-Ancestors. There are no "new" cowries; by definition they have been in circulation for a long time and have existed since the beginning of history. Thus, when a Mende is asked to make a sacrifice using an "old thing," he will usually bring cowries.[62] Cowries are the token to pay the debt of prayer answered and the acknowledgment of benefit received. The Sande Sowei prepares a common form of invocation: it is in the form of a cooking pot, filled with water with a handful of cowrie shells resting on the bottom.[63] As the request for divine help is carried through the water medium, so the offering, too, is made "under the water," the place from which all beauty and blessings flow.

Cowries are embedded in Mende ceremonies and rituals; they are a feature in divination for several reasons. Mende regard the cowrie as a "stone" that comes from the water. A diviner is a *tòtò-gbèmò*, "a stone reader" (Innes, 1969:145), one who listens to what the stones have to say, who tells the future using physical objects. Since divination is a means of receiving information from the spiritual realm, and since to Mende waters represent the supernatural world, then "a stone from the waters" is especially attuned to receive spiritual vibrations. Further, cowries have two distinct sides (one round and smooth, the other flat and ridged), making them thus suitable for "heads-or-tails" figuring. Usually a *tòtò-gbèmò* divines by throwing four cowries into the air, then letting them fall to the ground. From the pattern they form, the diviner reads the ground and interprets the message.

The Sande Society prizes cowrie shells for their beautiful and symbolic properties: they are white, smooth, cool to the touch, of aquatic origins. The society has made the cowrie the emblem of the *mbogboni*, the Sande initiate-in-training; a *mbogboni* wears a cowrie bead on a thong as a choker

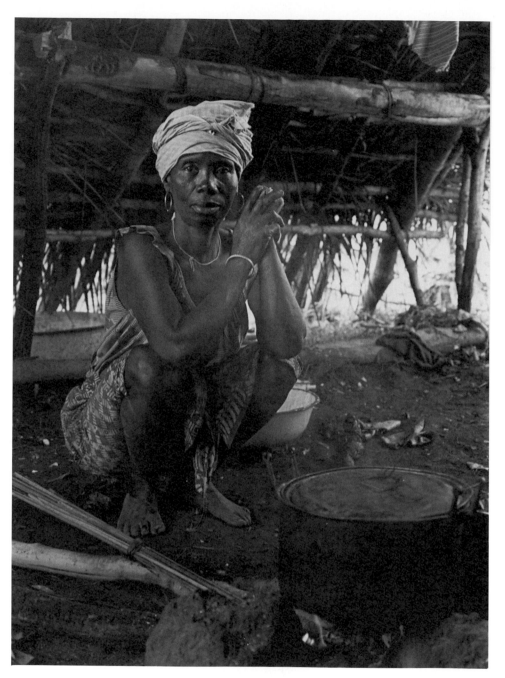

81

around her neck as an indication of her condition. True, Sande paints the novices with *hojo*, white clay, to warn the community that these girls are under the society's jurisdiction and that any tampering with them would be a serious violation of society sanctions. But clay washes off easily and has to be renewed; so it is a bead worn at the neck which marks an *mbogboni* clearly and definitely (fig.82). She never takes it off, whether bathing or sleeping; it is an indelible badge of her protected status. The cowrie shell's smoothness, cleanliness, and whiteness make it beautiful, appealing, delicate—the same qualities that Sande hopes for in its novices.

Sande loves to adorn its young girls with cowrie shells. In the olden days girls graduating from the society were bedecked with cowrie shell aprons, necklaces, and belts.[64] Where cowrie wealth is passed from generation to generation, and where Mende traditions still hold, *mbogboni* will be laden with cowrie jewelry upon their return from the final ritual bath, although they may appear later publicly in modern, urban dress. The headdresses for the Sande dancers are highlighted by strings of cowries. In conjunction with the presentation, cotton batting also is woven into the headdress to give more fullness to the hair and thus suggest abundance and wealth. The theme of abundance is amplified by the punctuation of the sacred money. This beautifying with cowries appears on certain *sowo-wui*, in which the motif of the cowrie strategically placed at the symbolically crowning section of the mask restates its importance in Sande art.

The cowrie shell is rich in occult and spiritual associations in Mende thought. Starting with the Mende word for cowrie, *kpòyò*, we can trace some of its references to other Mende concepts. As well as a "cowrie stone," there is also a "cowrie tree," *kpòyòga*,—literally, "cowrie-skin." This cowrie tree produces a fruit the seeds of which are used as beads (Innes, 1969:64). As the Sande Society esteems cowrie shells, so traditionally it uses the cowrie seed bead to decorate Sande girl dancers. More importantly, this same bead that can be used in ritual contexts can serve as a substitute for the cowrie stone; so girls in Sande training are often seen wearing one bead as they otherwise would wear one cowrie shell. This plant seed is a "stand-in" for the stone, a more plentiful equivalent of the rarer item. In Mendeland there is not one tree named "cowrie" but two. Besides *kpòyòba* (cowrie skin), there is a tree called simply *kpòyò*. This cowrie tree is the one traditionally used for the mask (Innes, 1969:64). Its wood is lightweight; when worked it gives a smooth finish and is nearly white in color. Sowo masks can be made of a variety of woods; but the connection in concept remains between the most sacred masks, especially those that emerge from the water, and the cowrie tree with all its aquatic associations.

As we have said, the cowrie shell is in the first instance a stone, a stone from the waters. Furthermore, God created it as a shelter for a living animal, a tender, tiny thing that lives in the water. Sande women always find anything of stones and water and encasements for life to be of special

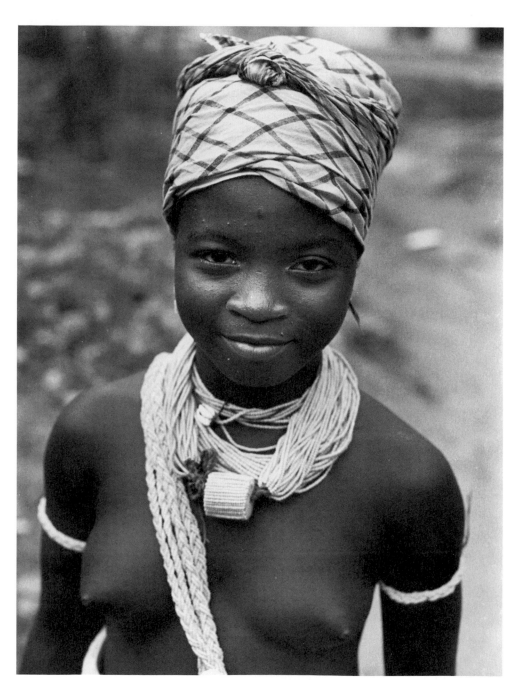

82

concern. The shape and appearance of the cowrie relate it even more firmly to women and to motherhood. The underside of a cowrie shell is an opening in the configuration of a vulva; the top-side has the roundness of a pregnant belly. The same word for cowrie shell, *kpòyò*, puns on the word for the front of the abdomen, *kpòyò*. *Kpòyò* is a "woman's word," not used for men. If a Mende is speaking of the human body, *kpòyò* refers to the front of a pregnant woman, or alternatively to the flat stomach of a young girl. So a woman's abdomen is her cowrie, the place where the Stone-of-Life is embedded. Iconographically, the image of a cowrie-in-the-belly does not appear in Mende figurative art. But its use in the decoration of the head and hair and its use as important jewelry leads, nonetheless, to its powerful mental image as the culmination of a particularly affective portion of the Sande symbolic process.

Talismans and Charms

Packets depicted on the *sowo-wui* usually refer to *lasimò* (ibid.:70), an amulet, charm, or talisman made by the Muslim diviner. The heart of the charm is a piece of paper on which is written a verse from the Koran in Arabic script. The paper is folded, often wrapped in a scrap of plastic, and then tied up with white or black thread. This small, tight kernel can then be put into a leather packet, rolled up in a lead, or stuffed into the tip of a horn, to further preserve it so that it can be worn.

A *lasimò* is just one of a rich variety of amulets, charms, and talismans that circulate in the Mende community. It is usually made as a form of protection for a person who feels anxious or threatened, either because she has grown psychologically ill-at-ease in her home surroundings or because she is facing a special test of her balance and strength. A *lasimò*, like other amulets, is an externalization and concretization of a human desire, wish, or intention; and like other amulets, it can be fashioned to correspond with any fear or hope a human being may have (fig. 83). Most charms deal with the troubles and desires of ordinary men and women as they go about living their lives. People ask for cure of illness, protection from rivals, help for children, a new job or career advancement, bountiful crops, good prices at the market, relief from melancholy or sadness, success in courtship, peace of mind. Other charms are used for extraordinary situations—victory in battle, success in land or chieftaincy disputes, safety in childbirth, acquisition of fame and riches, luck in big-game hunting, and the like.

Sowei, regular customers of other diviners, are themselves experts in making amulets. They are sensitive to the special needs of women and offer their clients psychological support along with the physical object. The Sowei's talismans are deemed especially effective in matters of love, courtship, marriage, and childbirth. Also, Sowei help women meet the emotional challenges of leadership or performance; the Sowo dancer needs special fortifying charms to help her face her audience. Sowei her-

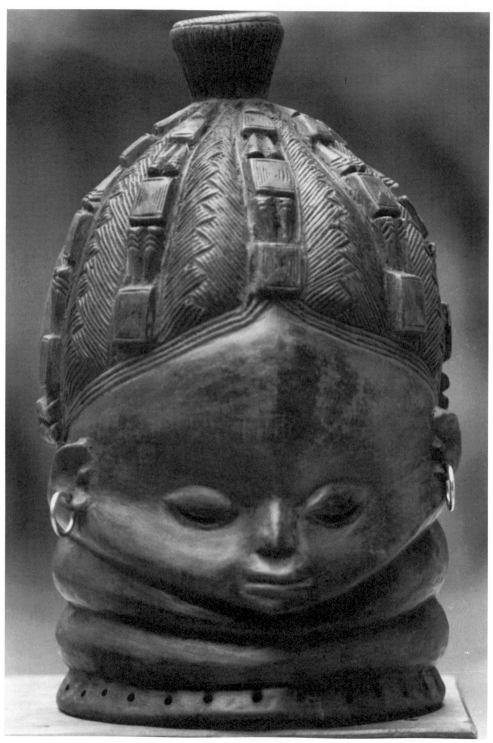

83

self has various charms and talismans hidden about her person,—for instance, around her waist under the lappa but most often tucked into her hair and out of sight under a head-tie. The talismans depicted on the mask refer to this habit of wearing charms on the head, where their powers to hearten and reassure can be absorbed directly into the mind.

Crests and Crowns

The *sowo-wui* is frequently topped with a crest consisting of a center peak flanked by one or two smaller crests on each side, as in figure 84. Although these crests are a persistent and popular feature of the coiffure, I have no firm information from my sources on what they might mean. Everyone I asked seemed to find crests commonplace and unworthy of much interest. Most people insisted that crests were just hair, plaited into this style. Others told me that crests were feathers, recalling the feathers worn by Sande members in their processions. W. L. Hommel, one of the field workers who mentions them, finds sexual symbolism in the three- and five-part projections: "Another Kpa-Mende variation has a five lobed hairstyle symbolizing the vagina with the clitoris represented by the same forms as the phallus" (1974:n.p.). Hommel does not document his sources for this information. From a general appreciation of Mende culture, aesthetics, and decorum, it is impossible to imagine female genitalia displayed atop the head and even more remarkable to find them spread wide open to public view. The whole notion is shocking to a Mende. It seems unlikely that an individual woman would be allowed to own such a graphically explicit mask. Until a Sowei decides to reveal the meaning of the crests we shall have to reserve our judgment.

Moving on here to less difficult problems of iconography, we find that a chief's hat or a western crown are sometimes carved onto the uppermost part of the mask, as in this richly detailed mask in the Brooklyn (New York) Museum collection aquired in 1969 (fig.85). Among a variety of embellishments alluding to Sande's mystical, spiritual aspirations and concerns, these crowned heads are different—they signalize the *earthly* authority of political rulership and monarchy, the *temporal power* of government. Dubinskas suggests that the popularity of this English crown motif links up with the fact of the reigns of Victoria and Elizabeth II, both ruling during crucial periods in Sierra Leone history—the time of colonization and, later, the winning of independence (1972:44). This is plausible, since one tribute to their majesties would be representation on the head of the Sande mask of the crowns seen on the heads of the queens. Surely, though, these crowns relate also to traditional jurisprudential and governmental power exercised by Mende women through the support of the Sande Society. Sande offers women the opportunity to acquire political expertise by virtue of the offices they hold in the society. When we recall that women have long held 10 to 12 percent of the paramount chieftancies in Mendeland,

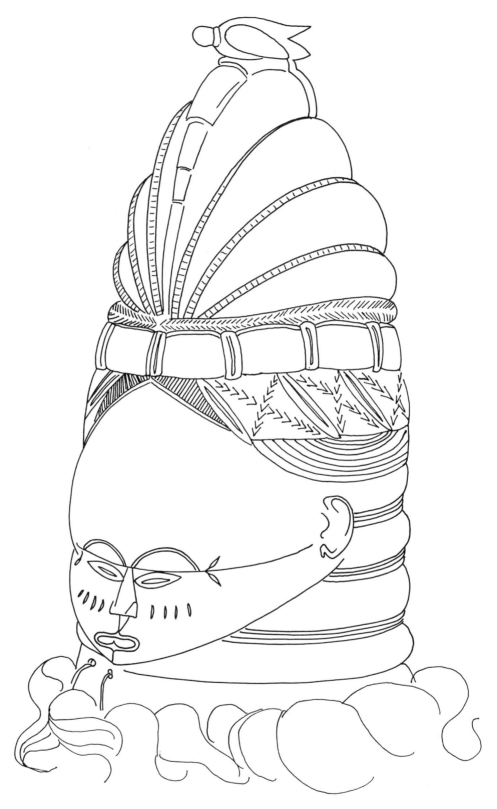

84

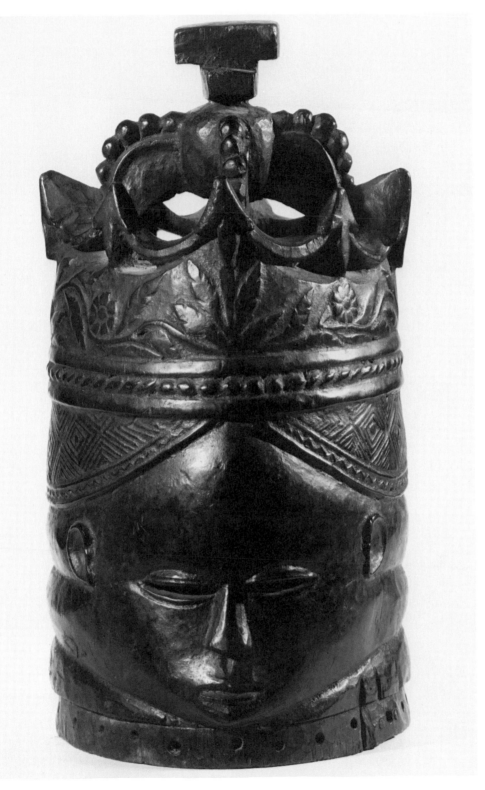

85

these crowns bespeaking temporal rulership may well be a reference to the extraordinary political power exercised by Mende women.[65]

REFLECTIONS ON THE *SOWO-WUI*

The Mask Is a Head

We have surveyed, piecemeal, questions of iconography and iconology in relation to the mask. But fundamental features concerning this precious object remain that demand explication. Every mask is a head, is made of wood, and is black—all evident to our eyes (fig. 86). We turn now to the full context of the relation of the mask to dress. Our western preoccupation is with the Sande mask as an object of sculpture—durable, transportable, stable—all features appropriate to display in a museum setting. There are hundreds of masks in collections but no more than a handful of the costumes worn by the masks. From a western point of view, it is normal to deal with the mask as an object in itself, without reference to the costume. But are we justified in doing so in a Mende context?

A most learned savant who taught me much about Mende language and thought feels strongly that the mask is not to be viewed as an object apart, that it has meaning only with its costume (figs. 87, 88). He thinks the community sees the *sowo-wui* as something to put on the head and dance with. And, he maintains that the majesty of the Sande spirit, Sowo, is judged by the gown; that the gown makes the full aesthetic and symbolic impression. There is little doubt that most of the male half of the community shares his view, as do many of the women. Mme. Boi, of *ligba* rank in Sande and an outstanding *sowo-lolimò* and dance teacher, was also most concerned about the costume.[66] To them all, the head is of "no use" unless it is part of performance.

Sande elders, on the contrary, gave strong evidence that the wooden helmet top of Sowo has a distinct artistic, symbolic, and ritual role of its own that it plays without reference to a costume or to its being worn by a dancer. If we can determine that the mask is indeed a distinct whole to a Mende, then we can proceed to examine the implications of its being a head-to-encase-a-head. First, a *sowo-wui* is given a name, and this name applies to the whole personage; on the other hand, costumes are not named and are interchangeable and replaceable.[67] Costumes are ephemeral and quickly become worn and tattered, but masks are strong and durable, and some are known to have been preserved for a hundred years. The individual dancing Sowo is known by the name given the head, since masks are easily noted by their appearance; but one costume is pretty much like another.[68]

The costume only appears when the head appears, but the head frequently appears in a social and ritual context as a separate item and functions without need of the gown. For example, in the Sande shrine corner

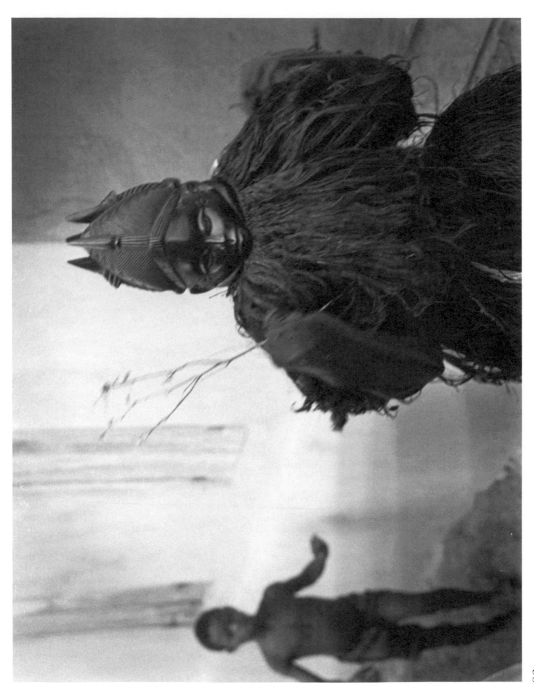

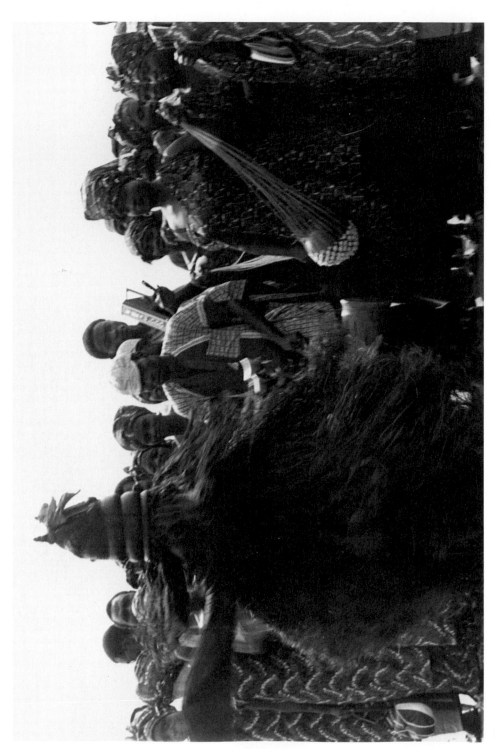

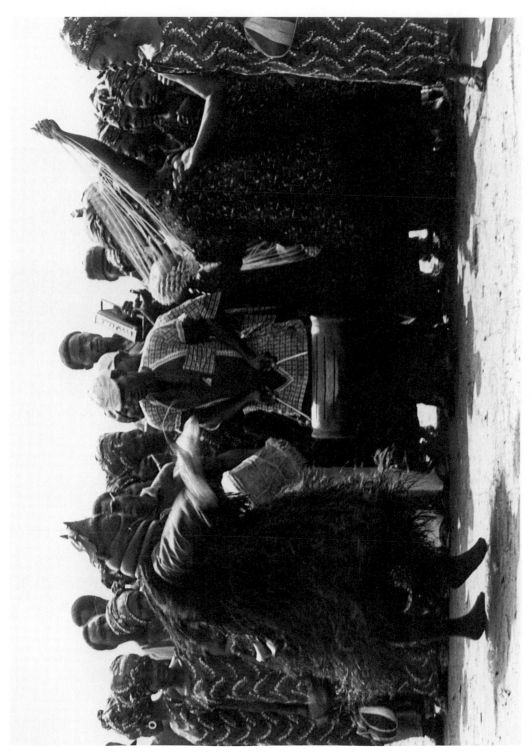

or in the initiation camp, the helmet can be seen displayed on an altar. The helmet alone is handled and approached in these religious or didactic contexts. On the level of entertainment, the magician, *njoso-lolimò*, manipulates a *sowo-wui* and by sleight-of-hand makes it appear and disappear to the amusement of the crowd. The most telling argument in favor of examining the head separately comes from the origins of the mask. The most important, mystical, awe-inspiring masks are those retrieved from deep rivers in public Sande Society religious ceremonies. Masks are seen to break the surface of the water and jiggle about in a dance, only to sink from sight, then be "captured" and brought back to the surface by a Sande diver.[69] The point here is that *only the mask is retrieved* unaccompanied by a costume; only the mask has supernatural origins, only the mask is made in heaven. The costume is secondary to the mask; the mask is of primary interest and importance.

Once we examine the mask separately we must deal with its implications as a head. Again our method involves collecting as much information from as many different sources as possible, then cross-referencing and comparing them to find the core points. To begin, the whole of the Sande spirit is known as Sowo. The sculpted head is the *sowo-wui*, "the head of Sowo." The word *ngu* (which mutates to *wu*) means, concretely, the physical head of a being and, conceptually, the most important part of something (Innes, 1969:190). So, when the community calls the wooden helmet *sowo-wui*, it is saying at once that the helmet is Sowo's head and its most important part (fig. 89).

The Mende word for head, *ngu,* is a pun in pitch of the word for "awake" and "wake up." The head is the part of the body that continually lives and dies, and which, like a light, turns "on and off," while other portions of the body are set, remain the same. The extreme Mende emphasis on alertness, observation, and intellect is evaluated by the individual's ability to perceive subtle variations in persons or the environment and to make deductions from these signs. To greet someone early in the morning you say, "*Bi wua*" (your head), that is, "How is your head?" or "Are you awake?"—all possible translations. There is difference of opinion about the meaning of the ordinary contracted greeting of "*Bua?*"; some think it is a contraction of "*Bi waa?*" "Have you come?" (Innes, 1967:9). Others think, rather, that it relates still to *Bi wua*," "your head." The meeting of persons is the meeting of heads as evidenced by the response to *Bi wua?* A person replies, "And your head?" Further, the Mende expression for a gathering of the community's important people, either for making laws or for judging and resolving disputes, is *nguhitè*, "head lowered"; the picture created is one of intense listening, concentration, without heads turning or eyes casting glances around. Head meeting head, mind meeting mind—the essence of Mende ideal noble human conduct and social harmony can be found in this.[70]

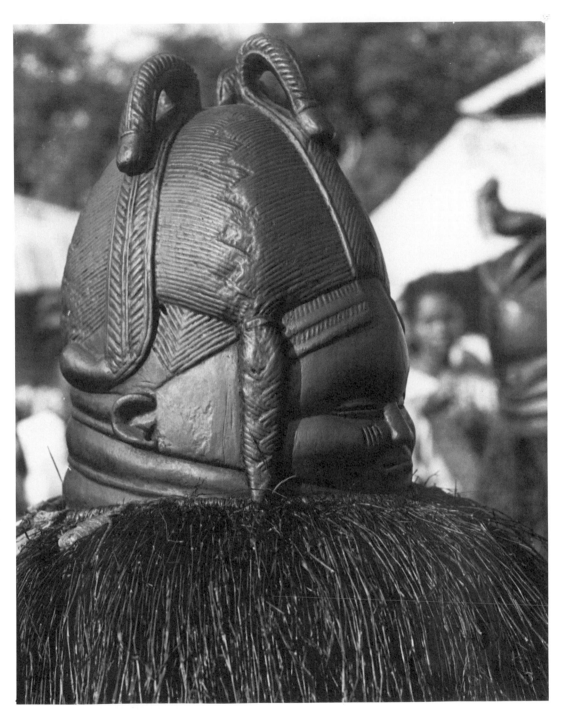

89

Western ideas of "you *are* your body," or "the mind and the body are one," strike Mende as strange and wrong. To them it is an obvious, indisputable fact that the head and the body are two separate entities linked by the neck. The head is completely superior to and master of the body. The head is the center of life, Mende declare, and to be without your head is to be dead—"You can lose a leg or an arm and still live, but you can't live without a head." Zahan's discussion of the importance accorded the face and head in Bamana thought is almost word for word what I have heard from Mende: "These parts of the human body constitute the 'summing up' of the personality, for, in the end, the senses by means of which man receives impressions from his outside surroundings and also communicates with these same surroundings, are all contained or represented in this part of the body. It is for these reasons that initiation society masks are worn either on top of the head or on the face itself" (1968:41–42). Extending these notions about the head's importance over the body, Mende think that feet are anonymous, that they are all alike and cannot be distinguished. Legs also are considered to have little allure or personality. While people find all aspects of the head compelling, riveting attention, legs and feet are lacking in interest.

Mende ideas about the importance of the head are illustrated by their expressions describing stages of the unfolding of an event, trip, or discussion. The human body is the route; however, unlike westerners, Mende start with the feet. *Kòòbu,* under the foot, or *kòòma,* on the foot, both mean "at the beginning" (Innes, 1969:52). Moving up the body and progressing in the program, one comes to *kobu,* under the stomach, "the middle." To be almost at the end or summit is *mbolo bu,* under the neck. And *nguma,* on the head, is "the end," the climax, the culmination. In Mende communications and transactions, the ideal situation allows for a gradual development of the argument, a slow progression toward the main point. Nothing is ignored or overlooked. Then, bit by bit, a speaker leads up to the main point. The main point he is moving toward is the "head" of the matter. Mende say: *Njèpè ye ngui tò*—"This is the head of the dispute, the key point in the matter." Or, *mu fuilò nguhu sòò*—"We have reached the head of it," we have arrived at the most important point, the last point.[71]

At a performance or a musical party, these anatomical gradings determine the unfolding of the event. At a traditional Mende musical party, the singer presides over the occasion, is the conductor and master of ceremonies. The instrumentalists follow the lead of the singer; the dances, in turn, are controlled by the musicians. There can be solo singing, then singing with a group, but there can be no playing of instruments without singing, and no dancing without instruments. Further, in the performing arts, an art is considered more or less noble by the relative position of the body part executing the motions. By this designation of hierarchy, singing, as "the art of the head," is deemed superior to the other arts. Mende are

effusive and unstinting in their admiration and praise of singing, songs, and singers—all adored for their beauty and sweetness as models, prototypes, of the most elegant, exciting, and intelligent of arts, creations, and performers. It follows in Mende thought that playing an instrument is "lower" than singing, because the part of the body used to play is the hands. The most mundane of the performing arts is dancing because it is done by the feet, the lowest body members, those considered most lacking in individuality and particularity (fig. 90).

Continuing the comparisons, the "gift of song" is exactly that, a blessing from God of a lovely voice, combined with a sense of rhythm and the wit for lyric poetry—a blessing denied the masses, bestowed by caprice on only a fortunate few. Whereas singing is the purest of inspired arts, the playing of instruments is a skill that can be mastered by many who care to apply themselves patiently. Dancing is the most popular artistic expression, the most widely cultivated in the community, the most fun and least demanding of the arts. That is, everybody can and must learn dancing as part of their socialization into Mende community life; dancing is a social achievement, a basic activity, with a minimum standard of performance required from all regardless of individual talent and inclination. Singing, like a head, is mind, and thus mental, individual, special; while dancing is heart—emotional, communal, necessary, essential.

Mende regard the head, then, as very special and worthy of the most careful handling. Relatives may touch a child's head in the process of cleaning or grooming it, but parents are wary of strangers putting a hand on their children's heads. From earliest childhood, a boy or girl is taught to fight to "protect his head" against physical or verbal abuse. It is a serious offense for one child to strike the head of another or to refer to it disparagingly. Children are critical of each other's heads; any lumps or bumps on the head, any deviations from the ideal of round smoothness will provoke ridicule and the expectation that the child will fight verbally or physically to defend himself.

Certainly one dares not touch the head of any member of the Sande Society. A *nyaha*'s head is sacred, not to be approached lightly or profanely; and the head of a Sowei is doubly awe-inspiring. Sowei carry their heads with surpassing dignity, a serious, composed expression on the face, a crowning kerchief on the head, the hair fully magical, filled with fortifying substances.

The commanding forehead of the mask relates to the Mende belief that intelligence is concentrated in that portion of the head. Mende distinguish between the brain and the mind. The brain is automatically defined as *ngu kpònò*,—literally, the "marrow" of the head, the soft tissue filling the cavity of the head bone, which is at the same time its innermost, most essential part. The *mind* is designated as *ngu hu*, "the 'something' that is inside the head"; the mind does not have a physical dimension—only a location

(Innes, 1969:110, 64). The head is therefore the seat of wisdom, and where wisdom dwells is sacred. We recall that formal Mende education takes place in a hallowed secluded environment removed from the mundane and regarded as part of the supernatural domain, as part of heaven. So this handling of the head, this treating of the mind as sacred, can best be done on sanctified ground that is spiritually removed to a celestial plane.

Just as in some respects the head *is* the person, so the *sowo-wui* is the spirit. And, just as the head is what is most distinctive and individual about a person, so the *sowo-wui* is the most important feature of the whole Sowo masked personage. Image of a divine head enveloping a human head, powers of the human mind and spirit elevated and enlarged by and into the might of the supernatural, head upon head, mind into everlasting mind—these are the points of Sowo masking.

The Mask Is Wood

Six masks are central to Mende Society rituals and ceremonies, one for Sande, five for Poro. Although there are a variety of other masks in the community, these six are considered to be core representations of Mende spirituality. The Sande head, *sowo-wui*, is carved in wood, while the tops of the five male masks are constructed of cloth, wood, string, shell, mirrors, and beads. So there are two questions: why is the *sowo-wui* made of wood? why is *only* the *sowo-wui* made of wood but not the five others? In response to these two questions, Mende explain, "Well, Sowo is a woman." The implication is that since it is the head of a woman it has to be made a certain specific way, and that way is beautiful. Conversely, the heads of the males should be masculine, which is fierce.

The only human images in Mende art are female; no images of men are ever made. Since the Sande mask has to be beautiful and since the one beautiful thing is the female face and head, then it must be made in a medium which can be fashioned into a beautiful effigy. And since the effigy is to be worn, stone is ruled out because it is too heavy, clay because it is too fragile. Wood, then, is the only choice. Wood can be appreciated as the most human of artistic materials. Because it has grown as a living thing, it is capable of a warmth and animation that make it appealing. But there is also a religious reason for Mende. Wood is a "leaf" as a person, too, is a "leaf." In the Judeo-Christian tradition man is fashioned from clay, but according to Mende thought we are the stuff of green, growing plants.

To review the myth of the coming of the masks, the original masks were natural stones in the water; the wooden mask is but a paltry human attempt to duplicate the divine original. In Mende cosmological thought, God is the creator of life; the stone is the receptacle of His life force, while the leaf is the manifestation of it. The polished hardness of the *sowo-wui* is like a stone, shimmering from the waters of God, while the luxurious hair and adorning attributes of physically and socially healing forces which

crown this "dancing stone" are its verdure and its herbs, the bursting out from the central stone of God's own loving, nourishing, and healing powers.

The Mask Is Black

Sowo presents a clear, shining black head to the world. In West Africa where masks can be painted, colored, or appliquéd, and in Mendeland where masks can take the form of bricolage constructions (which represent males), a *sowo-wui* is a rare instance of purity and intensity gained through a singleness of medium and color. The *sowo-wui* must be black, and blackness is of its essence. On the most practical and mundane level, the mask is colored black in order to keep it looking "clean and decent." Light-hued woods tend to oxidize and discolor, producing a dirty appearance; so for ordinary good looks the mask must be dyed. To add to this, the light color of the wood when mottled has a diseased, filthy appearance that a Mende would find repulsive. In Mende thought there are three basic colors: white, red, and black. The Sande Society's standard colors are black and white. If there were some other way of keeping overall white surfaces clean and fresh, white might have been chosen. But white color soils easily in handling, so white is ruled out. Red? impossible—red connotes danger and trouble. If the mask is to be attractive and pleasing, it cannot be soiled white or danger-signaling red. Black, then, is the only suitable color.

The mask is a woman and Mende women move in blackness, both pleasantly and unpleasantly. The work of preparing meals is colored black: soot-tinted hearthstones, charcoal, kitchen walls, and iron pots. Mende women dyers who work in indigo soon have their hands stained by the pigments. They display their hands with pride, for the color indicates their enterprise and prosperity. Likewise, when women are preparing a new Sowo costume their blackened hands hint of their privileged work. So, in a Mende village black hands mark a woman of substance and high standing.

Mende believe that the essence of strong leaves is black; so, too, the essence of the mask is that it is leaf/tree substance colored symbolically also black. Moreover, in alluding to human skin Mende say, "The blacker the better." A deep black in skin color is rare, alluring, and exciting, a dazzling beauty in itself. Formerly, black people were "the people"—i.e., the beautiful ones, the fabulous and passionately desired. Consequently, because it represents the head of a beautiful and desirable woman, the *sowo-wui* takes on tones of deep, deep black. But the black must be shining, luminous, picking up light on a smooth, glistening surface. The mask is often called " *mòò-mòò.*" *Mòò* is an ideophone expressing "a quality of shiny blackness" (Innes, 1969:88); doubling the word adds emphasis, namely, the mask as "shiny, shiny, jet, jet thing." This "shining blackness" is, then, in Mende terms, the essence of purity and exalted beauty (fig. 91).

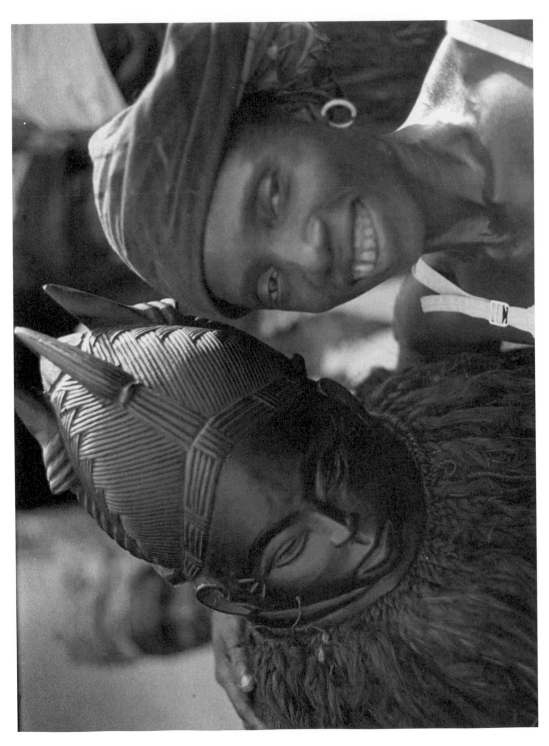

Turning to other images and ideas about the color black to be found in the language, we find further amplification of Sande's deep and extensive associations with water. Mende for black is *tèli*, and another name for the mask is the sentence, *tèli-ngò*, "it is [shiny, jet] black." Eastern Mende, according to Innes (1969:140), also use *tèli* to mean "wetness." Now shades of meaning become more complicated because in both east and south Mendeland the word for "coolness," a "moist cool place," is *ndèli*. When spoken, both *tèli* (black, blacken, and wetness) and *ndèli* (coolness, moisture) change to *lèli*, and so all sound the same. The meanings all join in *lèli*, a kaleidescopic word meaning "to blacken," "to moisten," "to cool with wetness." To blacken is therefore to moisten and to cool. A *sowo-wui* is an aesthetic summation: black, wet, and cool.

Returning again to Sande myth, we recall that the mask head is the replica of a stone. The mask is the profane object that can be seen by the public, but its counterpart is a stone which is the actual source of life, as the source of all life is a stone. The sacred Sande stone is never revealed publicly but rests hidden in the shrine. Now, in Mende color categories, a sacred stone is black, so when trying to replicate the original Sande image, the society approaches it by making the *sowo-wui* equally black.

Because the *sowo-wui* reflects its aquatic origins, we can see yet another reason for its black color. Clear, shallow water, or water in a glass, is "white" to a Mende. But water that is deep is black. It is under the deep, black waters that "paradise towns" are found, and it is from the denizens of these towns, themselves of extraordinary beauty and shiny blackness, that the *sowo-wui* comes.[72] If a diver is to retrieve a divine mask, it is into these black depths that she must valiantly descend. The black color of the *sowo-wui* is a statement about the blackness of the water and the magnificence that such blackness shelters and brings forth.

All these refractions and reflections of language and image bind together key Mende concepts of beauty and spirituality. The black stone taken from deep, cold waters, the black mask coming to earth from an aquatic heaven, a black-skinned girl emerging from her bath in a stream—all are blended into a Sande Sowo, that magical being that comes dancing into the village. When you have seen Sowo you have seen the depths and the perfection of all that is blackness.

Notes

1 R. Phillips has attempted an essay on appearances of Sowo in her 1978 article.
2 By definition, any of these *sowo-wui* circulating in the public are *kpowa jowui*, the uninitiate's *sowo-wui*. To be authentic and fully functional, a mask—like a woman— must be initiated into Sande and,—like a *Sande nyaha*,—must "abide by" its rules.
3 Chiefs, especially popular paramount chiefs, are given "retired" masks as prestige gifts when their Sande owners have no further use for them. For a mention of this in the literature, see W. L. Hommel (1974, n.p.). Chiefs frequently decorate their receiving rooms with traditional art, and several Sierra Leone chiefs have outstanding collec-

tions, most notably P.C. Foday Kai of Jaiima-Bongor, P.C. Moijue Koroma of Peja, and P.C. Bai Kurr Saki of Kholifa Mabang.

4 J. V. O. Richards, "The Sande Mask" (1974), offers a detailed, illustrated discussion of the making of the *sowo-wui*.

5 Regrettably, frequently reproduced *sowo-wui* heads in prominent western collections are neither representative of the traditional object nor of high quality. There are several reasons for this. Normally Sande officials will never dispose of a mask unless for some reason it is no longer adequate for ritual purposes. They sell masks that are misshapen, awkward or uncomfortable to wear, deficient in vital design elements or old and deteriorated. Western collectors may be bored with the seeming sameness of the icon mask and seek out examples that are "unusual," "one-of-a-kind" types, in the crass parlance of the dealers. Since these "unusual" masks are the very ones that Sande officials want to get rid of, the tastes of the two groups are mutually profitable. Mr. Fagg, former Keeper of the Ethnographic Collections of the British Museum, has chosen certain masks because they do not conform to the usual pattern (Fagg 1964: 79). Then, too, the mask may be mislabeled, so that an "anti-aesthetic" Gonde mask will be mistaken for a Sowo.

6 It must be understood that my description is of the Mende *sowo-wui* as paradigm. Generally, a Mende example will be more "horizontal" in appearance, as though pulled by the ears, while a Vai mask is longer, pulled longitudinally by the forehead peak and the chin.

7 J. V. O. Richards devotes much of chapter 3 of his dissertation on the "Factors of Limitation in the Art Forms of the Bundu Society of the Mende in Sierra Leone" (1970) to a discussion of the limitations imposed on the sculptor by the dictates of Sande requirements for the mask's appearance (pp. 75–85). W. d'Azevedo (1973), when studying the Vai and Gola of Western Liberia (across the border from Sierra Leone), writes that "the women, for their part, will attempt to direct the work of the carver by insisting upon particular stylistic elements. . . . The struggle between the carver and the Sande group may continue throughout the process of production and even for a long time after" (pp. 146–47).

8 Enquiries about criteria were only a small aspect of my research. Nonetheless, my finding, if understood as also "preliminary" and probably incomplete, can add another group of data to the literature of aesthetic evaluation of objects. The major part of L. Reinhardt's dissertation on "Mende Carvers" is given over to a "Preliminary Statement on Mende Aesthetics" (1975:108–48). Her conclusions are based on her "interviews with eight carvers" and "work sessions" with two others. The transcripts of these interviews (pp. 240–395) present much raw material for a developing study. Reinhardt compares her findings with those of R. F. Thompson's work and also S. Vogel's, summing up the relationships in table 4, "Comparison of Aesthetic Criteria among the Yoruba, Baule, and Mende" (p. 144). For Mende criteria, she lists "Naturalism, Visibility, Formal Discreteness, Delicacy, Smoothness-Shine-Blackness, Freshness, Virtuosity, and Symmetry." From my own short study, I find considerable agreement with Reinhardt's conclusions.

9 Innes notes the element *ngakpa* as "sharpen" (1969:101). The Bo preceptor defines it thus: "*Ngakpangò*—"It is sharp, or sharpened." It is brought to the point at which it can do its work well, for example, made fit for operation by bringing all the requirements to a workable head. *Jo* is a sound showing or bringing out the idea of "reaching demonstrable completeness" (19 September 1980). Innes has the unmutated form, *so*, as an ideophone meaning "exactly, completely" (1969:135).

10 Reinhardt missed these first two points, but they are evident from her interview transcripts. For example, in her interview with the famed sculptor Pa Jobu (in the presence of his brother), Reinhardt presents him with photographs of a variety of

Sowo masks and awaits his reactions. His comments have two clear, unmistakable themes: " 'Is that a Bundu mask?' " (p. 383), when deciding whether it is or is not on the basis of features; and, commenting on whether or not a mask is wearable, " 'It is not difficult to make, this mask. 'Why?' 'Too big.' " Again, speaking of another picture, " 'It is not just a toy, but not a Bundu mask for people to dance with' " (p. 384).

11 Americans know the story of another large, adult male in command of elfin workers hidden away in a remote workshop—Santa Claus and his helpers at the North Pole! Sierra Leone carvers explain that they retire to the forest, seeking peace and quiet for uninterrupted, concentrated work, and that there, in addition to privacy, they have easy access to all the wood and other botanicals they may require. Njala, June 1977.

12 This etiquette applies only to a *kpowa jowui;* an active, sacred mask cannot be touched in any way outside of the *kpanguima* ritual area. Even to get to see one is difficult; the request must be made to the chief. He or she then will summon a Sowei who has a mask and is known to be willing to cooperate. At his request he gives her a token payment, for she must "go under water"—*njabu*—and "pull out"—*gbua*—the *sowo-wui.* She will return accompanied by an assistant, the mask wrapped in a white cloth. She unwraps it carefully and holds it while the assistant folds the cloth into a cushion for the mask. The Sowei then places the mask down and the visitor may move around it, but at a distance (first experience at Lumley, April 1976).

13 Anthony Forge, in his introduction to *Primitive Art and Society* (London: The Wenner-Gren Foundation for Anthropological Research, Oxford University Press, 1973), reviews the history of the study of this art, then suggests methods for an "analysis of art as a systematic communication" (p. xxii).

14 The phenomenon of the market "dash" is a most familiar scene for anyone who has traveled in West Africa, as in the following anecdote from my own experience. I became friends with a little girl in Bo because of *bonya.* I would buy a few cents' worth of peanuts from her now and then. Each time she would measure out with her cup, then add a few more. I was charmed by her display of goodwill and by her gracious sharing of the little she had. It was her way of showing me how much she liked me, and I, of course, could not resist liking her in return.

15 For a discussion of *sondu* ("curse," "swear"), see Isaac Ndanema, "The Rationale of Mende 'Swears,' " *Sierra Leone Bulletin of Religion* 6 (1964): 21–25, and Harris and Sawyerr 1968: 59–64, 66–68.

16 Discussion by the Bo preceptor, July 1976.

17 Mme. K. compound, Bo, June 1977.

18 A favorite "spicy" scent is *hèwe,* which comes from a pepper tree, while the preferred "sweet" scent is *gbèsè,* frankincense (Innes, 1969:25, 19).

19 Discussion by Njala assistants, August 1976.

20 Telu preceptor, February 1977.

21 For discussion of these physiological facts, see Thomas Verny, M.D., *The Secret Life of the Unborn Child* (1981), and references to research in this field. Outstanding work on the ear and sound has been carried out by Audrey Wisby; see her dissertation, "Auditory Memory and the Acquisition of Literary Skills," 1977.

22 Mende term the fetus *ndo-gotu,* "child-stone" (Innes 1969:95), and consider it as a "stone in the water" (amniotic fluid).

23 See the funeral laments in Hofstra (1937); an uncle says to his dead niece: " 'You must not leave in such a short time! Remember me to my mother.' " In "The Ancestral Spirits of the Mendi," *Internationales Archiv für Ethnographie* 39 (Leiden, 1941): 177–96.

24 Though a study of Mende ideas about twins was not part of my research, I can conjecture that part of the holiness of twins and the attributing to them of special powers relates to the view of them as one person of single birth but possessing two sets of eyes, one set of which is used for magical pursuits.

25 *Mòri* means "Muslim" in Mende, but *mòrimò,* "Muslim man," has come to mean one of
 the Islamic faith who knows magical methods of divining and healing. In the past
 eighty years, Muslim clerics have settled in Mende towns as teachers and evangelists.
 They are famed as practitioners of rituals who can be consulted by anyone for a price.
 As "strangers," they are outside of the control of traditional Mende *hale* secret
 sodalities.

26 Discussion of *ngama wua* by Bo preceptor, personal communication, June 1980.

27 This is a conjecture implied in Sande comments that Sowo is two-eyed; I can only
 assume that the other set may be from the dancer. It may mean that Sowo is a spirit on
 her own without use of human eyes.

28 This is Mende metaphysical language for a rather straightforward happening. As has
 been said, Sowei are judges and counselors of the women and domestic affairs. Like a
 paramount chief, a Sowei is one of the best-informed persons in her village, constantly
 obtaining news of the latest happenings from her intelligence network. Indeed, she
 does "have eyes everywhere" because *nyaha* report to her, and anyone will come to her
 to confide, complain, or explain. A Sowei will never reveal the inner workings, prefer-
 ring to say that "Sowo's head" reveals the truth to her.

29 I am grateful to Cathy Burt, Washington, D.C., formerly an organizer of a Sierra
 Leone craft cooperative, for telling me of his work.

30 Cf. R. F. Thompson; his Liberian informant, George Tabman, remarks that for a Dan
 a slitted eye is "slumberous" (1974:251).

31 Discussion by the Bo preceptor, August 1977.

32 In the waiting room of any pediatrics clinic all the children wear thickly tied kerchiefs.
 When a child falls ill, the mother wraps its head as a way of protecting and pampering.
 Kenema nurses, November 1976.

33 Discussion by Bo preceptor, April 1978.

34 Discussion by Bo preceptor, December 1977.

35 In Mende religious thought the earth is understood to be the wife of God, *Ṅgewò.* God
 is the Father and Earth is the Mother, *Maa Ndòò,* the common "mother of mankind."
 For discussion of this point, see Harris and Sawyerr 1968:8, 99, 121.

36 Njala assistants, August 1977.

37 Njala assistants, August 1977.

38 Moyamba, July 1977.

39 My appreciation goes to the women and girls of Mme. K. compound, Bo, for many
 beautiful hairstyles and many beautiful lessons in feminine communication.

40 May 1977.

41 This information was gathered during a short stay in Kenema in October 1977. My
 informants were two nurse/midwives from the central maternity clinic, Mrs. C.N., and
 Mrs. N.F., both in their forties, mothers, Sande members. It is bad form to ask direct
 questions, but I gathered they were of *ligba* rank, and, partly because of their medical
 training, they took special care of the health of the initiates during the surgery.

42 *Gbua(a)* means "resemble, look like, take after," and *gbuaye* is "likeness, image" (under
 kpua in Innes 1969:64–65). I am not absolutely sure which of the two words was given
 since I was transcribing from oral data, but the meanings are almost identical.

43 This is very much the Mende "situational" translation. As has been pointed out before,
 the short, terse Mende lexicon leaves much unsaid, much understood from the tableau
 evoked by a single word. So, in translating, rather than explaining the whole picture of
 the initiates wearing a headpiece meant to make them in the image of Sowo, it is easier
 to use the implied key item, "cap," instead of "likeness."

44 Njala preceptor, March 1978.

45 The Satan figure in Mende thought is the *kònyòò.* Innes has the word as *kònyamu* and
 translates it as "enemy, foe," but that is a surface reading (1969:51). Mende distinguish

two types of enemies in life. One, *kugba,* is a bold, open adversary: he is a warrior, a fighter, out for conquest, ambitious for power and wealth (ibid.:67). *Kugba's* actions are direct, his motives clear. In contrast, *kònyòò* is almost more a concept than a person: he is the metaphor for all that opposes one's progress in life. *Kònyòò* is the bitter, disgruntled person who for some unknown reason rejoices at your failure and resents your success. Envious of your accomplishments, rather than using his knowledge and talents to build his own fortune and secure his own satisfactions, he covertly plots to destroy yours. This capricious wickedness, this rancor of a sullen heart and the harm and woe it produces, makes *kònyòò* Satan, the personification of evil. Discussion by the Bo preceptor, April 1978.

46 As mentioned earlier, there is scarcely anything written by a Mende about Mende culture. In a seventeen-line note about "Bondo" masks, the Mende historian Arthur Abraham writes, "The greatest differences appear in the top of the head and there are as many interpretations as there are differences." See Harry Turay and Arthur Abraham, *Catalogue of Sierra Leone Arts and Crafts in the Museum of African Art, Washington, D.C. U.S.A.* (Freetown: Ministry of Tourism and Cultural Affairs, April 1976), restricted, p. 16.

47 "Various birds . . . are believed to impersonate the ancestral spirits or transmit messages from them" (Harris and Sawyerr 1968:51). "The rhythm of life . . . is associated with snakes and serpents. This association is based on the fact that reptiles live underground" (Sawyerr 1970:75).

48 It is interesting to note that while birds and snakes star in Mende visual arts, they do not appear often in oral literature. In Kilson's collection of one hundred tales, there is only one bird (a cock) protagonist (1976: tale no. 14, p. 87), and no snakes at all. Noting that in Mende tales there are three "kinds of being— . . . spirit, animal, or persons," and that animals figure in 52 percent of the tales, Kilson thinks that many of these tales are "aetiological in that they explain existential antipathies or physical attributes of different animal species and in part through the differentiation inherent in animal speculation, aspects of the relations between non-kin within communities can be discussed readily" (ibid.:39). Kilson is saying that in these tales animals act as stand-ins for human beings. Since birds and snakes are not leading characters in the tales, this suggests that they are too powerful and evocative as creatures in themselves to be substituted for people, and too sacred to be talked of casually in secular entertainment. In a sense, birds and snakes are primary as concepts rather than (as spiders or antelopes) illustrations of a concept. When birds do appear, they are messengers (Innes 1965:58).

49 Discussion by the Bo preceptor, April 1978.

50 Discussion by the Bo preceptor, June 1977.

51 A snake-charmer performed at the Bo Agricultural Show, April 1978. I gathered this information about the Yambo Society during an informal chat with persons sitting nearby.

52 This discussion about the python touches on matters considered most sacred and recondite. I have no hard facts, and no specific informants; rather I have put this together from disparate bits of information and indirect observation. I did not think it wise to question even my preceptors for verification, so my remarks must be taken only as "informed conjecture."

53 Discussion by the Bo preceptor, July 1977.

54 This returns us to the Mende idea that initiation is an instruction in "seeing" what is invisible to or unnoticed by the *kpowa.* Considering also the primacy of vision among powers of perception, the Mende interest in birds fits into general Mende thought.

55 Discussion by Njala informants, March 1978.

56 Discussion by Mme. K. compound, Bo, April 1978.

57 The West African woman's avoidance of chickens and eggs is often noted in the literature. Physicians lament that a pregnant and lactating woman will shun these body-building foods just when her protein needs are especially high. We know that as a precaution against ever breaking the fundamental bird laws some women never touch chicken or egg dishes during their entire child-bearing years. Others voluntarily "give up" these inviting delicacies as a sacrifice to ensure their ability to have children.

Harris notes that in Mendeland, "One of the female esoteric societies, *Yègbèi*, so named after the night-jar [bird], forbids its members eating an egg. Indeed eggs are not usually eaten by the Mende on the grounds that to eat an egg is tantamount to killing the offspring of a hen. Women who have lost several children therefore join the *Yègbèi* society to ensure that any other children they bear will survive" (1970:68). Writing on "Traditional Midwifery amongst the Mende of the Southern Province of Sierra Leone," T. K. Kargbo, a specialist obstetrician and gynecologist, notes that "once the diagnosis of pregnancy is established the woman is now subjected to certain taboos and negations, the infringement of which are supposed to have disastrous effect on the outcome of the pregnancy. The admonitions are then combined with the judicious use of herbs and concoctions to be used during the antenatal period. . . . She is then warned to refrain from eating the following foods: 1. Eggs, chicken" (1975:3).

58 From his survey of traditional birth methods, D. Kargbo concluded that among the traditional midwives [Sowei], *"there is considerable expertise in the use of herbs. The various therapeutic agents in use are marshalled to produce a certain desired objective. There are drugs used to prevent abortion, stop hemorrhage and labour pain. Others are used to increase or decrease uterine contractions"* (ibid.: 11).

59 Both of these are "women's words," proverbs to and about women. Discussion by Mme. K. compound, Bo, April 1978.

60 Interview with seventy-year-old Sowei Y.J., of Mendekenema, Kenema District, recorded by an assistant in August 1977.

61 Cowries are the shells of the marine gastropod (family Cypraeidae) whose name is a variation of the Hindi word *kauri*. For a history of the use of cowries in trade, see references in C. Zaslavsky, *African Counts,* 1973.

62 As in the western bridal formula of "something old, something new, something borrowed, something blue," a Mende who goes to a diviner will be asked to bring, say, an old thing, a red thing, a favorite piece of cloth, and so on.

63 Mme. N.W., Bo, February 1977.

64 I am grateful to Mme. Muso Yavo, lead singer of the Sierra Leone Dance Troupe, for showing some fine examples of traditional cowrie jewelry.

65 These comments are based on C. P. Hoffer's 1972 article "Mende and Sherbro Women in High Office." It must be noted that her contention that female chieftancy is traditional with the Mende is upheld in an article by R. C. Ganga, "Mende Chieftancy in Nineteenth-Century Jaima" (1973), but is vigorously challenged by the Mende historian Arthur Abraham, in *Topics in Sierra Leone History* (1976) and in *Mende Government and Politics under Colonial Rule* (1978).

66 In watching dance performances, Mme. Boi seems first to notice the costume, and she will comment upon its quality. The impression I got from comments around me is that people are distressed by poor costumes but soon forgive them if the dance quality is outstanding. April 1978.

67 Noted by d'Azevedo 1973:145, and Phillips 1972:9–10.

68 "It may be observed too that, while during a day-long exhibition of dancing several masks may appear, the costume and dancer may remain the same, judging the latter by leg proportions, etc. Thus, during the breaks between dances a new mask is affixed to the costume" (Reinhardt 1975:49).

69 *Njabujo*, the "expert in diving." She is of *ligba wulo* rank in Sande.

70 Discussion by the Bo preceptor, January 1977.
71 Discussion by the Bo preceptor, August 1977.
72 Harris and Sawyerr have recorded several rites held at riversides to communicate with
 the ancestors who live in the rivers. In different versions of an "oft-told tale," the
 people of a town under siege flee to the river, which opens up and shelters them. They
 remain there, still living life as on earth but purer, as "ancestors." Also dwelling in the
 water are the female spirits (such as *Tingoi*), described as extremely beautiful
 (1968:23–25, 39–44).

 Conclusions

In a lament at the sudden death of a young Mende woman, an older Sande *nyaha* cries: "Let us not hear this! My child, big forehead, woman with plenty of hair, what brought this for you? My Sande-girl!" Another intones, "Do not leave me, Ô big forehead, Ô my child, fine neck!" A woman relative, after listing the girl's features—"hair like *Tingoi*, neck like rattan, teeth like white fruit"—adds, "How is it that you are going to leave us, the center of our friends!"

As these dirges attest, the woman's beauty should have shielded her from early death, maintained her in the fullness of life. "Big forehead"—expanse of good fortune, intellect, and social responsibility. "Plenty of hair"—hair growing thick and healthy, indicating communion with energies of fertility and abundance. "Hair like *Tingoi*"—length and fullness for elaborate coiffures, a sign of ethereal beauty, a likeness to a goddess who brings wealth. "Neck like rattan"—segmented stalk, cut round by God's hand, assuring divine munificence.

A young beauty is "the center of her friends." Beauty magnetizes the environment, sends out ripples of satisfaction. There is nothing more admirable than the ability of one human being to attract others to him or her. In her allure, a young girl is equal to a chief in Mende eyes, because they both have the ability to attract an entourage. If they are often linked in matrimony it is partly in recognition of their matching prestige. What a chief gains through authority, a pretty *nyaha* gathers through love—love from her mother and aunts, her young sisters, her toddler children, her swains and admirers, even her pets. They are all seen to circle around her, not to stray far before returning to her side. "My Sande-girl"—the Sande Society takes the natural good looks of a young girl and refines them into a metaphor of goodness for the community. Loveliness is achieved through care and grooming. A fine feature is highlighted to make it glorify the whole. Artistic abilities are developed to add a stimulating spiritual dimension. And worthy deportment is trained into an element of fine character.

Women are the beauty in Mende life. Beauty inspires love and is syn-onymous with the power to attract, and because it is female, it possesses the power to reproduce, to create new life: "If there were no love, there would be no life." In Mende culture, the Sande Society has these creative forces of life in its control. Sande has the power to make life good through showing the way to health, wealth, love, and self-expression. It offers the communi-ty cleanliness, freshness, health—all water-borne properties of physical well-being. It offers wealth through the organization of women at the *mawè* level united through their *kpanguima* sharing in productive farming teams. It offers a woman affection, attention, caring, fellowship, and lov-ing support, so that she is not alone but has sisters who wish her well. And Sande offers opportunities for intellectual development through graded instruction in herbalism, ethics, and jurisprudence.

There are two histories of the Sande Society, one factual, one mythic. The breakup of the Mali empire occasioned the Mani migrations to the Guinea Coast, then into the hinterlands of what is now Sierra Leone and Liberia under the leadership of the warrior-queen Mansarico. There is strong evidence that the Mani women brought with them developed powers of rulership based on knowledge of statecraft, herbal medicine, agriculture, and the fine arts. The basis of Mani female education and organization seems to have been a hierarchical initiation society. As the fusing of the Mani invaders with the indigenous people gave rise to the Mende ethnic group (among others), so the Mani sororities led directly to today's Sande.

According to myth, the Sande Society was an inspiration from the spirit world presented in a dream to one woman who had the conviction and the confidence to weld her community women into a strong sisterhood. The myth gives Sande its supernatural base and allies it with powers, forces, ideals, and concepts—all the workings of the intellect and the meta-physical imagination. Thus, through earthly might and spiritual certainty, the Sande Society has long been established as being firmly in control of the lives of Mende women and a leading force in the history of Upper Guinea coast civilization. The above text deals briefly with the origins of the society; it is the first to connect written data and oral traditions to find, in Mende myth, an actual charter for the firmness of Sande traditions.

Emerging from background study of the Sande Society is Sowei, an extraordinary personality in Mende life. She is seen as a remarkable wom-an of beauty, integrity, learning, and refinement who is at once the keeper of sacred learning and the promoter of practical female advancement. As guardian of the women, she sets up the *kpanguima* behind closed doors—an "anti-structure" that supports the structure, a private release that makes public decorum possible, a feasting that makes it possible to face scarcity, a world of women that can transcend male domination. The study of Mende aesthetics, then, starts with people before moving on to look

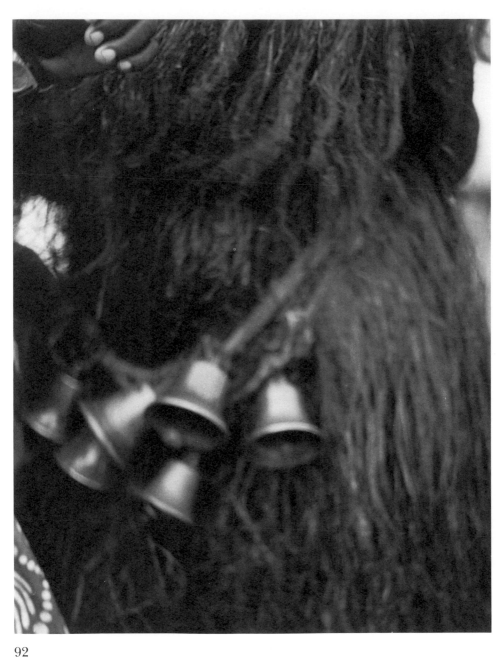

92

closely at objects. Sande teaches women the artistic presentation of the female self. Far from being natural, Mende feminine beauty is the product of lifelong discipline and grooming. In its shaping and molding of the female face and body, Sande is molding female character and comportment, insisting that beauty be an aid to efficacy.

It must be noted that Mende female beauty is not the product of leisure but is, rather, a victory over the reality of work. In the West beauty relates to ease of means: today when most people work indoors, tanned, "healthy" good looks bespeak carefree vacations in the sun, just as, in earlier times, a milky pallor indicated freedom from the prevalent outdoor farm work. Mende require that beauty not be the result of idleness but insist that it hold its own against the depredations of toil, and that it even contribute to productivity. A beautiful Mende woman is the warrior who goes to battle but comes back unscathed. The same farm labor under the hot sun that turns a man's skin leathery must leave hers fine, that makes a man's hands tough and calloused must leave hers soft and smooth, that makes a man lean and muscular must leave her round and delicate.

Mende ideas of beauty, morality, and power are embodied in the Sowo masquerade personage. In an observation fundamental to an understanding of Sowo iconography, I have distinguished, for the first time, between the two *sowo-wui* masks that are displayed by Sande. Although (a) the Sande head is the representative object of art of Sierra Leone, and (b) although mask-heads have been collected for one hundred years, and (c) although hundreds of pieces are owned by collectors and museums, and (d) although three dissertations have already appeared on Sande art forms, no one before has seen that there are in fact two masks, not one. Since everyone has said there is only one, it was very difficult to see that there are two and to realize, also, that it is the coiffure that determines the difference. Interestingly, again, quite contrary to western predispositions, the plainer mask is the more important and superior to the ornamented one.

In sum, Sowei as Sande's beautiful woman, Sowo as the embodiment of Sande's social and spiritual aspirations, and the *sowo-wui* as the summation of Sande intellect and ideals intersect and interweave as closely as do their very names. By finding strength in weakness and stature beyond subservience, Mende women have created a transcendent world as round and full and bright as the sharply etched *sowo-wui* neck rings that could be the emblem on the Sande escutcheon of women's authority, grace, and art. Scholars of women and art in the West hardly suspect the possibility of such a realm of beauty, power, and sweetness, while Sande women actually achieve this privileged, sublime level in their earthly existence (fig. 92).

GLOSSARY

Gonde	A comic Sande mask—the antithesis of Sowo beauty and decorum—who entertains the public with outrageous antics.
Hale	A religio-legal institution, a sodality, a "secret society." The two great Mende *hale* are the Sande for women and the Poro for men.
Halemò	An initiated member of a *hale* society; one who knows the properties and uses of plants. By extension, a healer or herbalist.
Hojo	Fine, white kaolin/porcelain clay, chalk, having several secular and ritual uses in Mende culture.
Informant	A term used by linguists, social scientists, art historians, and other field-workers, to refer to a person of a culture who provides information about his language, history, social structure, art, and so on.
Initiation	Rites, ceremonies, ordeals, or instructions by which one makes the transition from one stage in life to another, such as the change from childhood to adulthood, or by which one becomes the member of a sect or society. Sande initiation rites include excision, a period of seclusion for healing and study, tests of knowledge and performance, and dramatization of the belief that the novices are reborn, followed by their festive debut back into the community as beautiful, refined young women, prepared and groomed to be citizens, wives, and mothers.
Klèi	A woman of junior *ligba* rank who is mistress of Sande ceremonies, organizing and arranging for all public social events; she is Sande's town crier and announcer.
Kpanguima	An enclosure, encampment, compound, that is the venue for the Sande session of initiations.
Kpowa	A person who is not connected with any *hale* and is thus not knowledgeable about the workings of the culture. The word is extended as a noun to mean an ignoramus, a dummy, a fool; and as a verb to mean "become insane or deranged."
Ligba	Second rank in Sande. Within *ligba*, there are two grades: *Ligba Wa* (senior) and *Ligba Wulo* (junior). In any locale there is only one *Ligba Wa;* she is an executive, powerful officer in Sande.

249

Before she can take leading roles in Sande artistic activities, a woman must qualify at least as a *Ligba Wulo*. Promotion through the grades and ranks is on the basis of further study and knowledge of the Sande curriculum of botany/herbalism, ethics, ceremonies, dance, song, homecraft.

Mawè	Farming household, often a joint patrilocal family living together in a compound, "consisting of one or more older men and their wives, some or all of their sons and daughters, husbands and wives of the latter; and a number of grandchildren" (Little, 1967:96).
Mbaa	Pal, buddy, same-sex companion, friend; a term for Sande women who have undergone initiation together, and who thus owe each other lifetime affection, loyalty, and support. Also, a term for co-wives in a polygynous household, "mate."
Mbogboni	A girl undergoing Sande initiation.
Mende	An ethnic group of Mande heritage numbering some one million persons who live in southern and eastern Sierra Leone, on the West Atlantic coast of Africa.
Ndoli Jowei	"The expert in dancing," a woman of junior *Ligba* rank who dances the mask in public and teaches dancing to the girls in the initiation encampment.
Ṅgewò	God, the One-God, whom the Canon Reverend Harry Sawyerr has described as the "Creator of the Universe," "Ruler of the Universe," and "Father-Protector" (1970:62–67).
Nyaha	A woman, wife, female who has been initiated into the Sande Society. The one word indicates that Sande initiation makes a woman of a child, and every woman into a wife (as in the French *femme,* the German *frau,* etc.).
Poma Jowei	A "follower of Sowei"; a newly graduated initiate; thus the new *nyaha* herself is a Sande leader in the future.
Poro	The great *hale* society of Mende men.
Preceptor	Following the usage by D. Biebuyck (1973:xx) a senior informant who is a teacher and guide to arcane and recondite society knowledge.
Sande	The great *hale* society of Mende women.
Sande Jowei	"An expert in Sande," woman of Sowo rank who is keeper of Sande knowledge and head of a Sande lodge or speciality.
Sande Waa Jowei	"Sowei who initiates a Sande," a high-grade Sowei who is organizer of a Sande session; its chief administrator, who is responsible for its success.
Sande yo	A girl who has just completed Sande initiation.
Senior wife	First, leader wife in a polygynous and/or joint household, who has the *mawè* under her administration; she organizes the women's farm work, and is largely responsible for the harmony and productivity of the compound.

Sowei	Name and term of address for the esteemed women who hold Sowo rank in the Sande Society and who function in professional positions in the community as healers, judges, priestesses, educators.
Sowo	Large *s*, the Sande Society mask, dancing spirit, whose visible persona consists of a sculpted helmet head and a costume of cloth and fibers, all in stark black.
Sowo	Small *s*, an expert, male or female, who leads the activities or excels in the job because he or she has the requisite ability or know-how. *Sowo* is the top level in the Sande Society.
Sowo-lolimò	"Expert in dancing," a woman of *ligba* level who teaches and performs Sande festive and ceremonial dance.
Sowo-wui	"The head of Sowo," the helmet mask-head of the Sande Spirit. That is, *ngu*—head—mutating to *wu, wui* in definite form; thus *sowo-wui* is the mask-head.
Tingoi	A river spirit who appears as a mermaid. Said to be beautiful, shapely, light-skinned, long-haired, woman-to-the-waist, fish below.

SELECTED BIBLIOGRAPHY

GENERAL WORKS

Abraham, W. E. *The Mind of Africa.* Chicago: University of Chicago Press, 1962.

Adams, Monni. *Design for Living: Symbolic Communication in African Art.* Cambridge, Mass.: Harvard University Press, 1982.

African Studies Centre, Cambridge. *African Women: A Select Bibliography.* Cambridge: African Studies Centre, 1974.

Aidoo, Ama Ata. *No Sweetness Here.* New York: Doubleday and Co., 1971.

Allison, Philip. *African Stone Sculpture.* New York: Frederick A. Praeger, 1968.

Angelou, Maya. *And Still I Rise.* New York: Random House, 1978.

Antubam, Kofi. *Ghana's Heritage of Culture.* Leipzig: Koehler and Amelang, 1963.

Atkins, Guy, ed. *Manding Art and Civilization.* London: Studio International, 1972.

Balandier, Georges, and Jacques Maquet. *Dictionnaire des civilisations africaines.* Paris: Fernand Hazan, Editeur, 1968.

Becker-Donner, Etta. *Hinterland Liberia.* London: Blackie and Son, 1939.

Bell, Clive. "The Aesthetic Hypothesis." In *Aesthetics and the Philosophy of Criticism,* edited by Marvin Levich. New York: Random House, 1963.

Ben-Amos, Paula. "Patron-Artist Interactions in Africa." *African Arts* 13, no. 3 (1980).

Berlin, Brent, and Paul Kay. *Basic Color Terms: Their Universality and Evolution.* Berkeley: University of California Press, 1969.

Berry, J. *Spoken Art in West Africa.* London: University of London, 1961.

Biebuyck, Daniel. "Art as a Didactic Device in African Initiation Systems." *African Forum* 3, no. 4 and 4, no. 1 (Spring/Summer double issue, 1968).

_____. *Lega Culture: Art, Initiation and Moral Philosophy among a Central African People.* Berkeley: University of California Press, 1973.

_____. "The Problem of the Function of African Art." In *Colloquium on Negro Art* (Dakar, 1st World Festival of Negro Arts), vol. 2. Paris: Présence Africaine, 1971.

_____. "Textual and Contextual Analysis in African Art Studies." *African Arts* 8, no. 3 (1975).

_____, ed. "Introduction," etc. *Tradition and Creativity in Tribal Art.* Berkeley and Los Angeles: University of California Press, 1973 (also 1969).

Blitzer, Charles. *An Immortal Commonwealth.* New Haven: Yale University Press, 1960. Reprinted Hamden, Conn.: Archon Books, 1970.

Boone, Sylvia Ardyn. *West African Travels: A Guide to People and Places.* New York: Random House, 1974.

Botchway, Francis A. "Ontology of Ewe Judicial Thought and Religion." Unpublished paper, 1971.

Bravmann, René A. *Open Frontiers: The Mobility of Art in Black Africa.* Seattle: University of Washington Press, 1973.

Brett-Smith, Sarah C. "Symbolic Blood: Cloths for Excised Women." *Res,* no. 3 (1982).

Bullough, Edward. "'Psychical Distance' as a Factor in Art and an Aesthetic Principle." In *Aesthetics and the Philosophy of Criticism,* edited by Martin Levich. New York: Random House, 1963.

Butt-Thompson, F. W. *Secret Societies of West Africa.* London: H. F. and G. Witherby, 1929. Also Westport: Negro Universities Press, 1969.

Cole, Herbert M. *African Arts of Transformation.* Santa Barbara: The Art Galleries, University of California, 1970.

Conklin, Harold C. "Color Categorization." *American Anthropologist* 75, no. 4 (1973).

Crowley, Daniel. "An African Aesthetic." In *Art and Aesthetics in Primitive Societies: A Critical Anthology,* edited by Carol F. Jopling. New York: E. P. Dutton and Co., 1971.

———. "Chokwe: Political Art in a Plebian Society." In *African Art and Leadership,* edited by D. Fraser and H. M. Cole. Madison: The University of Wisconsin Press, 1972.

Curtin, Philip D., Steven Feierman, Leonard M. Thompson, and Jan Vansina. *African History.* Boston: Little, Brown, and Co., 1978.

Dapper, Olfert. *Umständliche und Eigentliche Beschreibung von Africa Anno 1668.* Stuttgart: Steingruben Verlag, 1964.

Dark, Philip J. C. "The Study of Ethno-Aesthetics: The Visual Arts." *Essays on the Verbal and Visual Arts, Proceedings, American Ethnological Society,* 1966. Published in 1967.

Davidson, Basil. *Africa: History of a Continent.* New York: Macmillan, 1970.

d'Azevedo, Warren L. *The Artist Archetype in Gola Culture.* Desert Research Institute, University of Nevada. Reprint no. 14, 1966.

———. "Mask Makers and Myth in Western Liberia." In *Primitive Art and Society,* edited by A. Forge. Published for The Wenner-Gren Foundation for Anthropological Research. London: Oxford University Press, 1973.

———. *Some Terms from Liberian Speech.* Monrovia: United States Peace Corps in Liberia, 1967.

———. "Sources of Gola Artistry." In *The Traditional Artist in African Societies,* edited by Warren L. d'Azevedo. Bloomington: Indiana University Press, 1973.

———, ed. *The Traditional Artist in African Societies.* Bloomington: Indiana University Press, 1975.

Delange, Jacqueline. *Arts et peuples de l'Afrique noire: Introduction à l'analyse des créations plastiques.* Paris: Gallimard, 1967.

De La Rue, Sidney. *The Land of the Pepper Bird: Liberia.* New York: G. P. Putnam's Sons, 1930.

Dieterlen, Germaine. "The Mande Creation Myth." *Africa* 17, no. 2 (1957).

Diop, Cheikh Anta. *The Cultural Unity of Negro Africa.* Paris: Présence Africaine, 1959.

Duerden, Dennis. *African Art*. London: Paul Hamlyn, 1968.

Ehrenreich, Barbara, and Diedre English. *Witches, Midwives, and Nurses: A History of Women Healers*. Oyster Bay, N.Y.: Glass Mountain Pamphlets, n.d. (1972?).

Eliade, Mircea. *Birth and Rebirth: The Religious Meanings of Initiation in Human Culture*. Translated by W. R. Trask. New York: Harper & Brothers, 1958.

———. *The Myth of the Eternal Return, or Cosmos and History*. Translated by W. R. Trask. Bollingen Series, 46. Princeton, N.J.: Princeton University Press, 1971.

Fage, J. D. *An Atlas of African History*. London: Edward Arnold, 1958.

Fagg, William. *African Tribal Images: The Katherine White Reswick Collection*. Cleveland: Cleveland Museum of Art, 1968.

———, and Margaret Plass. *African Sculpture*. London: Studio Vista, 1964.

Faris, James C. *Nuba Personal Art*. Toronto: University of Toronto Press, 1972.

Fernandez, James W. "Principles of Opposition and Vitality in Fang Aesthetics." In *Art and Aesthetics in Primitive Societies*, edited by Carol F. Jopling. New York: E. P. Dutton, 1971.

Field, M. J. *Angels and Ministers of Grace*. New York: Hill and Wang, 1971.

Finnegan, Ruth. *Oral Literature in Africa*. Oxford: Clarendon Press, 1970.

Flam, Jack D. "Some Aspects of Style Symbolism in Sudanese Sculpture." *Journal des Africanistes* 40, no. 2 (1976).

———. "The Symbolic Structure of Baluba Caryatid Stools." *African Arts* 4, no. 2 (1970).

Focillon, Henri. *The Life of Forms in Art*. New York: George Wittenborn, 1966.

Foltz, William J. *From French West Africa to the Mali Federation*. Yale Studies in Political Science, 12. New Haven: Yale University Press, 1965.

Forge, Anthony. "Introduction." In *Primitive Art and Society*, edited by A. Forge. Published for the Wenner-Gren Foundation for Anthropological Research. London: Oxford University Press, 1973.

Fraenkel, Merran. *Tribe and Class in Monrovia*. London: Oxford University Press, 1964.

Freud, Sigmund. *The Future of an Illusion*. Translated by the Reverend W. D. Robson-Scott and newly edited by James Strachey. Garden City, N.Y.: Doubleday, 1964.

Gabus, Jean. *L'Art Nègre: Recherche de ses fonctions et dimensions*. Neuchâtel: Les Editions de la Baconnière, 1967.

Gaskin, L. J. P. *A Bibliography of African Art*. London: International African Institute, 1965.

———. *A Select Bibliography of Music in Africa*. London: International African Institute, 1965.

Georges, R. A. "Structure in Folk-tales: A Generative-Transformational Approach." *Conch* 2 (1970).

Gerbrands, Adrian A. *Art as an Element of Culture, Especially in Negro Africa*. Leiden: E. J. Brill, 1957.

———. "The Study of Art in Anthropology." *The Social Sciences: Problems and Orientations*. The Hague: Mouton/UNESCO, 1968.

Germann, Paul. *Die Völkerstämme im Norden von Liberia*. Leipzig: R. Voigtländer, 1933.

Glaze, Anita J. *Art and Death in a Senufo Village.* Bloomington: Indiana University Press, 1981.

Griaule, Marcel. *Conversations with Ogotemmêli: An Introduction to Dogon Religious Ideas.* London: Oxford University Press, 1965.

――――. *Folk Art of Black Africa.* New York: Tudor Publishing Co., 1950.

――――. *Masques Dogons.* 2d ed. Paris: Institut d'Ethnologie, Musée de l'Homme, 1963.

――――, and Germaine Dieterlen. "The Dogon of the French Sudan." In *African Worlds,* edited by D. Forde. London: Oxford University Press, 1954.

Guy, Rosa. *The Friends.* New York: Holt, Rinehart & Winston, 1973.

Hall, Edward T. *The Dance of Life: The Other Dimension of Time.* Garden City, N.Y.: Anchor Press/Doubleday, 1983.

Harley, G. W. "Masks as Agents of Social Control in Northeast Liberia." *Peabody Museum Papers* 32, no. 2 (1950). Cambridge: Peabody Museum; also New York: Kraus Reprint Corp., 1968.

――――. "Notes on the Poro in Liberia." *Peabody Museum Papers* 19, no. 2 (1941). Cambridge, Mass: Harvard University Printing Office; also New York: Kraus Reprint Corp., 1968.

Harris, Marvin. *The Rise of Anthropological Theory.* New York: Crowell, 1968.

Haselberger, Herta. "The Study of Ethnological Art." *Current Anthropology* 2, no. 4 (1961).

Haughton, S. H. *Stratigraphic History of Africa South of the Sahara.* London: Oliver and Boyd, 1963.

Hemmings-Gapihan, Grace. "Base-line Study for Socio-Economic Evaluation of Tangay Solar Installation." In *Women and Development,* edited by Irene Tinker. Washington, D.C.: American Association for the Advancement of Science, 1979.

Herbert, Eugenia. "Smallpox Inoculation in Africa." *Journal of African History* 16 (1975).

Hersey, George L. *Pythagorean Palaces: Magic and Architecture in the Italian Renaissance.* Ithaca, N.Y.: Cornell University Press, 1976.

Herskovits, Melville J. *Backgrounds of African Art.* Denver: Denver Museum of Art, 1945.

――――, and F. S. Herskovits. *Dahomean Narrative: A Cross-Cultural Analysis.* Evanston, Ill.: Northwestern University Press, 1958.

Himmelheber, H. "Sculptors and Sculptures of the Dan." In *Proceedings of the First International Congress of Africanists,* edited by Lalage Bown and Michael Crowder. London: Longmans, 1964.

Johnston, Harry. *Liberia.* vol. 2. London: Hutchinson, 1906.

Kagame, Alexis. *La Philosophie bantu-rwandaise de l'Être.* Mémoires, Classe des Sciences Morales et Politiques, n.s. 12. Brussels: Académie Royale des Sciences Coloniales, 1956.

Kubler, George. *The Shape of Time.* New Haven: Yale University Press, 1962.

Lafon, Suzanne. "La Parure chez les femmes peul du Bas-Sénégal." *Notes Africaines,* I.F.A.N., no. 46 (1950).

La Fontaine, J. S. *The Interpretation of Ritual.* London: Tavistock, 1974.

Laìn Entralgo, Pedro. *The Therapy of the Word in Classical Antiquity.* Translated by L. J. Rather and J. M. Sharp. New Haven: Yale University Press, 1970.

Leakey, Lewis S. B. "The Kikuyu Problem of the Initiation of Girls." *Journal of the Royal Anthropological Institute of Great Britain and Ireland* 61 (1931).

Lévi-Strauss, Claude. *The Savage Mind.* Chicago: University of Chicago Press, 1966.

Little, Kenneth. "Africa's Women—Traditional and Liberated." *West Africa,* 14 July 1975.

————. "Voluntary Associations and Mobility among West African Women." *Canadian Journal of African Studies* 6, no. 2 (1972).

Lomax, Alan. *Folksong, Style, and Culture.* Washington, D.C.: American Association for the Advancement of Science, 1968.

Long, Richard A. "Africa and America: Race and Scholarship." *Occasional Paper No. 1,* Center for African and Afro-American Studies, Atlanta University, 1969.

McLeod, Malcolm D. "Verbal Elements in West African Art." *Quaderni Poro* 1 (1976).

McNaughton, Patrick R. *Secret Sculptures of Komo: Art and Power in Bamana (Bambara) Initiation Associations.* Working Papers in the Traditional Arts, no. 4. Philadelphia: Institute for the Study of Human Issues, 1979.

Mancuso, Arlene. "No Drums, No Trumpets: Working Class Women." In *Women's Issues in Social Work Practice,* edited by A. Mancuso and E. Norman. Itasca, Ill.: Peacock Publishers, 1980.

Maquet, Jacques. "An Approach to a Sociology of Traditional Sculpture." In *Colloquium on Negro Art,* Dakar, 1st World Festival of Negro Arts. Paris: Présence Africaine, 1968.

————. *Civilizations of Black Africa.* New York: Oxford University Press, 1972.

Marshall, Gloria. "In a World of Women: Field Work in a Yoruba Community." In *Women in the Field,* edited by Peggy Golde. Chicago: Aldine Publishing Company, 1970.

Mbiti, John S. *African Religions and Philosophy.* London: Heinemann, 1969.

————. *The Concepts of God in Africa.* London: Heinemann, 1970.

Mead, Margaret. *Male and Female.* New York: W. Morrow, 1949.

Memel-Fotê, Harris. "l'Idée d'une esthétique négro-africaine." *Revue de littérature et d'esthétique Négro-africaines,* no. 1 (1977).

————. "The Perception of Beauty in Negro African Culture." In *Colloquium on Negro Art,* Dakar, 1st World Festival of Negro Arts. Paris: Présence Africaine, 1968.

Mengrelis, Thanos. "Le Sens des masques dans l'initiation." *Africa* 22, no. 3 (July 1952).

Middleton, John. *Black Africa: Its Peoples and Their Cultures Today.* London: Macmillan, 1970.

Miller, Joseph C., ed. *The African Past Speaks: Essays on Oral Tradition and History.* Folkestone, Eng.: Dawson; Hamden, CT: Archon, 1980.

Mills, George. "Art: An Introduction to Qualitative Anthropology." *Journal of Aesthetics and Art Criticism* 16 (1957).

Monteil, Charles V. *Les Bambara du Ségou et du Kaarta.* Paris: W. Larose, 1924.

Moore, Bai T. "Categories of Liberian Songs." *Liberian Studies Journal* 2, no. 2 (1970).

Moore, Jane. "The Middle Society: Five Orientations Towards Husband-Wife Roles in West African Novels." Unpublished Paper, 1967.

Morales, Janet Campbell. " 'My Daughter Was Born a Month Ago,' and Other Poems." Typescript, 1967.

Munari, Bruno. *Discovery of the Square*. New York: George Wittenborn, 1965.

Murdock, George P. *Africa: Its People and Their Culture History*. New York: McGraw- Hill, 1959.

Mvusi, Selby. "Current Revolution and Future Prospects." In *Colloquium on Negro Art*, Dakar, 1st World Festival of Negro Arts, vol. 2. Paris: Présence Africaine, 1971.

Niane, Djibril T. *Soundiata ou l'Epopée Mandingue*. Paris: Présence Africaine, 1960.

Nkrumah, Kwame. *Consciencism*. London: Heinemann, 1966.

Olderogge, M. "Le Roi-Forgeron dans l'ancienne culture africaine." In *Colloquium on Negro Art*, Dakar: 1st World Festival of Negro Arts, vol. 2. Paris: Présence Africaine, 1971.

Panofsky, Erwin. *Meaning in the Visual Arts*. Garden City, N.Y.: Anchor Books, 1955.

_____. *Studies in Iconology*. New York: Oxford University Press, 1939.

Parrinder, Geoffrey. *African Mythology*. London: Paul Hamlyn, 1967.

Paulme, Denise. *Les Gens du Riz*. Paris: Librairie Plon, 1954.

p'Bitek, Okot. *Religion of the Central Luo*. Nairobi: East African Literature Bureau, 1971.

Rattray, R. S. *Religion and Art in Ashanti*. London: Oxford University Press, 1927 (also 1959).

Richards, Audrey I. *Chisungu: A Girl's Initiation Ceremony among the Bemba of Northern Rhodesia*. London: Faber and Faber, 1956.

Rudofsky, Bernard. *Architecture without Architects*. Garden City, N.Y.: Doubleday and Co., 1964.

Salmons, Jill. "Mammy Wata." *African Arts* 10, no. 3 (April 1977).

Sarpong, Peter. *Girls' Nubility Rites in Ashanti*. Accra-Tema: Ghana Publishing Corporation, 1977.

Schwab, George. "Tribes of the Liberian Hinterland." *Peabody Museum Papers*, vol. 31. Cambridge, Mass.: Peabody Museum, 1947.

Schwartz-Bart, André. *A Woman Called Solitude*. Translated by R. Manheim. New York: Atheneum, 1973.

Scully, Vincent J. *The Earth, the Temple and the Gods*. Rev. ed. New Haven: Yale University Press, 1979.

Sieber, Roy. *African Textiles and Decorative Arts*. New York: Museum of Modern Art, 1972.

_____. "Masks as Agents of Social Control." In *The Many Faces of Primitive Art*, edited with an introduction by Douglas Fraser. Englewood Cliffs, N.J.: Prentice-Hall, 1966. Also in *African Studies Bulletin*, no. 11 (1962).

_____, and Arnold Rubin. *Sculpture of Black Africa: The Paul Tishman Collection*. Los Angeles: County Museum of Arts, 1968.

Singer, Charles. *A Short History of Anatomy and Physiology from the Greeks to Harvey*. New York: Dover Publications, 1957.

Smith, Edwin W., ed. *African Ideas of God: A Symposium*. 2d ed. revised and edited by E. G. Parrinder. London: Edinburgh House Press, 1950 [1961].

Smith, Michael G. *The Affairs of Daura.* Berkeley and Los Angeles: University of California Press, 1978.

Sontag, Susan. "Beauty, How Will It Change Next?" *Beauty in Vogue.* London, 1975.

Soyinka, Wole. *Idanre and Other Poems.* New York: Hill and Wang, 1968.

Stendhal [Marie Henri Beyle]. *On Love.* Garden City, N.Y.: Doubleday and Co., 1947.

Talbot, D. Amaury. *Women's Mysteries of a Primitive People.* London: Frank Cass, 1968 (1st ed., 1915).

Tempels, P. *Bantu Philosophy.* Paris: Présence Africaine, 1959.

Thompson, Robert Farris. "Aesthetics in Tropical Africa." In *Art and Aesthetics in Primitive Societies: A Critical Anthology,* edited by Carol F. Jopling. New York: Dutton & Co., 1971.

———. *African Art in Motion: Icon and Act.* Los Angeles: University of California Press, 1974.

———. *Black Gods and Kings.* Los Angeles: Museum and Laboratories of Ethnic Arts and Technology, 1971.

———. "The Sign of the Divine King: An Essay on Yoruba Bead-Embroidered Crowns with Veil and Bird Decorations." *African Arts* 3, no. 3 (1970).

———. "Yoruba Artistic Criticism." In *The Traditional Artist in African Societies,* edited by Warren L. d'Azevedo. Bloomington: Indiana University Press, 1973.

Trimingham, Spencer J. *Islam in West Africa.* Oxford: Clarendon Press, 1964.

Turner, Victor. *The Forest of Symbols: Aspects of Ndembu Ritual.* Ithaca, N.Y.: Cornell University Press, 1967.

———. *The Ritual Process: Structure and Anti-Structure.* Middlesex, Eng.: Penguin Books, 1969.

———. "Three Symbols of *Passage* in Ndembu Circumcision Ritual: An Interpretation." In *Essays on the Ritual of Social Relations,* edited by M. Gluckman. Manchester, Eng.: The University Press, 1962.

Tylor, Sir Edward B. *Primitive Culture: Researches into the Development of Mythology, Philosophy, Language, Arts and Customs.* 3d ed. London: J. Murray, 1891.

USAID. *Liberian Educational and Cultural Materials.* Monrovia: The Department of Education, 1970.

Verny, Thomas. *The Secret Life of the Unborn Child.* New York: Summit Books, 1981.

Vogel, Susan. *Beauty in the Eyes of the Baule: Aesthetics and Cultural Values.* Working Papers in the Traditional Arts, no. 6. Philadelphia: Institute for the Study of Human Issues, 1980.

Volz, Walter. *Reise durch das Hinterland von Liberia, im Winter 1906–1907.* Bern: A. Francke, 1911.

Walker, Roslyn, *African Women/African Art: An Exhibition of African Art Illustrating the Different Roles of Women in African Society.* New York: The African-American Institute, 1976.

Wallis, C. B. "A Tour in the Liberian Hinterland." *Journal of Royal Geographical Society,* March 1910.

Warren, Lee. *The Dance of Africa: An Introduction with Dance Instructions.* Englewood Cliffs, N.J.: Prentice-Hall, 1972.

Webster, H. *Secret Societies.* New York: Macmillan Company, 1932.

Weiskel, Timothy C. "Nature, Culture, and Ecology in Traditional African Thought Systems." *Culture* (UNESCO), 1973–74.

Westermann, Diedrich, and M. A. Bryan. *The Languages of West Africa.* Published for the International African Institute. London and New York: Oxford University Press, 1952.

Western, Dominique Coulet. *A Bibliography of the Arts of Africa.* Waltham, Mass.: The African Studies Association, 1975.

Willett, Frank. *African Art.* New York: Praeger Publishers, 1971.

Williams, Robin. "Value Orientations in American Society." In *Social Perspectives in Behavior,* edited by R. A. Cloward and H. D. Stein. New York: Free Press, 1967.

Wingert, Paul S. "Anatomical Interpretations in African Art." In *Art and Aesthetics in Primitive Society: A Critical Anthology,* edited by Carol F. Jopling. New York: Dutton and Co., 1971.

Wisbey, Audrey. "Auditory Memory and the Acquisition of Literary Skills." Dissertation, University of London, 1977.

Witherspoon, Gary. *Language and Art in the Navajo Universe.* Ann Arbor: University of Michigan Press, 1977.

Zahan, Dominique. "Significance and Function of Art in Bambara Community Life." In *Colloquium on Negro Art,* Dakar, 1st World Festival of Negro Arts. Paris: Présence Africaine, 1968.

Zaslavsky, Claudia. *Africa Counts: Number and Pattern in African Culture.* Boston: Prindle, Weber and Schmidt, 1973.

SIERRA LEONE AND MENDE STUDIES

Unpublished Sources

Abraham, Arthur. "The Rise of Traditional Leadership among the Mende." Master's thesis, Fourah Bay College, University of Sierra Leone, 1971.

Avery, W. L. "Indigenous Worship in the Churches of Sierra Leone." Unpublished paper, 1973.

Boone, Sylvia Ardyn. "Meaning in the Sande Mask, *Sowo.*" Paper presented at the Triennial Symposium on African Art, Atlanta, April 1980.

———. "Sowo Art in Sierra Leone: The Mind and Power of Woman on the Plane of the Aesthetic Disciplines." Ph.D. dissertation, Yale University, 1979.

Carew, George M. "The Underlying Philosophical Connotations of Some Mende Proverbs." Paper presented at the Seminar on Black Civilization and Education, University of Sierra Leone, 1975.

Conteh, D. E. S. "The History of Harford School and the Part It Has Played in the Education of Girls in Sierra Leone." Dip. Ed. thesis no. 112, Fourah Bay College, University of Sierra Leone, 1963.

Cosentino, Donald. "Patterns of Dòmèisia: The Dialectics of Mende Narrative Performance." Ph.D. dissertation, University of Wisconsin, 1977.

d'Azevedo, Warren L. "Masked Spirit Impersonators." Unpublished paper, 1968.

Dubinskas, Frank A. "The Beauty of the /sowo/: Spirit of the Mende Women's Secret Society." Unpublished paper, 1972.

Fyle, Clifford N. "Languages as Reflecting the Thought of African People—The Case of Krio." Paper presented at the Seminar on Black Civilization and Education, University of Sierra Leone, 1975.

Ghonda, Millicent J. T. "The Problem of Wastage in Girls' Secondary Schools. Dip. Ed. thesis no. 192, Fourah Bay College, University of Sierra Leone, 1969.

Hoffer, Carol Pulley. "Acquisition and Exercise of Political Power by a Woman Paramount Chief of the Sherbro." Ph.D. dissertation, Bryn Mawr College, 1971.

———. "Advantages and Disadvantages of Being a Woman Paramount Chief, A Sierra Leone Example." Paper presented at the 14th Annual Meeting of the African Studies Association, Denver, 1971.

———. "Bundu: Political Implications of Female Solidarity in a Secret Society." Unpublished (?) MS, 1972.

Kargbo, Thomas K. "Traditional Midwifery amongst the Mende of Sierra Leone: Its Values, Relevance and Limitations in the Contemporary Context." Paper presented at the Seminar on Black Civilization and Education, University of Sierra Leone, 1975.

Koroma, M. S. "The Effect of Western Education on Secret Societies in the Southern Area." Dip. Ed. thesis no. 119, Fourah Bay College, University of Sierra Leone, 1965.

Lahal, Albert M. "Tribal Education of the Mende of Dasse Chiefdom, Moyamba District." Dip. Ed. thesis no. 255, Fourah Bay College, University of Sierra Leone, 1971.

MacCormack, Carol P. "Health, Fertility and Childbirth in the Moyamba District, Sierra Leone." Unpublished MS, 1978.

Ndanema, Isaac. "Mende Concept of the Ancestors." Unpublished MS, n.d.

———. "Societies That Guide the Moral Life of the Mendes." Unpublished MS, n.d.

Palmer, Marylyn. "An Examination of Songs and Dances for Educational Use." Higher Teaching Certificate thesis, Music Department, Milton Margai Teachers College, Freetown, 1974.

Pratt, Philomina A. G. "Some Problems in the Education of Girls with Particular Reference to Queen of the Rosary School, Bo." Dip. Ed. thesis no. 304, Fourah Bay College, University of Sierra Leone, 1972.

Reeck, Darrell L. "Religious Interactions in a Modernizing Mende Chiefdom in Sierra Leone." Unpublished paper, 1973.

Reinhardt, Loretta R. "Mende Carvers." Ph.D. dissertation, Southern Illinois University, 1975.

Richards, Josephus V. O. "Factors of Limitation in the Art Forms of the Bundu Society of the Mende in Sierra Leone." Ph.D. dissertation, Northwestern University, 1970.

Robinson, N. A. "The History of the Njalahun Girls' School and Its Influence on the Life of the People of the Surrounding District." Dip. Ed. thesis no. 82, Fourah Bay College, University of Sierra Leone, 1962.

Sulimani, Judith V. "The Role of Music in the Lives of the Kono." Higher Teaching Certificate thesis, Music Department, Milton Margai Teachers College, Freetown, 1975.

Todd, S. K. "Gift Situations among the Mende." Master's thesis, Department of Theology, University of Sierra Leone, 1971.

White, Elaine Frances. "Creole Women Traders in Sierra Leone: An Economic and Social History." Ph.D. dissertation, Boston University, 1978.

Published Sources

Abraham, Arthur. *Mende Government and Politics under Colonial Rule: A Historical Study of Political Change in Sierra Leone, 1890–1937*. Freetown: Sierra Leone University Press, 1978.

———. *Topics in Sierra Leone History*. Freetown: Leone Publishers [ca. 1976].

———, and Cecil Fyle. "Country Cloth Culture in Sierra Leone." *Odu*, n.s. 13 (January 1976).

———, and Harry Turay. *Catalogue of Sierra Leone: Arts and Crafts in the Museum of African Art, Washington, D.C., U.S.A.* Freetown: Ministry of Tourism and Cultural Affairs, 1976.

Addison, W. "The Palm-nut Tree and Its Uses." *Sierra Leone Studies*, no. 1 (1918).

———. "Steatite Figures from Moyamba District, Central Province, Sierra Leone, West Africa." *Man* 23 (1923).

———. "The Wunde Society: Protectorate of Sierra Leone, British West Africa." *Man* 36 (1936).

Agbonyitor, Alberto D. K. "The Informal Market for Credit in Sierra Leone." *Africana Research Bulletin* 7, no. 1 (1976).

Akar, John. "The Arts in Sierra Leone." *African Forum* 1 (1965).

Alldridge, T. J. *The Sherbro and Its Hinterland*. London: Macmillan, 1901.

———. *A Transformed Colony*. London: Macmillan, 1910.

———. "Wanderings in the Hinterland of Sierra Leone." *The Geographical Journal* 4, no. 2 (August 1894).

Andrzejewski, B. W. "Emotional Bias in the Translation and Presentation of the African Oral Art." *Sierra Leone Language Review*, no. 4 (1965).

Anonymous. *Mende Yèpèwu Bukui* [Mende Word List]. Bo: United Christian Church Literature Bureau, n.d.

Atherton, John H., and Milan Kalous. "Nomoli." *The Journal of African History* 11, no. 3 (1970).

Awuta-Coker, Arika. *Sierra Leone Stories*. Freetown: Sierra Leone, 1971(?).

Banbury, G. A. L. *Sierra Leone, or the White Man's Grave*. London: S. Sonnenshein, Lowrey and Co., 1888.

Banton, Michael P. *West African City: A Study of Tribal Life in Freetown*. Published for the International African Institute. London: Oxford University Press, 1957.

Battuta, Ibn. *Travels in Asia and Africa*. Edited by H. A. R. Gibb. London: Routledge and Kegan Paul, 1957.

Beauchene, Guy de. "Une Statuette en pierre ouest-africaine." *Objets et Mondes* 3, no. 1 (1963).

Blair, J. A. B. "Sierra Leone Studies, 1918–1968—Subject Index." *Africana Research Bulletin* 2, no. 1 (October 1971).

Bo Agricultural Show. *Programme*. Bo: Agricultural Show, 1976.

———. *Programme*. Bo: Agricultural Show, 1978.

Bokhari, A. "Notes on the Mende People." *Sierra Leone Studies* 1 and 2 (1918 and 1919).

Bokhari, J. "The Derivation of Mende Names for the Months of the Year." *Sierra Leone Studies*, n.s. 4 (June 1955).

Brown, S. *A Mende Grammar with Tones.* Bo: United Christian Church Literature Bureau, n.d.

_____. "The Nomoli of Mende Country." *Africa* 18, no. 1 (1948).

Butt-Thompson, F. W. *Sierra Leone in History and Tradition.* London: H. F. and G. Witherby, 1926.

Cartwright, John R. *Politics in Sierra Leone, 1947–1967.* Toronto: University of Toronto Press, 1970.

Catalog of the Sierra Leone Collection, Fourah Bay College Library, University of Sierra Leone. Boston: G. K. Hall, 1979.

Clarke, J. I., ed. *Sierra Leone in Maps.* London: University of London Press, 1966.

Clarke, Robert. *Sierra Leone: A Description of the Manners and Customs of the Liberated Africans.* London: James Ridgway, 1843.

Clarke, W. R. E. "The Foundation of the Luawa Chiefdom." *Sierra Leone Studies*, n.s. 8 (1957).

Cole, J. Abayomi. *A Revelation of the Secret Orders of West Africa.* Dayton, Ohio: United Brethren Publishing House, 1886.

The Commonwealth Institute. *Traditional Carvings and Craftwork from Sierra Leone: A Selection from the Massie-Taylor Collection.* London: The Commonwealth Institute, 1961.

Cosentino, Donald. *Defiant Maids and Stubborn Farmers: Tradition and Invention in Mende Story Performance.* Cambridge Studies in Oral and Literate Culture, no. 4. Cambridge and New York: Cambridge University Press, 1982.

Crosby, K. H. *An Introduction to the Study of Mende with a Phonetic Introduction to Mende by Ida C. Ward.* Published for the International Institute of African Languages and Culture. Cambridge: W. Heffer and Sons, 1944.

_____. "Polygamy in Mende Country." *Africa* 10 (1937).

Dabor, I. S., and F. K. Simbo. *Mende through Sentence Patterns.* Freetown: Peace Corps., n.d.

Dalby, David A. "An Investigation into the Mende Syllabary of Kisimi Kamara." *Sierra Leone Studies*, n.s. 19 (July 1966).

_____. "Lexical Analysis in Temne with an Illustrative Word List." *Journal of West African Languages* 3, no. 2 (July 1966).

Dawson, John L. M. "Therapeutic Functions of Social Groups in Sierra Leone." *Bulletin of the British Psychological Society* 17, no. 56 (1964).

_____. "Traditional Concepts of Mental Health in Sierra Leone." *Sierra Leone Studies*, n.s. 18 (1966).

Deighton, F. C. *Vernacular Botanical Vocabulary for Sierra Leone.* Freetown: The Government Printing Department, 1957.

Dorjahn, Vernon R., and Barry L. Isaac, eds. *Essays on the Economic Anthropology of Liberia and Sierra Leone.* Liberian Studies Monograph Series, no. 6. Philadelphia: Institute for Liberian Studies, 1979.

Easmon, M. C. F. "Madam Yoko, Ruler of the Mendi Confederacy." *Sierra Leone Studies*, n.s. 11 (December 1958).

_____. *Sierra Leone Country Cloths.* London: British Empire Exhibition, 1924.

Eberl-Elber, Ralph. "Two Mende Tales." *Bulletin of the School of Oriental and African Studies* 10 (1940).

————. *Westafrikas letztes Rätsel: Erlebnisbericht über die Forschungsreise 1935 durch Sierra Leone.* Salzburg: Bergland-Buch, 1936.

Ellis, A. B. *The Land of Fetish.* London: Chapman and Hall, 1883.

Fagg, William. *Afro-Portuguese Ivories.* London: Batchworth Press, 1959.

Fenton, J. S. "Characters in Mende Stories." *Sierra Leone Studies* 15 (1929).

Fitzjohn, William H. "A Village in Sierra Leone." *Sierra Leone Studies,* n.s. 7 (1956).

Foray, Cyril P. *Historical Dictionary of Sierra Leone.* African Historical Dictionaries, no. 12. Metuchen, N.J.: Scarecrow Press, 1977.

Fyfe, Christopher. *A History of Sierra Leone.* London: Oxford University Press, 1962.

————, and Eldred Jones, eds. *Freetown: A Symposium.* Freetown: Sierra Leone University Press, 1968.

Fyle, C. Magbaily. *Almamy Suluku of Sierra Leone, c. 1820–1906: The Dynamics of Political Leadership in Pre-Colonial Sierra Leone.* London: Evans Brothers, 1979.

————. *The History of Sierra Leone: A Concise Introduction.* London: Evans Brothers, 1981.

————. "Research Note on Segmentation and Succession in Upper Guinea." *Africana Research Bulletin* 4, no. 3 (April 1973).

Gamble, David. "Family Organization in New Towns in Sierra Leone." In *Urbanization in African Social Change,* edited by Malcolm Ruel. Edinburgh: Center of African Studies, Edinburgh University, 1963.

Ganga, Raymond C. "Mende Chieftancy in Nineteenth Century Jaima." *Africana Research Bulletin* 3, no. 4, 1972–73 (July 1973).

Gervis, Pearce. *Sierra Leone Story.* London: Cassell, 1952.

Goddard, T. N. *The Handbook of Sierra Leone.* London: Grant Richards, 1925.

Gorvie, Max. *Old and New in Sierra Leone.* London: United Society for Christian Literature by the Lutterworth Press, 1945.

Gower, Tess. *Art of the Mende from Sierra Leone: The Guy Massie-Taylor Collection.* Glasgow: City Museum and Art Gallery, 1980.

Grottanelli, Vinigi L. "Discovery of a Masterpiece: A Sixteenth-Century Ivory Bowl from Sierra Leone." *African Arts* 8, no. 4 (Summer 1975).

Hair, P. E. H. "A Bibliography of the Mende Language." *Sierra Leone Review,* no. 1 (1962).

————. "Early Sources on Religion and Social Values in the Sierra Leone Region: (1) Cadamosto 1463." *The Sierra Leone Bulletin of Religion* 2 (1969).

————. "Early Sources on Religion and Social Values in the Sierra Leone Region: (2) Eustache de la Fosse 1480." *Africana Research Bulletin* 4, no. 3 (April 1973).

————. "An Ethnolinguistic Inventory of the Lower Guinea Coast before 1700— Part I." *African Language Review* 7 (1968).

————. "An Ethnolinguistic Inventory of the Upper Guinea Coast before 1700." *African Language Review* 6 (1967).

————. "Material on Religion in Sierra Leone before 1780." *Sierra Leone Studies,* n.s. 21 (July 1967).

————. "Sierra Leone in the Portuguese Books of Complaint, 1567–1568." *Sierra Leone Studies,* n.s. 26 (January 1970).

————. "Sierra Leone Items in the Gullah Dialect of American English." *Sierra Leone Language Review* 4 (1965).

Hall, H. U. *The Sherbro of Sierra Leone.* Philadelphia: University of Pennsylvania Museum, 1938.

Hargreaves, J. D. "The Establishment of the Sierra Leone Protectorate." *Cambridge Historical Journal* 2, no. 1 (1956).

Harnetty, E. "Some Native Proverbs Revised." *Sierra Leone Studies* 9 (1927).

Harris, W. T. "Ceremonies and Stories Connected with Trees, Rivers and Hills in the Protectorate of Sierra Leone." *Sierra Leone Studies*, n.s. 2 (1954).

———. "How the Mende People First Started to Pray to Ngewȯ." *Sierra Leone Bulletin of Religion* 5, no. 2 (1963).

———. "The Idea of God among the Mende." In *African Ideas of God*, edited by Edwin Smith. London: Edinburgh House Press, 1950.

———. "Ngewȯ and Leve." *Sierra Leone Bulletin of Religion* 5, nos. 1 and 2 (1963).

———, and Harry Sawyerr. *The Springs of Mende Relief and Conduct*. Freetown: Sierra Leone University Press, 1968.

Hill, Matthew H. "Towards a Cultural Sequence for Southern Sierra Leone." *Africana Research Bulletin* 1, no. 2, 1970–71 (January 1971).

Hinckley, Priscilla. *The Sowo Mask: A Symbol of Sisterhood*. Brookline, Mass.: African Studies Center, Boston University, 1980.

Hoffer, Carol P. "Madam Yoko: Ruler of the Kpa-Mende Confederacy." In *Woman, Culture, and Society*, edited by M. Rosaldo and L. Lamphere. Stanford: Stanford University Press, 1974.

———. "Mende and Sherbro Women in High Office." *Canadian Journal of African Studies* 6, no. 2 (1972).

Hofstra, Sjoerd. "The Ancestral Spirits of the Mendi." *Internationales Archiv für Ethnographie* (Leiden) 39 (1941).

———. "The Belief among the Mendi in Non-Ancestral Spirits and Its Relation to a Case of Parricide." *Internationales Archiv für Ethnographie* (Leiden) 40, nos. 5–6 (1942).

———. "Personality and Differentiation in the Political Life of the Mendi." *Africa* 10, no. 4 (1940).

———. "The Social Significance of the Oil Palm in the Life of the Mendi." *Internationales Archiv für Ethnographie* (Leiden) 34, nos. 5, 6 (1937).

Hollins, N. C. "A Short History of Luawa Chiefdom." *Sierra Leone Studies*, n.s. 14 (1929).

Hommel, William L. *Art of the Mende*. College Park: University of Maryland Press, 1974.

Hornell, J. "The Indigenous Fishing Methods of Sierra Leone." *Sierra Leone Studies* 13 (1928).

Innes, Gordon. "The Function of Song in Mende Folktales." *Sierra Leone Language Review*, no. 4 (1965).

———. *A Mende-English Dictionary*. Cambridge: Cambridge University Press, 1969.

———. *A Mende Grammar*. London: Macmillan, 1962.

———. "A Note on Mende and Kono Personal Names." *Sierra Leone Language Review*, no. 5 (1966).

———. *A Practical Introduction to Mende*. London: School of Oriental and African Studies, University of London, 1967.

———. "Some Features of Theme and Style of Mende Folktales." *Sierra Leone Language Review*, no. 3 (1964).

———. *The Structure of Sentences in Mende*. London: School of Oriental and African Studies, University of London, 1963.

Jedrej, M. C. "An Analytical Note on the Land and Spirits of the Sewa Mende." *Africa* 44 (1974).

———. "Medicine, Fetish and Secret Society in a West African Culture." *Africa* 46, no. 3 (1976).

———. "Structural Aspects of a West African Secret Society." *Journal of Anthropological Research* (formerly *Southwestern Journal of Anthropology*) 32, no. 3 (Fall 1976), University of New Mexico, Albuquerque.

Jellicoe, Marguerite R. "Women's Groups in Sierra Leone." *African Women* 1, no. 2 (June 1955).

Joyce, T. A. "Steatite Figures from Sierra Leone in the British Museum." *Man* 9 (1909).

———. "Steatite Figures from West Africa in the British Museum." *Man* 5 (1905).

Kaplan, Irving, et al. *Area Handbook for Sierra Leone.* Washington, D.C.: U.S. Government Printing Office, 1976.

Kargbo, Kolosa John (author and director). *Strange the Sudden Change: A Tragic Bundo Society Ritual.* Baranta Actors Tiata, British Council Theatre, Freetown, 12 April 1976.

Kilson, Marion de B. "Mende Folk Tales" (in two parts). *West African Review* 31 (Dec. 1960) and 32 (Jan.-Feb. 1961).

———. *Royal Antelope and Spider: West African Mende Tales.* Cambridge, Mass.: The Press of the Langdon Associates, 1976.

———. "Social Relationships in Mende Dòmèisia." *Sierra Leone Studies,* n.s. 15 (1961).

———. "Supernatural Beings in Mende Dòmèisia." *Sierra Leone Bulletin of Religion* 3 (1961).

Kilson, Martin. *Political Change in a West African State: A Study of the Modernization Process in Sierra Leone.* Cambridge, Mass.: Harvard University Press, 1966.

———. "The Pragmatic-Pluralistic Pattern: Sierra Leone." In *Political Parties and National Integration in Tropical Africa,* edited by James S. Coleman and Carl G. Rosberg. Berkeley and Los Angeles: University of California Press, 1964.

Kup, A. Peter. *A History of Sierra Leone, 1400–1787.* Cambridge: Cambridge University Press, 1961.

Lamp, Frederick. "Frogs into Princes: The Temne Rabai Initiation." *African Arts* 12, no. 2 (1978).

Lewis, R. *Sierra Leone: A Modern Portrait.* London: Her Majesty's Stationer's Office, 1954.

Little, Kenneth. "The Changing Position of Women in the Sierra Leone Protectorate." *Africa* 18, no. 1 (January 1948).

———. "Conflict and Social Pressures in Sierra Leone." *Crown Colonists* (1947).

———. "The Function of Medicine in Mende Society." *Man* 48 (1948).

———. "The Mende Chiefdoms of Sierra Leone." In *West African Kingdoms in the Nineteenth Century,* edited by P. M. Kaberry and C. D. Forde. London: Oxford University Press, 1967.

———. "The Mende Farming Household." *Sociological Review* 40 (1948).

———. "A Mende Musician Sings of His Adventures." *Man* 48 (March 1948).

———. "Mende Political Institutions in Transition." *Africa* 17, no. 1 (January 1947).

———. "The Mende in Sierra Leone." In *African Worlds,* edited by D. Forde. London: Oxford University Press, 1954.

_____. *The Mende of Sierra Leone: A West African People in Transition.* London: Routledge and Kegan Paul, 1967 (also 1951).

_____. "A Moslem 'Missionary' in Mendeland." *Man* 47 (August 1947).

_____. "The Political Function of the Poro: Part I." *Africa* 35, no. 4 (1965).

_____. "The Political Function of the Poro: Part II." *Africa* 36, no. 1 (1966).

_____. "The Poro Society as an Arbiter of Culture: A Note on Cultural Inter-Penetration." *African Studies* 7, no. 1 (March 1948).

_____. "The Role of the Secret Society in Cultural Specialization." *American Anthropologist* n.s. 51, no. 2 (1949).

_____. "Social Change and Social Class in the Sierra Leone Protectorate." *American Journal of Sociology* (July 1948).

_____. "Structural Change in the Sierra Leone Protectorate." *Africa* 25, no. 3 (1955).

Littlejohn, James. "The Temne *Ansasa.*" *Sierra Leone Studies,* n.s. 13 (1960).

_____. "The Temne House." *Sierra Leone Studies,* n.s. 14 (1960).

Luke, H. C. *A Bibliography of Sierra Leone.* London: Oxford University Press, 1925.

MacCormack, Carol P. "Biologic Events and Cultural Control." *Signs: Journal of Women in Culture and Society* 3, no. 1 (Autumn 1977).

_____. "The Compound Head: Structure and Strategies." *Africana Research Bulletin,* no. 9 (1979).

_____. "Sande: The Public Face of a Secret Society." In *The New Religions of Africa,* edited by B. Jules-Rosette. Norwood, N.J.: Ablex Press, 1979.

_____. "Sande Women and Political Power in Sierra Leone." *West African Journal of Sociology and Political Science* 1, no. 1 (1975).

_____. "Wono: Institutionalized Dependency in Sherbro Descent Groups." In *Slavery in Africa: Historical and Anthropological Perspectives,* edited by Suzanne Miers and Igor Kopytoff. Madison: The University of Wisconsin Press, 1977.

McCulloch, Merran. *The Peoples of Sierra Leone Protectorate.* London: International African Institute, 1950.

Mansaray, Musa. *Practical Krio.* Freetown: The Peace Corps, n.d.

Margai, Sir Milton A. S. "Welfare Work in a Secret Society." *African Affairs* 47, no. 189 (March 1948).

Martin, F. J. *A Preliminary Study of the Vegetation of Sierra Leone.* Freetown: Government Printer, 1948.

Matthews, John (Lt.). *A Voyage to the River Sierra Leone.* London: B. White and Son, 1788.

Mauny, R. "Masques Mende de la société Bundu." *Notes Africaines,* I.F.A.N., no. 81 (1959).

Menzies, A. "Exploratory Expedition to the Mende Country." *Church Missionary Intelligencer,* 1868.

Michel, H. "Some Notes on the Mende Language and Customs." *Sierra Leone Studies* 3 (1920).

Migeod, F. W. H. "A Mende Dance." *Man* 17 (1917).

_____. "Mende Drum Signals." *Man* 20 (March 1920).

_____. *The Mende Language.* London: Kegan Paul, Trench, Trübner & Co., 1908.

_____. "Mende Songs." *Man* 16, no. 112 (1916).

_____. "The Poro Society: The Building of the Poro House and Making of the Image." *Man* 16 (1916).

————. *A View of Sierra Leone*. London: Kegan Paul, Trench, Trübner & Co., 1926. (Also, New York: Brentano's, 1927.)

Milburn, S. "Kisimi Kamara and the Mende Script." *Sierra Leone Language Review* 3 (1964).

Mitchell, Peter K. "A Note on the Distribution in Sierra Leone of Literacy in Arabic, Mende, and Temne." *African Language Review,* no. 7 (1968).

————. "Trade Routes of the Early Sierra Leone Protectorate." *Sierra Leone Studies,* n.s. 16 (1962).

Moity, Marcel. "Notes sur les Mani (Guinée française)." *Bulletin I.F.A.N.* 19 (1957).

Mu Jaleisia Lëenga. Bo: The Provincial Literature Bureau, 1966.

Mu Mèhèè. Bo: The Protectorate Literature Bureau, 1960.

Ndanema, Isaac. "The Rationale of Mende 'Swears.'" *Sierra Leone Bulletin of Religion* 6, no. 2 (1964).

N'Diaye, Samba. "Masques d'ancêtres de la Société Poro de Sierra Leone." *Notes Africaines,* no. 103 (1964).

Newland, H. Osman. *Sierra Leone: Its People, Products, and Secret Societies*. London: John Bale, Sons and Danielsson, 1916.

Newman, Thomas M. "Archaeological Survey of Sierra Leone." *The West African Archaeological Newsletter,* no. 4 (March 1966).

Person, Yves. "Ethnic Movements and Acculturation in Upper Guinea since the Fifteenth Century." *The International Journal of African Historical Studies* (Boston University) 4, no. 3 (1971).

————. "Les Kissi et leurs statuettes de pierre dans le cadre de l'histoire ouest-africaine." *Bulletin de I.F.A.N.,* series B, Sciences Humaines, vol. 23, nos. 1–2 (1961).

Peterson, John. *Province of Freedom: A History of Sierra Leone 1787–1870*. Evanston, Ill.: Northwestern University Press, 1969.

Phillips, Ruth B. "The Iconography of the Mende *Sowei* Mask." *Ethnologische Zeitschrift Zürich* 1 (1980).

————. "Masking in Mende Society Initiation Rituals." *Africa* 48, no. 3 (1978).

————. "The Vai Women's Society Mask." Paper submitted to the Manding Conference, School of Oriental and African Studies, University of London, June 1972.

Quilliam, A. "A Chapter in the History of Sierra Leone." *Journal of the African Society,* no. 9 (1903).

Ranson, Harry. "The Growth of Moyamba." *The Bulletin (Journal of the Sierra Leone Geographical Association),* no. 9 (1965).

Reeck, Darrell. *Deep Mende: Religious Interactions in a Changing African Rural Society*. Studies on Religion in Africa, no. 4. Leiden: Brill, 1976.

Richards, Josephus V. O. "The Sande: A Socio-Cultural Organization in the Mende Community in Sierra Leone." *Baessler-Archiv,* vol. 22, no. 2 (1974).

————. "The *Sande* and Some of the Forces That Inspired Its Creation or Adoption with Some References to the Poro." *Journal of Asian and African Studies* 8, nos. 1–2 (Jan.-April 1973).

Riddell, J. Barry. *The Spatial Dynamics of Modernization in Sierra Leone: Structure, Diffusion and Response*. Evanston, Ill.: Northwestern University Press, 1970.

Rodney, Walter. *A History of the Upper Guinea Coast, 1545–1800*. Oxford: Clarendon Press, 1970.

_____. "A Reconsideration of the Mane Invasions of Sierra Leone." *Journal of African History* 8, no. 2 (1967).

Rosen, David M. "Some Aspects of the Status of Women in Kono Society." *Africana Research Bulletin* 2, no. 1, 1971–72 (October 1971).

Ryder, A. F. C. "A Note on the Afro-Portuguese Ivories." *Journal of African History* 3 (1964).

Sawyerr, Harry. "Ancestor Worship—the Mechanics." *Sierra Leone Bulletin of Religion* 6, no. 2 (December 1964).

_____. "Do Africans Believe in God?" *Sierra Leone Studies*, n.s. 15 (1961).

_____. *God—Ancestor or Creator: Aspects of Traditional Belief in Ghana, Nigeria and Sierra Leone.* London: Longmans, 1970.

_____, and S. K. Todd. "The Significance of the Numbers Three and Four among the Mende of Sierra Leone." *Sierra Leone Studies*, n.s. 26 (January 1970).

Schurtz, Heinrich. *Alterklasses und Mannerbünde: Eine Darstellung der Grundformen der Gesellschaft.* Berlin: G. Reimer, 1902.

Senior, M. Mary. "Some Mende Proverbs." *Africa* 17 (1947).

Siegmann, William, and Judith Perani. "Men's Masquerades of Sierra Leone and Liberia." *African Arts* 9, no. 3 (April 1976).

Sierra Leone National Dance Troupe. *An Evening with the Sierra Leone National Troupe Programme.* Freetown: The British Council, 1965.

Spears, Richard. *Basic Course in Mende.* Evanston, Ill.: Northwestern University Press, 1967.

Staub, Jules. *Beiträge zur Kenntnis der Materiellen Kultur der Mendi in der Sierra Leone.* Solothurn: Vogt-Schild, 1936.

Sumner, A. T. *A Handbook of the Mende Language.* Freetown: Government Printing Office, 1917.

_____, and R. F. Hunter. "Names of Diseases in Mendi." *Sierra Leone Studies* (1922).

Tagliaferri, Aldo, and Arno Hammacher. *Fabulous Ancestors: Stone Carvings from Sierra Leone and Guinea.* New York: Africana Publishing Co., 1974.

Thomas, Northcote W. *Anthropological Report on Sierra Leone,* parts 1, 2, and 3. London: Harrison and Sons, 1916.

Thompson, George. *Thompson in Africa: An Account of the Missionary Labors, etc., of George Thompson in Western Africa at the Mendi Mission.* 2d ed. New York: Printed for the author, 1852.

Thompson, J. S. T., ed. *Sierra Leone's Past: Books, Periodicals, Pamphlets and Microfilms in Fourah Bay College Library.* [Freetown?], 1971.

Timothy, Bankole. "Sierra Leone's Women in the Lead." *West Africa,* 14 April 1975.

van der Laan, H. L. *The Lebanese Traders in Sierra Leone.* The Hague: Mouton, 1975.

_____. *The Sierra Leone Diamonds: An Economic Study Covering the Years 1952–1961.* London: Oxford University Press, 1965.

Van Oven, Cootje. "The *Kondi* of Sierra Leone." *African Music: Journal of the African Music Society.* Tear sheet, n.d.

_____. "Music of Sierra Leone." *African Arts* 3, no. 4 (1970).

Vergette, E. D. *Certain Marriage Customs of Some of the Tribes in the Protectorate of Sierra Leone.* Freetown: Government Printer, 1917.

Vivian, William. "The Mendi Country, and Some of the Customs and Charac-

teristics of Its People." *The Journal of the Manchester Geographical Society* 12 (1896).

———. "The Missionary in West Africa." *Journal of the African Society* 3 (1896).

———. "A Visit to Mendeland." *Journal of the Manchester Geographical Society* 12 (1896).

Wallis, C. Braithwaite. *The Advance of our West African Empire*. London: T. Fischer Unwin, 1903.

———. "In the Courts of the Native Chiefs of Mendeland." *Journal of the African Society* 4 (1905).

———. "The Poro of the Mende." *Journal of the African Society* 4 (1905).

———. "Tribal Laws of the Mende." *Journal of Comparative Legislation* 3 (1921).

Warren, Harold G. "Secret Societism." *Sierra Leone Studies*, nos. 1–3 (1926).

Watkins, H. H. "The West African Bush School." *American Journal of Sociology* 48, no. 6 (1943).

Welmers, W. E. "The Mande Languages." In *Report of the 9th Annual Round Table Meeting on Linguistics and Language Studies*. Georgetown University Institute of Languages and Linguistics. Washington, D.C.: Georgetown University Press, 1958.

Westermann, Diedrich. "Samba, un Mende de Sierra Leone, Paysan et Soldat." In his *Autobiographies d'Africains*. Paris: Payot, 1943.

Williams, Geoffrey J. *A Bibliography of Sierra Leone 1925–1967*. New York: Africana Publishing Corporation, 1970.

Winch, J. M. "Religious Attitudes of the Mende towards Land." *Africana Research Bulletin* 2 (1971).

Wright, A. R. "Secret Societies and Fetishism in Sierra Leone." *Folklore* 18 (1907).

Wright, E. J. "Psychotherapy and Witchcraft." *Sierra Leone Studies*, no. 21 (1939).

Wylie, Kenneth Charles. *The Political Kingdoms of the Temne: Temne Government in Sierra Leone*. New York: Africana Publishing Co., 1977.

Zeller, R. *Die Bundu-Gesellschaft: Ein Geheimbund der Sierra Leone*. Bern: Jahresbericht des historischen Museums, 1912.

NOTE ON ILLUSTRATIONS

Most of the photographs for *Radiance from the Waters* were taken on location in Sierra Leone by the talented photographer Rebecca Busselle. I was fortunate in having from her a marvelous choice of images that so well illustrate the ideas and concepts of this book; I feel that the aesthetic arguments made by the text are amply supported by her pictures. Specifically, the Busselle photographs are figures 3–8, 10–15, 17–30, 32–35, 38–53, 56, 59–66, 68, 69, 71, 72, 77, 81–83, 86–92. I appreciate her fine contribution to this work.

Grateful acknowledgment is made to several individuals and institutions for kind permission to use their materials. Priscilla Hinckley, Ed.D., provided the drawings for figures 54, 55, 57, 74, 75, 78–80, and 84. They correspond to figures 76, 30, 13b, 7a, 19, 16, 40, and 35, from her monograph, *The Sowo Mask: Symbol of Sisterhood* (1980). Figure 85 is from the collection of the Brooklyn Museum: "object #69.39.2, Sierra Leone, Mende, late 19th century, early 20th century; black stained wood helmet mask of female with European style crown as headdress, supposedly taken from coins of Queen Victoria; ht.- 40.6 cm; the Brooklyn Museum, Exchange." The photograph for figure 58 of "Mende, Sowei Masks, Bundu Dancers" was taken in Kenema, Sierra Leone, in 1973 by William L. Hommel, Ph.D. Figure 1, "The Mende Script," is from S. Milburn, "Kisimi Kamara and the Mende Script," *Sierra Leone Language Review,* no. 3 (1964), p. 21. Pamela S. Baldwin drew the map for figure 2. The remaining illustrations are photographs by the author. All masks pictured are Mende Sande Sowo wooden helmet masks, stained and polished black, approximately 14–18 inches in height, dated twentieth century and contemporary.

 Index